SEMANTICS AND THE BODY:
MEANING FROM FREGE TO THE POSTMODERN

In traditional semantics, the human body tends to be ignored in the process of constructing meaning. Horst Ruthrof argues, by contrast, that the body is an integral part of this hermeneutic activity. Strictly language-based theories, and theories which conflate formal and natural languages, run into problems when they describe how we communicate in cultural settings. *Semantics and the Body* proposes that language is no more than a symbolic grid which does not signify at all unless it is brought to life by non-linguistic signs.

Ruthrof reviews and analyses various 'orthodox' theories of meaning, from the views of Gottlob Frege at the beginning of the twentieth century to those of theorists in the postmodern period, then offers an alternative approach of his own. His theory features 'corporeal semantics,' and holds that meaning has ultimately to do with the body and that the meaning of linguistic expressions is indeterminate without the aid of visual, tactile, olfactory, and other bodily signs. This approach also remedies what Ruthrof sees as a loss of interpretive will in the postmodern era.

Pedagogy in many fields could be enriched by a systematic integration of non-verbal semiosis into the linguistically dominated syllabus. Those involved in discourse analysis, literature, art criticism, film theory, pedagogy, and philosophy will find the implications of Ruthrof's study considerable.

HORST RUTHROF is a professor in the Department of English and Comparative Literature at Murdoch University, Western Australia.

HORST RUTHROF

Semantics and the Body: Meaning from Frege to the Postmodern

UNIVERSITY OF TORONTO PRESS
Toronto Buffalo London

© University of Toronto Press Incorporated 1997
Toronto Buffalo London
Printed in Canada

ISBN 0-8020-4151-5 (cloth)
ISBN 0-8020-7993-8 (paper)

Toronto Studies in Semiotics
Editors: Marcel Danesi, Umberto Eco, Paul Perron, and Thomas A. Sebeok

Printed on acid-free paper

Canadian Cataloguing in Publication Data

Ruthrof, Horst
 Semantics and the body: meaning from Frege to the
 postmodern

 (Toronto studies in semiotics)
 Includes bibliographical references and index.
 ISBN 0-8020-4151-5 (bound) ISBN 0-8020-7993-8 (pbk.)

 1. Semantics. 2. Nonverbal communication. I. Title.
 II. Series.

 P325.R88 1997 401'.43 C97-931222-1

University of Toronto Press acknowledges the financial assistance to its publishing
program of the Canada Council and the Ontario Arts Council.

To Guy Butler, for his contributions to interpretation
and his encouragement of young colleagues

The idealist language is made up of hypostatized significations. But every time we will be asked about signifieds such as 'what is Beauty, Justice, Man?' we will respond by designating a body which can be imitated or even consumed.

<div align="right">Gilles Deleuze, The Logic of Sense</div>

Contents

PREFACE xi

ACKNOWLEDGMENTS XV

Introduction: The Missing Body in Semantics 3

1 Towards a Corporeal Semantics 23

 1.1 An Alternative Route to Meaning 23
 1.2 Meaning: An Intersemiotic Perspective 32

2 Natural Language and Meaning as Definition 53

 2.1 The Conflation of Two Kinds of Sense 53
 2.2 Frege's Error 59
 2.3 Carnap's Sleight of Hand 76

3 The Semantics of Negation and Metaphor 107

 3.1 Two Bugbears for Formalization 107
 3.2 Negation: From Frege to Freud and Beyond 112
 3.3 Metaphor: Heterosemiotic Pathway to Meaning 144

4 Meaning and Poststructuralism 176

 4.1 Transcendental Moves 176
 4.2 The Differend and Semantics 183
 4.3 Différance: Meaning and Transcendental Procedure 199

5 Semantics and the Postmodern 229

 5.1 The Postmodern Surface 229
 5.2 The Postmodern Conditions of Meaning 233

 Conclusion: The Corporeal Turn 254

NOTES 263

GLOSSARY 289

BIBLIOGRAPHY 295

INDEX 311

Preface

Why write a book about semantics and the body? One reason that comes readily to mind is my feeling of dissatisfaction with standard descriptions of meaning. This feeling appeared to increase gradually whenever I construed meanings in a non-habitual fashion, dabbled in translation, read poetry and novels, or merely lingered to explore meanings in ordinary social contexts. Once my suspicion strengthened that there might be something odd about the way meaning was described in standard accounts, I found it difficult to avoid testing the most trivial linguistic exchanges against that hunch. *Semantics and the Body* started as a guess, then turned into an obsession, which was exorcised in the end by the most gratifying research imaginable.

Dissatisfaction with traditional assumptions about meaning belongs perhaps to the broader background of methodological upheaval in the social sciences and humanities since the late 1960s. For as popular a book as *Writing Culture: The Poetics and Politics of Ethnography*, for instance, editors James Clifford and George E. Marcus chose as their focus a critical review of the methodological assumptions of ethnography and related disciplines. They saw cultural representation as inextricably tied to certain literary procedures, always contaminated by the fantasies of possible worlds and complicated by the intricacies of intrusive enunciative modalities. This is highly persuasive. What seems to have gone wrong in some of the contributions to *Writing Culture* is too radical a rejection of representation in all its forms. This is where the present study differs. Realist representation is regarded as only one candidate among many kinds of representation which I think are essential to all meaning acts in natural languages. Without them the link between verbal expressions and non-verbal signs, which I suggest is a sine qua non of meaning, cannot be achieved.

Much recent reorientation towards the body in critical theorizing owes a considerable debt to Maurice Merleau-Ponty. By shifting the focus from Husserl's phenomenology of idealization to the 'primacy of perception,' Merleau-Ponty initiated what I would like to call the 'corporeal turn.' However, he failed to draw the radical consequences from his central insight for the study of language, and so the description of linguistic meaning remains eidetic. By contrast *Semantics and the Body* places corporeality at the heart of semantics.

Who are the villains in my picture? They seem to turn up everywhere. From Gottlob Frege to Saul Kripke, from Ferdinand de Saussure to Jacques Lacan and Jean Baudrillard, we discover the fathers, sons, and daughters of the 'linguistic turn,' now gone berserk. As it turns out, Frege, the originator of the equivocation of formal sense and natural language sense, is less guilty than it would seem, since his main aim was the creation of a *Begriffsschrift*, a purely conceptual notation, rather than a theory of natural language. By contrast, Lacan has a lot to answer for. He misled an entire generation of feminist theorists and others into believing that the unconscious was nothing if not linguistic. In a less obvious sense, the emphasis on syntactic relations at the expense of semantics reappears in descriptions of the postmodern, notably in the surface metaphors of Baudrillard. I am not, of course, attacking the linguistic turn as 'a battle against the bewitchment of our intelligence by means of language.' What is being questioned is a certain blindness to the importance of non-verbal signs both within and without the linguistic.

I have chosen as the focus of my analysis the historical moment when Frege equated the formal sense of geometry with the sense expressions of natural language. This conflation can be traced to formal and syntactic convictions which curiously align the most divergent of theoretical discourses, from analytical philosophy to recent descriptions of the social. The formal bias appears in the flawed view that meaning is ruled by definitions as much as in the assumption that a string of surface phenomena of postmodern culture can provide a viable social description. Without a corporeal semantics, which restores the body to meaning, natural language itself and even less so the social can be theorized satisfactorily.

What I offer instead is an intersemiotic and heterosemiotic description of meaning as an event of linkage between different and only partially commensurate sign systems. Central to this position is the conception of meaning as the activation of linguistic expressions by way of haptic, olfactory, tactile, aural, visual, and other signs. This is argued to apply to all expressions, from the most 'concrete' to the most 'abstract' terms. As a consequence, *Semantics and the Body* revisits a number of orthodox notions, such as reference, synonymy, intension, extension, truth conditions, use, perception and 'world.' Three approaches to

meaning are taken to task: meaning as definition; meaning as a connection between language and a naturalistically given world; and meaning as the result of differential relations within language.

No full countertheory should be expected to emerge from these confrontations, but rather a different starting point and emphasis for semantic inquiry. Wherever the construction of meaning is at issue, the intersemiotic and heterosemiotic convictions which motivate this study are of relevance. If a semantics built on those principles is feasible, then its implications for language studies, discourse analysis, literature, art criticism, anthropology, pedagogy, and other hermeneutic disciplines will be considerable. *Semantics and the Body* is designed to reopen the question of semantics and suggest bridges across disciplinary divides.

Acknowledgments

I wish to thank many people for their inspiration and help: my students, my colleagues in our language sections for their help in chasing root metaphors of 'understanding' across cultures, Jenny de Reuck for reading an early draft of the book and making invaluable suggestions, John de Reuck for advice on questions of the metaphysical implications of semantics, Jeff Malpas for sticking to 'truth' in the face of my 'sufficient semiosis' as a cowardly alternative, Alec McHoul for his perspective from 'semiotic investigations,' Wojciech Kalaga for providing the Peircean view, Vijay Mishra for his insights in the literature of postcolonialism, and Niall Lucy for the clarity he brings to the distinctions between poststructuralism and the postmodern. For encouragement of my research I thank Thomas Sebeok, John Deely, Frederic Jameson, John Frow, Claire Colebrook, Carol Warren, and Ian Buchanan. Special thanks go to Mrs Diana Clegg for editing the final draft and to my family for their patience with their all too often absent-minded resident.

The following papers, which reappear in a modified form in this book, have been previously published. Part of Chapter 1 was published as 'Meaning and Intersemiotic Perspective' in *Semiotica* 104, 1/2 (1995): 23–43. A shorter version of section 2.2, 'Frege's Error,' appeared in *Philosophy Today* 37 (1993): 306–17. The same journal also brought out a version of section 3.2, 'Negation from Frege to Freud and Beyond,' in 39, 3/4 (1995): 219–44 and 'Differend and Agonistics: A Transcendental Argument?' in 36 (1992): 324–35, which forms part of 4.2. 'The Postmodern Conditions of Meaning,' which makes up part of Chapter 5, was offered as a plenary paper at a conference on 'Paradigms of Philosophizing' in St Petersburg in 1995. I thank the publishers for permission to include those materials in *Semantics and the Body*.

Part of the research for this book was carried out with the help of an ARC Large Grant from DEET in Canberra. The School of Humanities at Murdoch

University assisted with a number of smaller research grants, and the university allowed me to take research leave, during which I wrote a number of draft chapters. I gratefully acknowledge the generous assistance I have received.

Without the encouragement of Ron Schoeffel, Editor-in-Chief of the University of Toronto Press, and his editorial staff I could not have produced the book in its final form. In particular I wish to thank Camilla Jenkins for her meticulous and patient editorial input. Any shortcomings are certainly my own.

SEMANTICS AND THE BODY:
MEANING FROM FREGE TO THE POSTMODERN

Introduction:

The Missing Body in Semantics

Pending a satisfactory explanation of the notion of meaning, linguists in semantic fields are in the situation of not knowing what they are talking about.

Willard Van Orman Quine, 'The Problem of Meaning in Linguistics'

The Body

Any semantics which is to give a satisfactory explanation of how we grasp our world by means of language must find a niche for corporeality. Theories of language which emphasize linguistic idealization in matters semantic produce a semantics without bodies, both in terms of the body to be understood and of the body that does the understanding. At the extreme end point of this tradition we find formal semantics; here the body is radically eliminated. In this sense, formal semantics is no more than a systematic alignment of two different versions of a syntax. So we can say that formal semantics = syntax1 + syntax2.

Attempts at 'reincorporating' the body into semantics face obstacles other than those of persuading formal semanticists. One appears to be the notion of the arbitrariness of signs, another the concept of figurality as an immanent feature of language. In the sense of the conventionally symbolic nature of language, the arbitrariness argument appears, for example, in John Locke, Charles Sanders Peirce, and Ferdinand de Saussure. For Locke, signification works 'not by any natural connexion between particular articulate sounds and certain ideas ... but by a voluntary imposition whereby such a word is made arbitrarily the mark of such an idea.'[1] And in 1885, well before Saussure, Peirce wrote that signs were, 'for the most part, conventional or arbitrary.' Words 'denote the objects that they do by virtue only of there being a habit that associates their significations with them.'[2] Saussure's radical emphasis on

arbitrariness is well canvassed and needs no reiteration. If we wish to adjust the wholesale notion of arbitrariness of signs, we are able to take our cue from Peirce's qualification; arbitrariness rules, he says, 'for the most part.' This allows for the view of arbitrariness as a graded scale from iconic signs, which can be minimally arbitrary, to symbolic, or fully arbitrary signs. Various kinds of visual and aural representations can be envisaged to explore the entire spectrum, while language is to be located towards the arbitrary end of the scale, with onomatopoeic expressions indicating a tenuous relation to iconicity. As I shall argue throughout, however, iconicity is not altogether absent even from the most arbitrary symbolic expressions of natural language. Indeed, what distinguishes natural languages from their artificial cousins is precisely the traces of iconicity which form a crucial aspect of the 'sense' of the former, while their lack defines the 'sense' of calculus.

Even so, arbitrariness enters signification 'earlier' than via Locke's 'voluntary imposition.' Significatory practices, such as the reading of visual or tactile clues, are not entirely matched to one another. There is no strict identity of our non-verbal readings of the 'world.' Rather, the impression of the cohesive 'picture' which emerges from them is the result of interpretive work. The merely relative commensurability of such significatory activities increases with the complexity of social semiosis, and what appears to be our 'natural' grasp of things is no less than the shrinking of negotiatory interpretation to habitual acts.

As for figuration, we can accept Paul de Man's observation in 'The Epistemology of Metaphor' of 'the futility of trying to repress the rhetorical structure of texts' to the extent that figuration cannot be removed from natural language in the hope of arriving at a Fregean *Begriffsschrift*, a purely conceptual notation.[3] Nor can rhetoric 'be isolated from its epistemological function however negative this function may be' (27). Hence whatever epistemological claims we make with the aid of language carry with them aspects of figuration, with the result of a forever figural ontic. In this sense, de Man rightly regards rhetoric not as a literary or historical but as 'an epistemological discipline' (28).

What de Man refers to as the position of 'cratylic delusion,' or iconic prejudice, however, is not the only alternative, nor is it as deluded as it is made out to be (14). A broader picture is needed here. From the perspective chosen in this study, de Man's approach, in spite of its figural leaning, profoundly reflects the convictions of the 'linguistic turn' since Frege, a preoccupation with the verbal to the exclusion of non-linguistic signs. The correction proposed is a 'corporeal turn,' which would permit the re-incorporation of non-verbal signification into the discussion of semantics. From this viewpoint, the cratylic delusion, which leads us to regard language as a symbolic economization

of non-verbal grasp, is no more problematic than the 'formal' prejudice introduced to the explanation of 'sense' by Frege. Put more positively, an emphasis on the corporeal aspects of semantic representation as *Vorstellungen* permits us to say something about the relation between the linguistic and the way in which we constitute the world non-verbally, that is, by bumping into 'it.'

In speaking of the body in semantics one cannot, of course, regard the corporeal in terms of a simple presence. Rather, the body has to be reinstated as a significatory necessity if we are to make sense of the links between linguistic signs and 'the world.' The quotation marks here are essential in that they indicate the danger of vicious circularity in the assumption that the 'world as given' provides the sought-after 'outside' of language, when we have not clarified how much this 'world' is construed by signification in the first place. Derrida's absent extra-text makes a similar point. 'Il n'y a pas de hors-texte' insists that we do not have available a non-significatory referent or 'the transcendental signified' that would permit the construal of a straightforward empirical relation between language and world.[4]

If the body is to be reinstated in semantics, the argument must also take into account the kind of argument that Jacques Derrida has put forward with respect to 'presence.' On this point, the present study is in partial agreement with Derrida, in as far as it can be consistently argued that there is no non-mediated reality, not even of the body. When he says that 'what opens meaning and language is writing as the disappearance of natural presence,' the emphasis on the necessity of mediation is convincing as long as we include in this our non-verbal significations, and especially our perceptual grasp.[5]

Derrida's critique of presence appears to be a much larger conceptual leap for readers with an empiricist philosophical background than for readers familiar with the Kantian and phenomenological traditions. Immanuel Kant's heuristic view of concepts, to be discussed later, had already undermined the idea of security in philosophical presentation and self-presentation by way of a critique of conceptual boundaries.[6] Furthermore, Kant acknowledges the possibility of the non-positive ground when he argues that 'since all division presupposes a concept to be divided, a still higher one is required, and this is the concept of an object in general, taken problematically, without its having been decided whether it is something or nothing.'[7] And for Edmund Husserl, the target of Derrida's critique in *Speech and Phenomena*, the 'pure now' is no more than an 'ideal limit, something abstract which can be nothing for itself.'[8] When Derrida rejects the notion of presence, then, he cannot be attacking a philosophical belief in the actual positivity of presence but rather its already qualified and merely heuristic version. What he seems to be saying is that even

a merely heuristic use of presence blinds us to the fundamental non-presence of differential relations as the more promising pathway of inquiry.

In this sense, the body 'is not absent' for Derrida when he reads Plato or Descartes. It appears as 'ineluctable, undeniable, and passionate.'[9] Yet the body is 'an experience in the most unstable [*voyageur*] sense of the term; it is an experience of frames, of dehiscence, of dislocation' (15). If bodies were present in any straightforward sense, 'presence would mean death' (16). What we take as 'the thereness, the being there [*l'être-la*], only exists on the basis of this work of traces that dislocates itself' (16). As Derrida himself says, not much has changed in this respect in his writing. 'It is as if all that I have been suggesting for the past twenty-five years is prescribed by the idea of *destinerrance*' which includes 'the supplement, the pharmakon,' in short, 'all the undecidables' (12). The present book shares Derrida's post-Kantian emphasis on the instability of all our constructions, whether verbal or non-verbal.

Yet this study reverses another aspect of Derrida's theorizing. Whenever we read the non-linguistic, says Derrida, as we do in pictures, sculptures, or architecture, we 'interpret them as potential discourse' (13). In the kind of semantics I envisage, the process of transforming non-verbal signification into language is not disputed, but I want to highlight the converse. Instead of Derrida's movement, by way of deconstructive strategies, from the authority of an 'untouchable, monumental, inaccessible presence' to the liberating relativization of linguistic discourse, I foreground the inverse relationship. Linguistic meaning is possible only because expressions are no more than directional schemata activated by means of non-verbal signification. So when Derrida observes that 'the effect of spacing already implies textualization' (15), I would say yes, and add, 'and vice versa,' since all linguistic textualization relies not only on the possibility of spacing but also on the tactile, the haptic, and all other non-verbal interpretations. In short, language relies on intersemiotic relations. No matter how symbolic natural language may appear to us, it always carries the iconic traces of its fundamental link to the non-verbal. These traces do not constitute any sort of presence, nor are their relations homogeneous. Largely heterogeneous, and drawing on signs from diverse and conflicting systems, this iconicity is a necessary condition of meaning not only in so-called concrete but also in the most abstract expressions of natural languages. This is the heterosemiotic nature of linguistic meaning.

The body thus re-enters semantics in a twofold sense. First, it does so as the fleeting and differential mental–material content of semantic realization. This is the body, including our own, as 'world' and background. In this sense there appears the starkest possible separation of formal semantics from natural language semantics. In the former, there is no body, only a second syntax

systematically affiliated with the first. In the latter the rule holds that without body there is no meaning. Second, the body re-enters semantics as the epistemic apparatus, with its tactile, visual, olfactory, and all those other significations with which we constitute the 'world' within inferable limits. Both subjectivist mentalist and deterministic biologist readings will have to be avoided in this account, the first by stressing community constraints and the second by an emphasis on socially overdetermined interpretations rather than on sensory mechanisms. What will emerge are conditions for a semantics at odds with a number of orthodoxies.

Between Sufficient and Insufficient Reason

An alternative title for this book could have been 'Metasemantics,' to suggest its concern with the foundations of different ways in which one can theorize meaning. But then the task would have required either giving a fair hearing to a large body of works on semantics or restricting the argument to a formally tight analysis of the main premises of competing theories. The first task proved too large; the second demanded an author better trained in formal semantics. I therefore opted for an altogether different strategy, with two primary aims. The first is to offer an alternative approach to standard descriptions of meaning, entitled intersemiotic semantics and sometimes heterosemiotic semantics. In summary the terms suggest that meaning has ultimately to do with the body and that linguistic expressions mean anything or nothing at all unless they are activated by haptic, visual, tactile, gustatory, olfactory, and other non-verbal signs. Their interaction is marked by the term 'intersemiotic,' and the fact that they are not homogeneous by the term 'heterosemiotic.' Accordingly, there is no meaning in language and there are no meanings in dictionaries. Every phrase in the dictionary itself requires a semantics. The second major aim is to identify the Fregean conflation of natural language sense with formal sense and to trace its influence through a number of theories of meaning, including some recent theories of the postmodern. Despite this, I do not side simply with theories opposed to analytically informed semantics, nor do I underestimate the quality of Frege's thinking. Frege's achievements are beyond doubt, and in any case his main aim was not to offer a natural language semantics but rather to demonstrate the logical conditions for a semantics compatible with his *Begriffsschrift*. Yet as Alberto Coffa has pointed out, Frege's aim was always to go beyond a mere logical syntax and to focus on the expression: 'I had in mind the *expression of content* ... But the content must be given more precisely than in a natural language.' Coffa goes on to draw our attention to the distinction between a merely formal goal, such as Boole's logic, and Frege's attempts at

making more precise 'the relations between signs and the relations between the things themselves.'[10] As Frege formulates his intention in the *Begriffsschrift*, 'I did not want to represent an abstract logic in formulas, but to express a content through written signs in a more precise and surveyable fashion.'[11]

This is why Frege is crucial to this book. Logicians who address no more than the internal operations of their calculus are of no consequence for natural language semantics. Only where logical syntax makes claims about non-syntactic relations – that is, relations between the contents of the 'world' at large – is it of interest to our project; and Frege was instrumental in theorizing some such relations. A specific move in Frege's arguments concerning sense and the consequences of this move in the literature are at issue. I also ask what happens to the notion of meaning in the writings of some prominent poststructuralists. Throughout, the common thread is the intersemiotic starting point, which acts as the background against which I review a variety of semantic descriptions and their presuppositions. In this, the intersemiotic project offered is a proposal and a question to those interested in how meaning has been defined rather than a fully worked-out theory.

The present study resumes an investigation of questions and issues scattered over previous writings: the predominance of the presentational process over the presented world; appresentation and concretization (1981); the topic of inferable modality (1984, 1988); the destabilization of meaning (1986); an engagement with *différance* (1988); the digital as a kind of syntax (1990); the directionality of meaning; three kinds of opacity; the reversed sequence from saturated discourse to the formal, instead of the traditional movement from the formal to discursive complexities; the semiotic redefinition of meaning and reference; and, above all, the intersemiotic corroboration thesis (1992).[12] As in those previous studies, my indebtedness to other sources is large: to English literature as the trigger of my discontent with the prescriptions of meaning which literary readers have to live with; to Husserl, Heidegger, Schutz, and Ingarden; to Leibniz, Kant, and the hermeneutic tradition; to Locke, Peirce, Quine, and Davidson; and to Lyotard and Derrida.

Today's competing doctrines of meaning bear the traces of their philosophical roots. From the perspective of a metasemantics or the manner in which different kinds of semantics justify their basic assumptions, two broad polarities of heritage are visible. Simplifying them, one could suggest that one takes its cues primarily from analyticity, in particular the pioneering work of Gottlob Frege, and that the other does so from the elaboration of reflective reasoning, and more specifically from the hermeneutic tradition. These poles should not, however, suggest a simple binary divide but rather a broad spectrum of different kinds of semantics, some of which tend to be more easily associated with

formal procedures and Leibniz's 'sufficient reason,' and others of which have as their base conditions an emphasis on interpretation and hence on the idea of 'insufficient reason.'

The purpose of stipulating such polarities is of course heuristic, in the sense that it allows us to develop a descriptive vocabulary for drawing comparisons between different semantic positions, including my own intersemiotic version. To turn briefly to Leibniz, the distinction between sufficient and insufficient reason is important, not only if one is prepared to accept literally the parallels I am drawing but even if the reader is willing only to go along with them as a guiding metaphor. I am suggesting that at least the main branches of philosophy which have addressed the question of meaning group themselves in a recognizable order of relations to one another once we adopt a distinction gleaned from Leibniz. For example, if we leave reference aside for the moment, Frege's collapse of natural language sense into the sense of formal signs positions the Fregean approach to semantics close to the pole of sufficient reason. By contrast, Heidegger's elaboration of meaning as the result of interpreting understanding can be aligned quite readily with the idea of an infinite chain of reasoning, one having no logical closure and permitting no more than pragmatic termination.

In *The Monadology* Leibniz observes that 'there can be no fact real or existing, no statement true, unless there be a sufficient reason, why it should be so and not otherwise, although these reasons usually cannot be known by us.'[13] In his earlier works Leibniz had called this kind of reason 'the determining reason,' a term revived by Kant in his *Critiques*. While Leibniz argues that 'truths of reasoning are necessary and their opposite is impossible,' he declares that 'truths of fact are contingent and their opposite is possible' (236). No matter how far we carry our analysis, we will never be able to establish an end point for contingent reasoning. Leibniz suggests that truth of fact must 'have its origin in a *prevailing reason*, which inclines without necessitating.'[14] By contrast, 'when a truth is necessary, its reason can be found by analysis, until we come to those which are primary' (236). But even though we cannot proceed with contingency in the same assured manner, we need a procedure of reasoning, 'a sufficient reason for contingent truths or truths of fact, that is to say, for the sequence or connexion of the things which are dispersed throughout the universe of created beings, in which the analyzing into particular reasons might go on into endless detail, because of the immense variety of things in nature and the infinite division of bodies' (237). For Leibniz knowledge is 'adequate' when our analysis has been 'completed.' He doubts, however, 'whether human knowledge can supply a perfect instance of this.' An approximation perhaps, he surmises, is 'the knowledge of numbers.'[15]

The reason Leibniz gives for the necessity of completing the reasoning chain of contingent truths is that 'the sufficient or final reason must be outside of the sequence or series of particular contingent things, however infinite this series may be' (238). In Leibniz's scheme of things God is employed both as proof of the distinction and as that which is to be proven by it: 'There is only one God, and this God is sufficient' (239). While necessary truth is grounded in definitional certitude, contingent truth is a function of a host of other truths, each of which is open to infinite analysis, a series to be completed only by God. Leibniz compares the difference between the two kinds of truth to that 'between commensurable and incommensurable numbers.' Contingent truths, like incommensurable numbers 'require an infinite analysis, which God alone can accomplish.'[16] If we are unable to complete any analysis of contingent truths, Leibniz demands that 'there must at least be some *satisfactory* or sufficient reason why it should be so and not otherwise.'[17] In this sense of sufficient reason, the satisfactory explanation steps in 'where a perfect reason is not to be found' (62).

Taking a larger perspective, Leibniz wants to account for his observation that 'everything in nature proceeds ad infinitum' (414). For Leibniz, 'nothing takes place without sufficient reason' – that is, 'nothing happens without its being possible for one who should know things sufficiently, to give a reason which is sufficient to determine why things are so and not otherwise' (414–15). Furthermore, 'this sufficient reason of the existence of the universe cannot be found in the sequence of contingent things.' If this is so, says Leibniz, then 'this ultimate reason of things is called God.' Without stipulating such a final reason 'we should not yet have a sufficient reason with which we could stop' (415).

Leibniz, then, associates sufficient reason with necessary truths, as we find them in stipulated systems such as formal logic, and insufficient reason with contingent truths or truths of fact. In the first case the primary principle or sufficient reason can be found by analysis. In the second case we must engage in a series of reasoning which is infinite and so cannot yield a primary principle unless we designate God as ultimate cause, as Leibniz does. From a secular viewpoint no such finality is available and so insufficient reason turns out to have been well named.

Leibniz also prevaricates between two uses of 'insufficient reason.' On the one hand he presents it as 'satisfactory' reason, on the other as 'ultimate' reason. This apparently serves his purpose of distinguishing between what humans can and cannot achieve in its application and the principle of God in which everything finds its ultimate cause. If we take insufficient reason as satisfactory reason and place it in opposition to sufficient reason, we can distinguish between two fundamentally differently grounded semantics: between one which

regards meaning as a series of elaborations of further and further possible details of conceptual content and one according to which meanings are ruled by definitions. Frege takes the latter route when he treats natural language sense in the same fashion as formal sense at the opening of his seminal paper 'On Sense and Reference.'[18] This move enables him to apply the apparatus of logical analysis to natural language, as if it were geometry. The majority of versions of semantics in philosophy and linguistics has followed Frege's path, either consciously or non-consciously.

There are considerable advantages in choosing this route. Meanings inherit the clarity of propositional contents and the question of the possibility of communication is resolved in terms of the shared definitions held by a speech community. Reference can be theorized empirically, as in Frege's work, as a specific relation between language and the world, or formally, as a relation between two stipulated systems, as in the work of Rudolf Carnap. Yet every theory has its blind spot, and the analytical semantic tradition is no exception. The collapse of natural language meaning into formal sense has a number of major drawbacks. One is that the meanings of historically evolving languages cannot be shown to be ruled by definitions. Here one cannot help but side with Friedrich Nietzsche's succinct observation that 'only that which has no history is definable.'[19] Certainly, the sort of descriptions we find in dictionaries are no more than strings of verbal substitutions of varying length, depending on the size of the dictionary, designed after the fact of the social acts of language use. They are always a posteriori. A second, related, matter is that dictionary entries are not definitions at all if we accept the concept of definition as used in formal procedures. Definitions are supposed to be unique and finite descriptions, but dictionary entries are open ended, which means that we can always add further signifiers, allowing for alternative, more or less closely related descriptions. No such freedoms exist in definitions proper.

A semantics which eschews the definitional path, on the other hand, is in the reverse situation. It must show how communication is possible at all if a semiotic community does not have access to fully shared definitions of meaning except to those of its formal systems. What then are the constraints that prevent semantic anarchy? Or is semantic anarchy a reality? The first question can be answered by saying that the necessary community agreement is furnished by social acts, or sufficiently shared *Lebensformen*, in combination with the typical use of linguistic expressions – in short by 'sufficient semiosis' (section 1.2). The second question is ruled out by its own non-anarchic presuppositions. In intersemiotic terms the constraints are provided by typical rather than by identical linkage procedures between different sign systems, such as the aural and the linguistic, the visual and the tactile, and so forth (Chapter 1). In

other words the constraints without which we could not conceive of a semiotic community in the first place are located outside the linguistic expression rather than inside it as a definitional or intensional core.

A semantics which chooses this path finds it easier than does its definitional cousin to cope with the complexities and alleged murkiness of everyday speech as well as with its experimental extensions, such as those in literary use. Rather than having either to push these phenomena to the margins of its explanatory horizon or to ban them altogether, a non-definitional semantics can treat them as exemplary: the murkier, the better; the more complex, the more readily able to demonstrate the myriad interactions between different significatory systems in the event of meaning. A number of philosophical precursors have furbished arguments with which to shore up such an approach to semantics. Kant's distinction between determining and reflective reasoning is an important case in point.

For Kant, determining or subsumptive reason is available only when we are dealing with closed systems, such as in mathematical or other logical processes. In other words it belongs strictly to analyticity. This precludes its use in the vast majority of judgments in which we make statements about how the 'world' appears to us, including statements about ourselves. For these cases Kant reserves the notion of 'reflective reason,' which is open ended and heuristic. Not only is the procedure as a whole to be placed under permanent revision but its concepts are themselves forever fluid at the boundaries and open to further and still further analysis. In the *Critique of Judgment* Kant associates two kinds of teleology with these two forms of reasoning: a narrow teleology which goes with determining reason and produces closure; and a teleology based on reflective reason, in which we modify the rules of judgment as we go along.[20] Definitional semantics can be aligned with determining reason and closure, while non-definitional semantics seems to take its cues from Kant's notion of reflective reason. Only the latter is able to account well for the historicity of meaning and specifically for semantic drift.

Perhaps it is not too long a shot to suggest that the entire hermeneutic tradition from Friedrich Ast to Hans-Georg Gadamer and Hans Robert Jauss is profoundly indebted to Kant's description of the processes involved in reflective reasoning. The part–whole relation, the concomitant quasi-circularity, the emphasis on *Verstehen*, the importance of the relation between speech partners, the question and answer pattern, the relative indeterminacy of meaning, and the fusion of horizons are all at the very least highly compatible with Kant's position, if not indeed a more direct reflection of its basic principles. The first section of Chapter 4 will address in some detail the question of hermeneutics and its relation to recent theorizing. Suffice it here to indicate that any semantics

which wishes to avoid the definitional route must acknowledge the work done by Kant and hermeneutics over the last two centuries.

Other alternatives to the Fregean semantic tradition can be pursued by emphasizing certain principles to be found in the writings of Peirce, many of which, not surprisingly, continue Kant's basic scheme. Umberto Eco, for example, has offered explanations along Peircean lines.[21] The most attractive principles for a critique of semantics are Peirce's emphasis on the logical priority of signs in general, of which language signs are a special and dominant case; his statements concerning the interrelation of signs, such as iconic, indexical, and symbolic signs; his observation of the infinite regress inherent in any description of meaning; and the significance of the community. The first section of Chapter 1 will elaborate these and other features of Peirce's semiotics in order to prepare the ground for the arguments offered in favour of an intersemiotic and heterosemiotic semantics.

If one wished to show how an approach could be reversed, there would be no better comparison than the one between, on the one hand, the conflation of natural and formal sense which we find in Frege and the tradition he inspired and, on the other, Heidegger's collapse of the formal, or what he termed the apophantic, into general interpretation. For Heidegger social discourse is not an incalculable expansion of logical possibilities but rather the reverse: the apophantic, active in minimal assertion, for instance, is a shrunken version of 'concernful understanding.'[22] The Heideggerian picture of meaning unfolds roughly as follows.

In agreement with the hermeneutic tradition, to which he owes much, Heidegger in *Being and Time* begins with the notion of understanding which has 'its own possibility – that of developing itself.' Developed *Verstehen* he calls 'interpretation' or *Auslegung*, a way of laying things out before ourselves. In the process of *Auslegung* 'understanding does not become something different. It becomes itself' (188). Interpretation can be regarded as 'the working-out of possibilities projected in understanding.' For Heidegger it is important to acknowledge that all interpretation 'has the structure of *something as something*.' The as-structure is a vital part of everything we can know: 'the "as" makes up the structure of the explicitness of something that is understood. It constitutes the interpretation.' We see a something as a table, another something as a door; in short we understand the world never immediately but mediated by the as-structure. One could speculate that Jacques Derrida's foregrounding of the rudimentary nature of metaphoricity is an elaboration of Heidegger's point (sections 3.1 and 4.3). All pre-predicative experience also falls within the as-structure: 'Any mere pre-predicative seeing of the ready-to-hand is, in itself, something which already understands and interprets.' Moreover, anything

that is so encountered is always already 'understood in terms of a totality of involvements' (189). The fact that the 'as' cannot be articulated must not make us assume that it is not there as 'a constitutive state for understanding, existential and *a priori*' (190).

If we accept that 'the ready-to-hand is always understood in terms of a totality of involvements,' then we are tied to a holistic argument according to which any specific meaning event can occur only against the background of a preinterpreted 'world.' Yet this 'world' cannot be a random assembly of pieces if specifics are to make any sense. Hence all 'interpretation is grounded in *something we have in advance* – in a *fore-having*' (*Vorhabe*); it is based on '*something we see in advance* – in a *fore-sight*' (*Vorsicht*), as well as on '*something we grasp in advance* – in a *fore-conception*' (*Vorgriff*) (191).

The essential fore-structure of interpretation radically distances the Heideggerian semantic project from analytical positions, which construe meaning under definitional control. And recent analytical attempts to catch up with the missing background for sentence meanings, as for instance in John R. Searle's work, do not achieve the depth of relations envisaged by Heidegger.[23] The exception here may prove to be Donald Davidson, whose position has been characterized by Jeff Malpas as closer to Heidegger's than Davidson has himself been aware.[24]

Understanding, for Heidegger, is our way of realizing the specifics of our 'world' in an ontic sense: 'in the projecting of the understanding, entities are disclosed in their possibility.' Heidegger regards the character of this possibility in terms of a correspondence 'with the kind of Being of the entity which is understood.' We note the hermeneutic part–whole circularity in the manner in which 'entities within-the-world generally are projected upon the world' which is always 'a whole of significance.' It is at this point in his argument that Heidegger introduces the concept of 'meaning' (*Sinn*) as a function of the relation between the detail of 'entities within-the-world' and the 'Being of Dasein' as their frame (*Being and Time*, 192). Ultimately, what is understood is Being. Being frames all meaning. At the same time, Heidegger specifies meaning as follows.

Meaning is the display of the intelligibility of entities; it is '*the "upon-which" of a projection in terms of which something becomes intelligible as something; it gets its structure from a fore-having, a fore-sight, and a fore-conception*' (193). In this sense meaning acts as the 'formal-existential framework of the disclosedness which belongs to understanding.' Contrary to any view which associates meaning with the properties of things, Heidegger insists that meaning must be viewed as 'the *existentiale* of Dasein.' From this perspective he assumes a central tenet of Wilhelm Dilthey's work, the claim that 'meaningfulness fundamentally grows

out of the relation of part to whole that is grounded in the nature of living experience.'[25] In Heidegger's terms this claim is transformed into the assertion that *'only Dasein can be meaningful or meaningless'* (*sinnvoll* or *sinnlos*) (*Being and Time*, 193).

Given this conviction, it is not surprising that the circularity of interpreting reason which is common to all hermeneutical inquiry should resurface at this point. Interpretation is that form of reasoning which has already understood what it is exploring interpretively. Now Heidegger makes an important move. He does not merely concede the circularity of the procedure but turns it into a positive feature and superior critical tool. 'According to the most elementary rules of logic,' he says, 'this *circle* is a *circulus vitiosus.*' But this is shortsighted, for *'if we see this circle as a vicious one and look out for ways of avoiding it, even if we just "sense" it as an inevitable imperfection, the act of understanding has been misunderstood from the ground up.'* If we were to reduce understanding and interpretation to a formal procedure, 'to a definite ideal of knowledge,' we would be guilty of confusing what is subordinate with the larger order. Formal procedures, such as minimal assertions, are no more than 'a subspecies of understanding' (194).

It is worth staying close to the text of *Being and Time* on this point. 'What is decisive,' Heidegger writes, 'is not to get out of the circle but to come into it in the right way.' Nor will it do to admit 'any random kind of knowledge' into the orbit of understanding. Rather, the hermeneutic circle is 'the existential *fore-structure* of Dasein itself' in its triple character of fore-having, fore-sight, and fore-conception. Instead of circular viciousness, Heidegger offers a contrary reading: 'in the circle is hidden a positive possibility of the most primordial kind of knowing' (195).

From this position Heidegger reviews the claims made on behalf of formal reasoning. Instead of separating the formal from the non-formal by way of a Kantian distinction between determining and reflective reason, Heidegger reincorporates the formal under the broader umbrella of *Dasein*. Both formal and non-formal kinds of understanding and interpretation are part of the circularity of meaning, which has its ultimate roots in the existential constitution of *Dasein*. 'Mathematics is not more rigorous than historiology,' says Heidegger, 'but only narrower, because the existential foundations relevant for it lie within a narrower range' (195).

To drive this point home, Heidegger dedicates an entire section of *Being and Time* to arguing that assertions belong to a 'derivative mode of interpretation.' This is important for one of my pivotal concerns, the minimization of natural language sense in the Fregean tradition. Heidegger's comments on assertion are not entirely in line with my own reasoning, however, since his aim is to unearth the hidden interpretive ingredients in '*S* is *p*,' while I wish to show

primarily that the conflation of natural language sense and formal sense rests on a confusion of heterosemiotic and homosemiotic signification. Nevertheless, I do agree with Heidegger that even the most reduced form of language still carries the traces of its socially saturated ancestors.

In this sense Heidegger is right to stress that 'all interpretation is grounded on understanding.' If meaning is 'articulable' or has been articulated 'in interpretation' and 'sketched out beforehand in the understanding,' then any assertion as judgment ' "has" a meaning' (195). Furthermore, the interpretive process buried in the assertion can be brought to light by isolating the three kinds of signification of which every assertion consists: a 'pointing out' (*Aufzeigen*); a 'predication' (*Aussage*) (196); and a 'communication' (*Mitteilung*) (197). Given this structure, Heidegger defines assertion as 'a pointing-out which gives something a definite character and which communicates' (199).

Above all, in order to make an assertion, no matter how narrowly conceived, we have to have a knowledge of the 'world,' a 'fore-having of whatever has been disclosed.' The unconcealed is what the assertion 'points out by way of giving something a definite character.' And whenever we predicate in this sense we are bound to take 'a look *directionally* at what is to be put forward in the assertion' (emphasis added). Thus we cannot assert anything without some kind of fore-sight, and without a prestructuring of what we are going to see we could not see ahead. So Heidegger concludes that 'like any interpretation whatever, assertion necessarily has a fore-having, a fore-sight, and a fore-conception as its existential foundations' (199). In terms of the fundamental as-structure of all understanding and interpretation this means that assertion functions by collapsing the 'primordial "as" of circumspective interpretation' into the ' "as" with which presence-at-hand is given a definite character.' Yet no assertion can 'disown its ontological origin from an interpretation which understands.' Instead it transforms the ' "existential-*hermeneutical* 'as' " ' into the "*apophantical* 'as' " of assertion' by way of reduction. Between the two extremes Heidegger allocates an array of 'intermediate gradations' which cannot simply be turned into reduced, theoretical equivalents 'without essentially perverting their meaning' (201).

Brief as it is, Heidegger's sketch of the processes of understanding and meaning in *Being and Time* at least suggests a point of departure for theorizing meaning radically differently from the orthodoxies of semantics. Above all, the holistic emphasis on understanding the 'world' before any understanding of specifics is conceivable is a position of considerable force. Sentence meanings, as any other meaning acts, become functions of the speaker's position in relation to *Dasein*, which includes both the material and the social 'world,' as well as the idiosyncrasies of the subject. The consequences for interpretation

are substantial, not the least of which is infinite interpretive regress, a position reached by Peirce, for example, from very different premises.

Of particular importance for Chapter 1 and the remainder of my argument in subsequent chapters are the non-verbal implications of Heidegger's triple fore-structure. *Vorhabe, Vorsicht,* and *Vorgriff* all suggest non-linguistic acts of meaning constitution. They emphasize the body prior to language. Without being able to construe the world in relation to our corpo-real-ity, without visual and tactile signification, we would not be able to construe the specifics of the semantic relations of linguistic expressions. This could be expanded into a theory of meaning in which linguistic expressions require activation by way of non-verbal signs to become meaningful. Such a picture of language, though more indebted to Peirce than to Heidegger, will emerge in the course of the first chapter.

A more recent example of a theory of language which elaborates rather than formalizes signification can be found in Jean-Jacques Lecercle's *The Violence of Language.*[26] Lecercle's focus is on what he terms the 'remainder,' which is responsible for the fundamental instability of natural languages. It marks 'the return within language of the contradictions and struggles that make up the social' as well as 'the persistence within language of past contradictions and struggles, and the anticipation of future ones.' Hence for Lecercle, 'there is no such thing as a stable *état de langue*' (182).

Viewed from the perspective of Gilles Deleuze's and Felix Guattari's five principles of the rhizome – the rules of connection, heterogeneity, non-signifying breaks, cartography, and corruption – the remainder appears to function as an umbrella concept. It is unstructured; it lacks unity; it forges links and makes sense 'even in the most adverse circumstances of syntactic dereliction.' In agreement with the principle of cartography, 'it records the lie of the land, develops according to its own lines of flight,' and is characterized by 'arbitrary branchings off and temporary frontiers'; and finally, it corrupts the rules of synchrony and so of *langue* (133). In this the remainder exposes a fundamental paradox of natural language: the inevitable corruption of its values by semantic drift and its task as the main instrument of conservation of the past.

By emphasizing 'the multiplicity of creative idiolects or social dialects,' Lecercle offers a correction to the structuralist linguistic doctrine of a symmetrical and stable *langue* (135). If any rule at all applies to the speaker of a natural language, it 'can be only a form of double bind: I order you to disobey' (137). The remainder, then, is 'language gone wrong,' or 'language minus *langue*,' or 'the "other" of *langue*.' Seen negatively, the remainder 'destructures *langue*'; put positively, it is 'the core of naturalness in natural languages against which *langue* is constructed, but which no structure can overcome' (141).

To this extent Lecercle appears committed to the exploration of an area which is also the focus of the present study: features of natural language for which the formalization of language fails to offer satisfactory explanations. Where the two studies part company is on the question of how Lecercle's remainder relates to the 'world.' By his account the remainder is the corrupted and corrupting part of language which functions as 'the frontier between language and the material world' (225). The invocation of a non-mediated material world is incompatible with my project. However attractive the theory of the remainder appears to be, I do not think it is able to theorize coherently the frontier that Lecercle himself has identified unless it pays some attention to non-linguistic signification. Only the latter is able, I suggest, to provide the kind of bridge required between language and 'world.' Without non-verbal mediation an empiricist 'world' is bound to reappear as ontic closure.

In spite of this disagreement I too wish to trace some of the conditions which permit and necessitate what Lecercle dramatizes as 'corruption.' Furthermore, I suggest that there is something more tangible than the 'remainder' between language and the material world: the order of non-verbal sign systems. And far from the non-linguistic belonging to the unfathomable mists of human prehistory, it plays a systemic and, in certain respects, analysable role in the process we call meaning. Specifically, formalization in either its Fregean or its Saussurean form fails to capture the quasi-referentiality and quasi-deixis inherent in every item of natural language. It is these two features (not to be confused with specific reference and deixis) which separate language from *langue* and meaning from formal sense. A theory which reconciles linguistic and non-verbal semiosis is well placed to explore such problems.

Another recent publication close to the interests of this study is Augusto Ponzi's *Man as Sign: Essays on the Philosophy of Language*.[27] Its title announces both its Peircean leanings and its general aim of intervening in a tradition not generally associated with semiotics. In both senses Ponzi pursues goals compatible to a certain degree with those of Umberto Eco's *Semiotics and the Philosophy of Language*. Ponzi's study shares with the present book a predilection for a group of writers, notably Kant, Peirce, Husserl, and Mikhail Bakhtin, with Emmanuel Levinas playing a much larger role in Ponzi's thinking. His reinterpretation of Peirce's interpretant as a conflictual response to other signs is fruitful and compatible with my emphasis on the heterosemiotic nature of meaning, though both positions need to be recognized as extensions of Heidegger's fundamental statements about the as-structure of all understanding. Drawing on both Kant and Peirce, Ponzi presents a semiotically founded semantic holism, which is intuitively attractive and well argued. Among a host of other features compatible

with the position advocated here is Ponzi's reincorporation of reference into semiosis.

The present study differs from Ponzi's in its much narrower focus on the critique of sense in the analytical and structuralist traditions and on its intersemiotic alternative. Another difference is Ponzi's leaning towards Bakhtin's version of the double directionality of natural language expressions. From Bakhtin's perspective words point us towards a projected world and to general heteroglossia, whereas the directionality of expressions I argue is that of a double projection: the viewed and the viewing; the projected 'world' and its entailed utterance situation as an integral part of words. Above all, the present study offers a redefinition of meaning from an intersemiotic perspective and tests this description against orthodox positions, such selected issues as negation and metaphor, and recent positions in poststructuralist and postmodern writings. The argument unfolds in five main chapters, each divided into two or three sections.

Towards a Corporeal Semantics

The first section of Chapter 1, 'An Alternative Route to Meaning,' introduces the topic of an intersemiotic semantics by drawing mainly on the work of Charles Sanders Peirce. Section 1.2, 'Meaning: An Intersemiotic Perspective,' advocates a multisemiotic semantics as an alternative to analytical models. It suggests that there is no meaning in language and that meaning is an intersemiotic event in which different sign systems are aligned with one another. As a consequence, it is argued, 'reference' and other traditional terms such as 'perception' and 'world' require redefinition to fit the intersemiotic frame. The chapter concludes by drawing a sharp distinction between two kinds of semantics, the homosemiotic semantics of formal systems and the heterosemiotic semantics of natural languages and other non-formal systems.

Natural Language and Meaning as Definition

The introductory section of Chapter 2, 'The Conflation of Two Kinds of Sense,' introduces the equivocation of formal and natural language sense and its consequences for semantics. The most forceful argument for a strict definitional approach to meaning is shown to have been proposed by Willard Van Orman Quine, who demands a radical division between a theory of meaning and a theory of reference. The kinds of things Quine associates with meaning, such as synonymity and analyticity, provide a continuation of the conflation of two kinds of sense employed by Frege. Sections 2.2 and 2.3 then attempt

to pinpoint some of the consequences of this conflation by looking at Gottlob Frege and Rudolf Carnap. Section 2.2, 'Frege's Error,' examines how Frege undermines the referential background without which natural language terms cannot be understood by opening his argument in 'On Sense and Reference' with an illegitimate move from geometrical sense to natural language sense. This is dealt with separately from his arguments concerning reference. Section 2.3, 'Carnap's Sleight of Hand,' demonstrates how the equivocation of natural and formal sense surfaces in specific observations made throughout the work of Carnap.

The Semantics of Negation and Metaphor

'Two Bugbears for Formalization' introduces sections 3.2 and 3.3, which deal with negation and metaphor. Both negation and metaphor have proven difficult for analytical accounts for the same reasons that an intersemiotic approach to semantics is attractive. Section 3.2, 'Negation: From Frege to Freud and Beyond,' traces a list of analytical arguments about negation in order to demonstrate certain inefficiencies in the theories available. In particular the section demonstrates that such approaches are too narrowly conceived to be able to come to terms with more complex forms of negation such as those in psychoanalytical writing and cultural negation. Section 3.3, 'Metaphor: Heterosemiotic Pathway to Meaning,' employs a similar strategy in arguing that the majority of theories of metaphor fail to guide us in construing meaning when we encounter highly original and novel metaphors. Instead, a counterexplanation is offered according to which metaphors behave in principle like other, habitual meanings, except that metaphors foreground the non-verbal imaginary activities which we have to undertake before we can produce linguistic texts as substitutes.

Meaning and Poststructuralism

Section 4.1, 'Transcendental Moves,' provides a rationale for the two following sections on the fate of meaning in poststructural theories. It argues that the conflictual nature of meanings in diverse discourse genres (Lyotard) and the polysemic destabilization of meaning (Derrida) display traces of philosophical and hermeneutic traditions from Leibniz and Kant, via Friedrich Ast and Wilhelm Dilthey, to Heidegger. Jettisoned, this introduction points out, is the project of semantic recovery, while the methodological concern with more or less radical semantic elaborations is retained. In this regard section 4.1 acts as a supplement to standard explanations which foreground the

heritage of Nietzsche, Saussure, and Freud. With reference to Gilles Deleuze's commitment to a transcendental empiricism, the section draws the reader's attention to the crucial difference in poststructuralist writing between the rejection of transcendental signifieds and the procedural use of transcendental inquiry.

Section 4.2, 'The Differend and Semantics,' examines how Jean-François Lyotard arrives at the claim that discourse genres are fundamentally conflictual, and hence at a general agonistics. In doing so it traces the claim back to the particulars of his description of the sentence and suggests that we are dealing here with a concealed transcendental reduction requiring non-verbal supplementation. Section 4.3, 'Différance: Meaning and Transcendental Procedure,' is a commentary on the meticulous craftsmanship displayed in Jacques Derrida's seminal paper 'Différance.' The section traces in detail the way in which Derrida proceeds towards the stipulation of a general, empty condition without which we could not conceive of the multitude of forms of differentiation. Meaning is shown in both sections not merely to be a function of syntactic processes but always also to require a reference point in the non-verbal signification of the body.

Semantics and the Postmodern

'The Postmodern Surface,' the introductory section of Chapter 5, leads the reader into the final argument on the postmodern condition of meaning. As a methodological introduction to the organization of section 5.2 it highlights the problematic relation of syntax and semantics as a possible cause of some serious misunderstandings in any description of social reality. The reader will be reminded of what I term Frege's 'error' early in the book and the consequences of its repetition on the larger canvas of the depiction of the social. In section 5.2, 'The Postmodern Conditions of Meaning,' I propose a heuristic schema in which the social is characterized in terms of syntax and semantics. The postmodern appears as an ambiguous cultural pyramid whose syntax is marked by the indifferent differentiation of the digital bit stream and whose ruptured surface phenomena reflect the seeming randomness of that syntax. This is how a large body of literature articulates the character of the postmodern, often in celebratory and emancipatory terms. The chapter concludes with the suggestion that this same syntax of mere differentiation turns out to function as the control base for an entirely different and largely concealed semantics of the power structures of international capital.

Semantics and the Body opposes the syntactic bias throughout by supporting the 'corporeal turn,' which we can trace to Merleau-Ponty. Like Merleau-Ponty

I emphasize corporeality. I differ on the relation between body and language. While Merleau-Ponty retains certain Husserlian eidetic convictions in his approach to linguistic signs, which entail the 'absenting of the body,' I offer a different narrative. In *Semantics and the Body* our perceptual readings *inhabit* the empty schemata of linguistic expressions. Without corporeal signification language means nothing. Even when it appears 'vacated,' as in the display of divine sexuality of Bernini's St Teresa, it is the body that determines the *imago*, the desire, and the discourse.[28]

1

Towards a Corporeal Semantics

If natural languages behaved primarily in the manner one associates with for-
mal and technical expressions, there would not be much point in looking for
explanations beyond those offered by standard analytical accounts. If, how-
ever, one is interested in the intricacies of social discourse and its experimental
extensions in literature, jokes, metaphors, and other non-technical usage, then
those explanations look unsatisfactory. Moreover, once we have taken cultur-
ally saturated discourse as the starting point of our inquiry, even the description
of technical language use takes on a different appearance.

In *Language and Reality: An Introduction to the Philosophy of Language*, Michael
Devitt and Kim Sterelny give an introductory overview of standard analytical
positions on language and semantics. Speaking of the indicative sentence, the
authors note that 'the core meaning of such a sentence is its truth conditions:
its property of being true if a certain situation in the world obtains and not true
if the situation does not.'[1] In their account 'the notion of truth conditions' (17)
is fundamental to the explanation of meaning.

To include non-indicative sentences in the analysis we can imagine a similar
test by introducing the idea of 'compliance conditions' (19). According to this
test, the meaning of an expression is not 'its property of being true if and only
if a certain situation obtains' but, they say, 'its property of being *true, complied
with, and so on*, if and only if a certain situation obtains.' Thus meaning is a
function either of truth conditions or of 'other analogous conditions' (19). As
in indicative sentences, the syntactic structure of the expression and Fregean
reference together provide the explanatory mechanisms for those conditions.
Summarizing, Devitt and Sterelny emphasize that 'an explanation of meaning
must somehow relate language to the external world' (28).

This sounds perfectly plausible until we ask the Kantian question how it is possible that we 'realize' the external world in the first place. One disturbing suggestion is that Devitt and Sterelny argue within a circle and without being aware of its viciousness. The external 'world,' as far as humans see, grasp, and 'know' it, is always already the result of significatory processes such as ways of seeing, scientific measurements, and linguistic expressions with reference to that 'world.' As Max Black puts it, 'the world is necessarily a world *under a certain description.*'[2]

There are a number of ways out of this vicious circularity. One is the formal path, which makes meaning strictly definitional by replacing reference to the external world with reference to a secondary formal system. This is the calculus ˊ solution. Another avenue is advocated by Willard Van Orman Quine, who recommends a meticulous segregation of the theory of meaning from the theory of reference. This could result in either a strictly definitional notion of meaning, as in the first solution, or a non-definitional alternative not provided by Quine (cf. section 2.1). A third path is exemplified by Heidegger's acknowledgment of the inevitability of circularity in all understanding as the ground of any kind of reasoning. From this position, Heidegger makes a virtue out of circularity by describing it positively as the hermeneutic trajectory of all interpretation. The interpretation may be elaborate and self-reflexive, as in philosophical or literary interpretation, or minimal and concealed, as in technical and logical assertions. Throughout this book I prefer an intersemiotic and heterosemiotic approach, which draws on a range of diverse positions.

From this perspective, meaning is regarded as a virtual event in which at least two, and normally several, sign systems are associated with one another, such that visual, tactile, haptic, and other non-verbal signs are engaged in the activation of linguistic expressions. Non-linguistic meaning is likewise conceived in this way. This requires a redescription of perception in significatory terms. The role of the syntactic structure of the expression is retained from the analytical-naturalistic picture offered by Devitt and Sterelny. Reference, however, is regarded as a specific link between sign systems, rather than as a relation between two incompatible domains: the signs of language and a non-semiotic external world. In this way, the world as we know it is significatory, rather than a physicalistically given.

To meet the objections against relativism, the intersemiotic position must come to terms with the question of constraints. I suggest that there are two kinds: base constraints and community constraints. The former are realized as necessary inferences derived from events during which our significations consistently fail. If we cannot consistently act on the text that humans can drink mercury instead of water and survive, then we must infer a base constraint

which prevents such a scenario. As soon as we formulate this constraint, however, we are once more in a textual rather than a physicalistically given 'world.' The second set of constraints is required to account for the charge of subjectivism and mentalism. We refer to this kind of constraint as 'the social,' or 'the community,' and it regulates to a very large extent the manner in which individuals are able to signify. The metaphysical position underlying a semantics within such boundaries could be called an inferential realism, or a textual realism.

Another avenue for semantics available to analytical philosophy is speech act theory. With its phenomenological beginnings in the work of Adolf Reinach in 1913, resumed in comments made by Ludwig Wittgenstein in *Philosophical Investigations*, and launched as a branch of language philosophy by John Langshaw Austin, speech act theory is now associated most closely with the early writings of John R. Searle.[3] In Searle's revision of Grice's non-natural meaning we find the following summary:

Speaker S utters sentence T and means it (i.e., means literally what he says) = S utters T and

(a) S intends (i-I) the utterance (U of T) to produce in H the knowledge (recognition, awareness) that the states of affairs specified by (certain of) the rules of T obtain. (Call this effect the illocutionary effect, IE).

(b) S intends U to produce IE by means of the recognition of i-I.

(c) S intends that i-I will be recognized in virtue of (by means of) H's knowledge of (certain of) the rules governing (the elements of) T.[4]

This seems to imply that meaning is understood as a relation between linguistic expressions and states of affairs. What we neither know nor are able to find in *Speech Acts* is a comprehensive definition of one of the main elements in Searle's study, *meaning* itself. Whether states of affairs are part of a given world, or constructions about a given world, or constructions within a constructed world is likewise not clear. Yet we do know from Searle's other writings that he tends to hold a realist perspective of the world and that his 'semantics' roughly follows a Fregean path, at least as far as Frege's *Sinn* is concerned. By contrast, in an intersemiotic picture of meaning, states of affairs are redefined in terms of non-verbal signs in order to provide a *tertium comparationis*. Meaning, in turn, is the virtual event of alignment between different and only partially commensurate signs under social rules.

In the spirit of Searle's analyses, Dieter Wunderlich proposes a definition of literal utterance meaning. This requires that the neutrality of context be stipulated: 'The meaning of an utterance of a sentence s of language L is literal

iff [if and only if] the context used to determine the meaning is neutral with respect to s.'[5] The problem with this formulation is that no social situation which would guarantee the sort of neutrality postulated is thinkable. This applies equally to the speech act theorists quoting 'sentence s.' The reduction of reference and deictic reference to zero results not in a neutrality of context for natural language expressions but rather in a radical change from linguistic to formal signs. The counter-reading of Wunderlich's formulation is that there is therefore no such thing as a literal utterance meaning. This is the solution via pragmatics, a position compatible in this respect with an intersemiotic semantics.

The position championed in this book is also at odds with Ferdinand de Saussure's account of meaning. Given the fairly recent arrival of languages in human history, Saussure's observation that 'nothing is distinct before the appearance of language' leaves homo sapiens in a chaotic lurch for a very long time. It is an improbable description even of less communicative life forms. Likewise, the claim that 'language is a system of interdependent terms in which the value of each term results solely from the simultaneous presence of others' should be regarded as less persuasive than it has been to a broad group of structuralists. For once, I am able to agree here at least partially with Devitt and Sterelny, when they discard the Saussurean narrative on the grounds it has no room for reference and so cannot exit the circle of differential syntactic substitutions.[6] If we substitute a somewhat different definition of reference, one based on intersemiotic principles, this criticism appears likewise appropriate. Saussure's description of meaning as a systemic differential relation works perfectly for someone who knows the language – say, French – but this begs the question of how meanings come about in the first place and hence of semantics.

The present study is also opposed to 'linguistic truth-based semantics' as described in Ruth M. Kempson's admirable *Presupposition and the Delimitation of Semantics*, for reasons which will become clear later. Nevertheless, her definition of meaning marks perhaps the furthest possible advance within an analytical frame of argument. Meaning, argues Kempson, in agreement largely with Manfred Bierwisch, is first to be equated with sense, Frege's *Sinn*. Second, the meaning of an expression 'could be defined as a statement of the conditions necessary and sufficient for the relation of reference to hold in *some* state of affairs.'[7] Analogously, sentence meaning, Kempson's preferred level of analysis, 'can then be independently characterized for any sentence Sn as a statement of the necessary and sufficient conditions for that Sn to be true' (33). These formulations allow semantics to consist of two systematically aligned orders: the order of language and the order of 'the world as we know it' (31). At the same time, Kempson's definition resolves some major bugbears of analytical

descriptions of semantics. She provides strong arguments on the role of vagueness in negation, on fictional expressions, and on non-indicative expressions, such as performatives, imperatives, and questions.

Kempson does not, however, resolve the problem of the relation between language and 'world' satisfactorily. Having posited a 'world as we know it,' she must simultaneously provide an adequate explanation of how this knowledge relates to the very signs to be explained with its help. For if she persuades us, as I think she does, that we are dealing with a human version of the world, then we have to accept that such a world is significatory rather than brute, which leaves unexplored the important question of how language relates to the non-verbal signs which make up this 'world.' Whatever the answer, 'truth-conditions' have now turned into relations between different sign systems and hence, at least logically, into an infinite regress of signs. The constraints which we must find to reduce the improbability of such semantic relativism require further exploration. They certainly cannot be resolved by either a relativist or a naïvely empiricist fiat.

A very different route to semantics offers itself if one takes as a point of departure certain principles found in Kant's *Critiques*. In the 'schematism' chapter of the *Critique of Pure Reason*, Kant asks several questions. How can intuitions (*Anschauungen*) be subsumed under concepts? How is it possible for us to apply categories to appearances? How can such heterogeneous entities be associated with one another? If we remain at the same level of their specificity, no such relation can be established, for we would be comparing like with unlike. In order to establish such a relation Kant makes a transcendental move to a more general level, that of representation. Both intuitions and concepts, appearances and categories, can be formulated by means of representations – pure representations and sensible representations – at the level of a transcendental schema. In this way, Kant achieves a *tertium comparationis*, a level of comparison, at which the mediation of otherwise heterogeneous elements is conceivable. Human reality, for Kant, is thus a 'production' with the help of mediating schemata. The constraints for our productions are summarily indicated as the noumenal, that which we cannot directly apprehend but are bound of necessity to infer.[8]

From this angle, the meaning of linguistic expression appears to be embedded in the schematic production process of our reality in toto, just as is the meaning of an image or sound sequence. Meanings, from the most corporeally sensual, such as a caress, to the purely formal of symbolic logic, find their place in the holistic perspective of the way humans typically 'realize' the 'world.' The theme of semantic holism is one of the threads which will guide the reader through this book. Other Kantian themes of relevance to this study are his suggestions

concerning the basic instability of non-formal concepts, the notion of reflective reason, open teleology, and the procedure of transcendental argumentation.

Kant's insistence on the merely heuristic nature of the concepts of natural languages, including those of philosophy, supports a perspective in which meanings cannot be seen to be governed by definitions in any strict sense.[9] The clear segregation of determining or subsumptive reason from reflective reason allows a distinction to be drawn between formal semantics, as no more than the systematic alignment of two closed bodies of syntax or two systems of calculus, and natural-language semantics, as the relation between a syntax and the non-verbal construal of our world or, expressed more radically, between a syntax and the body. Insofar as Kant's reflective reason is also a way of interpreting by inventing the rules as we go along, it serves an argument for meaning-making as tentative elaboration rather than as the application of definitionally provided rules.[10] This position is particularly attractive in situations in which the constitution of meaning proves problematic.

Of special interest here also is the notion of an open, or non-closure, tele-ology. In recent popular accounts of cultural studies, in particular, teleology has suffered much abuse. Impugned is a narrow concept of *telos* as a totalizing master plan. This is ironical considering that Kant advances a critique of such a use of teleology, explicitly replacing the teleology of subsumptive reason with the open-ended interpretive schema of a reflective teleology which adjusts its explanatory functions as interpretive difficulties arise.[11]

Lastly, transcendental arguments will be shown to prove useful to a semantics that cannot rely on the definitional security afforded by formal systems and so has to trace, by retrogressive reasoning and as far as is possible at present, the conditions without which its alternative explanations are unthinkable. More-over, it will turn out that even the most radical recent attempts at reformulating the mechanism of signification in certain poststructuralist writings are fundamentally committed to transcendental procedures, especially where they denounce the possibility of transcendental signifieds.

A major source of inspiration for the kind of semantics I wish to suggest is the work of Charles Sanders Peirce.[12] For Peirce, Kant is 'the King of modern thought,' whose protosignificatory approach to our knowledge of the world via appearances has left traces throughout the diverse Peircean corpus of writings (1.369). For this and other reasons, Peirce is arguably the richest source for a semantics of a broad intersemiotic persuasion. Throughout his writings Peirce defends the fundamental nature of cognition as significatory. This is well known and needs no special explanation. Suffice it on this point to quote his succinct aphorism, 'A pure idea without metaphor or other significant clothing is an onion without a peel.'[13] Apart from this broad commitment,

the following seven themes are of special interest: his generous, 'non-linguistic' notion of the sign; his repeated emphasis on the infinite regress of semiosis; his suggestions about the indefinite nature of signs; his comments on the procedure of abduction; his focus on semiotic holism; his 'inferential realism'; and his inclusion in his scheme of a conception of the 'community.'

Non-linguistic semiosis, according to Peirce, occurs in two ways: in the form of non-verbal communication and by way of our relation to the object world. 'Tones and looks act dynamically upon the listener, and cause him to attend to realities.' They are, for Peirce, 'the indices of the real world' (2.337). Tones are defined as 'signs of visceral qualities of feeling.' Odours likewise play an important role in our cognitive processes in that they 'bring back old memories' and sometimes 'occupy the entire field of consciousness, so that one almost lives for the moment in a world of odour.' In a Proustian manner, Peirce refers to odours as signs resulting from both 'contiguous association' and 'resemblance-association,' the latter in the case where odours call to mind 'mental and spiritual qualities' (1.313). Following Peirce, Roman Jakobson regards linguistic meanings as linked to non-verbal signification by way of 'transmutational' relations.[14] He quotes John Dewey, who also refers us to Peirce when he says that 'the meaning of any linguistic sign is its translation into some further, alternative sign, especially a sign "in which it is more fully developed."'[15] This crucial insight, however, remained undeveloped.

Climbing down the transcendental ladder towards the base conditions of signs, Peirce suggests that all significatory processes are ultimately grounded 'either in an idea predominantly of feeling or in one predominantly of acting and being acted on.' At this base line semiosis arises 'from the experience of volition and from the experience of the perception of phenomena' – in other words, from the body.[16] This is compatible with Peirce's protophenomenological observation that 'whenever we think, we have present to the consciousness some feeling, image, conception, or other representation, which serves as a sign.' The external world, our own bodies, and the 'self' are all phenomenal manifestations of ourselves and appear as signs (5.283).

One of the favourite topics of poststructuralist theorizing has been the concept of infinite regress. In this Peirce's comments have been highly influential. Once a sign acquires currency, he argues, it spreads 'in use,' and 'its meaning grows' (2.302). This he generalizes to a claim that 'meanings are inexhaustible' (1.343). The Peircean sign consists of a dynamic, triangular relation between a representamen (signifier), an object referred to, and an interpretant (a signified). The relation is dynamic because the interpretant becomes 'in turn a sign, and so on *ad infinitum*' (2.303). Viewed from the perspective of meaning,

the meaning of a representation can be nothing but a representation. In fact, it is nothing but the representation itself conceived as stripped of irrelevant clothing. But this clothing never can be completely stripped off; it is only changed for something more diaphanous. So there is an infinite regression here. Finally, the interpretant is nothing but another representation to which the torch of truth is handed along; and as representation, it has its interpretant again. Lo, another infinite series. (1.339)

Likewise, indeterminacy and underdetermination of meaning loom large in recent theories of signification. Peirce speaks of the indefinite nature of the sign. 'No sign,' he writes, 'is absolutely precise,' for two reasons. We are dealing with 'indefiniteness as to what is the Object of the Sign, and indefiniteness as to its Interpretant, or indefiniteness in Breadth and in Depth.' This fundamental indeterminacy he sees reflected in the relation between the subject and predicate of ordinary propositions. The predicate is 'a term explicitly indefinite in breadth.' It determines its breadth by way of a subject, a term whose breadth is 'somewhat definite,' but the depth of which is itself 'indefinite.' At the same time, 'the depth of the Subjects is in a measure defined by the Predicate' (4.543). The precision possible in formal logic is not available in significations pertaining to the 'world.' This proves to be an important difference when it comes to the description of meaning in natural languages.

Peirce's procedure of abduction owes much to Kant's transcendental reduction, which is a form of reflective reasoning. Its logical form looks like this: 'The surprising fact, C, is observed. But if A were true, C would be a matter of course. Hence, there is reason to suspect that A is true' (5.189). Abduction is important for semantics in that interpretation and hence the construction of meaning can be regarded as an abductive process in Peirce's sense. Like all but the most technical and habitual meaning processes, 'the conclusion of an abduction is problematic or conjectural.' But even technical meanings arrived at by 'assertoric judgments' Peirce regards as no more than 'problematic judgments of a high grade of hopefulness' (5.192). In this sense, abduction is the rule rather than the exception in the process of meaning constitution.

Peirce's semiotic holism informs his entire oeuvre. We are able to signify specifics, he asserts, only because we have at the same time a significatory relation to the 'world' as a whole. This conviction is exemplified by Peirce's criticism of common and narrow conceptions of the copula. The copula, he says, 'is often defined as that which expresses the relation between the subject-term and the predicate-term of a proposition.' Nevertheless, 'the essential office of the copula is to express a relation of a general term or terms to the universe,' which cannot be regarded as a 'mere concept, but is the most real of experiences.' For 'my universe is the momentary experience as a whole' (3.621).

This Heideggerian aspect of Peirce's theorizing is attractive to a semantics in which specific meanings are tied to the background of a meaningful 'world.' It is incompatible with a semantics which grounds its procedures on the reality of isolable sentence meanings.

Peirce's realism, like Kant's is inferential. A realist, for Peirce, 'is simply one who knows no more recondite reality than that which is represented in a true representation' (5.311). We infer the reality of the 'world' via the representations we must perform. 'The entire phenomenal manifestation of mind,' according to Peirce, 'is a sign resulting from inference.' The mind itself is a complex sign 'developing according to the laws of inference' (5.313). This first supports the view that no serious semantics can escape the theorization of its metaphysical assumptions, and second lends strength to arguments for a broad textual view of the world and against radical relativism. Our texts cannot be entirely random.

Lastly, I wish to offer a word on Peirce's 'community.' When he says that 'men and words reciprocally educate each other' and that the 'increase of a man's information involves, and is involved by, a corresponding increase of a word's information' (5.313), Peirce is speaking not in a mentalist or individualist way but against the background of the principle of the community. To speak of reality, for Peirce, 'essentially involves the notion of a *community*, without definite limits, and capable of a definite increase in *knowledge*' (5.311). Likewise, his ubiquitous term 'habit' is to be read as community sanctioned rather than as individual performance. The words of a speech community, for example, 'denote the objects that they do by virtue only of there being a habit that associates their signification with them' (4.544). To a very large extent, the community steers the trajectory of semantic habits.

Barring Husserl's eidetic convictions concerning meaning, another powerful set of arguments in support of an intersemiotic semantics can be drawn from part of the phenomenological tradition: a forceful emphasis on noetic modifications, the life-world, Husserl's concept of appresentation and its adaptation to concretization in Roman Ingarden's writings, Ingarden's description of the schematic nature of language, and Alfred Schutz's elaboration of typifications. Such a project would far surpass the limits of the present study, however, and can only be indicated as a pathway for further work. The same disclaimer must apply to the possibility of developing further the promising relation between 'forms of life' and 'language games' in Wittgenstein's *Philosophical Investigations*. Here too we can do no more than note the compatibility of *Lebensformen* with community-directed, non-verbal kinds of signification as part of a generously conceived semantics. This compatibility perhaps makes it possible to rescue the notion of *Lebensform* from its status of theoretical primitivum by an inquiry into how it is made up of heterosemiotic sign practices.

Meaning is not well described as a merely linguistic notion. Yet in the majority of works of semantics, what someone means by doing something is strictly separated from what a linguistic expression means, what a visual sign means, what an action means, and from 'what this all means.'[17] We tend to look at the meaning of a word, phrase, or sentence: in short, the meaning of a linguistic expression on its own or in the context of other expressions. To simplify, the meaning of such an expression is then secured by showing how its structure, its syntax, is related to its referential background, usually summed up as 'the world.'[18]

A further step in this direction is the formalization of both syntax and world into a *tertium comparationis*, a fully formalized language, such that natural language and world can be compared without loss or surplus.[19] This arena of formal semantics has achieved formidable complexity, a complexity, however, of a very different kind if we compare it to that found in natural languages.[20]

I shall address these and related issues later and concentrate here on presenting an alternative starting point. In doing so I draw on a broad range of writers and fields: among others, from Peirce to Umberto Eco, from Husserl to Heidegger, from Frege to Donald Davidson; from semiotics to analytical philosophy, from Reinach's phenomenological speech act theory to Derrida's critique of Searle. Uniting these disparate writers and fields is the holistic assumption that meaning is best described if it can address under one theoretical umbrella both what is meaningful in toto to a community and also the meanings of specific significatory acts, from reading a specific visual impression to a gesture of regret, the utterance of a complex sentence in a natural language, reading a traffic sign, a chemical formula, or a digital identification.[21]

We must ask of course whether we are not in danger of losing all precision of description if we open up the field of meaning in this manner. No doubt there are risks, but I suggest that much of the precision achieved with a narrow focus is a precision of theoretical tools rather than a precision in accounting for what actually goes on; and the more precise we are in formalizing natural languages, the less likely we are to describe the object of inquiry.

Unfortunately there is no neutral standard against which we can judge the success of competing methods. The only available test is the relative comparison of competing descriptions, each with its special relation of target language to suitable metalanguage. The chosen relation between definiendum (a natural language) and definiens (a metalanguage) predetermines to a considerable degree what we will find. Ultimately, I believe that our method of investigation

must be guided by our intuitive grasp of what typically goes on when meanings are being produced. And if a semantics fails to cater to our hunches and falls short of providing persuasive reasons why we need to reject our commonsense notions, the theory needs to be given a very hard look.

To be sure, not all accomplishments in analytical and formal semantics are necessarily under attack in the present approach. A broad semiotic description of meaning must be able to grant formal insights a place in the larger picture. But what would such a picture look like? Let me begin with a number of axiomatic assumptions. Suppose meaning is not in any way a feature of language but a broader feature of social *doing*, of which language is a part. Let us say that social doing of any kind is regarded as either meaningful or meaningless by a community. The community could be a tiny group or the population of the planet. If an act is meaningful, even marginally and aberrantly so, it is interpretable; if it is meaningless it is not. Or, vice versa, if a community is able to put an interpretation on an activity it is regarded to have meaning; if interpretation fails, it is meaningless. In this crude ontology, then, we have a 'world' consisting of meaningful and meaningless acts.

To this scenario let us add an epistemic perspective. A community knows its world because its members have imposed and continue to impose a significatory matrix on whatever there is. In other words, everything the community and its members can know they know via signs and not as such and in itself. This Peircean epistemic starting point furnishes a crucial part of the methodological axiomatics for everything that follows. In this picture there are no non-signs, at least not pragmatically speaking.[22] Non-signs can of course be stipulated as the general transcendental possibility for signs, without themselves being knowable: a kind of non-semiotic noumenon. For the purpose of describing meaning, though, this is of no further interest, since everything we can see, touch, and talk about is available to us only in the form of signs: more or less meaningful and very rarely meaningless.[23]

An important axiom in this general background is the assumption that meaning is the realization by a community of the relation between different sign systems. Members of the community are defined primarily by their ability to negotiate such relations according to the community's recipes for interpretation. We could formulate this assumption as a general principle, which I have called the semiotic corroboration thesis, that reality is the result of the corroboration of one sign system by at least one other sign system. Or, more simply, reality occurs when signs from different significatory systems support one another.[24]

The visual image of a tree is meaningful because it can be and has been corroborated by tactile and other significations. I am able to recognize by

touch – that is, to classify as a meaningful part of a set of experiences – a bolt underneath my car's gearbox even if I cannot see it because the tactile signification is corroborated by recollected visual signs of bolts, as well as by other signs.[25] The more complex signs that make up a sexist or racist comment are understood not primarily on the grounds that they stand in a long linguistic chain of similar and already familiar verbal signs. We understand them because they are embedded in a web of non-linguistic signs such as speech stance, construed speech attitude and, importantly, imagined, quasi-physical, social situations which in our example amount to an ugly world.[26]

Evidently, we are not talking here of sense data. If anything, sense data could be argued to be a supporting stage in the chain of meaning-making but are not themselves interpretive perceptions of any kind. Retinal images are not meanings, though meanings are produced with their help. This significatory picture of the world collapses traditional ontic and epistemic descriptions into the one field of semiosis. Having said this, we need to circumscribe our 'world' a little more clearly in terms of its limits and structure. What are the limits of this 'world'? The answer here is not the suggestion made by Ludwig Wittgenstein in the *Tractatus Logico-Philosophicus* but its semiotic extension. The limits of our 'world' are not constituted solely by our language but by our sign systems in toto. The limits of our signs are the limits of our 'world.'[27]

If instead of accepting 'the world' as an empirical *primitivum* we say that sign systems are the limits of our world, we must clarify the consequences of this assumption. Since we cannot know anything outside semiosis, the dynamic totality of signs, whatever 'world' we do experience is a significatory or *textual* construct. Yet if we were to say nothing else about this 'world,' this textual reality would amount to a radically relativistic construal. Radical relativism, however, is marred by two fundamental impediments: self-contradiction and intersemiotic constraint. With respect to self-contradiction, radical relativism is incapable of arguing its own case consistently because it has demolished any non-relative basis on which to do so. This is its methodological weakness. In addition, radical relativism has an impossible task in persuading us that its field of description has no limitations whatsoever and is entirely the result of our tools of inquiry. This point can be made more clearly by the notion of intersemiotic constraints.

Let us understand intersemiotic constraints as those features in the diverse sign systems of different communities, such as cultures, which in different ways point to the basic boundaries of Being. Organic death – the fact that humans die if they drink mercury instead of water – the realization of gravity, the distinctions between the starry sky and the firm earth are all signified consistently,

however differently, in quite unrelated communities. From this and a vast amount of similarly corroborating significations we must not conclude, as does a naïve empiricism, that we have direct, or non-significatory, access to 'the world.' We still live in a textually interpreted world.

The inevitable conclusion is that if there is no evidence of any fundamentally different or contradictory significations on a range of basic matters concerning Being, radically relativist explanations are at least highly improbable. Certainly the constraints which our various sign systems reflect are still textual, those suggested by the latest tools of physics included, but they are massive. The intersemiotic constraints of the sign systems of diverse communities form a frame for living which bounds our world.

Emerging from all this is the realization that we must reject not only meta-physical realism of the kind found, for instance, in naturalist accounts but also all forms of radical relativism.[28] What remains is an inferential realism or what I have called elsewhere a realist textualism. This position acknowledges the re-ality of constraints while emphasizing the textuality of everything we can know, including those boundaries.[29]

So far, then, we have drawn the following picture: the broad ontological category of doing consists largely of meaningful acts, though meaningless acts are also possible. This state of affairs is corrected epistemically by adding that none of this would be knowable were it not for signification. Whatever we know we know as signs. Reality is guaranteed by the corroboration of signs from different sign systems (visual, tactile, olfactory, proximic, haptic, gustatory, auditory, verbal, etc.), and meaning occurs as the result of the relational instantiation of such signs.

General semiosis has been stipulated as what gives cohesion to a community and what in turn is sanctioned by the community. Semiosis is all there is, subsuming as it does both ontic and epistemic perspectives. Rather than saying that our language constitutes the limits of our world, we have extended this to the claim that our sign systems are the limits of this world. We have asserted that we neither have access to the world outside signification nor are able to argue consistently for a radical relativism. Hence we are forced to accept something like a realist textualism, a position which acknowledges the broad intersemiotic and intercultural agreement about fundamental constraints on the way in which we can textualize the world. At the same time, realist textualism insists that those constraints are knowable only in the form of texts.

The remainder of this chapter is designed to clarify and flesh out some of these incipient observations, and in the process to offer a coherent al-ternative approach to semantics: a community-sanctioned, intersemiotic and heterosemiotic directional theory of meaning.[30]

To start with acts, why not simply speak of objects or states of affairs in the world? Preference of 'acts' over 'objects' is partly an acknowledgment of the work of Husserl, tempered by Peirce's emphasis on community control over meaning. In this sense objects, states of affairs, and 'all else' are subsumed under significatory acts. While these acts have Franz Brentano's and Husserl's directionality and certainly require a consciousness, they are by no means merely mental or subjective. The acts we are speaking of here are species bound and socially regulated, and hence can be performed by typical members of the semiotic community – a community which to a significant degree shares and guides and is itself constituted by a common semiosis, the social semiotics. This preference also suggests a dynamic rather than a static view of the background to meaning. All signs are enacted, so that the constitution of meaning is never a 'now,' like some point in a coordinate system, but a process which is connected to previous meaning constitutions as well as to subsequent ones. To use Husserl's notion of retentions and protensions, meanings are acts which retain the shadow of preceding meanings and, by way of protensions, always already lead into subsequent meaning events. Nor should we stay happy with Husserl's linear metaphor.[31] Eco's net of semantic relations is a preferable approach to the matter, as long as such a net is seen as a dynamic field, which changes its total structure as it moves along its historical trajectory.[32]

What is the advantage of insisting on the significatory nature of knowing 'the world'? Would we not be equally well off by simply referring to a house as a 'house' instead of insisting that we can only be aware of a sign. Indeed, the fact that we put the metalinguistic version of the item in inverted commas suggests that we are drawing the reader's attention to the sign quality of the word. But why should our visual cognition of a house be a sign? Why our tactile bumping into it? Why our varying proximic impressions as we drive past it? And so forth. The commonplace assumption that all these processes point to the same 'item' without our ever being able to get to it except by mediation – by using some sort of significatory process – provides the answer. Our noun 'house,' like our various visual and tactile 'impressions' of 'it,' are the different ways in which we are able to construe into meaningful units what we then term an 'experience.'

Should we then not simply speak of 'experience' and 'world'? After all, the majority of works on semantics use both terms quite comfortably without their authors feeling compromised by the convention. See how 'world' functions in the following example: 'A promising suggestion for explaining the meaning of indicative sentences is to focus on explaining *truth conditions*. For it seems that the core meaning of such a sentence is its truth conditions: its property of being true if a certain situation in the world obtains and not true if the

situation does not.'[33] Yet terms such as 'experience' and 'world' are precisely those which beg the questions semantics is addressing. If meaning has anything to do with the way human communities understand the world, the notion of 'experience' short-circuits the argument, for we want to find out precisely what this experience of making sense of the world is. As for 'world,' on the one hand even sophisticated approaches to the question of meaning tend to address in great detail one part of the problem: expression, syntax, sense, and the way it determines reference. On the other hand, they resolve in one sweep the remainder of the equation under the notion of 'the world.' But the way in which signs refer to the details covered by that collective noun is what tells us about the nature of reference. Hence we cannot accept 'the world' as that to which signs refer. Rather, the 'world' is the whole within which specific links between different kinds of signs take place. In this revised picture, the world can appear only as a backdrop, not as part of the process under investigation.

To return to 'experience,' objections can be raised to treating visual and other forms of perception as sign systems, mainly on the grounds that we did not design perception as a process of communication. Since hearing, smelling, touching, or seeing are simply natural processes, perception should not be treated as a sign system. My counterargument is that anything that has to be deciphered, interpreted, in short, *read* must be treated as a form of signification. Even if we did not literally invent seeing or hearing, the way cultures tend to see or hear amounts to an imposition of historically and otherwise differing readings on sense data. Moreover, these construals on top of sense data are learned rather than 'natural' and so carry with them the instructions of the community. However slight, any difference in readings so produced must result in semantic drift, a feature which is the hallmark of fully developed sign systems. In sum, what needs to be read must be regarded as a sign system.[34]

To satisfy the reader who wishes to mark off cognitive from communicative signification, we could introduce the notions of Read-Only Sign Systems (ROSS) and Communicative Sign Systems (COSS). The distinction between COSS and ROSS could be pursued considerably further without, I think, requiring a shift in the axiomatic observations made so far. In addition to the comments made above on the semiotic corroboration thesis, I should add that we cannot simply assume that different sign systems pick out the 'same' item from our world and so produce significations which could in any strict sense be claimed to be identical. Rather than presupposing the congruence of objects projected by different kinds of signs, we should be happy with a less formal result.[35] We recognize objects we touch and hear and smell, or touch and see, or taste and touch as 'the same.' But this is an approximation and not

any sort of strict identification. It appears, then, to be preferable to speak of a negotiatory assimilation between signs of different systems.

The hole in the tooth felt by the tip of the tongue is quite different from the 'same' hole seen in the mirror, and both are distinct from the impression we get when we look at the dentist's X-ray picture. And it would be misleading to say that the tongue has produced the wrong impression, which was then corrected by our more accurate vision or by scientific evidence. What Niels Bohr had to say about the interdependence of measuring instruments and subatomic events applies equally to our banal example. It is impossible to separate the tools of observation from what is observed. Or, as Nietzsche put it, 'there is no right standard,' to which one should perhaps add that the idea of 'no standard' is equally problematic. There are always only standards, a metaphor which reveals a craving for reassurance by identity rather than the ability to produce it.

This debate has a long history. In *De Anima* Aristotle speculates 'for what purpose we have several senses and not only one.' He arrives at the following intriguing, tentative answer. First he finds that it would be very difficult to perceive 'common-objects' (as opposed to 'special-objects,' which are signified singularly) as distinct if we had to rely on one sense alone. His second important observation is that of continuous perceptual self-reflexivity: 'We perceive that we see and hear.' Here his resolution is an either/or: 'Either there will be an infinite regress or there will be some [sense] which is concerned with itself.' The 'right standard' in Aristotle's account is sight, which rules the other senses by virtue of its close association with the imagination. After all, he says, 'the name for imagination [*phantasia*] is taken from light [*phaos*], because without light it is not possible to see.' This still leaves the possibility, not further pursued by Aristotle, of the infinite regress of perceptual self-reflexivity.[36]

The two positions – of the signification of objects as distinct and of an infinite regress of perceiving perception – can be reconciled by agreeing with C.M. Meyers's argument in 'The Determinate and Determinable Modes of Appearing,' where he proposes that an item of perception 'is apprehended incompletely but is not apprehended as incomplete.'[37] That we have cognizance of objects as complete has to do with sufficient semiosis, which always allows for underdetermination. No matter how far we pursue the signs which constitute an object, we can always discover at least one more additional sign.

Twentieth-century physics has enlarged our available sign systems considerably without, however, altering the relation we are trying to capture by the term 'semiotic corroboration thesis.' Take an example from John Gribbin's *In Search of Schrödinger's Cat: Quantum Physics and Reality.* The strange behaviour of electrons in superconductivity can be explained 'in terms of Bose-Einstein

statistics' (sign system 1) and by way of experiments at the subatomic level (sign system 2), as well as demonstrated at the level of ordinary human perception by spinning 'helium cooled below 2.17 K' in a cup. Defying the laws of physics, 'the spinning helium will never stop' (sign system 3).[38] Beyond the minimal requirement for our significatory reality stipulated in the corroboration thesis, we can say that the more sign systems corroborate one another the more real the world appears for us; the more are we at home. The apparently high degree of cohesion and self-righteousness we can observe in certain cultures has to do with multiple confirmations and reconfirmations of their dominant readings of 'the world.'

This should not lead us to assume the inherent stability of meanings. Strictly speaking, it makes little sense even to speak of 'the meaning' of a sign. To do so suggests a static empirical basis for the production of meanings, an assumption introduced by the wrong sort of analysis. As far as the meanings of visual images, auditory information, or words and phrases are concerned, we have to be able to account for the phenomenon of more or less dramatic semantic drift. Traditional standard semantic theories find it hard to cope with this situation. Instead, analytical and formal semantics tend to treat the stability of meaning (or sense) in an axiomatic way. I suggest throughout this book that a very different approach is needed.

Having provided a schematic axiomatics in the form of a realist textualist view of the world, in which our sense of reality is the result of a lattice of significatory confirmations, we can now proceed to a brief account of a directional semantics. Such a semantics cannot assume, as do most current theories of meaning, that intension or definitional certitude is a sound slab on which to build further, elaborate structures. On the contrary, as we shall see, intensional meaning, or strict sense, will turn out to be a special case in an otherwise much less well prescribed reality.[39]

Let us start from the premise that semiosis *works*, that communities function by way of sign systems. Having said this, we should not be tempted to conclude that the reason for this functioning is a fully shared set of meanings. There are other and more probable possibilities. It is quite sufficient for most social interaction, for example, that participants understand *more or less* what is expected and required. In highly technical exchanges and certainly in strictly formal signification this understanding amounts to actual identical meanings being exchanged.[40] For the vast mass of exchanges in a natural language no such identity is either required or indeed possible. Here we are in a different landscape.

Consider meaning production in terms of two axes: (1) an axis along which meanings are negotiated between the boundaries of determinacy and

TABLE 1.1 The Directionality of Intersemiotic Meaning

Kinds of communication	Utterance of signs	Degree of inter-semiotic constraints	Meaning acts	
Pragmatic	(crossed arrows between two pairs of signs)	High: multiple systems required to guarantee viable social cohesion	Narrow negotiation	
Formal	(parallel double-headed arrows between two signs)	Zero: no other systems required (though possible)	Strict sense	Axis of negotiation — Determinacy/Indeterminacy
Ludic	(crossed arrows between two pairs of signs)	Low: any system; directionality of play	Broad activation	
Breakdown of social semiotic	(single vertical double-headed arrow)	None: multiple systems active without exerting control: random interaction of signs	All meaning amounts to no meaning	

Axis of directionality
(underdetermination)

indeterminacy; and (2) an axis along which meaning is viewed as a directed process between the boundaries of an always underdetermined directionality, on the one hand, and communicative chaos, on the other.

In highly fluid meaning 'exchanges' the utterer's meaning and (re)constructed meaning require a generous spectrum for negotiation. The more ludic, or play-ful, the discourse, the greater the spectrum. On the other hand, the more pragmatic and technical the exchange, the narrower the range of meaning possibilities. This suggests two extreme cases: fully determinate and directed signification; and its opposite, the dissolution of signification. In the first case the spectrum of meaning negotiation shrinks to zero, as in the strictly formal semiosis of symbolic logic (though underdetermination is still operative). In its extreme alternative we have a disrupted dis-course with an infinite spectrum of meanings to be construed: the breakdown of social interaction.

Let us take the signs of everyday life, such as linguistic expressions or touch, as typical of meaning transactions. We could describe the process as a more or less directed negotiation between possible modalities, in the broadest

possible sense, and propositional contents. Unlike Jakobson's model, in which the addresser and the addressee of the message are very much locked into the process of exchange as it occurs, in this version of meaning production individual as well as collective readers are always in a position to renegotiate the modalities and propositions which they construed initially.[41] More radically, such renegotiation, whether uttered or thought, is the rule rather than the exception in the process of meaning 'exchange.' In this view misunderstanding and myriad shades of partial understanding replace the ideal of perfect meaning transactions.

Nor should we feel that the most successful meaning exchange is that of formal signs; they are a heuristic fiction for special technical tasks and are not altogether suited to illuminate the operations of ordinary discourse. In ordinary social intercourse the wobbliness of meaning production is not to be seen as a drawback. Rather, it should be acknowledged as an important emancipatory potential which guarantees the possibility of historical political progress.[42]

This may strike the reader as an unwarranted and improbable extension of our discussion so far. I merely state my conviction here to indicate the political stakes attached to any kind of theorizing in semantics and the specific politics underlying the sort of stance I am offering in this book. Not that standard formal semantics in the line of Alfred Tarski and Rudolf Carnap could be accused of entailing an antidemocratic attitude. What can be said and shown is that the will to rigorously formalize cultural signification, such as natural languages, makes it difficult for the description of meaning to address, for example, the complex ideological saturations we discover in gender- or class-dependent meanings. As we shall see later, the distillation of meaning into strict sense compatible with formally empty signs is the sort of procedure I have in mind. Ironically, the popular notion of an empty signifier very much shares this problem.

It must be remembered in this context that Alfred Tarski himself never argued that formal methods and truth conventions should be applied to natural languages or to their colloquial ingredients: 'It is only the semantics of formalized languages which can be constructed by exact methods.' As for colloquial language, 'the results are entirely negative. With respect to this language not only does the definition of truth seem impossible, but [so does] even the consistent use of this concept in conformity with the laws of logic.'[43] Carnap and his adherents did not follow Tarski's instructions. It is to their projects that we will have to turn later on.[44]

Having said that formal signification is an extreme case rather than a centre, origin, or basis of signification, we can legitimately regard as central the discourse practice of everyday life in its verbal and non-verbal forms. Along

the axis of directionality guidance is neither formally strict nor so loose as to invite chaotic meaning explorations. Hence the axis of meaning negotiation displays a spectrum of pragmatically sound meaning possibilities, which allows daily business to be conducted free from the hard rule of formal signification yet is narrow enough to enable us to jockey for a sensible position.

Semantics must be able to cope with this phenomenon of negotiation. It is important in ordinary social semiosis because even if the message were to be regarded as unequivocal, no sign has only information content; it is always also a sociopolitical act. When a person is asked again and again to open the window, the information content begins to pale before the political modality of domination. To say that the meaning of the expression 'open the window' remains the same under these conditions is a stance which runs into difficulties, as I will try to demonstrate later. Suffice it to say here that we will need to debate whether we can speak about the meaning *of* a text, of a sentence, let alone of words, in the manner adopted in traditional semantics. In the view taken here, meaning is not a property of any sign, either linguistic or non-linguistic. Hence neither words nor sentences are by themselves in a position to mean anything. They need to be activated in a process which is typically negotiatory and, to a large extent, non-linguistic.

For meanings to be construed in a dialogical dynamic signs must be activated. I prefer to call this event of activation an instantiation: without non-linguistic instantiation, no language; without instantiation, no signification whatsoever; without instantiation, no meaning. Even *langues*, formalized language systems, at whatever level of abstraction, are *paroles*, or speech events, as soon as they are formulated or read, i.e., instantiated. Without being instantiated in some way they are not available. This suggests the collapse of the two Saussurean terms into one kind: instantiation. The difference pointed to by Saussure is thus transformed into one of degree between instantiations which mimic the phenomenal level of discourse and those which we construe at different levels of formalization.[45]

If instantiations by addressers and addressees negotiate meanings in the use of an expression (typically characterized by sound waves or, more generally and following Derrida's usage, by an inscription), a gesture (supported by sense data or a camera), or an olfactory signification (corroborated by chemical analysis), then signs must have a special kind of structure. The minimal requirement of a structure allowing for this sort of explanation is that signs be schematic. Accordingly, I have previously referred to words and expressions as 'directional schemata' for meaning-making.[46] I now want to extend this notion to include all signs such that semiosis is the process of transforming the directional schemata

of signs into meanings. And a social semiotics is the sum of such meaningful signs produced in a particular community.

Pragmatically, both the axis of directionality and the axis of meaning nego-tiation are cut short according either to the requirements for effective social interaction or to the imposition of political rule. Theoretically, however, both axes are infinite. The heuristic exceptions are our two limiting cases of signi-fication: formal signs and significatory breakdown. In the first case the axis of negotiation has shrunk to zero, though the axis of directionality remains in-finitely underdetermined.[47] In the case of significatory breakdown, the axis of negotiation becomes pragmatically infinite; that is, all meaning is no meaning. At the same time, directionality has collapsed to zero. There is no directional-ity. Meaning can be explored 'in all directions,' which turns out to be the same as 'in no manner recognizable to the community at all.'

To return to the broad spectrum of socially negotiated signification, even if purpose-rational and especially instrumental semiosis is typically short lived in social practice we must not underestimate the potential of signs for infinite regress. This notion has become popular in recent years, mainly as a result of Jacques Derrida's critique of conceptuality. We need to acknowledge though, as Derrida himself does, that the idea of the fluidity both of our epistemes and hence also of our ontic projects has a very long history, which in Western philosophy goes back to pre-Socratic thinkers. Not so well known is that one of the targets of Friedrich Nietzsche's relativist attack, Immanuel Kant, draws our attention to the instability of concepts in the *Critique of Pure Reason*, in which he warns that 'no concept given a priori, such as substance, cause, right, equity, etc., can, strictly speaking, be defined ... [and] ... the completeness of the analysis of my concept is always in doubt.' The same, says Kant, applies to empirical concepts.[48]

If Derrida owes far less to Kant than to Nietzsche, his immediate debt – as far as *mis-en-abyme*, his version of infinite regress, is concerned – is to Charles Sanders Peirce. After all, it is not the traditional principle of infinite regress but its semiotic form that is central to Derrida's poststructural stance. In Peirce the significatory abyss is formulated thus:

The meaning of a representation can be nothing but a representation. In fact, it is nothing but the representation itself conceived as stripped of irrelevant clothing. But this clothing never can be completely stripped off; it is only changed for something more diaphanous. *So there is an infinite regression here.* Finally, the interpretant is nothing but another representation ... and as representation, it has its interpretant again. Lo, another infinite series. [emphasis added]

And a little later Peirce sums up what this means for the process of meaning constitution: 'In general, we may say that *meanings* are inexhaustible.'[49] The infinite regress of the sign is important for two reasons. First, taking a linear perspective, to brush this 'ad infinitum' aside makes room for the claim that formal semantics is not so far off the mark after all. For if meaning-making is typically not an ongoing dynamic but a process terminated in practice, there are good grounds for pairing its closed meaning entities with formal equivalents. To avoid this, we must draw a more complex picture, in which pragmatically terminated signification goes underground, as it were, and lingers on, revivable at crucial thematic moments in future social interaction.

Second, from a multidimensional perspective, the theoretical potential of semiotic infinite regress is vital for our understanding of the network activity of the distinct sign systems that make up a social semiotics as a whole. The phenomenon of experiencing a 'world' rather than something seen or touched is the result of multiple sign systems impinging at the same time on the 'object' of our attention. Scientific apparatuses are attempts to reduce this multiplicity to singular systems of signification, which are then paired with other such isolated systems. The multidimensional, infinite regress of signs has been noted in somewhat different terms by Umberto Eco. He draws our attention to the point that one could unravel the total of signs in any culture by beginning with an isolated sign and following its myriad interconnections.

The end of this process is of course forever deferred, for by the time the colossal task of extrication could be finalized, the culture under scrutiny would have evolved further, leaving the investigators with a dead system, a pale shadow of the actual target of the description. Again, the distinction between potential and actual cultural practice is significant. Both the linear and the multidimensional regressive potential of signs is never fully realized in social interaction.

Typically, both processes tend to be terminated by what one could call, in Leibnizian fashion, sufficient semiosis.[50] Yet sufficiency here is determined neither by logical limits nor by a grammar or *langue*, but by what a community judges to be communicatively economical. In technical, instrumental interaction this limit is narrowly circumscribed, in symbolic interaction it can be more generously negotiated, while in art this very boundary becomes itself a target of ludic exploration.

I have postponed clarification of the notion of community to the end. The minimal description I gave earlier was that it could be as small as a tiny tribe or as vast as the global population. Size here is not a vital consideration, perspective is. If we are interested, for example, in the digitization of cultural production, then the largest possible description is appropriate. For any small-scale

sign usage, such as family idiosyncrasies, the narrowest possible focus is what we want. If size is not a crucial factor in determining the role of the community in the production of meaning, what is? The short answer is the guardianship over the dialectic between old and new signs. A more elaborate explanation would have to address the means of such retention and production, both of which can be subsumed under *use*. The conservative part of use poses no problem to formalization and is not so interesting for the present argument. On the other hand, the question of how the community accommodates sign invention, or production, in its social semiotics is pertinent to what I wish to say.

Whenever the ghetto, computer design, fashion, literature, or genetics offers new significations and hence also new linguistic expressions, such expressions become part of a social semiotics if they find a constituency or die if they do not. The import of the community for semiosis was noted by Charles Sanders Peirce, who claimed that the conception of a significatory reality 'essentially involves the notion of a *community*, without definite limits, and capable of a definite increase in knowledge.'[51] Both community and *knowledge*, a collection of signs in Peirce's account, are conceived as open ended and dynamic. Peirce does not say that human reality 'typically also goes with' what we call a community. Rather, he speaks of an 'essential' involvement. Without the notion of community we cannot consistently produce human signification and, consequently, not even a single social sign.

If the community is such a crucial 'factor' in signification, how could one inscribe it, for example, into Jakobson's model of 'factors' and 'functions'? Community would have to be the holistic horizon, of which all of Jakobson's elements are a part: addresser and addressee as members; context and code as the world of a culture and social semiotics; and message and contact as, respectively, a specific set of signs and a specific sign system channelling the message. Likewise, Jakobson's six 'functions' can be regrouped to meet the demands of communicative transcendentality, the frame without which human signification or social semiotics is not thinkable. This communicative metafunction would have to be regarded as the transcendental horizon for all of Jakobson's directional 'functions': emotive and conative indicating the personal direction of expression and impression; referential and metalinguistic pointing towards two kinds of outside, a 'denotative' non-linguistic and a linguistic or 'glossing' function; and poetic and phatic respectively indicating the direction of self-sufficiency of signs and aiming at the continuation of communication.

From a realist textualist perspective, this arrangement of operational aspects of communication can be modified to allow for the community as the necessary frame for all communication and the collapse of the Jakobsonian scheme into a simpler structure: community, semiotic agents (addresser/addressee), social

semiotics (context/code), and sign system (message/contact). The advantage of generalizing addresser and addressee into a plural category accommodates the semantics of mass communication;[52] the fusion of context and code into social semiotics emphasizes the textual nature of the 'referential' world (context) as the signifieds of social signifiers (code); and message and contact become the signified/signifier sides of any specific sign system activated in acts of communication.

As a discipline semantics has not been keen to embrace such a fuzzy frame. It has shrunk the scope of its observations to a much more narrowly focused field: the sense-meanings of linguistic expressions. As a result, and Eco has rightly pointed this out, 'the continuum, the pulp itself of the matter which is manipulated by semiosis, escapes semantics.'[53] I want to go further and say that semantics has thus not only unduly restricted its vision but that many of the specific findings so produced are themselves unsatisfactory. The meanings of linguistic expressions cannot be described appropriately if we stay within language and merely gesture towards a cursorily invoked 'world.' Two radically different kinds of semantics suggest themselves: one acknowledges the fuzzy frame of social doing within community constraints and so is able to accommodate meaning as an intersemiotic and heterosemiotic event; the other is based on the assumption of meanings as definitionally ruled entities and operates within a homosemiotic frame. We can now formulate the differences between these two kinds of semantics in the form of six theses.

Two Kinds of Semantics: Six Intersemiotic Theses

There is no meaning in language or in the dictionary. Semantics is the rationalization of social meaning, an abstraction derived from the activities of semiotic communities. Such an idealization is possible because the horizon of our understanding, the horizon of culture, limits the dynamics within which all meanings and their constraints are negotiated. This description includes the strict sense of formal logic. On the one hand, formal semantics cannot be strictly separated from the semantics of social signification, whether linguistic or non-linguistic, but remains a derived set of procedures and so does not provide a founding level for all semantics. On the other hand, we need to stress the consequences of idealization, by means of which new kinds of formalization are produced. In the following six theses I shall try to isolate some major differences between natural language semantics and its formal cousin.

Thesis one: Formal semantics is homosemiotic, whereas non-formal, or natural language, semantics is heterosemiotic. Homosemiotic semantics – the systemic relations of

a first-order language L1 and a second-order language L2 – is radically different from heterosemiotic semantics as we find it in natural languages. All formal semantics is homosemiotic and so operates within a structurally homogeneous arena, with full commensurability of L1 and L2. By contrast, all natural language semantics is heterosemiotic, as are those of all non-linguistic, non-formal varieties of signification. The difference between homosemiotic and heterosemiotic semantics lies in the way in which meaning is achieved and reference secured. In the former, meaning can be equated with strict sense, governed by definitionally stipulated rules; there is neither semantic loss nor surplus in meaning exchange. The same cannot be said about the latter. The heterosemiotic relations between linguistic schemata and the non-linguistic signs (tactile, visual, aural, proximic, thermal, gravitational, haptic, etc.) with which we concretize meaning are fundamentally different. Here, we are dealing with interpretive approximations; we reconcile the various kinds of non-linguistic readings under the directionality of the linguistic expression.

Thesis two: Reference in non-formal semantics is an intersemiotic relation. In formal semantics reference is an internally consistent or homosemiotic relation, the link between an expression in L1 and its specific counterpart in L2. Reference in natural sign systems, with the exception of self-reference, is always a nexus between radically different, heterosemiotic signs. Hence meaning in natural sign systems always has reference, whether material, ideal, or purely intentional (e.g., fictional). In disagreement with realist stances, I do not regard reference as the association between a sign system and the 'world,' such as the association between language and unmediated objects. A broad range of analytical theories of language construe the relation precisely in this fashion. Thus neither realist nor formal semantics is compatible with the position in this book. Rather, natural sign reference is understood semiotically as the relation between different sign systems, resulting in the identification of a sign complex.

In formal systems, reference is secured by definitionally relating a first-order system to a second-order system. Rudolf Carnap developed the classical strategy for this case.[54] As long as this relation is seen to apply strictly within the limits of the purely formal, there is no case to be argued. Yet significantly, formal convictions have a way of transgressing their own principles. In spite of assurances to the contrary, an entire tradition of formal semantics again and again steps outside the formal domain into the realm of natural language and culturally saturated non-linguistic sign systems. When this happens, equivocation ensues: the 'sense' of formal procedures (sense 1) is identified with the 'sense' of natural language and non-formal, non-linguistic signs (sense 2).[55]

Thesis three: What is called sense (and sometimes meaning) in formal semantics is radically different from sense (or meaning) in non-formal systems. In formal sense, variables and constants are strictly defined. No referential background is required; its definition suffices. By contrast, non-formal sense, for example in natural language expressions, is regulated by community practice, allowing for semantic drift. The signifier 'democracy,' for example, can be understood only if we are able to construe a non-linguistic, referential background for it. The same applies to its dictionary substitutions. Subject and predicate, and even the copula, require non-linguistic signs to be activated. No such requirement can be stipulated for formal sense. The difference between sense 1 and sense 2 lies in the way in which they are constrained.

I suggest that there are two kinds of constraint: definitions, or strict synonymy, on the one hand and community practice on the other. For as Peirce observes, the conception of reality 'essentially involves the notion of a *community*.' [56] Sense 1 requires a strict form of semiosis, homosemiosis, governed by analyticity; sense 2 is always the result of an historically dynamic semiosis, heterosemiosis, regulated by discursive practice. In Kantian parlance, the first is subject to subsumptive or determining reason, the second to reflective reason. Strictly speaking, for non-formal sense, definitions are not available. Rather, what we call definitions are predications of variable length, depending on the size and specialization of the lexicon. Moreover, the so-called definitions of natural languages are a posteriori construals, summary statements after the fact of social semiosis.

Why are there no a priori definitions for natural meanings? The answer lies in the difference between homosemiotic and heterosemiotic relations. In homosemiotic relations the systems compared are isomorphic, so that all 'grammatically sound' relations reveal commensurability. This is not so in heterosemiotic relations. Furthermore, in formal linkages both commensurability and identity are possible. By contrast, in heterosemiotic bonding neither commensurability of the systems nor identity of the results can be assumed. Matching can be achieved only by negotiation, even at the perceptual level. (Compare the earlier example of the hole in the tooth as a tactile, visual, and X-ray construal). If no identity is guaranteed even at the perceptual level, it should not be surprising that the social and historical complexities reflected in natural language disallow strict synonymy. Hence definitions cannot claim to be the primary guarantors of sense 2.

Thesis four: Sufficient semiosis is to natural sign semantics what truth-conditional procedure is to formal semantics. Given the relative incommensurability argued for, how is communication possible? Unlike formal semantics, which relies on

truth-conditional judgments, natural language semantics cannot guarantee meaning exchange by way of a two-valued logic. Instead, communication is sanctioned by sufficient semiosis. Sufficient semiosis is the principle of a chain of *Vorstellungen* (mental representations) and reasoning in support of synthetic judgments. The point at which such a chain is regarded as sufficient is determined not logically but only pragmatically, when a community is satisfied that the judgment is well grounded in shared social experience.

So far, sufficient semiosis appears to be a significatory replica of Leibniz's sufficient reason (*zureichender Grund*). Whereas sufficient reason has traditionally been employed to handle synthetic judgments as if they were analytic ones, however, sufficient semiosis sanctions no such transfer. Instead, it emphasizes the cultural horizonality of natural language and its non-linguistic relations. In so doing, sufficient semiosis provides an explanation of how ordinary communication is possible without the necessity of invoking truth conditions. In truth-oriented semantics 'this politician is corrupt' is intelligible because we can judge whether it is true or false. From the perspective of sufficient semiosis all that is required is that we are able to imagine a sufficiently coherent 'world' with the help of quasi-perceptual acts.

Thesis five: Perception is an umbrella term for the sum of read-only signs. In order to link communicative sign systems (COSS) such as linguistic expressions or gestures to the 'world,' we need to redefine 'world' in terms of signs. Following Peirce and rewriting Kant, we can achieve this by regarding perception as signification. However, we are dealing here not with communicative signs but with 'read-only sign systems' (ROSS). Together, communicative signs and read-only signs make up social semiosis. From this perspective, we can now explain better how in natural languages the directional schemata of linguistic expressions are typically activated by non-linguistic signs, such as olfactory, haptic, aural, visual, tactile, proximic, and other readings. The manner in which we habitually link the verbal and the non-verbal has to do, on the one hand, with what we must infer to be the deep constraints of the universe and, on the other, with the rules of the community.

Thesis six: Natural sign semantics cannot be located at the pole of either radical relativism or metaphysical realism. Given the previous five theses semantics requires a frame which we could term inferential realism (to stress constraints) or 'realist' textualism (to emphasize our intersemiotic construals).[57] Every semantics presupposes some kind of metaphysical perspective. The Fregean tradition offers a semantics based on realist metaphysical assumptions. True, Frege was much more interested in projecting a coherent *Begriffsschrift*. Yet once he postulated that reference was the link

between expressions and world, with the world as given, he was bound to a re-alist semantics. By contrast, the Nietzschean path, according to which semantic relations are no more than rhetorical processes, presupposes a radical rela-tivism. The position advocated in this book locates itself somewhere between these poles; it wants to have its cake and eat it too. Given its heterosemiotic constructivist bent and the inference of necessary constraints through our con-struals, this semantics acknowledges the demands of realism while emphasizing the fundamentally textual nature of all knowledge.

Meaning: An Intersemiotic Description

Given the intersemiotic frame outlined, we can now venture the following de-scription of meaning. Meaning is the event of linkage between signs from at least two different significatory systems. It is therefore always both an inter-semiotic and a heterosemiotic relation. It is intersemiotic because meaning requires a linking operation between distinct systems, and heterosemiotic be-cause such linkages do not produce identical 'contents.' Rather, the production of meaning is the result of interpretive negotiation which reconciles the varia-tions that different signs produce about the 'same' portion of the 'world.' From this perspective, the 'world' is as much produced by signs as it constrains them, such constraints being inferred, paradoxically, by the signs sanctioned by the social.

Meaning is negotiatory in a double sense. Even at the most rudimentary level of perceptual read-only signs, such as hearing something, meaning results from an alignment of heterosemiotic information. If we could not imagine tactile and visual equivalents, we would not be in a position to interpret what we hear. Even at this semiotically primitive level, the interpretant sign is an act of transient *Aufhebung* in a chain of significatory regress. In a second, and more consequential, sense meaning as event is always the result of a community-sanctioned negotiation among a host of related alternatives.

Given the premises outlined in this chapter, it cannot be coherently argued that meaning is free play. Meaning events are constrained in two ways: by inferable base constraints and by the interpretive boundaries of the semiotic community. Cultures tend to avoid consistent violation of physical or brute constraints in the interest of survival. What is culturally meaningful is thus realized against brute boundaries even if such limits are given only indirectly, via those cultural readings which have regularly failed. It is at this point that base constraints are subsumed in the grammar of the social. The social provides both the possibility of meaning negotiation and its typified limits. Readings

against the norm are themselves social and appear to be restricted to the necessary possibility of transformation of the historical.

Applied to the semantics of language, this suggests that linguistic meaning is an event of activating expressions by way of tactile, olfactory, visual, aural, proximic, haptic, and other signs. In virtue of such relations, all expressions, including syncategorematic terms, carry the iconic traces of their social origins. When Frege eliminated the idea (*Vorstellung*) from 'objective' sense on the grounds that it was entirely subjective, he appears to have been rash. Why should the syntactic substitutions, misleadingly called 'definitions,' which language users access be in any way more objective than the typified image chains, bolstered by highly structured televisual reinforcement, that increasingly constitute our grasp of the social? I suggest that syntactic substitutions and images cannot be conveniently distinguished along the divide of objectivity and subjectivity. They are both intersubjectively dynamic and receive what control they do via the interpretive constraints of a speech community.

Complex meanings, such as the meaning of 'democracy,' are compound events. Nevertheless, even the meaning of 'democracy' relies on our ability, trained into habitual grasp, of imagining the typical social situations economized by the concept. The more sign systems we are able to draw upon in a meaning event, the more constant the meaning. At the same time, even the most overdetermined meaning event is fundamentally noetic and hence unstable, forever turning into aspects of other such events. Meaning, as Peirce rightly emphasized, is coherently thinkable only in terms of infinite regress.

In this picture, what do the various elements of a meaning event contribute? Natural language expressions, unlike their formal counterparts, are related to syntactic substitutions via degrees of similarity and dissimilarity. Formal expressions relate to other formal expressions within the same system in terms of identity and non-identity. This stage of analysis, however, cannot address meanings but only syntactic relations. Meaning occurs when a secondary system of signs is aligned with syntax. In natural language such a secondary system must consist of non-verbal signs. In the event of meaning syntax and non-verbal sign systems fulfil different functions. The linguistic expressions act as two-directional schemata: directing us towards the portion of the 'world' that is to be activated by way of quasi-perception, i.e., an assemblage of non-verbal signs; and retrospectively towards the kind of speech situation which must be inferred as a typical speech stance for the expression, an imagined scenario likewise construed by means of non-verbal signs. We could term this twofold, quasi-representational directionality of natural language expressions their 'sense.' If we do so, we must note the radical difference between this sort

of sense and the definitional kind. No such double directionality towards quasi-referential and quasi-deictic background can be associated with formal sense as objective thought.

The role that non-verbal signs play in the occurrence of linguistic meaning is also twofold, yet in a very different manner. In its most schematic form, non-verbal signification is required for numerical, minimal, or 'this–there' identification. At the same time, non-verbal signs provide graded, qualitative identification, from highly schematic realizations to the most intricate representations, on a sliding scale of iconicity. The more 'concrete' an expression, the more obvious is this relation. Yet even the most formal features of natural language, which appear to be entirely conventional or symbolic, such as the copula and other 'function' words, have been able to acquire their conventionality only as a result of continuous, habitual usage in a history of diminishing representationality. Even the copula, or 'and' and 'either–or,' still reflect the social, non-verbal situation of likening, linking, and separating.

The fear that with the reintroduction of corporeality into the process of meaning we are bound also to commit ourselves to some sort of metaphysical presence is unwarranted. Why should tactile, haptic, or olfactory signs be less subject to the regressive play of signification than their linguistic cousins? It should not be surprising that the 'now' of meaning forever slides into the past, if meaning has been described in terms of temporality. Thus the reincorporation of the body cannot alter the virtual nature of meaning; it remains a fleeting occurrence resisting arrest.

Viewed in this way, meaning in natural languages differs sharply from the Fregean sense. The latter receives its instructions, as it were, from definitions, the former from the praxis of community-sanctioned, intersemiotic linkages. As a result, syntactic substitutions (e.g., dictionary entries) are effects rather than the cause of meaning. It follows that there is no such thing as a non-pragmatic meaning. Descriptive practices from analytical curtailment of meaning events to their full formalization are of course possible, but they produce neither the necessary nor the sufficient conditions of meaning. Such formulations are no more than possible syntactic effects ensuing from the pragmatic, intersemiotic facts of meaning as event.

2

Natural Language and Meaning as Definition

2.1 THE CONFLATION OF TWO KINDS OF SENSE

ALFRED: Snow is white is true, iff snow is white.

HORST: What kind of snow do you have in mind? Most kinds of snow I know are not white.

ALFRED: It doesn't matter what kind of snow it is. The biconditional characterizes a formal relation.

HORST: You mean you didn't really mean 'snow' when you said 'snow.' You could have used any sign from one formal system and linked it via a conjunction to another formal system.

ALFRED: My Convention T is a formal relation which holds in all systems as far as their formal features are concerned.

HORST: Then Convention T cannot be used to characterize natural language semantics.

ALFRED: That's what I said a long time ago.

In this introduction I focus on the equivocation, customary in analytical approaches to semantics, of two different kinds of sense, while section 2.2 takes a sharp look at one of the most influential moments of this conflation, Gottlob Frege's seminal paper 'On Sense and Reference.'[1] While most of the literature accentuates the difference Frege draws between the sense of expressions and the reference to which we point by means of expressions, the present study is primarily interested in Frege's 'sense.' Section 2.2 examines how Frege arrives at his central examples, 'morning star' and 'evening star,' from his formal starting point in geometry. In doing this, the section provides the platform for a general offensive against equations of formal and natural language sense in semantics and so lays part of the ground for the remainder of the book.

Section 2.3 then explores the role the Fregean conflation plays in the work of Rudolf Carnap, which is important for arguments distinguishing syntax from semantics.

Looking back to the introduction of this book, one could say that Leibniz's distinction between analytic truths, for which we are able to give conclusive reasons, and contingent truths, for which sufficient reason is merely an abbreviated procedure of an infinite chain of reasoning, provides a convenient parallel for the issue before us. Formal sense appears to operate on the principles of definitions, while natural language sense does not quite fit into this neat mould. A different explanation is required. What counts as a useful description of natural language sense is one of the themes which will accompany the reader throughout this book. But first a few more preliminary remarks.

Some of the distinctions needed for this discussion are canvassed by Ludwig Wittgenstein and Willard Van Orman Quine. Investigating Wittgenstein's notion of meaning, one finds a separation of referential meaning (*Bedeutung*) and strict sense (*Sinn*) in the *Tractatus Logico-Philosophicus*. While the former is real or actual, strict sense is 'a mere possibility,' so that 'names have *Bedeutung* but not *Sinn*, propositions have *Sinn*, but not *Bedeutung*.' Likewise, since 'variables have no referents' they cannot have meaning. Including states of affairs in this picture, one can agree with Garth Hallett in saying that 'propositions show possible states of affairs.'[2] This is in line with Wittgenstein's observation that 'logic deals not with facts but with possibilities.'[3] Perhaps it is permissible, then, to say that natural language expressions, by contrast, deal with actual or fictional states of affairs, and so unlike mere names have both sense and referential meaning. Nevertheless, we must still ask whether the sense of propositions and the sense of natural language expressions can be the same kind of thing. And we must also ask whether natural language sense is not always already a kind of referential meaning, quite apart from any specific reference which linguistic expressions may have.

Reference is important in both Wittgenstein's and Frege's accounts of meaning. When Wittgenstein says that 'the use of the word *in practice* is its meaning,' we are bound to read this in conjunction with his assertion in *Philosophical Investigations* that meaning 'is not a thing referred to, but the use of the word to *refer* to such a thing,' a view also central to P.F. Strawson's notion of reference.[4] Meaning as practice, then, is tied to a 'referring use' of linguistic expressions. Missing in Wittgenstein for our purposes is an argument that would link meaning so defined to the way in which language games are embedded in forms of life. Had he provided such an argument he might have done so from a constructivist rather than a hard-headed realist position.

In Frege, reference is more simply conceived as the object to which an expression refers by means of its sense. And sense is not understood as attaching to the expression, but always defined 'in the context of a proposition.'[5] As section 1.2 argued, this 'realist' form of reference, as well as Wittgenstein's referring use, can be rephrased in intersemiotic terms such that reference is neither the thing referred to nor even the image of the thing referred to but the act of linking linguistic expressions and the non-linguistic signs by which we constitute the part of the 'world' on which we happen to focus. Even so, my disagreement is not so fundamentally with Frege's reference as with his unitary notion of sense.

Frege's equation of natural language with formal sense makes it difficult to accommodate either Bertrand Russell's arguments concerning the vagueness of words or Wittgenstein's observation of the absence of strict meaning. According to Russell, meanings are not 'absolutely definite' but characterized by a 'greater or lesser degree of vagueness.' He compares meaning to a target area with a 'bull's eye' and 'outlying parts,' which are still part of the meaning yet 'in a gradually diminishing degree.' No matter how precise our language, 'the bull's eye never shrinks to a point' and so there always remains 'a doubtful region.'[6] This is as incompatible with the opening of 'On Sense and Reference,' as is Wittgenstein's assertion that many words 'don't have a strict meaning.' To say that this is a flaw 'would be like saying that the light of my reading lamp is no real light at all because it has no sharp boundary.'[7] To continue Wittgenstein's comparison, under certain circumstances it would be a defect if our light did have such a boundary. Likewise with natural language.

The Fregean goal of a sense which would comply with the ideal of a purely conceptual language ruled by strict definitions, appears to be echoed in Quine's demand for the radical separation of a theory of meaning from a theory of reference. In *From a Logical Point of View* Quine writes,

When the cleavage between meaning and reference is properly heeded, the problems of what is loosely called semantics become separated into two provinces so fundamentally distinct as not to deserve a joint appellation at all. They may be called *the theory of meaning* and *the theory of reference*. 'Semantics' would be a good name for the theory of meaning, were it not for the fact that some of the best work in so-called semantics, notably Tarski's, belongs to the theory of reference. The main concepts in the theory of meaning, apart from meaning itself, are *synonymy* (or sameness of meaning), *significance* (or possession of meaning), and *analyticity* (or truth by virtue of meaning). Another is *entailment*, or analyticity of the conditional. The main concepts in the theory of reference are *naming, truth, denotation* (or truth-of), and *extension*. Another is the notion of values of variables.[8]

From a strictly logical point of view, Quine is disarmingly right. If our aim is to have theoretical clarity rather than a description of what we typically do, then the separation of meaning and reference is just the starting point of a series of further necessary distinctions. Moreover, all of the clarifications Quine is proposing are in agreement with Frege's move at the beginning of 'On Sense and Reference.' Ironically, the more proficiently this radical program is worked out, the less competent it will prove in coping with the demands of natural language. Let us take Quine's terms in turn. 'Meaning' itself, in order to be stripped of all referential ingredients, has to be reduced to a strictly definable entity, in short, a formal concept. This, as the present study argues, is a drastic violation of essential features of linguistic expressions as far as they are used to constitute meaning.

'Synonymy,' as sameness of meaning, is likewise problematic pending clarification of 'sameness.' If it is conceived strictly, then formal identity is required, a feature unavailable in natural languages. If, on the other hand, 'sameness' is stretched to included a range of similarities, then meaning requires a non-formal description, and referential background is returned to the picture. 'Significance,' or 'possession of meaning,' remains a useful way of drawing the kinds of distinctions that Wittgenstein did, as indicated above. It can also be employed to demonstrate an important difference between formal and natural language sense. In formal language sense significance is a function of a stipulative fiat; in natural language sense it is a function of 'emergence' and fading. Terms and their shifting meanings appear here from specific socioeconomic domains, such as the ghetto or the computer industry.

'Analyticity,' as I shall demonstrate below, is an ideal imposed on linguistic expressions. It works as a metaphor rather than as the sort of thing its nomenclature suggests, namely a formal relation of truth via meaning. In natural language sense truth by virtue of meaning always turns into what Quine calls 'truth-of,' or some kind of denotative truth. Suffice it to observe here briefly that neither truth in Quine's sense of analyticity nor even truth in a macrostructural, ontological sense à la Heidegger is able to deliver the semantic goods. As for formal truth, a sliding scale of diminishing returns suggests itself. It works best when analyticity can be guaranteed by definition: in formal logic and, with a grain of salt, in technical language use.

Yet truth conditions carry decreasing conviction as we address the linguistic representation of more and more complex social situations. In circumstances in which a number of people disagree over the 'facts' of what was meant in a linguistic exchange, both meaning and truth become the targets of dispute. To say that without a broad notion of truth people would not know what the dispute was about is a confusion of truth with awareness of social semiosis as

the necessary background for all instances of signification. As far as natural language semantics is concerned, truth is a metaphysical hangover.

Finally, 'entailment' – or the analyticity of the conditional – is subject to the same distinction between formal and non-formal sense. What is a matter of strict definitional relation in the former turns into a chain of elaborations in the latter, the semantic equivalent of insufficient reason.

An altogether different theory, says Quine, is required to deal with anything associated with reference: reference itself, naming, truth, denotation as truth-of, extension, and the values of variables. It has already been pointed out that the separation of a theory of meaning from a theory of reference leaves natural language expressions without referential background, which amounts to a removal of sense. We could not understand the sense of 'morning star' if we did not have a good grasp of what typical mornings felt like and typical planets looked like. Moreover, all of the terms listed on the side of reference by Quine appear to have two different conceptual characters, depending on whether we apply them to formal semantics or to the semantics of natural languages. Reference is homosemiotic in the former and heterosemiotic in the latter. Truth is unproblematic in formal semantics and increasingly problematic as the complexity of the 'world' indicated in the linguistic expression grows. Extension refers to definitionally secured sets of classes in the formal and to groupings of items without neat boundaries in the non-formal. While the values of variables can be fixed in formal semantics, no equivalent procedure is available for natural language, in which the values of words, if we count them as variables, are open to interpretative negotiation.

The distinction between a theory of meaning and a theory of reference is brought out in the difference between the roles the notion of *definability* plays in each. In a theory of meaning, writes Quine in 'Notes on the Theory of Reference,' 'the word "definition" has indeed commonly denoted synonymy, which belongs to the theory of meaning.' By contrast, in mathematics 'a general term t is said to be *definable* in any portion of language which includes a sentence S such that S has the variable "x" in it and is fulfilled by all and only those values "x" of which t is true. Definability so construed rests only on sameness of reference – sameness of extension on the part of t and S' (132). Quine's reasoning is flawless, as long as we remain within the confines of logic. As soon as we step outside its boundaries and apply 'meaning' so defined to terms in natural language, we note that we are not in a position to grasp the meaning of the term. Synonymy provides no more than a syntactic substitution. Now we have two terms whose meanings are said to be identical. Nor will a third term or an infinite regress tell us what the first term meant unless we know the language, which begs the question of meaning. Meaning in natural language cannot be

defined by way of synonymy. The Quinean separation leaves natural language sense stranded either in calculus or in a position with no suitable semantic theory to support it. The second option prompted Quine to write that 'pending a satisfactory explanation of the notion of meaning, linguists in semantic fields are in the situation of not knowing what they are talking about' (47).

In its strictly intensional sense, the possibility of meaning seems to be ruled out by Quine's indeterminacy thesis.[9] He is supported in this by Hilary Putnam's indeterminacy theorem and attacked ferociously by Jerrold J. Katz, who believes that 'it is no trick to specify the criterion for saying that a sentence has a particular intension: the sentence has the intension just in case the best hypothesis to account for the totality of such evidence says so.'[10] An intersemiotic theory of meaning is incompatible with such a stipulated notion, as it is with any other kind of intensional meaning.

When we compare formal and non-formal 'analytical' statements we note a number of differences, suggesting either that analyticity can be present in non-formal expressions but not on its own, or that we cannot apply the notion of analyticity to natural languages, or, perhaps, that there are two kinds of 'analyticity.' Consider the following example. In *Language and Reality: An Introduction to the Philosophy of Language*, Michael Devitt and Kim Sterelny introduce two statements, both of which are said to be true:

> Everest is Everest;
> Everest is Gaurisanker.[11]

They use their example to attack the Millian view that 'the meaning of a name is its role of designating a certain object.' In agreement with the Fregean tradition, the authors say, 'identity statements show that this cannot be the whole story' (26). Nor, one could add, is 'identity' as straightforward as Devitt and Sterelny would have us believe.

Is it not possible that in culturally saturated language there is no such thing as pure analyticity, that analyticity is always accompanied by contingency? Hence 'Everest is Everest' unlike 'x = x' is also contingent in that it tells us not just that the names are identical but that the objects to which they refer and the perspectives from which the objects are seen are so too. If this is acceptable, then the difference between the two statements is that 'Everest is Everest' has the same name, the same reference, and the same deictic perspective, while 'Everest is Gaurisanker' has two different names, the 'same' reference, and two different utterance perspectives. So in the Millian view Everest and Gaurisanker have the same meaning for they direct us towards the same object.

Nonetheless, we should accept neither Mill's view nor that of the authors, for there is a complication. In this particular case the meaning is both *the same and not the same*. It is the same as far as the most general identification of the mountain is concerned: 'This, not that mountain (Anapurna).' 'Everest' and 'Gaurisanker' at the same time have different meanings, as a result of the special perspective from which we 'see' the mountain geographically and culturally.

In other words, 'Everest is Gaurisanker' has different meanings at different levels of semiosis. (1) At the level of analyticity there is the difference between two linguistic signs, and so we have two different meanings (strict sense). (2) At the level of contingency we have (2.1) sameness of reference at the level of identification of objects (this–there, not that–there; Husserl's outer horizon) and (2.2) difference of reference and hence meaning at the level of specification such that (2.2) splits into (2.2.1), the physical angle which produces a certain set of vistas of the mountain from the Tibetan versus the Nepalese side, and (2.2.2), the cultural specifications about which the semiotic network of meanings is triggered by 'Gaurisanker' and 'Everest.' To complicate the matter further, (2.2.2) could be argued in turn to split into (2.2.2.1), what the Nepalese cultural specifications mean in the Tibetan community, and (2.2.2.2), how the Tibetan understanding is understood by the Nepalese. Indeed, this kind of splitting could, at least theoretically, be carried on until, as both Peirce and Eco have shown, the whole semiosis of a culture is unravelled. What's in a name? An entire culture.

According to these complications, the copula in 'Everest is Gaurisanker' cannot be replaced by a formal equal sign without semantic distortion. Yet no such distortion appears to occur in the formal domain. It would seem, then, that the transition from formal sense to the sense of natural language expressions is no straightforward matter. The following section addresses this issue in greater detail with reference to Frege.

2.2 FREGE'S ERROR

Interpretations of Frege's works amount to a formidable corpus of literature. This section makes no attempt to review even a portion of this critique. Its purpose is merely to focus on one issue, the untheorized transition from a formal sign system to that of a natural language, from logical symbols and their geometrical extensions to German, a move on which hinges Frege's seminal distinction between sense (sense meaning) and reference (referential meaning).[12]

In focusing on Frege's move from geometrical sense to sense in natural language, I will not enter the dispute about whether Frege should be regarded as a philosopher of language, a logician, or a philosopher of mathematics. Of interest here is the powerful influence his writings have had on the analytical branch of language philosophy.[13] In particular, I wish to address the assumptions in Frege's description of sense which allowed him to equate formal, geometrical sense with the sense we find in natural language expressions. In *The Interpretation of Frege's Philosophy* and his more recent *Frege and Other Philosophers*, Michael Dummett has offered the most comprehensive and authoritative perspective available to date.[14] It is to some of his observations on Frege's sense that I now wish to turn.

Frege's sense displays two aspects, an objective side which is a part of thought and a cognitive side which belongs to the process of its grasp. Dummett addresses this Janus-faced sense on numerous occasions. Thoughts, Dummett says in *Interpretation*, 'are immutable objects existing independently of us, and the sense of an expression which forms part of a sentence is part of the thought which the sentence expresses: thoughts are what are true or false, and senses are that to which reference primarily attaches.' At the same time, 'thoughts are expressed by sentences, and the senses that are part of thoughts are expressed by parts of sentences,' and the sense of an expression 'is part of what we understand when we understand the expression' (77).

This double facade of sense plays a role in two distinct kinds of determinations. Objectively, sense is 'a manner of determining its referent [*Bestimmungsweise*]' and cognitively, 'to grasp the sense of an expression is to grasp its contribution to determining the truth-condition of the thought expressed by a sentence in which it occurs, of which that sense is a constituent' (80). How can the Fregean two faces of sense be reconciled with one another? Unlike reference, sense is something that the speaker is able to know. We never fully know reference, just as we never fully know objects. Like reference, objects are never given except in an intensional, objective sense: 'The way in which the object is given is always a sense which can be a thought-constituent.'[15] As Dummett puts it in his *Interpretation*, 'the transparency [of sense] is in contrast to the opacity of reference' (325).

Thus, in Frege, Dummett says, 'sense is the content of understanding, or rather, the principal ingredient of that content: it is what one who knows the language apprehends as objectively associated with the expression' (82). There remains, then, a tension between sense as governed by rules embodied in community practice and Frege's sense as objective thought, whereby thought 'exists objectively and independently of us' (476). Dummett's explanation of this tension is psychological. He sees it as a 'desire to safeguard the *objectivity*

of sense' (103). Yet if sense is to be objective without the character of objects, which are never fully knowable, then there is only one kind of objectivity available to Frege: the objectivity of *intension*. This is what Frege found in logic and arithmetic. Since Frege was trying to establish the logical relations between sense and reference, it should not be surprising that he speaks of logical, intensional sense whenever he uses the term. This is the sense analysed here.

Dummett is aware of Frege's failure to account satisfactorily for other important features of sense, such as 'an individual speaker's understanding of an expression' as distinct from 'its sense in the common language' (195).[16] He notes, however, that Frege does have room elsewhere for such 'ingredients of meaning classified as *Färbung* or tone' as well as for 'the separation of the thought from its wrappings (*Umhüllungen*)' (78). These wrappings, as well as Frege's indirect sense and indirect reference – including Dummett's correction, in which there is only one sense but which retains indirect reference (87ff.) – have no room in the present discussion. Likewise, there is no place here for an analysis of the fundamental principles that inform Frege's theory of semantics. Let it suffice to sum them up in the manner in which Dummett presents them. First, a proper name or any singular term refers to 'the sort of object that we intuitively take to be its bearer' (159). Second, 'the *Bedeutung* of a sentence is its truth-value' (161). Third, 'if a constituent of a complex expression lacks *Bedeutung*, the whole lacks *Bedeutung*' (161). Fourth, 'the *Bedeutung* of an incomplete expression is itself incomplete' (163).

Lastly, I have postponed the question of fictional expressions, which plays a much more important role in an intersemiotic account of meaning than in analytical approaches. For Frege fictional expressions can have sense but no reference. As Dummett rightly says, again in his *Interpretation*, 'although a thought can be grasped without being judged to be true or to be false, it cannot be grasped by anyone who lacks the conception of its being true or false' (114). This means that in reading novels, we remain within the narrow confines of Frege's sense and never proceed to his meaning, or *Bedeutung*. Fictional reference is banned from this picture, an account which most readers of literature would find entirely unsatisfactory. We now have to return to the reasons for this barrenness of Frege's sense.

Essential to the argument here is that Frege believed in the identity of sense as a strictly logical notion even if, as Dummett has shown, he argued this point in a somewhat psychological manner (323). The main divergence between Dummett's purpose and my own is that for Dummett the problem of synonymy is not particularly important, so that to offer a 'philosophical analysis of the notion of sense, one does not really need a sharp criterion for

that relation to hold' (341–2). Since synonymy is made possible in the strict sense of identity by Frege's intensional picture of sense, it is at the heart of this discussion. To put it bluntly, for reasons related to strict synonymy, Frege's sense cannot occur in natural language.

Philosophical semantics in its various guises owes much to Frege's attempt to distinguish *Sinn* (sense) from *Bedeutung* (reference, meaning). To sharpen the point, I suggest that Frege was attempting to separate an intensional or strictly definitional sense from an extensional or referential meaning. The crucial procedural steps he takes to demonstrate the universality of this distinction are first to elaborate it by way of formal signs and second to transfer his insights to natural language expressions.

In semiotic terms, or from the perspective of meaning as a linkage of different sign systems, Frege's semantics rests on the distinction of a sense defined by the rules of a single sign system and a referential meaning resulting from the interaction of at least two different systems.[17] Furthermore, Frege established a relation between his main concepts such that sense contains the manner of the presentation of the sign. For him there is a sign (signifier), a sense (signified 1), and a reference (signified 2), the last of which is equated with the signified object. What I see as a puzzle is the untheorized move from formal sense and reference to their natural language equivalents. I am addressing myself then to Frege's account of the relation between sense (signified 1) and reference (signified 2) and its consequences.

There should be little doubt that the separation of sense as an intensional entity from the referential, extensional features of natural language is an important starting point for an entire tradition which represents natural language semantics in both analytical and formal terms. Indeed, if it is possible to isolate intensional sense in natural language in this manner, then one could expect entire languages to be reformulated in formal terms without the need of re-translation to recover the possible loss of culturally saturated meaning. The divorce of intensional sense from extensional meaning is therefore a crucial move. But is this separation actually achieved in Frege's famous argument concerning the sense of 'the morning star' and 'the evening star' and their common referent, Venus?

In opposition to Frege's argument, I want to show that in the account of *Sinn* in contrast to *Bedeutung*, the former is always already a case of the latter. That is, there is no sense without some sort of reference, though we should distinguish between referential background and specific reference. Only in a formal language can we speak of a purely intensional sense (*Sinn*). On the other hand, in a formal language there is no such thing as an extensional meaning,

except if the further step of relating this formal language to yet another formal system is taken.

One can introduce such a second system, say a system of charts, which can be linked to a formal language in a systematic way such that certain formal expressions correspond to certain signs in the chart system. This is in fact what Frege does at the beginning of 'On Sense and Reference.' He introduces a, b, and c to formulate statements of different cognitive value: a = a to demonstrate a priori identity; and a = b as an informative alternative. Frege then complicates the picture by matching this formal system with another system, the geometry of three intersecting lines a, b, and c. Now two distinct formal systems interact: a set of geometrical significations and a fully definitional formal vocabulary. Extensional meaning here, as in natural language, is the link between (at least) two different sign systems. Yet this interaction between intensions and extensions does not occur in the same form in natural semiosis, where what is referred to is not made available in a fully defined artificial schema.

Now to Frege's planet:

It is natural, now, to think of there being connected with the sign (name, combination of words, letter), besides that to which the sign refers, which may be called the reference of the sign, also what I should like to call the *sense* of the sign, wherein the mode of presentation is contained. In our example, accordingly, the reference of the expressions 'the point of intersection of *a* and *b*' and 'the point of intersection of *b* and *c*' would be the same, but not their senses. The reference of 'the evening star' would be the same as that of 'morning star,' but not the sense. (57)

It is at the transition from the formal operation to the natural language example that the hub of the problem is located. As long as Frege extends the formal system (a, b, c) to another formal system (geometry) he has done no more than equate sense with a signifier (signified 1 = signifier 2), which varies, and differentiate it from a formal signified, which remains identical (signified 2 = reference). Note, however, that we do not make *sense* of such a signifier in the way in which we *understand* a natural language expression. In the latter, to make sense means to move without hesitation from expression to reference (actual or fictional, though Frege rejects the idea of a fictional reference). The exception is when we read or hear an expression in a language of which we are ignorant. Only then do we remain with the signifier (Frege's sign). But do we then make sense of the signifier? I think not.

When Frege, in the last sentence of the quotation, transfers his formal finding to natural language something goes wrong. It is true that the signifiers

of 'evening star' and 'morning star' are different, while their common signified, Frege's referent, remains the same. Frege should not conclude, however, that by noting the different signifiers of 'evening star' and 'morning star' we also grasp a different sense without relating the signifier to another sign system. We do not. At least not without having also constructed a separate referential backdrop for each. If we did not know English, we would still be in a position to register the difference of signifiers without, however, being able to grasp the sense of the expressions.

Let us look at a simplified version of Frege's procedure. This is how one could align his natural language expressions with formal signifiers.

(1) The morning star is the morning star.
(1.1) P is p.
(2) The morning star is the evening star.
(2.1) P is q.
(3) The morning star and the evening star are both Venus.
(3.1) P and q are both n.

The identity statement of (1) is said to be tautological and follows the logical law of self-identity. No doubt we recognize the formal relation of identity in the repetition of any natural (or formal) language term. This is one issue. But Frege's point is a different one. He says that we understand this identity as a result of having recognized two *senses* which are the same.

Leaving aside the question of how we comprehend identity in general, the important point is whether we are able to understand 'evening star' as an intensional sense *without* referential ingredients – that is, whether we understand (1) in the same way as (1.1). I suggest we do not. The so-called sense of 'morning star' is understood because we already have a non-linguistic understanding of 'morning' and 'star.' In contrast, the senses of p and q are 'understood' as syntactical units of a formal sign system. They are 'understood' merely at the level of syntactically arranged signifiers. P and q are all that is given, without provision of referential backdrop. Not so in the natural language expression. Here we are in a comparable position with respect to (1) and (1.1) only if we are unfamiliar with the language. Both 'morning' and 'star' are at the same time signifiers (Frege's sign) like p and q and are also directional schemata; as Frege says himself, they contain the 'mode of presentation' for a referential act.

Likewise, in the informative version, (2), we first understand both 'morning star' and 'evening star' because we have a prior non-verbal as well as verbal grasp of mornings, planets, and evenings. The sentence is meaningful because we are able to link at least two sign systems: verbal and non-verbal kinds of

signification. Second, we note the double information given beyond (1): that p is not only identical with itself but is the same as something else, q. As far as the mere form of the distinction between identity statement and informative statement is concerned, the formal presentation (1.1), (2.1), and (3.1) will do. But the kind of sense required here is different from the kind of 'sense' available in Frege's natural language example.

How does this difference come about? We need to emphasize the relation between different linguistic items (directional schemata) and their semantic fields (networks of non-linguistic signs). In making sense of (1), (2), and (3), linguistic signs are habitually linked with tactile, respiratory, thermal, aural, haptic, and other systemic readings ('typifications,' in phenomenological parlance) of possible evenings as well as with our visual grasp of planets, stars, or their charted images. This is not the case in (1.1), (2.1), and (3.1). Here our comprehension is restricted to syntactic entities, their place values, and substitution rules. It is a common yet dubious practice to call syntactic substitutions following such rules a 'semantics.' I suggest that when we replace one set of signifiers with another in this manner we are, strictly speaking, performing syntactic, not semantic, operations. We are able to *understand* formal procedures in this manner, yet we remain within one and the same definitionally ruled sign system when we constitute formal sense.

If it is acceptable that in Frege's natural language example the sense-making mechanism requires more than one sign system, as I have claimed, and since reference is nothing but a special kind of link between diverse sign systems, it follows that in natural language expressions *Frege's sense is always already referential.* It follows further that there is no such thing in natural language as a sense without some kind of reference. Hence understanding in natural languages is always in some form referential. I shall argue later that meaning in fictional expressions is construed in a similar vein.

To complicate matters further, not only is 'morning star' understood as a result of 'referential background' (mornings, planets, and so on) but it also entails a perspective of speaking, its deictic reference or utterance reference. The sense of 'morning star,' just as that of 'evening star,' presupposes a community perspective of the world. The example of 'Gaurisanker' and 'Everest' given earlier makes this point more persuasively. The sense of the term 'Gaurisanker' is inextricably linked with two kinds of referentiality: a reference to the highest mountain in the world, which can be climbed only from the other side; and a *deictic* referential background which directs us back to the cultural speech situation of Tibetan communities, where the term is 'at home.'

Unlike formal terms, natural language expressions cannot be cleansed of the semantic traces of their typifiable utterance situations (deixis). Frege's examples

demonstrate this complication in a minimal manner, 'Gaurisanker' makes it more obvious, while a phrase such as 'I do not drink' is saturated with the perspective of puritanical values. To say that this is somehow outside its 'sense' – that we are able to separate some kind of formal sense from those murkier semantic ingredients – requires additional arguments to those of Frege and his successors. In the absence of such arguments, corporeality invades natural language sense in a fundamental way, by virtue of the non-verbal signs that we are bound to activate in imagining the referential and deictic conditions without which natural language sense makes no sense at all. In this, our own bodies intrude as the organisms that make non-verbal signification possible; the community intrudes indirectly as the collective body that controls our habitual ways of signifying; and the represented, material world, including the bodies of signified persons, intrudes by turning the empty schema of a signifier or term into sense.

But is the body also present in so-called syncategorematic words in natural language, such as conjunctions, prepositions, quantifiers (all, some, no), or the copula? The short answer is that in all meaning-making processes they too are enmeshed in the linkages between discrete sign systems and so are integrated into our corporeal, social semantics. Function words do what they do as a result of having emerged from social action and so carry the traces of the non-verbal forms of signification from they evolved.

'All' can be used as a formal quantifier as the result of acts of dereferential-ization and the neutralization of deixis. But even in the formally empty usage the social roots of the concept are still traceable: the embracing glance of horizonal vision, the gestural domain of what is reachable with our arms, the olfactory sphere of the outreach of the interpreted scents around us, or the aural field that we explore with our hearing. 'All,' just like 'some' and 'no' and more refined kinds of grouping and dividing, still reflects the social acts of inclusion. Thus even quantifiers in natural languages remind us of the imposition of linguistic signs at varying levels of abstraction on the non-linguistic signs by means of which we make sense of the 'world.'

In this light, the copula can be seen as a schema directing us towards what Heidegger described as the fundamental 'as-structure' of human understanding and interpretation.[18] In our grasp of 'the evening star' as 'the morning star,' or for that matter of any juxtaposed signifiers in a dictionary, two distinct realizations of the world are merged and so allow for a third, their common referent. In this, the 'is' reveals itself as a rudimentary semantic element of human understanding as a comparative social act. The copula does not play the significant role it does in formal logic because it is by nature formal. Rather, it is one of the most important elements of all human sense-making operations, from

culturally saturated acts to those performed with formal signs. So important is the copula to human semiosis that one can say that understanding is no more or less than the typified social acts of conciliating disparate systems of signs. Such conciliation can vary in form from the negotiation and approximation characteristic of meaning processes in social discourse, as well as their ludic extension in literature and art, to the starkness of identity in symbolic logic. Yet the copula is never merely a relation between the subject and predicate of a proposition. As Charles Sanders Peirce put it, 'the essential office of the copula is to express a relation of a general term or terms to the universe.'[19] In this holistic sense the copula is the most fundamental ordering sign available, and all specialized usage still carries the early trace (*frühe Spur*) of this function.

What of Frege's distinction, then? Is there a distinction at all? There certainly is. From an intersemiotic perspective, however, it requires an alternative formulation, producing an altogether different account. There is indeed a difference between the morning star / evening star pair and their common reference, the 'object' Venus, but it is a disparity between diverse referential relations and not, as an entire tradition following Frege has it, a difference between sense as thought and reference as object. The meaning of 'morning star' results from a link between the directional schema of 'morning star' and a number of non-linguistic realizations, or typifications, of mornings and stars or planets (reference 1). Likewise, the meaning of 'evening star.' Furthermore, the meaning of 'morning star' and 'evening star' as 'Venus' involves the double linking process between linguistic items and non-linguistic signs and hence the specifici realization of the shared referential object (reference 2).

In the case of the statement 'the morning star is the morning star' we have the double (not single) identity of signifiers and signifieds, which is one kind of meaning process. In the case of the statement 'the morning star is the evening star,' namely Venus, we have a triple identity between signifiers and signifieds, which is a more complicated process. Yet in both cases we cannot arrive at a sense meaning *without* a minimum of links between linguistic and non-linguistic signs – that is, without minimal reference. We have now been forced to generalize the notion of reference in such a way that Frege's reference as specific object becomes a special case.

This leads us to conclude that Frege's distinction is incoherent. Alternatively, it needs to be rephrased to become a distinction between different kinds of extensional meaning. As it stands, the distinction is incoherent because it is drawn between an intensional sense in a single sign system semantics (the *Sinn* in a natural language) and an extensional, 'referential' meaning which links language and 'world' (the *Bedeutung*, or object) in a double sign system semantics.

Frege should agree with this account. He is quite explicit when it comes to describing what is required to understand the sense of a proper name in a natural language (as well as of sentences, which he treats as proper names). Sense 'is grasped by everybody who is sufficiently familiar with the language or totality of designations to which it belongs' (57–8). Since designations are relations between expressions of a language and their references, how can one avoid drawing on its reference when one makes sense of an expression? How is it possible to 'understand' an intension in natural language without its extension? In other words, one cannot understand directions unless one recognizes them *as* directions, and this involves grasping the point that the same object, or an alternative object, is being indicated. Perhaps there are different kinds of familiarity with a language. Consider the following language learning experiment.

A student is introduced to a foreign language, called Sense, by a native speaker who teaches him pronunciation by ostensive feedback, vocabulary by way of a dictionary, typical sayings and repartee with the help of a phrase book, and the rules of syntax, conjugation, declension and so on as described in a standard grammar. At no point in her teaching does the native speaker refer to a language familiar to the student, restricting the process of correction to the repetition of standard use. After a year of study, the student, who has an excellent memory and has worked diligently to please his teacher, has accomplished a considerable degree of mastery. He is asked to knock at the door of another native speaker, say one of the teacher's colleagues, who knows nothing of the experiment. He welcomes the student, who is able to respond to the greeting. For a while phrases are exchanged and the student, able to recognize a considerable number of expressions, applies what he has learned. The teacher's colleague is of course aware that the student is a novice to Sense. Not wishing to discourage him, the teacher overlooks a number of stylistic oddities and non sequiturs in his replies and compliments him on his considerable progress. Apart from a hopeful guess that the initial exchange had to do with some sort of greeting (and he could have been wrong), the student still does not have the slightest idea of what he is talking about when he speaks Sense. He cannot make even minimal sense of Sense without some sort of reference. He has progressed only to the level of Frege's sign (signifier) and its syntactic relations. The limiting case in this respect is the Turing machine.

John R. Searle's refutation of the view that 'mental processes and program processes are identical' runs along similar lines. His summary of the argument is as follows:

To repeat, a computer has a syntax, but no semantics. The whole point of the parable of the Chinese room is to remind us of the fact that we knew all along. Understanding

a language, or indeed, having mental states at all, involves more than just having a bunch of formal symbols. It involves having an interpretation, or a meaning attached to those symbols. And a digital computer, as defined, cannot have more than just formal symbols because the operation of the computer, as I said earlier, is defined in terms of its ability to implement programs. And these programs are purely formally specifiable, that is, they have no semantic content.[20]

Searle surely clinches the argument as far as it goes, but he does not pursue the consequences for descriptions of meaning in general, including his own view of the stability of literal meaning.[21] Suffice it to say here that if semantics is a linking of different sign systems then it is likely that meaning is affected by the specific links drawn in each case.

The remainder of this section will address a number of related issues raised by Frege to buttress his fundamental distinction: his notions of 'associated idea,' 'sense as thought,' 'customary and indirect sense and reference,' 'same reference, differing signs,' 'same sense, differing expressions,' 'sign and definite sense,' 'sense and definite reference,' 'reference as object,' 'reference as truth value,' 'the expression of sense and the designation of reference,' and 'sense as containing the mode of presentation.'

According to Frege, 'the reference and sense of a sign are to be distinguished from the associated idea.' An idea can be an 'internal image' as a result of immediate or remembered 'sense impressions' and internal or external acts performed in the past. The important difference between this and the sense of a sign for Frege lies in the fact that 'the idea is subjective,' whereas the sense as thought 'may be the common property of many' (59).

How do we arrive at this abstracted, communal sense? Is it given in the relations between the signifiers (Frege's signs) of the language? Or do we have to anchor it in the life-world? When we first learn a natural language the ostensive linkage between expressions and other sign systems cannot be denied. Nonetheless, I would insist that even in standard use the community of speakers re-establishes possible, likely, and above all economical links between language and 'world,' however fleetingly. If this is so, the difference between sense and idea is one of degree rather than of kind. What they share is the embedding reference: a minimal and loose linkage between language and other sign systems. Frege's idea could be located at the periphery of this operation: references and quasi-references decreasingly shared by the speech community. And just as television viewers increasingly habitualize their visual typifications by comparison with linguistic descriptions, Frege's sharp distinction between the objectivity of sense and the subjectivity of mental representations becomes blurred. The standardized visual images of Bosnia to which millions of people have access defy the claim that linguistic sense as thought is sharable while

mental representations are not. It seems that both are intersubjective and so shared to the degree that satisfies sufficient semiosis.

Frege complicates his definition of *Sinn* and *Bedeutung* further by detaching a customary from an indirect sense and reference. 'We distinguish,' he says, 'the *customary* from the *indirect* reference of a word; and its *customary* from its *indirect* sense.' Indirect reference is the kind of reference we find in *oratio obliqua* and virtual *oratio obliqua*. He argues the same way with respect to indirect sense: 'The indirect reference of a word is accordingly its customary sense' (59). These distinctions do not change the relation between our central terms. They merely draw our attention to the status they have in ordinary discourse as distinct from their metafunction.

In natural language, Frege says with some regret, the same sense can be generated by different expressions. In a 'perfect language' this would be improper, but we have to accept that 'the same sense has different expressions in different languages or even in the same language' (58). Yet this is not seen as a major flaw as long as the relation between sense and reference remains unchanged: in cases where there is a reference at all. What if there is no reference, no specific object to which we can 'tie' our expression? In that case, says Frege, we have a sense without reference. But how would we understand such a sense purely within the relations of the signifiers of a language if we were not at the same time able to activate them semantically by way of other sign systems? Put more traditionally, how could we know what the sense of an expression was if we could not connect it in some way to the 'world,' or to some 'world'? The language expressions themselves do not do so, as we have demonstrated by way of our language learning experiment, which was restricted to morphemic, phonetic, and syntactic operations. Frege should therefore have argued that a member of a semiotic community has learned to use language signs in such a way as to be able to produce a general or loose referential sense and, in the case where the language refers to a specific object, also a specific reference.

Frege speaks of the 'regular connexion' between the vehicle, its sense, and its reference such that 'to the sign there corresponds a definite sense and to that in turn a definite reference' (58). But since this ideal relation is not always fulfilled in natural languages he suggests that we should be satisfied with the same word having 'the same sense in the same context' (58). Here Frege has moved considerably from his initial formal ideal, for 'context' could be interpreted very broadly. The discursive formation 'he merely defended his honour,' for example, allows for highly disparate constructions of sense and 'reference' in different historical circumstances, say France at the beginning of the First World War compared to Los Angeles in 1992. In 1914 a fairly

specific set of possible social actions would have constituted the reference of the expression, while the phrase is either meaningless or an ironic metaphor for something else in a text dealing with the Californian riots in the spring of 1992. So 'definite' can be taken to be a good deal less strict than the term suggests without violating Frege's theory on this point.

Next we need to probe briefly Frege's equation of reference and object. 'The reference of a proper name,' says Frege, 'is the object itself' (60). This phrasing completely eliminates any form of mediation between language and world. Language itself points at the object, its reference. This view finds a more elaborate form in the picture theory of Wittgenstein's *Tractatus Logico-Philosophicus*, in which atomic sentences square with the atomic simples of the world. A crucial step beyond this stark empiricism is Strawson's amendment offered in 1950 in his paper 'On Referring,' which distinguishes between referring as an act, as a particular use of a sentence, and as the referent towards which this act is directed by a speaker.[22]

A further, equally significant step is the textualization of the referent as object – Frege's reference – in semiotic terms. From this angle, the object is *semiotically overdetermined*. We see it: we look at Venus with the naked eye or through a telescope. We calculate it: we describe its size, mass, trajectory in mathematical terms. We touch it: we send a probe to its surface. And so forth. Thus a textual object emerges as a summary overlap of interacting sign systems whose 'realism' is guaranteed by a high degree of significatory corroboration and the absence of falsification (for the time being). As Nelson Goodman phrases it, 'where otherwise equally well-qualified hypotheses conflict, the decision normally goes to the one with the better entrenched predicates.'[23] This leaves unclear why some predicates are more persuasive than others. Answering intersemiotically we could say that 'the preferable hypothesis is the one which allows for a majority of corroborating judgments in different sign systems.'

Where does this leave Frege's fictional entities? Contrary to Frege's account, as well as that of a whole tradition following in his footsteps, fictional entities also have reference but lack intersemiotic overdetermination. Their references are underdetermined. Fictions are constituted by such signs as proper names, entire texts, or images but remain uncorroborated by such systems as tactile, olfactory, thermal, and other signs. This view is perhaps supported by the fact that an entire industry is occupied with trying to reduce this fundamental underdetermination of the fictional. Electronic games and movie equipment now being designed will ultimately fill the significatory gaps which tell us when we are not dealing with the actual.

Likewise, Frege's equation of reference and truth value can be qualified. Instead of presenting 'the truth value of a sentence as constituting its reference'

(63), one could say that truth value becomes a function of quantitative corroboration by different forms of signification. 'True' refers to corroboration, 'false' to falsification, and 'undecidable' to a mixture of corroborating and falsifying semiotic evidence. In this sense the past is often less easily corroborated than the present. Where past and fiction compete with one another with neither being able to demonstrate semiotic overdetermination, 'the better entrenched predicates' win. The notion of truth value has now been altered by semiotic textualization and bears little resemblance to Frege's original.

Frege's view of reference and truth value is important in this context because of the tight relation he construes for sense and reference. The manner in which he sees truth tied to natural language via sense constitutes, I believe, a special case. Strictly speaking, referential meaning can be mapped onto truth only in formal systems. I take here the path of inquiry suggested by Donald Davidson, who weakens the relation between truth and meaning in natural language when he says that 'trying to make meaning accessible has made truth inaccessible.'[24] Beyond Davidson, as I have argued elsewhere, one could say that there is a point at which the notion of meaning as used in analytical philosophy needs to be questioned itself.[25]

If I see Frege's association between sense and truth as too objective, Michael Dummett has offered an altogether different reading. In spite of the formal origin of Frege's distinction, Dummett discovers a highly subjectivist foundation.

Despite his reiterated emphasis on the objectivity of sense, Frege in fact described language as governed by the private understanding of it possessed by each speaker: the sense that a given speaker attaches to a word is the manner in which he or she takes it as contributing to determining the truth-value of any sentence in which it occurs. What, on such a view, makes language a possible instrument of communication is the ascertainability by one speaker of another speaker's private understanding of it; what makes it an efficient instrument of communication is the approximate coincidence of the private understandings of different speakers.[26]

Elsewhere I have suggested that neither an objectivist nor a subjectivist interpretation but an intersubjective reading is the most fruitful way of approaching Frege's theory.[27] Whichever direction is more persuasive in the long run will have to be seen. Here we need to ask why Frege thinks that sense and reference are linked so tightly to produce truth. Curiously, he gives a psychological reason: 'a kind of drive. It is the striving for truth that drives us always to advance from the sense to the reference' (63). This need not be read as a subjective account. It could be a species argument: we are such that we must proceed from sense to reference because it is part of our gene pool to look

for the truth. An alternative narrative would say that we are significatory be-
ings who must construe semioses that are as cohesive as we can make them.
But in doing so we *appear* to be constrained in such a way that certain texts
turn out to be consistently corroborated while others fall by the wayside as a
result of falsification. Witches tend to be discarded, levers tend to be widely
accepted. Hence we have to stipulate realist constraints on social semiosis as
necessary inferences. But what is it that 'drives us' to combine the two, cohe-
sion and constraints? Not, I suspect, as Frege believes, 'the striving for truth,'
but rather a long history of survival. Texts which violate both the construction
of cohesion and the necessary inference of realist constraints lose credibility
in the very long run. This is the position of an inferential realism or a realist
textualism.

From this perspective, a recent paper by David Wiggins takes on special
relevance in that it brings truth-oriented arguments up to date while at the same
time offering a sophisticated rescue of that tradition.[28] And if one were to accept
its premises Wiggins would be difficult to refute. I leave aside both his summary
of other arguments and his discussion of Stephen Schiffer's recent *Remnants
of Meaning*, which I will address elsewhere, and focus on a few fundamental
assumptions made by Wiggins, which I suggest are untenable.[29]

Wiggins resumes the traditional but, as I have argued here and elsewhere,
illegitimate presupposition that 'the institution of *Begriffsschrift* at once extends
and (albeit in microcosm) illuminates natural language' (62), an assumption
which conceals the difference between sense in formal sign systems and sense
in their natural counterparts. While the former is definitionally controlled
and therefore unproblematically tied to truth conditions, the latter requires a
complex social semiotics to be realized, a linkage of verbal and non-verbal sign
systems, typically governed by community-sanctioned, or cultural, negotiation.

A favourite prejudice of truth-oriented theories of meaning is the distinction
between use and meaning, whereby a literal meaning acts as a foundation. In
Wiggins this takes the form of the following argument:

There is no simple route from a sentence's use to something back to its proper meaning.
The proper response to this problem is to ... adjust the Frege–Wittgenstein thesis to
read
 sentence *s* has as its use to say *literally* (in the thinnest possible acceptation of 'say')
 that *p* just if whether *s* is true or not depends upon whether or not *p*,
and then imbed that new formulation in a larger, more comprehensive theory. The
larger theory will persist in the Fregean explication of the literal meaning of a sentence
as consisting in its truth-condition but explain the fuller kind of saying by building
upwards from literal meaning. (66)

From an intersemiotic angle this procedure appears dubious, since what is called a *literal meaning* is a special stipulation imposed on general social semiosis rather than its universal principle and therefore cannot act as a starting point. The historical and dialogical components of semantics are undermined when we rely on a synchronically defined literal meaning. Also, the 'proper meaning' of a sentence, in contradistinction to its 'use,' suggests that there is some kind of meaning to be found without a sentence being used at all. This strikes me as absurd, since every construction of a 'proper meaning' cannot be anything but a use.

Wiggins is shyly (and parenthetically) aware of the possibility that matters other than linguistic ones may need to be considered in a 'larger theory.' But this insight remains untheorized except as part of his formula for a truth-conditional explanation of meaning, where he refers to 'the shared life and conduct of L-speakers' (73–4). In a footnote the author adds, 'thus rendering their beliefs and other propositional attitudes intelligible in the light of the reality they are exposed to.' This reveals the semiotic problematic of the whole argument. While Wiggins here appears to be nodding in the direction of the later Wittgenstein, he does not draw the consequences of this shift, let alone acknowledge more recent moves to fragment the relative cohesion of Wittgenstein's *Lebensformen*.

How, we must ask, is the 'reality they [L-speakers] are exposed to' constituted? Is it naturalistically given or formally stipulated, or is it read as a complex web of interacting signs? If the first option is the case, then Wiggins has to demonstrate how we could ever link such different 'items' as language and world to form a truth-conditional theory. If the community of L-speakers is established via formal definition, then the linkage with the 'world' is at least as problematic. If, on the other hand, reality is available to us only in a semiotic form, then we can indeed compare language and world as sets of signs. But then the whole truth-conditional argument presented by Wiggins needs to be rephrased in semiotic terms.

Assuming that such a reworking could be done, one consequence would be the realization that the 'semantical dependence' Wiggins speaks of would yield different relations in different discursive domains. I suggest that the account offered by Wiggins works well in formal and technical languages and less well in culturally highly saturated discourse. In other words, while *meaning* is a relation between different sign systems – i.e., between linguistic and such non-verbal signs as tactile, olfactory, gustatory, aural, visual, or haptic readings – that relation is not well characterized by the general notion of *truth*. 'Truth' describes well the relations between signifiers of formal logic and between arithmetic and geometric entities but does poorly when we are dealing with

the complexities of human symbolic interaction. In the latter case you have to stretch the notion of 'truth' to take on a degree of vagueness which violates the expectations we tend to attach to the signifier. Tarski was aware of this problem and Davidson has again drawn our attention to it, even though he does not to my mind follow up with the kind of radical consequences for analytical terminology which need to be drawn from this insight. In a theory distinguishing a range or ladder of diverse discursive practices, truth-conditional theory would have its place but could not be regarded as an umbrella explanation for all kinds of meaning.

To return to Frege, another way in which he talks about the relation between sense and reference is that language '*expresses* its sense' and '*stands for* or *designates* its reference,' so that 'by means of a sign we express its sense and designate its reference' (61). How is this possible? Or what must the expressed sense be like in order to stand in for, substitute for, or act as a derivative sign (*de-signare*) for reference? The answer is provided in part by Kant in the schematism section in the *Critique of Pure Reason*. In order to understand like and unlike – *Anschauung* and a purely formal category – we need a *tertium comparationis*, a schema which can be related to both. In understanding an expression, then, we activate a directional schema capable of negotiating diverse significatory *Anschauungen*. In this way 'the evening star' turns into an umbrella sign by acting as a directional schema which reconciles our various non-linguistic signs (tactile, visual, aural, thermal, proximic, etc.) in an economical fashion. Now we are in a position to understand the phrase, as Wittgenstein says, 'in a flash.'[30]

This kind of explanation goes at least some way towards accommodating Frege's view that the sense somehow *contains* the mode of presentation of reference. Early in his paper he speaks of 'the *sense* of the sign, wherein the mode of presentation is contained' (57). If what Frege calls a sense is a schema directing us towards an act of reconciling diverse non-linguistic 'impressions,' we can accept the metaphor of containment as a 'holding together.' But now we have shifted the meaning of sense in a significant way. To make sense of something is to embed it in a referential or quasi-referential non-linguistic context. Sense as schema marks a transitory condition between uttering a signifier and realizing a meaning, a signified. The schema is not activated if we can pronounce but do not understand the language; it is an event structure which facilitates meaning that is always already intersemiotically referential.

In conclusion, we are led to say that we cannot conceive of any sense-making operation in natural languages without the performance of some sort of referential embedding of the linguistic sign in the 'background' of non-verbal signification. We can say that for any discursive formation to mean at all we have to be able to see it as a directional schema by means of which we focus

a number of diverse and overlapping non-linguistic signs. Frege was successful in making a distinction, but not between a *Sinn*, a sense without referential linkage, and a *Bedeutung*, a meaning which requires reference. Rather, he has drawn attention to the fact that whenever we activate linguistic expressions in a *semantic* way – whenever we constitute sense or meaning – we do so by regarding expressions as directional schemata which we 'fill' to a greater or lesser degree, according to cognitive and communicative circumstances, with at least one non-verbal sign system. Such semiotic referential linkage occurs in all natural language use.

Towards the end of his life Frege began to doubt the formal purity even of arithmetic and came to the conclusion that 'the whole of mathematics is actually geometry.'[31] This must be regarded as a fundamental change of mind which could have produced a very different theoretical base for philosophical semantics. The next stage in this process of reorientation towards corporeality is the kind of argument we find in Husserl's *The Origin of Geometry* and Derrida's critique of it.[32] Unfortunately, Frege did not pursue the turn from the analytic a priori to the synthetic a priori in terms of his sense–reference distinction in natural language. Had he done so, I believe he may very well have offered the foundations for a more coporeal semantics.

2.3 CARNAP'S SLEIGHT OF HAND

Calculus as Universal Medium

On several occasions Rudolf Carnap acknowledges his intellectual debts, especially to Frege, who introduced him to the logistics of Alfred North Whitehead and Bertrand Russell in *Principia Mathematica*, to the metamathematics of David Hilbert, and to the metalogic developed by Polish logicians Kasimierz Ajdukiewicz, Stanislav Lesniewski, Jan Lukasiewicz, Tadeusz Kotarbinski, and Alfred Tarski. Carnap also reminds the reader of the considerable influence that both Kurt Gödel and Ludwig Wittgenstein have had on the evolution of his own thinking.[33] I draw this to the reader's attention to emphasize the range of theories in logic and related disciplines with which Carnap was familiar. At the same time I want to make it clear that I am not in a position to add to or detract from Carnap's undisputed success in logical syntax in any way. Rather, my aim is limited to showing the problematic nature of any theory that cannot help but say something about our 'world' at large while at the same time professing to stay within the confines of what is logically 'pure.' Carnap's work strikes me as exemplary in this respect. Much as his attention tends to be focused on the logical intricacies of establishing a general calculus

for scientific statements, there are numerous passages in his writings which significantly transcend the foregrounded frame. Carnap isolates as crucial the relation between a logical syntax and a concomitant semantics. Yet no matter how tightly construed such a semantics turns out to be, it leads Carnap again and again to bridge the gap between the purity of his symbols and the semantic murkiness of the 'world.' It is on the boundary terrain between these two realms and the hazardous transition from one to the other that this section will focus. The moves which Carnap makes with respect to this transition I have pertly termed 'Carnap's sleight of hand.'

Despite the strong logical bent of most of Carnap's writings, his aim is often more general, as in *Meaning and Necessity*, in which he develops 'a new method for analyzing and describing the meanings of linguistic expressions.'[34] Yet there is no contradiction for Carnap between the logical and the everyday, in the sense that logic can be used to better understand its foggy counterpart. Indeed, 'the task of making more exact a vague or not quite exact concept used in everyday life or in an earlier stage of scientific or logical development, or rather of replacing it by a newly constructed, more exact concept,' for Carnap 'belongs among the most important tasks of logical analysis and logical construction.'[35]

In the previous section I presented a critique of the untheorized drift from formal signs to natural languages in Frege's 'On Sense and Reference.' Carnap, as well as an entire tradition of formal and analytical philosophy, has inherited this theoretical weak spot from his teacher, a feature which can be recognized in many of his broader arguments. In distinguishing necessary from contingent truth, for example, Carnap illustrates the former by suggesting that in 'Fido is black or Fido is not black' and 'If Jack is a bachelor, then he is not married' it is quite 'sufficient to understand the statement in order to establish its truth; knowledge of (extra-linguistic) facts is not involved' (222).

This sort of argument is so widely accepted that it seems monstrous to query it at all. Yet we are dealing here with two different issues. One is whether or not we need to know 'extra-linguistic facts' in order to understand natural language sentences at all, and the other is what specific facts are required for a judgment to be made properly. As for the question of so-called necessary truths, no matter what specific facts we encounter, we are able to attach a truth value to our understanding. Or more precisely, understanding in a semantic sense is not required when it comes to identity: the recognition of identical signifiers is all we need. Only when we deal with expressions which require knowledge of 'extra-linguistic facts' does a semantic problem arise. Without such knowledge, we simply could not understand the sentences quoted, let alone judge their truth. And herein lies the difference between formal sense (sense 1) and natural

language sense (sense 2). In purely logical, symbolic formulation this problem does not occur. Carnap's sleight of hand is to speak as if the natural language cases did indeed behave exactly in the manner of their symbolic 'equivalents.' As in my argument concerning the two kinds of sense which inform Frege's 'On Sense and Reference,' I suggest that Carnap is mistaken in this respect. Formal sense and natural language sense are construed differently and, as a result, are two different animals. If Carnap is indeed wrong here, as I argue he is, then this error informs much of his work and has more serious consequences than one might at first assume.

Having said this, I must add that Carnap not only recognizes but, more to the point, deplores, 'the great difficulties and complications of any attempt to explicate logical concepts for natural languages' (223n. 3). These difficulties, however, do not prevent him from treating natural language expressions quite often *as if* they were logical terms, or from pursuing the task of making more exact what is vague in our signifying processes. In *The Logical Syntax of Language* Carnap insists that philosophy be replaced by a 'logic of science – that is to say, by the logical analysis of the concepts and sentences of the sciences, for the logic of science is nothing other than the logical syntax of the language of science.'[36] Given this conviction at the outset, it is not surprising that the book is able to conclude with the dictum, 'The logic of science is syntax' (331).

If this is a boast, it belies the caution with which Carnap proceeds from construing a Language I which 'is simple in form, and covers a narrow field of concepts' and a Language II which 'is richer in modes of expression,' in that with the help of it 'all the sentences both of classical mathematics and of classical physics can be formulated.' Chapter 4 of *The Logical Syntax of Language* proposes a more generally designed syntax which can be applied to 'any language whatsoever,' and although Carnap concedes that this syntax is far from satisfactory he reiterates that 'the task is one of fundamental importance' (xiv).

Remember that Carnap here speaks of syntax and not of semantics. As long as we are dealing with the syntactical relations of a natural language, a highly if not fully formalized language is quite feasible. This is in fact what occurs in machine translation, except that the process is usually presented as a semantics. I believe that semantics is poorly served by the confusion of its two traditional alternatives: a semantics of natural languages as part of social semiotics which associates language and 'world'; and a semantics which functions merely by way of linguistic substitution, as in dictionaries. The former semantics is shared by members of a speech community. The latter is required for machine translation; in short, it is a form of calculus. I suggest that the difference has not been adequately accounted for, and I shall have more to say about this later.

Consistent with the argument thus far, my contention is that a semantics for natural languages requires a multisemiotic and heterosemiotic structure rather than a monosemiotic or homosemiotic one. Computer translation works by way of linguistic substitutions which, as I shall argue below, belong properly to syntax or calculus rather than to semantics. Thus from an intersemiotic perspective, machine translations, at least so far, produce equivalent syntactic orders, which need to be reactivated by speakers of the language to be returned to a full semantics.

Carnap's interest points in the opposite direction. Instead of trying to show at what point natural language and hence all complex social signification differ from calculus, Carnap discovers a calculus in science and philosophy and indeed in the 'world' at large. He makes the radical claim, for example, that 'the method of logical syntax, that is, the analysis of the formal structure of language as a system of rules, is the only method of philosophy.'[37]

Though consistent with everything that Carnap says, this claim runs into difficulties at its own periphery: the unsayable that demands a new way of speaking or the no longer effable that requires translation into a current idiom. If we go along with Carnap and throw out these two crucial areas of marginal signification, all philosophy is transformed into a well-formulated deductive system, large and complex enough to keep us occupied for a very long time but incapable of investigating its own foundations. Yet these foundations are inextricably bound to philosophical questions about the historical horizons of our world. Indeed, if we follow Carnap we inevitably confront the task of turning every such horizon into *The Logical Structure of the World*, one of Carnap's earlier projects.[38] Note that he does not speak of the logical construction of the 'world,' which would allow for a textualist reading, but rather of a structure which we can decipher logically if only we are prepared to pay syntactic attention.

Pragmatics, Semantics, Syntax

How does Carnap contextualize his project? Following Charles W. Morris, Carnap distinguishes between '*pragmatics*, that is, the empirical investigation of historically given *natural languages* [and] *semantics* (here understood in the sense of pure semantics, while descriptive semantics may be regarded as part of pragmatics), that is, the study of constructed *language systems* given by their rules.'[39] This he elaborates, again in agreement with Morris, into the well-known triadic system of semiotics, consisting of pragmatics, semantics, and syntax. If we refer to the speaker, or user, of a language, we are dealing with pragmatics; 'if we abstract from the user of the language and analyze only the

expressions and their designata, we are in the field of semantics'; and if we 'abstract from the designata also and analyze only the relations between the expressions, we are in (logical) syntax.'[40]

Semantics falls into two fields. Descriptive semantics addresses questions of social semiotics, to use Michael Halliday's term, while pure semantics deals with the formalization of such complexities and hence with 'the construction of corresponding syntactical systems' – that is, with the construction and elaboration of systems of rules (9). In Carnap's practice 'pure semantics consists of definitions of this kind ['designation in S' or 'true in S'] and their consequences; therefore, in contradistinction to descriptive semantics, it is entirely analytic and without any factual content' (12).

One advantage of using artificial symbols instead of words is the 'brevity and perspicuity of the symbolic formulas.'[41] A further advantage of pure semantics and syntax is that they are 'independent of pragmatics,' with its ambiguities and historical dynamics.[42] According to Carnap, in a constructed language it is possible to design both a logically consistent syntax and a corresponding, pure semantics. Such a *semantical system* is 'a system of rules' which state *truth-conditions* for the sentences of the object language and thereby determine the meaning of these sentences (22). By implication, no sentences are construed for which truth conditions do not apply, a feature not afforded in natural languages, in which declarative sentences form only a small part of overall operations.

Carnap's 'semantical system (or interpreted system)' is a web of rules stipulated in a metalanguage about an object language, such that 'the rules determine a truth-condition for every sentence of the object-language, i.e., a sufficient and necessary condition for its truth' (22). In formulating such a system, Carnap proceeds from a classification of signs to 'rules of formation,' then to 'rules of designation,' and in the end to 'rules of truth' (24).

If pure semantics always requires two systems, a metalanguage and an object language, syntax remains within its own domain; it is nothing but 'a calculus.' Above all, calculus requires rules of deduction, or transformation. They are needed for proofs and derivations and tell us how to construct definitions for 'provable in K' and 'derivable in K' and sometimes for 'other concepts.' Once we have established primitive sentences, rules of inference are stipulated and sometimes also rules of refutation, such as 'directly refutable in K.' As for definitions, they 'introduce a new sign on the basis of the primitive sign of K and the signs defined by earlier definitions; thus the order of the definitions is essential' (157).

The crucial question to ask from the perspective of an intersemiotic theory is whether, given the procedures employed by Carnap, semantic substitutions in pure semantics do not also follow syntactical rules. Although Carnap explicitly cites reference in relation to designation, and since designations are purely

formal, it seems consistent to argue that pure semantics is nothing but a syntax across two formal systems. As Carnap says himself, 'anything represented in a formal way belongs to *syntax*' (10).

Carnap has already relegated descriptive semantics, the semantics of natural languages, to the domain of pragmatics. Thus we can now say that pure semantics is part of syntax or calculus. More radically, semantics has actually vanished. Whereas the intersemiotic, social ingredients of semantics have been absorbed by pragmatics, the merely linguistic substitutionary elements which make up Carnap's formal semantics now belong to syntax. Radicalizing this line of thinking further, we could say that there is now only pragmatics, since logical procedures such as calculus form a specialized domain within general social semiotics. Yet the domain thus specialized is no longer well described by the term semantics.

This allows us to explain the difference between machine semantics and the semantics of natural languages. In the former we have only syntax or calculus, and all semantic operations are reduced to their substitutionary rules. In the latter, by contrast, we would not speak of à semantics in the sense of understanding a language if speakers were to mouth syntactic substitutions without having the slightest idea what the expressions referred to.

The main methodological consequence of this argument seems to me that the study of semantics in general must review its terminology and conceptual delimitations. As it stands, the term semantics covers two incompatible realms: the realm of social semiotics at large, in which semantics must address the corporeal interaction between different sign systems (such as the visual, tactile, gravitational, olfactory, gustatory, kinetic, proximic, and haptic), none of which is ruled by definitions proper but rather by social negotiation; and the realm in which semantics is restricted to definitionally strictly circumscribed formal procedures. Finally, we return to my question of whether semantics is not actually a syntax: for natural languages the answer is negative; for formal sign systems it is affirmative.

This has consequences for a number of details in Carnap's work as well as for a broad tradition of formal and analytical semantics. In the following I will flesh out some of the implications of an intersemiotic approach for formal procedures in semantics. Let us take a closer look at Carnap's distinction between intension and extension and at other items in his logical toolkit.

Intension and Extension

In order to get a tighter grip on the description of expressions Carnap introduces what he calls 'the method of extension and intension,' according to which an expression does not name anything but rather has an intension and an

extension.[43] Intension expresses a proposition, and extension is the truth value of that proposition (its truth or falsity).[44] Going into greater detail, Carnap says that the theory of extension 'deals with concepts like denoting, naming, extension, truth, and related ones' whereas the 'theory of intension deals with concepts like intension, synonymy, analyticity, and related ones,' in short with its 'designative meaning component' (233). Carnap believes that the usefulness of this distinction can be shown when we are concerned, for instance, with so-called psychological or belief sentences. According to Carnap, a sentence such as 'John believes that it is raining now' has neither extension nor intension 'with respect to its subsentence.' Semantical problems of belief sentences can be resolved 'with the help of the concept of *intensional structure*' (1).

The double theory of intension and extension also allows Carnap to contrast what he calls the intensionalist versus the extensionalist thesis in pragmatics. According to the intensionalist thesis, 'the assignment of an intension is an empirical hypothesis which, like any other hypothesis in linguistics, can be tested by observations of language behaviour.' This is the position Carnap supports. By contrast, the extensionalist thesis holds that 'the assignment of an intension, on the basis of the previously determined extension, is not a question of fact but merely a matter of choice.' According to this position, we are 'free to choose any of these properties which fit to the given extension.' As a result, we can neither be right nor wrong in our choice (237).

Carnap goes on to quote Quine, who attacks the notion of synonymy in his support of the extensional thesis: 'The finished lexicon is a case evidently of *ex pede Herculem*. But there is a difference. In projecting Hercules from the foot we risk error but we may derive comfort from the fact that there is something to be wrong about. In the case of the lexicon, pending some definition of synonymy, we have no stating of the problem; we have nothing for the lexicographer to be right or wrong about' (237).

Carnap counters this with an illustration:

Suppose, for example that one linguist, after an investigation of Karl's speaking behaviour, writes into his dictionary the following:

(1) *Pferd*, horse

while another linguist writes:

(2) *Pferd*, horse or unicorn.

But 'since there are no unicorns' the intension in each case of 'Pferd' differs, while the extension remains the same. 'If the extensionalist thesis were right,' says Carnap, we could not distinguish (1) and (2) empirically. Further,

the linguist must attend not only to actuality but also to its possible thinkable variations, for, as Carnap points out, 'all *logically possible* cases come into consideration for the determination of intensions. This includes also those cases that are causally impossible.' In the end, the linguist could 'just point to a picture representing a unicorn' (238).

In order to highlight the weakness of the extensionalist thesis Carnap invokes a further example. We are asked to 'consider, on the one hand, these customary entries in German–English dictionaries':

(3) *Einhorn*, unicorn. *Kobold*, goblin,

and, on the other hand, the following entries:

(4) *Einhorn*, goblin. *Kobold*, unicorn.

Now the two German words (and likewise the two English words) have the same extension, viz., the null class. Therefore, if the extensionalist thesis were correct, there would be no essential, empirically testable difference between (3) and (4). The extensionalist is compelled to say that the fact that (3) is generally accepted and (4) generally rejected is merely due to a tradition created by lexicographers, and that there are no facts of German language behaviour which could be regarded as evidence in favour of (3) as against (4). (239)

In order to determine the intension of a predicate we may choose as our starting point 'some instances denoted by the predicate.' Then we must find the rule for what 'variations of a given specimen in various respects (e.g., size, shape, colour)' are legitimately part of the predicate's range, which may be defined as its intension. It covers all kinds of objects for which we can say that the 'predicate holds.' As a result of this investigation Carnap discovers a 'new kind of vagueness,' which he terms '*intensional vagueness*.' He claims that this opacity does not worry Karl very much since it does not affect the practical goals of his everyday life (239).

Carnap's entire argument against Quine here rests on the stipulation of a null class. From an intersemiotic perspective, however, this stipulation appears illegitimate. A null class is a class with no signs, a merely theoretical end point in a chain of classes with diminishing members. But since in an intersemiotic world everything we can know is significatory, i.e., is known by way of signs, such a class would merely mark the negation of signification and the knowable world. Yet fictions are significations and occupy a specific place in an intersemiotically constituted universe. Quine's position on extension becomes perfectly defensible (although he would probably not approve of my strategy) if we extend our starting base by saying that a null class could not even contain

fictions. Fictions can be distinguished from non-fictions by being considered 'thinly' or weakly signified entities as opposed to heavily overdetermined signs (so-called empirical objects).

Given this alternative starting position, the argument now runs differently. There is no strict synonymy in the dictionary. Its assumed intensions are expressions which we attach to other expressions to construe a single sign system map, a linguistic grid, which roughly corresponds to its extensional multisignificatory world. We cannot be right or wrong about the intensions themselves but only about their relations with their non-linguistic equivalents. And this relation across different sign systems is governed, more or less loosely, by community agreement. Unicorns are not members of a null class but members of a class of fictions for which extensional rules hold, just as they do for non-fictional entities. Quine's extensional thesis works, though on the role of fictions his account is incompatible with my corporeal semantics.

This way of rephrasing Quine's position depends of course on a redefinition of Carnap's notion of extension as the combination of different sign systems. Instead of regarding extension as a link between expressions and the 'world' which is named, denoted, and so on, we now see extension as the way in which one sign system, say a natural language, becomes semantic by pointing beyond its own domain to the domains of non-linguistic signs, such as visual, tactile, haptic, aural, olfactory, gustatory, proximic, and other forms of signification, with the help of which we find our way about. Once extension is redefined in this fashion we can explain why an ordinary person like Carnap's Karl is not confused. The reason is not, as Carnap sees it, that Karl does not pay any attention to the impractical subtleties of logic. Rather, Karl finds his way about in both fictional and non-fictional domains of meaning because he has learned the extensions which the semiotic community regards as appropriate for language expressions.

At the same time, given the intersemiotic stance, we realize that if there were such things as intensional operations by themselves they would not be semantic but merely syntactical; without extensional links to non-linguistic signs, they do not mean at all. As far as natural language is concerned it is quite impossible to entertain intensions without extensions. Once we know our way about in the world – once we belong to a semiotic community – we have extensions in the sense redefined above. And whenever we have extensions we are also able to construe intension by way of abstraction, by way of generalization and formalization. Carnap sees this relation as reversed and in any case primarily as a logical rather than a social semiotic issue: 'Intensional sentences are translatable into sentences of an extensional language; translatability is here meant

in the strong sense of L-equivalence.'[45] This is where a fundamental difference between formal and natural languages is to be located: the formalization of natural language is a one-way street; one cannot reconstruct the original text from its formal symbolic alternative. L-equivalence is denied to natural language semantics.

Meaning and Sense

When Carnap deals with the signifying operations of language he has in mind 'a theory of meaning and interpretation' (ix). Meaning is defined as 'designative meaning,' covering such phrases as 'cognitive,' 'theoretical,' 'referential,' and 'informative' meaning but not 'emotive' or 'motivative' kinds of meaning.[46] Carnap also believes that 'truth and logical consequence are concepts based on the relation of designation, and hence semantical concepts.'[47] The meaning of sentences is thus tied to truth in the sense that 'a knowledge of the truth-conditions of a sentence is identical with an understanding of its meaning.'[48]

Further, the systematic study of these relations is the province of '*semantics* [which] contains the theory of what is usually called the meaning of expressions, and hence the studies leading to the construction of a dictionary translating the object language into the metalanguage.'[49] Semantics, for Carnap, is 'the fulfillment of the old search for a logic of meaning.' In his earlier work, *The Logical Syntax of Language*, he had regarded 'analysis of language [as] either formal, and hence syntactical, or else [as] psychological.' Later, in *Semantics and Formalization*, he became convinced that in addition to the study of syntax and pragmatics there existed the legitimate field of '*a logic of meaning*' (249). The phrase 'a logic of meaning' may suggest to the reader that Carnap is concerned only with the formal structure of language itself. Yet when he speaks of the 'meaning criterion' he ties the meaning of statements to states of affairs, that is, to non-linguistic events.[50] Conversely, if a statement 'does not express a (conceivable) state of affairs, then it has no meaning.' In that case, it is 'only apparently a statement.' If it does express a state of affairs, 'it is in any event meaningful.' At this point Carnap allows for the separation of meaning and truth. A statement is true if the expressed state of affairs exists, false if it does not. However, a statement can be meaningful prior to our knowing whether it is true or false: 'One can know that a statement is meaningful even before one knows whether it is true or false' (325).

If we accept that states of affairs are the result of combinations of a number of sign systems, such as aural, tactile, and other interpretations, then we could say that the second-order representations of fictions could also be looked upon

as states of affairs. In that case fictional statements would be meaningful as well as true or false within their specific frames, which they are not, for example, in Bertrand Russell's account.

If meaning, then, is the statement's expression of a state of affairs, sense is defined by Carnap as 'the intension of an individual expression.'[51] As such, sense is the strictly logical proposition into which the expression of a state of affairs can be put. Whatever is 'grounded only in the analysis of senses' and does not involve 'any observation of fact' is logical for Carnap. For meanings concerned with the domain of the empirical Carnap reserves the terms '*non-logical,* or synthetic.' Likewise, any analysis concerned only with sense is termed 'logical,' while concepts which involve observation are descriptive, factual, or non-logical. This is why Carnap thinks that any 'analysis of sense' belongs properly to 'logical analysis' (16).

The main objection I have against this account is that while the procedure poses no problems when we are dealing with non-referential sign systems, for instance with symbolic constants and variables, as soon as we apply it to natural language we run into difficulties. It requires, as in Frege, that sense be understandable in terms of formal systems alone. As I have shown earlier in the chapter this is indeed what happens in the performance of signs stripped of reference and deixis. In other languages, notably in natural languages, this can be neither assumed nor demonstrated. The sense of natural language items cannot be established by way of a dictionary. For at least one component of the definition, either the definiens or the definiendum requires anchorage outside the dictionary. Without such anchorage Carnap cannot proceed to his second step. As far as natural languages are concerned, both his procedural steps require a semiosis beyond an internal sense.

A further important feature of Carnap's semantics is that he restricts the range of sentences which have meaning in any precise sense by introducing the criterion of meaning independence. Only declarative sentences have a strict designative meaning 'of the highest degree of independence.' Other expressions have derivative meanings that arise from the manner in which they assist a sentence in expressing its meaning. Carnap is cautious about suggesting a schema for such meanings, except to say that 'one might perhaps distinguish – in a vague way – different degrees of independence of this derivative meaning.' The obvious candidates for derivative meanings are so-called function words or syncategorematic expressions 'with no or little independent meaning.'[52]

An example of dependent meaning in Carnap's sense is the universality of articles. When articles are used in ordinary language the intention of universality as an important part of their meaning depends on the context. The example adduced by Carnap is the phrase 'the lion,' which 'has a universal sense in

the sentence "the lion is a beast of prey" but not in the sentence "the lion is now fed."' The solution offered for instances of this kind is 'to produce a correct symbolic translation of a sentence containing words like "a", "the", "something", "anyone", "nothing,"' by rephrasing the sentence so that 'expressions such as "for every x" and "there is an x" appear in place of the words mentioned.'[53]

There appear to be two issues here. One is that natural languages contain a large number of terms whose semantic fields shift more or less radically in different contexts. This feature is not restricted to so-called function words, connectives, disjunctions, quantifiers, and others. The second issue is the claim that syncategorematic words receive whatever meaning they may have from other parts of a sentence, if they have any independent meaning at all. Here we need to stress that there is no such thing as a natural language item, not even such words as 'if,' 'and,' 'either,' or 'is,' whose semantic background could not be reconstructed into a full social semiotics. The idea that there are natural language words without any meaning at all needs to be rejected. Meaning will even accrue to the artificial phrases of 'Jabberwocky' given extended social use. On the question of the at-least-minimal semantics of syncategorematic words I refer the reader back to section 1.2.

Carnap's solution to the ambiguity cited above rests on the notions of translatability, interchangeability, and substitution, which in turn depend on the possibility of logical identity. Identity, then, is crucial to the logical analysis of meaning. Carnap defines identity as 'agreement in all properties' (111). Again, this concept works perfectly in fully formalized systems and between formalized systems, but when it comes to natural language, identity can never be guaranteed. Its meanings are not given by a substitutionary phrase but by reference to non-linguistic signs which do not stand in an identity relation to the language in question. Rather, we are dealing here with a negotiable significatory overlap which shifts with the shifting boundaries of social intercourse. History, class, gender, region, and even the different horizons of the broader or narrower units of the family are determinants of the activation of linguistic signs by their non-linguistic relations as social acts.

Yet identity in the strict sense is required for the very idea of substitution, which plays a major part in Carnap's work.[54] Carnap also elaborates on substitutions for sentential variables, individual variables, and predicate variables.[55] About variables, for example, he says that 'if, when an expression is substituted for a variable of a given formula, there is produced another meaningful (but not necessarily true) formula, we say the expression is *substitutable* for the variable and call it *substitutable expression*' (24). Likewise, his comments on interchangeability make it clear that he deals exclusively with formal identity

or, as he calls it, with L-equivalence (28ff., 62–3, 94–5). It is important, however, that the application of the principle is not restricted in Carnap's work to the purely formal. Among other applications, Carnap uses the notion of substitution when he speaks of 'equipollent' sentences. He suggests that much confusion and many pseudo-problems can be avoided by rephrasing 'material mode' sentences, for example, into sentences which follow a properly logical syntax.[56]

It is important to point out here that undoubtedly a great number of natural language sentences can be made clearer in practice by this sort of rigour. Problems arise when we assume that natural language terms have accurate semantic equivalents in the lexicon in general. This is not the case, and the general application of Carnap's method would lead to an unacceptable simplification and indeed violation of the nuances of discourse. I am trying to stress here, though, that the principles on which the stipulation of identity as a universal rule rest only apply to the realm of formal logic and not to that of natural language. The difference has to do with the distinctive manners in which the two are meaningful. Formal logic is made meaningful by idealization and natural language by regulated readings of the body.

In the final analysis, we are bound to say of course that both those processes are social acts, the one the social act of a logical fiat, the other the social act of plugging into the current of living semiosis and corporeality. I suggest that it is the differences between these acts which are at issue in Carnap's enterprise. Before we can embark on a broader critique of his project we need to flesh out the picture given so far by listing a number of relevant tools that Carnap employs in his semantics.

Satisfying a Rule

An important part of Carnap's semantical considerations encompasses the concepts of rules and criteria and what it means to satisfy a rule. As he sees it in *Introduction to Semantics and Formalization of Logic*, 'the concept of fulfillment (or satisfaction) to be defined now is closely related to that of determination' (47). The example he gives is, 'the ordered pair (i.e., sequence of two members) Castor, Pollux (a pair of objects, not of names!) [which] fulfills the sentential function "x ist ein Bruder von y" in German.' Fulfilment, then, becomes 'the basic concept in the construction of a semantical system,' circumscribed by rules. Fulfilling a rule then replaces the notion of determination.[57]

In *Meaning and Necessity* Carnap tells us what a complete set of semantical rules would look like for an extensional system S1 and its intensional counterpart S2:

(i) Rules of formation, on the basis of a classification of the signs; these rules constitute a definition of 'sentence.'

(ii) Rules of designation for the primitive descriptive constants, namely, individual constants and predicates.

(iii) Rules of truth.

(iv) Rules of ranges.[58]

The first group of rules is strictly syntactic and poses no problem in the sense that the rules can be represented purely in terms of a calculus. Carnap divides sentences into 'atomic sentences,' which 'contain neither connective nor variables (e.g., "$R(a,b)$," "$b = c$")'; molecular sentences, which are made up of atomic sentences and connectives but no variables (e.g., '$\sim P(a)$,' '$A \vee B$'); and general sentences 'containing a variable (e.g., "$(\exists x)P(x)$").'[59] A definition for Carnap is an expression consisting of two parts, the definiendum, which contains new signs, and the definiens, which contains only signs already defined.[60]

The second set, rules of designation, is crucially different from the first in the following respect. If we remain within the domain of the formal in the definition of our constants, we have constructed basic semantic rules which are also representable as a calculus whose senses can be fully matched with the syntactic formulae of the first group. As soon as we replace the formal constants by natural language expressions, however, we have introduced into this group items with a social semiotic meaning, a quite different sort of sense. These can be semantically activated only by access to the social semiotics within which they are in use. This process is traditionally abbreviated by a chain of linguistic signifiers terminated with the help of 'sufficient reason,' which varies according to the length of entries in different dictionaries.

This, however, merely postpones the problem. In the end, all such clusters of expressions have to be resolved semantically by giving them historically and otherwise specific social semiotic content. If we pay attention to the semantic double directionality of natural language terms, this means that we must construct, by way of some form of quasi-corporeal, mental representation, a plausible utterance situation (deixis) and a portion of the 'world' (reference). Such constructions depend to a very large extent on non-verbal signs. Our ability to perform such acts is what is cursorily called 'knowing a language.' Once more, the untheorized transition from strictly formal procedures to the non-formal seriously damages Carnap's argument, since he introduces natural language examples in a manner suggesting that they can be equated with their formal cousins.

The same problem affects the rules of group (iii). Rules of truth are straightforward if they mark a relation between two formal systems. When, by contrast,

we are concerned with the constructed objectivities of the 'world' as utterance situation and projected event, the notion of truth takes on an entirely different role. I shall have more to say about Carnap's 'truth' below. The last group of rules perhaps best demonstrates the distinction I have been trying to foreground. Rules of range address the way in which sentences include or exclude statements about the world. 'A sentence says something about the world in that it excludes certain cases which are possible in themselves,' thereby telling us 'that the excluded cases are not real cases' (21).

As for the predicate, its intension may be defined as 'its range, which comprehends those possible kinds of objects for which the predicate holds.'[61] In terms of analyticity, 'we call a sentence *L-true* provided its range is the total range, hence provided it is true in every possible case.'[62] Likewise, a sentential formula can be said to be '*L-true* just in case its range is the total range, i.e., it is true for every value-assignment.'[63]

Carnap offers a perhaps puzzling but consistent formulation when he says that 'the more the sentence excludes, the more it says.' In this he suggests that range and content stand in a reciprocal relation whereby the content of a sentence is regarded 'as the class of possible cases in which it does not hold, i.e., those value-assignments which do not belong to the range of the sentence' (21). This has the following consequence for the description of logical deduction:

> The essential character of logical deduction ... consists in the fact that the content of *Sj* is contained in the content of *Si* (because the range of *Si* is contained in that of *Sj*). We see thereby that logical deduction can never provide us with new knowledge about the world. In every logical deduction the range either enlarges or remains the same, which is to say the content either diminishes or remains the same. Content cannot be increased by a purely logical procedure (21).

In a formal account this makes perfect sense since the definiens and the definiendum belong to the same sign system, namely a calculus. When we use natural language expressions, however, the relation changes drastically to one between signs from distinct systems. With reference to range, as the 'possible kinds of objects for which the predicate holds,' Carnap notes the change by conceding that 'in this investigation of intension, the linguist finds a new kind of vagueness,' mentioned above, 'which may be called *intensional vagueness*.'[64]

I suggest that Carnap's 'intensional vagueness' is a euphemistic expression for a fundamental feature in the semantics of natural languages not satisfactorily captured by a formal or even a 'linguistic' semantics. To account for what Carnap calls intensional vagueness we must step beyond the confines of the verbal into the larger domain of intersemiotic relations and hence corporeality.

It is also worth noting that the principle of vagueness conceded for the last group of rules can appear as early as in group (ii) – that is, whenever the semantics of natural language is in question. A more important issue is whether Carnap's reciprocal schema can be transferred to the semantics of the social life-world, as he assumes it can when he refers to objects and, as we shall see later, to persons. In one sense it certainly can, namely in the way in which the removal of reference and deixis transforms natural language into calculus, or syntax, for which substitutions can be found to facilitate machine translation among other things. But again, the actual semantic activity is performed by social speakers at the interface between language and 'world' rather than within the machine. Its syntax does not mean anything.

This is not an argument against machine meanings in principle, in the way that Searle, for example, tries to refute them. For Searle's reference to mental states appears to beg the question.[65] Nor does his discussion of 'intentionality' improve the picture.[66] A machine that is able to combine a series of distinct sign systems (pictures, haptic interpretations, aural, olfactory, and other signs) is at least thinkable as performing minimal intersemiotic acts. To the degree that it was able to do so it could be said to produce and understand meaning in an intersemiotic sense. This is what seems to happen in a minimal way in robotics. Yet those 'acts' would once more be definitionally ruled by a program, a syntax, rather than negotiated within shifting community constraints. What sort of 'program' would have to be installed to permit us to speak of 'negotiation' in a human sense? What defines the difference between functional and social? Is it not possible that it is no more than a difference in complexity on a scale still too vast to imagine?

From another angle, Carnap's move from calculus to 'world' via natural language can be shown to run into difficulties. If the intension of a predicate specifies its range and if intension is the formal definition of the range of the predicate, then according to the theory I have advanced strictly speaking it cannot say anything about the world at all. By Carnap's own schema, as formalization increases so deformalization, or the filling of the formal with material content, decreases. At the poles of this scale we have full material content without the possibility of formalization and full formalization without material content; in other words, without the possibility of meaning as it appears in natural language. Put differently, a sign system which is entirely analytic is all range and no content; it has no signified world, only formula. In the reverse a fully material world cannot be formulated in the sense of being graspable via intensions in Carnap's sense.

We can also follow Karl Popper and say that as meaning increases – meaning in the intersemiotic sense of a social act of combining several sign

systems – falsifiability also increases. Or, corroboration and falsifiability are directly proportional.[67] Systems, the sentences of which have total range, cannot be falsified. Any system can be falsified only to the degree to which it makes synthetic statements: the extent to which it is concerned with meanings in the intersemiotic sense. If intensions are fully ruled by definitions, and if definitions are themselves fully formal, then intensions and hence the range of predicates can never say anything about the world. Range and content outside formal systems are, strictly speaking, incommensurate. To combine the formal and non-formal in the reciprocal linkage of range and content is yet another aspect of Carnap's sleight of hand.

I argue against Carnap's 'ideal language programme,' in which analyticity and material world are faultlessly aligned, not only on the grounds that there is no test to confirm the validity of the bridge between the two realms but also because I think that an intersemiotic theory of meaning is able to show why the bridge cannot be built. As well, truth, including truth conditions, is not the most appropriate way of guaranteeing meanings in a semantics for natural languages. In the following, I shall try to demonstrate why this is the case.

Truth

As far as the traditional distinction between analytic and synthetic truth is concerned, Carnap offers the following improvement. Instead of saying that 'a sentence (or a proposition, or a judgment) is logically true or logically necessary or analytic' if its truth is independent from facts 'or if it holds in all possible worlds (Leibniz),' Carnap introduces the notion of L-true such that 'we call a sentence L-true provided its range is the total range, hence provided it is true in every possible case.'[68] An expression which is either L-true or L-false Carnap calls 'L-determinate.' If it is neither, the expression is 'L-indeterminate': 'A sentential formula is L-indeterminate provided its range is neither total nor empty, i.e., when there is at least one value-assignment at which it is true, and at least one value-assignment at which it is false. Of an L-indeterminate sentence (though not of an open sentential formula) we can also say that it is *factual*' (18).

Here Carnap's intention is to replace the traditional synthetic judgment with a more strictly formulated description. He observes that 'logical analysis does not suffice to ascertain the truth-value of a factual sentence' and that we need to take empirical facts into consideration in deciding on truth and falsity. A factual sentence which is true in this sense he calls 'F-true' as against one that is false, which he calls 'F-false' (18). This leads to the distinction of three kinds of judgments: analytic, synthetic, and contradictory. In the same vein,

the traditional notions of logical implication or entailment and their inverse concepts of logical consequence and deducibility are rephrased in terms of L-implication and so on to distinguish them clearly from their synthetic (F-) counterparts (20).

At the beginning of the section I quoted one of Carnap's examples illustrating the distinction between L-truth and F-truth and suggested that he is wrong when he says that 'knowledge of (extra-linguistic) facts is not involved' in our judgments about (1) 'Fido is black or Fido is not black' and (2) 'If Jack is a bachelor, then he is not married.'[69] If we replace the natural language examples by variables, Carnap's point of course holds. Yet the natural language expressions dramatically alter the picture for the speaker of the language. We are no longer in a position to dissociate the place value of the terms from their sociosemiotic meanings. We no longer attend only to the linguistic signifiers, instead imagining two different dogs and the circumstances of what it is to be a bachelor. To do what Carnap, and an entire analytical tradition, says we do requires a special step: a radical reduction of deictic and referential background. One may object by arguing that in habitual language use we do not elaborate the non-linguistic backdrop in any detail. That may be so and, furthermore, this depends on the communicational circumstances. But even a highly schematic presentation of possible states of affairs differs radically from strictly logical moves in that non-formal schematizations are intersemiotically grounded in our overall construction of the social life-world, including the projection of the body.

When Carnap proceeds to explain the different steps which we are bound to take in order to establish both meaning and truth-value he performs a vicious circle. Ultimately this is unavoidable, yet it is regarded with dismay by the tradition within which Carnap writes. He envisages two distinct steps, both divided into smaller steps:

The procedure necessary to this end can be divided into two steps. Clearly we must, to begin with, understand the sentence; therefore, *the first step* must consist in establishing the meaning of the sentence. Here two considerations enter: on the one hand, we must attend to the meanings of the several signs that occur in the sentence (these meanings may perhaps be given by a list of meaning-rules, arranged, e.g., in the form of a dictionary); and on the other, we must attend to the form of the sentence, i.e., the pattern into which the signs are assembled. *The second step* of our procedure consists in comparing what the sentence says with the actual state of the affairs to which the sentence refers. The meaning of the sentence determines what affairs are to be taken account of, i.e., what objects, what properties and relations of these objects, etc. By observation (understood in the widest sense) we settle how these affairs stand, i.e., what

the facts are; then we compare these facts with what the sentence pronounces regarding them. If the facts are as the sentence says, then the sentence is true; otherwise, false.[70]

Carnap's mistake lies in conceiving of logical procedure as underlying, rather than abstractable from, the structure of everything, instead of seeing it as a particular kind of signification which yields a certain kind of picture. Note that the title of one of his early works is *The Logical Structure of the World* (1928) rather than *The Logical Construction of the World*. The moves of Carnap's first step suggest a self-contained structure. We establish the meaning of an expression by reference to the dictionary and to syntax. This gives us the meaning of the sentence. Again, as a logical procedure this is sound. In the case of natural language expressions it is not. We could assemble an infinite chain of substitutable signs in a well-ordered syntactic sequence and never establish the meaning of the expression in question unless we were able to activate at least one of these substitutions by reference to non-linguistic signs and so to social corporeality. This is not part of Carnap's first step. Hence meaning is argued in a circular fashion, as it would be in a deductive system of definitionally ruled terms.

Only when it comes to the second step do we go beyond linguistic signs. Here Carnap has us make four distinct moves. First, we determine what objects, their properties and their relations are indicated by the sentence; second, we observe how these objects constitute a certain state of affairs; third, we compare these facts with the meaning of the sentence; and, fourth, we make a decision about the truth-value of the expression by judging whether or not sentence and 'world' match.

That some sort of alignment takes place between the linguistic signs and their non-verbal cousins is not contentious. But to begin with we should say that such an alignment occurs twice rather than only once, as Carnap suggests. Every natural language expression is activated by a referential procedure in which we activate non-verbal significations about the world. At the same time the specific conditions of the states of affairs addressed by the sentence in question are aligned. We need to distinguish between general referential and deictic background on the one hand and specific reference on the other. In both cases, the alignment is a more or less rough matching of a variety of sign systems. This is not a strictly logical process, not so much because of what is often called the vagueness of natural language as because the various non-verbal sign systems do not give rise to fully congruous interpretations. If this is the case, then we are dealing from the outset with negotiatory processes rather than with matching techniques, and this situation is exacerbated when it comes to the activation of language by representations of complex social states of affairs.

This is why Carnap's description of 'interpretation' works in the formal domain yet requires modification when applied to natural languages. Assuming a language B, Carnap constructs two systems, a syntax and a semantics, both in formal terms. The semantic system, then, 'furnishes an *interpretation* of language B, since it contains rules which yield for each sentence Si of B a truth-condition pi such that Si is true if and only if pi.' Given pi, he says, 'we "understand" Si, we know what it "says" about individuals of the domain in question, what its "meaning" is.' From this starting point the meaning of the sentence Si is simply 'the proposition pi.'[71]

If we apply this truth-conditional account of meaning to natural languages, we must first turn the sum of states of affairs – or in short 'the world' – into declarative sentences. Then we would have two sets of declarative sentences, both capable of yielding propositions of the kind stipulated. If this were an appropriate procedure for natural languages, Carnap's move would be cogent. The problem lies in the assumption that the linguistic is a perfect match for the non-linguistic and that all non-verbal signs can therefore by represented by linguistic ones without loss or surplus. Such formalization is possible, but we must acknowledge the procedural violence involved in the process.

From an intersemiotic perspective, the 'world' as it is constituted for human use by members of semiotic communities is always already a significatory compromise between interpretations drawn from distinct sign systems. Thus the read-only signs, as we called the various forms of perception in section 1.2, are in conflict not only with one another but also with the dominant communicative sign system – language. To characterize this situation by way of truth conditions, as certain logicians do, is inappropriate. Tarski understood this when he first proposed the kind of formal relation which Carnap develops further.[72] I assume that it is not a violation of the spirit of Carnap's style to say that types of truth-conditional arguments should be clearly distinguished: they are either part of formal procedures describing formal systems and thus should be used strictly, or part of a looser description of the relations between linguistic and non-linguistic signs and thus to be used at best as metaphor.

Other Tools

Bearing in mind Carnap's assumptions about the logical structure of our 'world' as well as his formal starting point at its description, let us see how some of his other tools relate to the intersemiotic nature of natural language. When Carnap speaks of the 'principle of tolerance in syntax' he wants to empha-size the difference between prohibition rules and conventions. 'It is not our business,' he says, 'to set up prohibitions, but to arrive at conventions.' In this

Carnap reminds us of Wittgenstein's notion of rules.[73] It seems that something very similar could be said about the description of natural language. Indeed, linguistics speaks of the conventions for ordering the flow of languages in terms of grammatical rules, noun phrases, participles, definite and indefinite articles, and so forth. Yet this similarity between conventions of natural language and those of formal sign systems is at best superficial.

When a convention is changed in symbolic logic, for example, the earlier version has not thereby vanished but is still available in its entirety because of the definitional rules used for its initial constitution. This is not the case with the conventions applied to natural languages. Formal conventions are a priori rules, while their natural language relations are a posteriori rules. To reconstruct a natural language from its surviving rules, assuming we were to discover such a 'grammar,' would require not just the language itself but a reconstruction of the specific sociohistorical conditions to which that language referred; in short, the reconstruction of an entire culture. This is more or less what has been attempted in a hermeneutic manner in Sanskrit, Greek, and Latin language teaching. In these cases what is taken to be Sanskrit, Greek, and Latin undergoes considerable change over time. More significant is that a profound hiatus remains between the use of certain terms in one culture and the use of their translation equivalencies in another, as Heidegger has argued, I believe successfully.[74]

A good explanation for this difference in the term 'convention' takes seriously the intersemiotic description of meaning, without which syntax cannot be accessed in a natural language. It seems that only once we 'know' a natural language can we let go of its meanings and describe its syntactic structures: can we replace the interpreted natural language constants by variables. Ironically, we can do so only because we can map the syntax onto the background of a semantics, which in turn is the way in which terms are socially linked with an intricate web of non-verbal signs. Hence there is no such thing as a natural language syntax without a socially sanctioned intersemiotic dynamic. Semantics, in the sense of interpreted language, is the virtual field between the two.

In Carnap's terms, an interpreted language is 'a language for which a sufficient system of semantical rules is given,' that is one which is definable as 'an ordered triple (a, S, D).' Carnap stipulates an axiom for the first domain of the relation D such that it 'is identical with the class S.' Introducing the convention of a metalanguage, Carnap regards D as 'the relation of value-assignment for the sentences of the language.' Thus the expression ' "D (Si, the moon is spherical)" means as much as "The sentence Si is true if and only if the moon is spherical." '[75]

In natural languages the relation between the sign system 1 and its exten-
sional metasystem 2 is different. First, there is the obvious difference that system
1 is socially given rather than formally construed. This in itself would be no
obstacle to transferring Carnap's formal semantic principles to the description
of natural languages. Second, and more important, the role of the metalan-
guage is carried out by the heterosemiotic and non-verbal quasi-corporeality
by which we have been taught to constitute the 'world' at large. We cannot
strictly call this metasystem 2 a 'language' without metaphoric fudging. If we
do so, we are bound to re-erect the distinction at the level of two different
kinds of language, such as the clumsy distinction between verbal and non-
verbal languages. In order not to lose sight of this important difference between
the homosemiotic system of natural language and its heterosemiotic seman-
tic background we need to emphasize rather than downgrade the relevant
distinctions.

In contrast to this actual relation we are of course free to follow Carnap's
route and construct an artificial metalanguage 2 for any natural language. But
when we do this we cannot claim, as Carnap can for the formal examples just
quoted, that the metalanguage supplies the natural language with *meanings*. The
meanings of 'moon,' 'spherical,' and 'is,' or their combination in a sentence, are
not given by the expression of the metalanguage; rather, in natural languages
the meanings of both S and D are provided by the intersemiotically constituted
world to which they refer. We need a theorization of this background of signs. In
its untheorized version 'background' plays an important part in Searle's writing,
which I have criticized elsewhere.[76] Without that intersemiotic background D
is no more than a set of syntactic substitutions. The Tarskian convention T
and Carnap's version of truth condition are not transferable from the formal
domain to the semantics of natural languages without serious flaws either, as
I have argued above.

A similar problem appears when we apply the concept of logical 'deriva-
tion' to natural languages. Carnap is aware of this to the extent that he dis-
tinguishes 'pure' derivations from their looser cousins. He regards a deriva-
tion as pure 'when it utilizes no other presupposition than those specifically
enumerated.'[77] This has proved useful in formal procedures, and for practi-
cal purposes will go some way towards producing clarity in natural language
expressions. A problem arises when we try to apply the notion of 'pure deriva-
tion' to natural languages in which the chain of presuppositions cannot ever
be fully enumerated. Resorting to the principle of sufficient reason by termi-
nating the chain of implications, presuppositions, and less obvious traces, we
follow pragmatic and political rather than logical rules. When this happens we

need to add a text that spells out the agenda guiding our decision unless we are inclined to give up Carnap's rigorous project altogether.

Several of the specific tools developed or adapted by Carnap also work for natural language description, if not with precision then at least in a rough sort of way. Even so, they tend to restrict the domain of description in a peculiar way. A case in point are such concepts as 'formation' and 'transformation,' which play an indispensable role in formal operations. As Carnap rightly observes, 'for the construction of a calculus the statement of the transformation rules, as well as of the formation rules, as given for Language I, is essential.' Without the formation rules we could not get started, and the transformation rules are required for us to know 'under what conditions a sentence is a consequence of another sentence or sentences (*premises*).'[78] One can immediately see the usefulness of a weakened version of these rules for the analysis of natural language. It turns out, however, that only a certain portion of language benefits from this transfer. Though they serve very well the sort of purpose Carnap is interested in, namely argument, report, description, and other technical uses, the vast bulk of language exchange has to do with shifting grounds, innuendoes, power games, and insincerely indirect speech acts, structures not well described in terms of logical transformation rules. Without fairly complex and essential additional information, such as imaginative texts of social reconstructions, or practical fictions, we are rarely in a position to perform transformations from premise to consequence. And when additional material has to be introduced to give a semblance of stability to the interpretive wobbliness of the explanation, the rigour of logical necessity looks spurious.

Two classes of signs form the staple diet of formal syntax and semantics – namely constants and variables – and are also central to Carnap's work. Constants have fixed specific meanings, while variables 'refer to unspecified objects' as well as to 'classes, properties, relations, functions, propositions' and other items.[79] Constants can be purely formal, that is logical, or descriptive. Descriptive constants such as 'individual constants, predicates, and the sentential constants' refer to things or relations 'in the world.' By contrast, logical signs comprise 'all the variables and the logical constants.' They do not refer to anything in the 'world.' As Carnap observes parenthetically, 'the world of things has nothing like negation, disjunction, etc.' The task of logical signs is syntactic in that 'they bind together the descriptive constants of a sentence.' In this way they make an indirect contribution to the meaning of an expression. Logical constants include all connective signs as well as such diacritical material as parentheses, brackets, and ordinary punctuation. According to Carnap, the distinguishing feature of a descriptive compound expression is that it has at least one descriptive sign. If it does not, he calls it logical (16–17).

A number of points in this account deserve our careful attention. First note the traditional demarcation that Carnap draws between signs (e.g., of language) and the world. We must ask in a Kantian way how in this case language and 'world' could ever be comprehended as a relation. What we need is a *tertium comparationis*, a platform on which language and 'world' can be aligned. Signification, in the general sense of regarding both language and world as systems of signs, provides such a platform. As a communicative instrument language is by definition significatory, while the world can be seen as such by interpreting it as the sum of the non-communicational signs of various forms of perception.

A more delicate problem is posed by Carnap's insistence on the logical purity of connectives, and he is not alone in making this assumption. Negation, disjunction, and all other function terms are dissociated from 'the world of things.' From the perspective chosen in this critique, however, the opposite picture emerges. Though they can only be sketched here, a few rudimentary observations should be able to make the point. The world of things, as Carnap puts it, is what it is from a human standpoint only by virtue of the specific conceptual apparatus we have at our disposal. The things of the world are signified in the peculiar manner in which we know them, a process tied to the historical evolution of human understanding. Carnap's world of temporal slices is, as we shall see below, an identifiable historical moment in this process.

Our ability to invent a purely logical version of negation, disjunction, copula, and other such syncategorematic features appears to be part of this evolutionary change. Rather than forming the ground for all socially elaborate forms of negation and other non-formal connectives, Carnap's pure forms are the result of a long history of dereferentializing acts, acts of imaginative variation, as Husserl describes them – in short, acts of fantasy. Just as it must have come as a surprise to generations of humans in prehistoric time to realize that number signs and their relations could be dissociated from thing signs, transferred to similar situations, and indeed used purely formally, so too are we now surprised by the reconstruction of the inverse process from formal purity to intersemiotic, social, quasi-corporeal act. As I have argued before with reference to Heidegger's position on the interpretive nature of assertions, the formal copula as well as Carnap's other logical constants are related to their descriptive forebears and ultimately to culturally saturated interpretion with the help of which we have been taught to constitute the world we know.

That in much of his formal writing Carnap is never far from wanting to say something about 'the world of things' surfaces also in his definition of a compound descriptive sentence as one which contains at least one descriptive sign. His examples such as 'Der Himmel ist blau' or 'the book on my desk is

black' are therefore already part of his broader project of describing not just a formal syntax and semantics but natural language and through it the world of things and persons, and ultimately the entire social political life-world. This is not stretching a mere inference but reflects closely what Carnap has to say on the meaning of the individual constants of a language L. Their meanings depend on the sphere of things to which L is applied, and 'these things,' he writes, 'may be space–time points, events extended in space–time, physical bodies, persons (of any historical epoch) persons now alive, etc.' (95–6).

The passage also appears to suggest that Carnap would accept the description of meanings in terms of links between one sign system such as a language and, for instance, an historical person, something that is not a language at all but primarily a corporeality signified by non-linguistic signs. This feature in Carnap's work will assume further significance below, where the constitution of objects in the 'world' is looked at more closely. A specific critical comment must be reserved for the very idea of a constant in both a formal and a non-formal sense. We find once more that the untheorized transition from the formal to the domain of natural language is a kind of sleight of hand. Accepting purely formal constants as indispensable tools in logic does not imply that we should do the same when it comes to natural language, at least not without being aware of a shift in conceptual content. This shift is not so obvious in examples like 'table' and 'cat,' but is self-evident in terms like 'honour,' 'parliament,' 'academic freedom,' or 'Gothic.' They are 'constants' in a different sense from 'a' or 'b.' Contrary to Carnap's view or that of Husserl on eidetic idealization, their signified content shifts with general semantic drift, more or less quickly, depending on semiotic relations outside language. Nor are natural language 'constants' like logical variables, which are merely place holders and can be replaced by any other signifier. Rather, natural language terms are at best 'inconstant' constants, which highlights the paradox of this kind of transfer of tools.

A related discrepancy arises when we look at the notion of 'operator,' a generalized quantifier indicating what sort of operation is to be performed on the operand. Carnap's 'vacuous operator,' for example, can always be removed from a formula without changing its logic (19). Not so in natural languages. Indeed it would be quite rash to suggest that any word or expression could be called a 'vacuous operator' because even the seemingly most spurious operator may have a pragmatic function of irony, devaluation of the discourse, or some other qualification on which the 'logic' of the relevant sentence or passage is dependent. In natural language redundancy is functional.

Also relevant to our discussion of semantics is Carnap's concern with various types or sorts of expressions. Different language forms, he says, 'can be used in symbolizing sentences about things.' Their distinctive characteristics are

'the different types employed.' The questions we need to ask about expressions used in this way are: '(1) What do expressions of the individual type designate? (2) To what type do the designations of things belong?' (158). The motivation for division into types or sorts stems from the observation that languages may include 'various kinds of individuals for which the same predicates are not uniformly meaningful.' Accordingly, a 'language with n individual types is said to be *n*-sorted,' while the majority of symbolic languages is 'one-sorted' (83).

Beyond the notion of 'many-sorted languages' one can also conceive of languages that lack all type distinction: 'In a language of this kind, individuals, classes of individuals, classes of classes of individuals, etc., can each occur as values of the same variable – and thus also as elements of the same class ("inhomogeneous classes").' Carnap reminds us of Quine's contributions to such systems before demonstrating a disadvantage for non-formal expressions. The passage is worth quoting for the reasons I give below:

For since in such a language a type-differentiation is also omitted for descriptive signs, formulas turn up that can claim admission into the language as meaningful sentences and that have verbal counterparts running as follows: 'The number 5 is blue,' 'The relation of friendship weighs three pounds,' '5% of those prime numbers, whose father is the concept of temperature and whose mother is the number 5, die within a period of 3 years after their birth either of typhoid or of the square root of a democratic state constitution.' (84)

One can see why many logicians think that poetry is made up of meaningless sentences. On the positive side, Carnap appears to have supplied an alternative way of describing the sorts of deliberate distortions that literary discourse effects on standard expressions. The sentence 'The number five is blue' would be a perfectly meaningful expression, for instance, in Wallace Stevens's poem 'The Man with Blue Guitar,' while Carnap's last elaborate example, chosen no doubt to clinch the argument, could well be included as meaningful in a new edition of *Finnegan's Wake*. The point is that meaning is a relation between different sign systems and hence an expression receives its meaning from the relation we are able to establish between, say, a language expression and corporeality. In relation to a 'world' made up of various non-sorted, nonverbal sign systems Carnap's examples could make perfect sense. However, what counts as meaning in Carnap appears artificially restrictive.

Space–Time Points, States of Affairs, and World

How do we conceive of the 'world' according to Carnap? Passages from both his earlier and his later work suggest a captivating perspective. A thing is

grasped in terms of the 'temporal series of its slices.' More precisely, 'the entire space–time region occupied by a thing,' says Carnap, 'is a class of particular space–time points which we speak of as "the space–time points of the thing"' (158). This constructivist position appears strengthened by the introduction of various senses by means of which we construe the 'world line' of objects.[80]

Perhaps it is pressing the point too far to say that Carnap's metaphysical position could be read as intersemiotic and heterosemiotic constructivism, as a view that the 'world' which we typically experience is construed by us with the help of signs which are not entirely compatible. Though Carnap speaks of senses by virtue of which we build a coherent picture of our surroundings, it is clear from some of his comments that he does not mean the senses do the constructions. Rather, the synthesizing tasks are reserved for the interpreting faculties of the mind. Yet such interpretations are possible only because the 'world,' as Carnap sees it, does have a logical structure independent of our semantic endeavours.

Nonetheless, Carnap's discussion of how we trace this 'world' with the help of different senses is worth reviving. A phrase such as 'after my body has been constructed as a complete thing, namely as a tactile–visual thing' certainly suggests that he is persuaded that our understanding of the world relies on different kinds of signs (201). It also prompts us to note that Carnap's is an odourless body reduced to image and touch, lacking a host of other, less tangible signs. He accepts that visual, tactile, olfactory, and auditory senses have some sort of function, yet notes their incommensurability with one another when it comes to the construction, or tracing, of 'bundles of world lines.' Specifically, 'the qualities of certain other senses, for example, the sense of balance, the kinesthetic sense, the sensation in organs, can be assigned to certain world lines or bundles of world lines, i.e., visual things, only with great difficulty or perhaps not at all' (206). Carnap's solution to the problem is simply to favour visual and tactile signification and to subordinate the rest to them: 'Almost without exception, it is points of the tactile–visual things to which the qualities of the remaining senses are assigned in the indicated way.' There is no doubt that the systems of visual and tactile signs are dominant. They have the greater force when it comes to negotiating perceptual experience, and the sum of these negotiations, 'the entire space–time world, with the assignment of sense qualities to the individual world points,' Carnap concludes, 'we call the perceptual world' (207).

Unfortunately, Carnap does not expend much further thought on the relative incommensurability of different sign systems (interpreted sense messages). He does conclude that 'the conceptual formation (and thus also the construction which follows it) of the perceptual world has only provisional validity.' The

reason for this appears to be 'the completion of the perceptual world through analogy' via causality and substance (208). This is reminiscent of Husserl's ap-presentation, or the construction by way of imaginative acts of what is not given: 'Through such supplementations, new things and regularities become known, or old ones become better known; with the aid of this information, further supplementation becomes possible. Thus we find mutual advancement between the recognition of general laws which hold for things and processes on the one hand, and the supplementation of the assignment of qualities to points in the perceptual world on the other' (209).

This kind of grasp, however, in no way contradicts our formal attempt to understand the world in an unequivocal way, for 'in the progress of knowledge (and of construction)' such a provisional conception 'must give way to the strictly unambiguous but completely quality-free world of physics' (207).

To be sure, Carnap acknowledges the problematic 'transition from the qualitative perceptual world to the quantitative physical world' (51ff.). The two are linked via a 'special relation,' which Carnap terms 'physicoqualitative correlation.' Further, the correlation is not altogether 'free from the imprecision which attaches to the perceptual world generally.' Even so, Carnap insists, with reference to Moritz Schlick, that 'the world of physics is completely free from sense qualities' (211).

Whether physics is indeed as Carnap describes must remain a moot point. In practice at least physicists tend to have certain metaphysical commitments to the origin of the universe that do not obey Carnap's rule. The idea of the 'big bang' as a beginning comes to mind here. More important for our purposes, it is a pity that Carnap did not pursue the implications of his findings for the construction of the ordinary world, the life-world of social actors, for in their constructions the lack of congruence of the signified world has important implications. This relative incommensurability would allow at least partial explanations of cultural diversity, individual valuation of things, perhaps even class and gender differences. Beyond Carnap, a fully developed intersemiotic theory of meaning certainly has significant sociopolitical implications.

An important feature of Carnap's picture of the perceptual world is the notion of 'overdeterminateness,' which arises as a result of certain logically 'dispensable relations' in our experience. Hence he argues with reference to certain problems in mathematics that 'the logical character of the theoretical content of our experiences' is their overdeterminateness. In the same vein 'our experience is (epistemologically) overdetermined.' Simply put, we 'experience more than is necessary in order to gain the knowledge that can be obtained.' At the same time, we leave 'unevaluated' what we believe to be unnecessary constituents of our experiences. And he adds in parentheses that fictional

expressions 'could disappear from our experience' without in any way affecting our knowledge of the world (311).

While we must acknowledge the general validity of the argument for overdetermined acts, the superfluousness of fictions is to be rejected. Without fictions we could not imaginatively vary the possibilities of the actual, and if we could not play we would stand still and die. Fictions in a broad sense, of which novels or poems form merely a small part, appear to be essential to our decision-making processes in the most straightforward acts of the identification of material objects, let alone in more complex operations such as the interpretation of concealed speech acts in political texts. Works of art such as sculptures, paintings, poems, or music are the experimental extensions of the intersemiotic fantasies of everyday life. Far from being dispensable, then, fictions are vital elements in the construction of the perceptual world.

Further, we need to draw a distinction between redundancy, a syntactical notion, and intersemiotic overdetermination. The former is logical and hence goes with synonymy and identity; the latter is pragmatic and goes with relative incommensurability or 'partial overlap.' It is to redundancy that Carnap's notion of overdeterminateness applies, whereas intersemiotic overdetermination is indispensable for the forward motion (rather than the stagnant state) of interpreting our 'world' forever anew. Once again note the sleight of hand from Carnap's starting point to the end of his argument. He begins by talking about the 'logical character of the theoretical content of our experiences,' the abstractable propositional relations which we can derive from actual experiences; then he talks of actual 'fictional expressions,' which could be removed from experience without loss. To remain consistent, he should have investigated the theoretical relation between fantasizing, or making fictions, and experiences which relate directly to the 'world.' Indeed, once abstracted, this 'logical' relation can be shown to be 'logically' indispensable for coping with new situations.

Carnap's position on fictional statements reappears in the context of his critique of metaphysics. His 'anti-metaphysical thesis' states 'that metaphysical propositions – like lyrical verse – have only an expressive function, but no representative function.' And like metaphysical propositions fictional expressions 'are neither true nor false,' because they assert nothing. They 'contain neither knowledge nor error'; they are altogether outside 'the field of knowledge.' Rather, they are expressive, 'like laughing, lyrics, and music.'[81] This represents a well-known position in logical positivism. And again, the particular restriction of the fictional to the merely expressive side of signification is to be rejected on the grounds that Carnap has defined a representative function too narrowly. In terms of intersemiotic relations the fictional is certainly

representative, except that the signs it is able to employ fall significantly short of those available to the representation of the actual. That the imagination does play a part in the construction of the perceptual world even at the level of physics is acknowledged by Carnap when he speaks of the relation between perception and natural laws. Note how his starting point forces him to retreat once more to the domain of the formal when it comes to the reliability of our abstractions drawn from perceptual experience, so-called natural laws not being exempt:

Since all natural laws have been derived inductively, that is to say through the comparison of experiential contents, a variation of the material at any given point can very well change the content of the laws and thus the content of reality as it is known, but cannot prevent the recognition of laws in general and hence reality. Strictly speaking, contents of experiences cannot contradict one another; they are independent of one another in the strict logical sense. Strictly speaking here is no overdeterminateness of the total content of experiences: they are overdetermined only in relation to the empirical-inductive regularities.[82]

One should perhaps also add that with reference to the totality that could theoretically be experienced, our typifications of the olfactory, visual, thermal, gravitational, aural, tactile, and so on could always also be further determined. Like language they are schematic, forever open to further determinations. So in addition to the overdeterminateness of experience we need to acknowledge, paradoxically, that it is also fundamentally underdetermined.

I have traced what I believe is a seminal 'sleight of hand' in Carnap's writing by addressing specific parts of his argument and his choice of tools. In all cases I think the stated or implied transition from the formal domain to natural language, from ideal constructions to the 'world' can be demonstrated to be flawed. But nowhere is this problematic better demonstrated than when Carnap commits himself to a realist position, which his ideal language program is supposed to support. As it turns out, an intersemiotic textualist position makes what he wants to show so much more plausible. A concluding case in point is the following passage, in which his scientific realism confronts a suppressed textualism:

The topological structure of the physical world is independent of measurable magnitudes. However, the method ordinarily used in physics to treat topological properties of space and time makes use of measurable magnitudes, viz. of coordinate systems. Such a coordinate system associates with each space–time point a quadruple of real numbers; while this association is based on certain arbitrary conventions, the arbitrariness is

subsequently eliminated in topology through the device of considering only those prop-
erties which are invariant under any one of a certain class of transformations from one
coordinate system to another. This usual procedure is convenient mathematically be-
cause it utilizes the familiar and effective means of real numbers and real functions;
nevertheless it is, so to speak, methodologically impure.[83]

How does Carnap know that there is a topological structure? What he can
know is the result of his descriptions, for instance those of physics, i.e., 'meas-
urable magnitudes' such as coordinate systems. Carnap acknowledges that the
link between what we assume is there and what we thus measure 'is based
on certain arbitrary conventions,' the arbitrariness of which 'is subsequently
eliminated in topology' by getting rid of all but the invariant properties of a
number of coordinate systems. The use of 'real numbers' and 'real functions'
here is of great help and yet, as Carnap concedes, what is procured is never-
theless 'methodologically impure' (197). Carnap should also concede that he
cannot strictly speak of a 'topological structure' *without* some sort of textual de-
vice, such as a coordinate system. All he can say is that our measuring activities
are fundamentally constrained. At the same time, though these constraints are
invoked as necessary inferences, they are available to us only as another set of
signs. Having started with confident, scientific realist conviction, the remain-
der of the passage testifies to something quite different: a kind of textualism
and inferential realism.[84]

3

The Semantics of Negation
and Metaphor

3.1 TWO BUGBEARS FOR FORMALIZATION

This chapter applies some of the principles elaborated in the previous chapters to two troublesome features of language: negation and metaphor. Sections 3.2 and 3.3 ask what happens when we theorize specific semantic issues from the perspective of a narrowly conceived semantics, as well as what a broadly conceived semantics has to say about them. Negation and metaphor have been chosen on the assumption that analytical and intersemiotic approaches should produce descriptions which differ in important respects. In particular, the conflation of natural and formal sense as demonstrated with reference to Frege and Carnap will be shown to run into certain difficulties when it comes to giving a comprehensive picture of negation and metaphor. Missing in the idealized description of meaning as sense in the Fregean tradition is corporeality, the important role the body plays in the event of meaning. Negation and metaphor are two features of natural language which accentuate this absence.

From the perspective of an intersemiotic, corporeal semantics a different picture emerges. Not only will negation and metaphor receive an alternative description but the intersemiotic account will also serve as a critique against which orthodox observations can be analysed. This is not to say that in an intersemiotic approach negation and metaphor lose their notoriously difficult character. On the contrary, the difficulties they pose to any analysis will be used to support as generous an inquiry as possible. In particular traditional methods of describing negation tend to remain confined to the narrowest frame of linguistically marked forms of negation, unable to address a range of macrostructural variants. Any negation beyond the sentence level, such as cultural negation or the kinds of negation central to psychoanalytic writings, proves to be strictly outside semantic analysis based on minimalist assumptions concerning sense.

Section 3.2 looks at a way of approaching negation from a holistic perspective, one which could include large-scale negation without losing the sharpness of analysis already accomplished in more traditional studies. Given this bias, the minimal sense approach to negation will have to subordinated to a broad intersemiotic frame within which orthodox findings can be given their specific location. Not all such findings will prove compatible with the new umbrella argument, and in these cases I will seek reasons for the failure of the explanation. The assumption underlying this way of proceeding is that negation is a fundamental structure of social doing which precedes language in both an historical and a logical sense. Linguistic negation is thus likely to reflect that more fundamental structure in specific ways. Furthermore, if this basic assumption is correct it makes sense to draw as broad a frame as possible in order to account for a range of distinct discursive formations under the term of negation.

If one wants to exemplify opposing positions, one should avoid choosing weak candidates. One of the most persuasive analytical approaches to negation can be found in Ruth Kempson's tightly argued *Presuppositions and the Delimitation of Semantics*, in which negation plays a much more prominent role than the title suggests.[1] Kempson puts her finger on an vital aspect of negation, which she terms the 'vagueness' of negation, in the sense of unspecifiability. She demonstrates that the answer to the question 'Was that a woman knocking on the door?' – 'No, it wasn't a woman' – provokes a series of different interpretations. In fact one could argue that this series is an infinite regress. According to Kempson, this is not a case of ambiguity, as suggested by Jerrold J. Katz and Manfred Bierwisch, but a problem of the 'delimitation of scope.' By way of componential analysis Kempson shows that while ambiguity can be resolved syntactically, vagueness in negation requires a rule 'which has no parallel in the transformational processes of syntax' (29). Kempson then goes on to argue that a small number of linguistic features, such as 'scope variation in negation' or 'the interdependency of scope and stress,' cannot be handled within the confines of 'the formal system of a linguistic model' and require instead a 'theory of communication' under the umbrella of a 'theory of performance,' in addition to semantics (220–1).

I strongly disagree with Kempson's suggestion that ambiguity can be resolved syntactically. My main concern, however, is with a kind of semantics that needs to push certain complexities to the periphery of its focus. If the strictly analytical parameters of Kempson's approach are unable to cope with a number of very important 'semantic' features of natural language, then perhaps the reverse procedure is at least worth considering. This avenue is suggested here, a procedure which begins with the large horizon of social semiosis, a close

enough parallel perhaps to Kempson's 'performance,' and then finds a position for the specifics of analytical questions within its larger frame. What such an approach appears to lose in precision may be made up by gains in the kinds of things that had to be left out of a strictly circumscribed semantics. Beyond Kempson's examples certain macrostructural forms of negation appear to support such a view, as we shall see in section 3.2.

I have chosen metaphor as the second phenomenon for investigation because it is one of the most intriguing structures with which linguists and philosophers of language have been concerned. Since Aristotle philosophers have tried to pin down the mechanisms which allow metaphor to do the kind of work it does. As a result the literature on metaphor is as vast as it is inconclusive. The more precise the descriptions, the smaller the range of metaphors they include. Aristotle's work is an exception because he left behind a number of different explanatory paths, some of which have been followed diligently and others of which have been neglected. Two less well-trodden avenues are suggested by his comments on metaphor in terms of resemblance and riddle, both of which deserve to be revived under an intersemiotic and heterosemiotic umbrella.

Almost all theories of metaphor remain unsatisfactory mainly because they fail to give any indication of how we typically construe meanings if we encounter an unfamiliar and highly original metaphor. Section 3.3 addresses a number of representative theories against the background of an intersemiotic semantics in order to show where they go wrong. It will come as no surprise to the reader, of course, that metaphor is shown to yield best to a heterosemiotic explanation, according to which we resolve the conflictual semantic fields at the non-verbal level. Only after we have achieved such a quasi-corporeal grasp are we able to furnish an explanatory linguistic text.

Perhaps the strictest application of analytical rules to metaphor is found in the thesis that the meaning of metaphor is what the metaphor says at the most literal level. This thesis is associated with Donald Davidson but was formulated earlier by George Yoos.[2] If we accept the definition of meaning as it is used in the Fregean tradition, Davidson is irrefutably right.[3] Yet the strength of the argument causes the downfall of both its result and its definitional tools. Metaphorical meaning, as it is understood by the speakers of typical semiotic communities, does not corroborate Davidson's view. Why do the users of language disagree with his solution and what are the consequences of the disagreement? The vast majority of speakers of any natural language regard the import of a metaphor as the legitimate semantic level because normally it is only at that level that metaphors can form a meaningful component of communication. The dissension has resulted in competing definitions of meaning. Since Davidson is no doubt correct from a strictly

analytical point of view, and since his description of meaning is useless for ordinary users of language, users must reject the usefulness of analytic semantics as far as metaphors are concerned. If meaning is defined in a way to make it inapplicable to social use, then the definition itself must be flawed. It may allow logical cohesion, but it no longer addresses what it purported to provide, namely a plausible description of language. Having laid bare this deficiency in the tool Davidson could be expected to turn on the tradition that provided the toolkit. Yet if he had done so, an avalanche of other revisions would have resulted, a consequence that he was evidently not prepared to embrace.

To move from Donald Davidson's position to Jacques Derrida's is jumping from a view of metaphor at its most literal level of meaning to one of metaphor as the groundless ground of metaphysical thought. Derrida has argued his case most ingeniously in 'The *Retrait* of Metaphor.'[4]

In Derrida's hands, the critique of metaphor turns into nothing less than a critique of metaphysics by turning Heidegger's metaphysical concept of metaphor into the condition of metaphysics itself. Derrida does this by looking at metaphor from the perspective of its structural process of withdrawal, *retrait*, a word 'endowed with a rather rich polysemy' (18). As Heidegger sees it, metaphor exists only within the domain of metaphysics, and metaphysics is the discourse of the self-concealment of Being. Metaphor (*meta pherein*, to carry away), whose structure of carrying away marks the process of withdrawal in any discourse, 'corresponds to a withdrawal of Being' (21).

If metaphysical discourse produces the concept of metaphor, Derrida argues, then it stands in a 'quasi-metaphoric' relation to Being and thus is itself metaphorical in the sense of 'englobing the narrow-restrained-strict concept of metaphor,' a concept which cannot have more than 'only strictly metaphoric sense' (21–2). Since metaphysics is the withdrawal of the ontological discourse of Being, the withdrawal of metaphysics is, in Derrida's words, 'a withdrawal of the withdrawal of Being.' With the emphasis on 'retrait,' withdrawal, the metaphorical process par excellence, metaphor now appears as the shifting 'ground' of the discourse of Being, the condition of beings. This leads Derrida to the 'abyssal generalization of the metaphoric,' the infinite regress of metaphor. And so, 'Being withdraws into its crypt':

The withdrawal of Being, in its being-withdrawn, gives place to metaphysics as ontotheology producing the concept of metaphor, coming forth and naming itself in a quasi-metaphoric manner. In order to think Being in its withdrawal, it would be necessary to allow a withdrawal of metaphor to come forth or to *vanish away* (se reduire) which however (leaving room for nothing which might be *opposed*, opposable to the metaphoric)

will spread out without limit and will charge any metaphoric trait with supplementary surplus value. (22)

In order to get closer to the question of the relation of Being to metaphor Derrida avoids the move from the 'determinate meaning' of retrait given in the quasi-definition of a dictionary. Instead he prefers the procedure of tracing the syntactic–semantic web associated with retrait and so comes 'to comprehend, understand, read, think, allow the withdrawal in general to manifest itself, only from the withdrawal of Being as a withdrawal of metaphor in all the polysemous *and* disseminal potential of withdrawal.' As a result 'withdrawal' has taken on a role not initially associated with the term. It no longer merely describes metaphorically what occurs when we engage in the metaphysical discourse of Being but provides the ground, though a shifting ground, for both Being and metaphor. So Derrida speaks of the 'withdrawal-of-Being-or-of-metaphor' as refocusing our attention from Being and metaphor to the condition and metaphor of withdrawal, 'the way and the vehicle, or their fraying' (23). Instead of a ladder of meta-rungs, such as metalanguage, metalinguistics, metarhetoric, metaphysics, there is always only yet another metaphor whose withdrawal as metaphor widens its boundaries.

Rather than delimiting the metaphoric process of withdrawal in a formal manner, Derrida offers a tentative answer to Heidegger's riddle of 'what speech is, and what is image, and up to what point language speaks in images, even if it speaks in general in that manner.' Instead of replacing the metametaphoric with an endless string of metaphors, Derrida unravels the polysemy and dissemy of retrait. In this way he approaches his final question: 'Would there not be, in the last instance, behind all this discourse … a metaphor of withdrawal which would authorize speaking about ontological difference and, by way of it, about the withdrawal of metaphor' (27)? His playfully serious etymological wanderings reveal that in the end, what can be said about the trait could be said about language in general: 'the trait is itself remarked while withdrawing; it succeeds in effacing itself in an other, in re-inscribing itself there, *in a parallel way*, hence *heterologically*, and *allegorically*' (31). By pursuing the disseminating polysemy of 'retrait' Derrida shows that there is a point at which metaphor questions the foundation of our descriptions of the ontic via the ontological copula, 'there is.' In withdrawing certitude from the copula, metaphor reveals itself as a condition of ontology.

Having denied himself the privilege traditionally given to propositional phrasing, Derrida opts for a 'non-tautological' alignment of metaphorical relations: 'The trait treats or is treated, traces the trait, therefore retraces and retreats or withdraws the withdrawal, contracts, is contracted and signs with

itself, with the withdrawal of itself, a strange contract, which for once, no longer precedes its own signature, *and therefore carries it off* ' (31). The process of carrying away and being carried away, as exemplified by retrait, points to a feature of language that cannot be identified with objects, or with a being present, or with anything semantic but rather with a structural precondition of signification. In this 'it *incises* ontological difference itself' (33), that is, Heidegger's difference between Being and beings. This is why Derrida regards the retrait as neither proper nor literal, nor even figurative. And it is why metaphor in which the retrait is the essential structural ingredient can be regarded as a quasi-transcendental, as a condition without which signification could not occur, and least of all the discourse of metaphysics.

Both negation and metaphor prove excellent candidates for testing the kind of corporeal semantics advocated in this text, as well as for demonstrating certain deficiencies in orthodox theories. An intersemiotic (and heterosemiotic) frame is preferred in both cases, if for no other reason than its capacity for including all those 'deviant' or unwieldy cases made inaccessible by a semantics based on the equation of natural language sense with its formal relation. In particular the exclusion of the body from Frege's sense has left its traces in the literature. Negation and metaphor can be used to show that this absence can turn into a concealed form of censorship. This is the case when large-scale negations of a cultural kind, such as genocidal negation, are ruled out as topics under the definition of negation or when the discussion of metaphor is confined to the level of syntax while its semantic deep structure remains concealed. This may strike the reader as no more than a reductive procedure. As I shall argue in Chapter 5, especially with reference to Baudrillard, metaphor also entails an insidious politics if its syntax is used to conceal the deep semantics which governs the postmodern.

3.2 NEGATION: FROM FREGE TO FREUD AND BEYOND

Die Blätter fallen, fallen wie von weit
Als welkten in den Himmeln ferne Gärten.
Sie fallen mit verneinender Gebärde.

Rainer Maria Rilke

Like metaphor, negation has both aroused and resisted formal approaches. As Laurence Horn puts it, 'negation is to the linguist and linguistic philosopher as fruit to Tantalus: waving seductively, alluringly palpable, yet just out of reach, within the grasp only to escape once more.'[5] Some philosophers have

tried to get rid of negation altogether; others have attempted to demonstrate its derivative character. Horn cites Parmenides, who cautions the philosopher to 'keep your mind from this path of investigation' for 'never shall this thought prevail, that non-being is.' Plato's answer is to split negation into an opposite or contrary on the one hand and 'something else' or contradictory on the other, so that the *mé-kalon*, the non-beautiful, merely means something other than ugly.[6]

Since then negation has evolved into a well-canvassed topic which, like metaphor, reveals a grey area where logic labours over the formalization of natural languages. This section traces some of the difficulties arising from such attempts and links them to my observations concerning Frege's equivocation about formal and natural sense and its extended use in the analytical tradition. The position from which I propose to discuss this tradition is an intersemiotic and heterosemiotic view of semantics, according to which meanings are events of linkage between different forms of signification, including in particular our non-linguistic 'readings' of our environment, traditionally and summarily referred to as perception. From this corporeal perspective meaning occurs when we activate the directional schemata of linguistic expressions by way of tactile, olfactory, gustatory, haptic, oral, proximic, visual, and other readings under social rules.

Given this approach, negation is not identical with linguistically marked negation. Rather, marked negation in both natural languages and formal systems is broadly conceived as a special case and viewed as something more like a significatory attitude. The main reason for using this inclusive approach is that we are able to read affirmations as negations of other affirmations and, furthermore, that this state of affairs is by no means restricted to the linguistic. Gestures, posture, glances, and other non-verbal 'utterances' can likewise be read in positive or negative ways, depending on the interpretive frame a member of a semiotic community wishes to adopt. In this very broad picture, to speak of negation as if it were an empirically secure item of observation is not acceptable. Negation is always the result of interpretive labour.

Stating this position does not eliminate either formal or linguistically marked negation. Rather, formal and analytical discussions of negation are shown to stumble over the precision which they have themselves brought to the topic. I am suggesting here that the conflation of two kinds of sense initiated by Frege – formal sense and natural language sense – colours standard perspectives in a manner detrimental to our understanding of negation in natural sign systems. Specifically, the seductive assumption that such negating prefixes in natural language as *in-, un-, dis-, non-*, as well as *not*, can generally be treated as logical operators has had a baneful influence on the literature on negation.

In the relevant literature we find the common presumption that only human language users are able to negate. Animal communication, no matter how evolved its structures, is deemed to lack the capacity for negation altogether. Instead whatever can be interpreted as a prohibition of some sort in gestural communication tends to be regarded as equivalent to an affirmative expression in language: 'No animal communication system includes negative utterances, and consequently none possesses a means for assigning truth value, for lying, for irony, or for coping with false or contradictory statements.'[7] In his earlier studies Thomas Sebeok distinguishes firmly between 'the largely digital nature of linguistic representation in human language,' which easily accommodates negation, and 'the purely analog mechanisms of animal communication,' which disallows it.[8]

I wish to raise here the question of whether digital systems such as natural language would be at all meaningful if we were not able to transform them into analogous concretizations. In other words I suggest that the symbolic systems of natural languages are intelligible only if their directional schemata are activated by the iconic relations of non-linguistic signs. I have argued this point elsewhere under the notion of the semiotic corroboration thesis.[9] If we accept this premise, then linguistic negation and any other language operation is dependent on extralinguistic, or perceptually significatory, acts. Negation seen in this manner assumes a broader scope and may very well include animal semiosis.

We also have to pay attention to the affirmative act which forms the basis of any utterance, linguistic or otherwise. A compound linguistic negation is in the first instance the affirmation of an utterer's intention, for example the intention to negate another expression or a certain state of affairs. The primacy of affirmation is further supported by the Jakobsonian notion of 'markedness,' according to which negated expressions are characterized by overt marking in contrast with affirmation, which normally remains unmarked.[10] The same observation can be made not only about mathematics and formal symbolism but also about other non-linguistic signs.

Apart from noting the affirmative base of all utterances, we must ask whether negation is restricted to language, natural and formal, or whether one can demonstrate that it is a much broader field of signification. This is not to doubt that certain intricacies of negation can appear only in linguistic and formal systems. But should negation be regarded primarily as a linguistic and formal phenomenon or are linguistic and formal versions of negation perhaps better placed in a wider heterosemiotic frame? In offering this larger picture I am greatly indebted to Laurence Horn's *A Natural History of Negation*, an erudite yet highly readable tome which brings into focus a vast array of writings on the

subject. In spite of my debt to Horn and my tactic of using his recent work as a stalking horse throughout this chapter my corporal perspective nevertheless demands that I deviate quite radically from what I take to be his central position.

I will try to reassociate certain forms of negation found in the formal realm with the broader semiotic domain of human action. I take the view that strictly formal procedures do not capture the full range of possibilities for negation, that in fact only a generously designed differential and heterosemiotic theory of meaning is able to account for what is going on in negation in a broad sense. Again, this approach should not be read as a rejection of logic but rather as a critique of the tempting assumption that formal and natural sign operations are interchangeable. This raw, critical picture will have to give way a little later to a more qualified position. What I offer here is a scenario of interacting heterosemiotic signs constituting meaning acts as events of which negations are a special kind.[11]

If such a bias is persuasive, a generous approach to negation can contribute to debate about the foundations of the social, such as Jürgen Habermas's transcendental argument about 'communicability' or Humberto Maturana's autopoietic constitution of living systems.[12] My approach thus supports the view that negation in language and in formal logical formations, just like other principles which we can abstract from the linguistic, is a refinement of prelinguistic and non-linguistic signification. The negating gesture is a forerunner of later, more elaborate types of negation.

This position has a number of important consequences, one of which is the rejection of the *symmetricalist* position, which claims logical equality for negation and affirmation. The argument presented here will support, at least at the level of language, the so-called *asymmetricalists*, who insist that every negation presupposes an affirmation, while the converse is not the case. This is where the relationship abruptly ends, however, as asymmetricalists, like their opponents, are formally oriented and would have little time for the intersemiotic case presented here.

Formal Negation

Given Frege's assumption that 'the being of a thought consists of it being true,' it is not surprising that linguistic negation, like any other expression, should be argued in terms of truth values.[13] I leave aside the discussion of what I believe to be an unwarranted restriction of 'thought' to a narrow field of semiotic activity and instead focus on what follows from Frege's starting point. He asks, 'Has the interrogative sentence "Is $(21:20)^{100}$ greater than $10\sqrt{10}^{21}$?" got sense?'

(118). Then he notes that in order even to consider an answer we must have been able to understand 'the sense of the interrogative sentence.' Evidently, Frege concludes, truth or falsity are not required for the grasp of the sense of questions: 'The very nature of a question demands a separation between the act of grasping a sense and of judging' (119). Sense comes first, judgment is a secondary matter. From an intersemiotic corporeal viewpoint the relation is reversed: senses are grasped within the horizon of larger judgments about the world. Alter the overall judgment and you change the specific sense you grasp. Making sense of a linguistic expression within a larger context reflects this relation.

Having taken as the basis of his analysis the separation between the more immediate 'grasping a sense' and a mediated 'judging,' Frege asks whether we could regard the negation of a thought as the 'dissolution of the thought into its component parts' (122). At the same time he reminds us that our act of judging cannot have any effect on the constitution of the negated thought. He also rejects the possibility of affecting a false thought by way of negation, reasoning that falsity does not transform thought into non-thought and that negation can also be part of a true thought. Clinching the argument, Frege then refers to the law of *duplex negatio affirmat*, which demonstrates that 'negation has no separating or dissolving effect' (123).

Having cleared his ground Frege now addresses the content of negation. What are the objects of negation? Surely not merely sentence components? Certainly not the elements of a thought. Are they perhaps objects of the 'outside world'? But how could such objects in any way be affected by acts of negating? Are they subjective mental images? If so we could not interact socially, for then 'each juryman would perform his own act of separation in his own private world, and this would not be a verdict.' And so Frege concludes: 'It thus appears impossible to state what really is dissolved, split up, or separated by the act of negation' (124).

From this argument Frege goes on to claim that there is no ground on which we can distinguish 'negative and affirmative premises when we are expressing the law of inference' (125). The thought of either can be expressed in affirmative or negative terms. For logic, at least, the distinction is deemed irrelevant, and any such differentiation belongs to a domain outside the boundaries of the formal. His sharp separation of the act of judging, as bound to the intentionality of an 'owner,' and negation, as a feature of 'thought' which does not require a subject, allows Frege to stipulate the symmetricalist view of negation, according to which affirmation and negation are symmetrical components of logical procedures outside human consciousness (128). For every affirmative we can construe a negation and vice versa.

As for the act of judgment, Frege wonders whether negative and affirmative answers perhaps require two different kinds of judgment. Perhaps, he suggests, even in a negative answer to a question the act of judgment consists of 'acknowledging the truth of a thought,' in which case the negation of the thought of the question would be the basis of the judgment (129). So truth value remains the criterion of judging a thought, a fact which can be altered neither by negation nor by double negation (135).

Since thought and thus formal sense are the basis of Frege's argument, affirmation and negation are secondary and symmetrical features. From an intersemiotic perspective the situation looks different, and the question of how affirmation and negation are related receives different answers at different levels of generality. If we regard the multisemiotic act of cognition as primary – a kind of perceptual, ontic affirmation – negation is a possible modality, and the relation is asymmetrical. At the level of judgment, the modality of negation, as with any other modality, is a dependent function rather than secured by linguistic or logical markers. Almost any 'utterance,' verbal or non-verbal, can be read as either an affirmation or a negation. In this sense there is no 'negation' but rather acts of judgment which are used to negate or affirm. At this level formal negation of the Fregean kind appears to stand in a symmetrical relation to affirmation but only against the background of general semiosis, which seems to be ruled by asymmetry. An intersemiotic approach suggests that we can have it both ways: an included middle at different levels of generality.

Since Frege the formal study of negation has flourished. Traditionally, negation has been defined in opposition to affirmation. We have already distinguished a base affirmation underlying all utterance in the sense of the affirmative social act, which we perform no matter whether we affirm or negate. By saying or gesturing something we are making a point. In this sense affirmation appears to be logically prior to negation. But is this also the case at the level of the linguistic utterance?

Crucial for my argument is that the distinction between symmetricalism and asymmetricalism is insufficient to explain negation by natural signs. You can be either a symmetricalist or an asymmetricalist and still share Frege's equivocation about formal sense and the sense of natural language expressions. Indeed, this is the rule rather than the exception in the literature. But if you hold, as I do, that formal sense and linguistic sense must not be confused, then you are bound to join the asymmetricalists even though your asymmetricalism will turn out to be of a special kind. For the 'match' in question is a different one. Formal negation, like any other formally stipulated operation, is governed by definitional rules, and as a result causes neither loss nor surplus of meaning. By contrast, linguistic negation, like any other operation in natural languages,

requires the interpretive labour of activating linguistic schemata by means of non-linguistic signs. Such marked negations as 'not fortunate enough' and 'unfortunate enough' therefore do not produce identical meanings, as we will see below. Marked negation is also no guarantee for the construal of negated meanings. At the broader level of meaning construction any linguistic feature can be read as a negation, depending on the context. Furthermore, at a deep corporeal level of perceptual cognition negation appears to require the primary condition of affirmative construal, an asymmetrical relation.

A selective list of forms of negation will help us to get inside the problematic before us. Logic distinguishes two kinds of negation: *contradictory negation* and *contrary negation*. The merely contradictory says no more than that something (p) cannot be something else at the same time (non-p). The contradictory of a proposition is the negation of that proposition and nothing more. In contrary negation two expressions are strictly opposed to one another in a one-to-one relationship, the terms furthest apart in the same class. Contrariety is to negate and say something beyond the negation: if p is true, q is false; however, if p is false, q may be true or false. While contradiction isolates one item against all else, the contrary requires a shrinking of our focus to two items, a binary pair selected from our total vision of things and relations. The difference is also reflected in intuitionist logic, which distinguishes the two in terms of strong or 'must not' negation and weak or 'may not' negation.[14]

If we accept the idea that both the contrary and the contradictory are universal possibilities of negation, then we are saying that the phenomenal world should yield unproblematically to the perspective of binary contraries. The contradictory certainly can be found everywhere. But what are the contraries of green, melancholy, a chair, parliament, eucalyptus, or a BMW? Which terms in the same class in each case are the furthest from the examples given here? Is black, for example, further from green than is red? In order to locate certain natural language expressions as contraries we have to invent specific frames. That is, we can find contraries if we are so inclined, an inclination which has to do with the constraints imposed by interpretive communities. For some a Hyundai is the contrary of a Ford. Hondas don't enter the picture. The complex and heterogeneous framing required for this situation cannot be accurately represented. In formal procedures, on the other hand, contrary pairs are a relatively simple matter of definitional stipulation. If, however, we apply the formal mould to social semiosis, we are dealing with an artificial freeze frame which alters the dynamics of actual signification.

Such freeze frames organize the world in terms of homosemiotic binaries, as in a digitized world expressed in bytes made up of 0 and 1. That we can retranslate this frozen word into intersemiotic complexities has to do with the

possibility of tagging as many separate items as we wish, but the differentiation we put in place via Boolean logic has to be achieved beforehand by other means. Digitization is no more than a translation of non-formal differentiation into binary equivalents. The textual nature of our reading and mapping of the world remains. Certainly we can achieve a very large number of differentiations with the help of 0 and 1. These differentiations are already in place in our social semiosis, in language, visual field, and olfactory mapping, for example. Binaries are able to list differentiations for semiotic management. The problem of contrariety remains the same. In an eight-bit byte system, an item identified as '0010 1101' is not the contrary negation of '0110 1101' but only one of many, namely the rest of the semiotic system. In order to make them contraries, we have to return to our framing requirement.

The claim that negation – in either its contradictory or its contrary varieties – is restricted to the formal and the linguistic does not seem tenable. One could say that the basis for the possibility of any linguistic formation lies in a broader social semiotics, so that verbal negation is merely an economical refinement of more rudimentary non-linguistic signs of negation. Here we could remember Wittgenstein's understanding of language as 'refinement.'[15] Imagine a series of social acts suddenly interrupted by some kind of prohibition. Imagine being instructed by a gesture to follow another person for a while on a path, only to be barred from further progress by an abrupt gesture of interdiction. You may only retreat, and not advance any further. In this case a series of communicative acts was read as an affirmation of actions, of which the final barring gesture must be regarded as a negation. Since in this case there are no alternatives, since a narrow interpretive frame has been established, only the specifically opposite or contrary is permitted.

Importantly, this is only one pathway by which non-linguistic signs can be seen to evolve into the more specialized linguistic signs. Other pathways result in natural language expressions which do not easily yield to the perspective of binary contraries. If we wish to express the distinction between contrariety and contradiction, we could say that in formal systems the first has two pathways, the second has many. In natural languages and non-verbal systems contradiction behaves in much the same way as in their formal counterpart. Contrary meanings, on the other hand, are insufficiently described by the rule of multiple pathways. In social semiosis the number of pathways and the degree of interpretive constraint are functions of interpretive communities.

A different form of negation is its implied variety, or *incompatibility*. A proposition is said to be incompatible iff the proposition is self-contradictory. Contradiction and contrariety are cases of incompatibility. If something is said to be red, it cannot be said to be blue at the same time without violation of

compatibility. Under altered circumstances it may well be the case that the object in question is blue but not at the same time as red; we are dealing here with a form of *implied negation*. This kind of negation can be used to describe all semiotic processes. Every sign could be regarded as implicitly negating all other incompatible signs at a given time.

More generally, we can speak of negated classes in terms of *otherness*: everything that is not heavy is other than anything that is heavy, a kind of negative form of identity. In this sense all sign systems have negation. Perception or, in our terms, non-linguistic readings, entails this kind of negation. Without it, the most basic differentiation of visual, aural, tactile, olfactory, and other signs is logically unthinkable. The class of signs that is other than all its members is the excluded remainder of classes of signs. Such is the picture that emerges from the perspective of formal systems. From an intersemiotic viewpoint the possibilities of incompatibility and otherness themselves cannot be said, however, to act as the basis for negation. Negation belongs to the level of pre-linguistic judgment which governs all signifying processes. If there were no community constraints, it would seem that we could read what we wanted, except that we would not know what we wanted if we were not constrained in this manner. Hence negation, like any other signifying process, is directed at the level of social semiosis rather than directed from inside linguistic expressions.

It is tempting to think that the traditional distinction between internal and external negation – 'It is the case that not-p; it is not the case that p' – is a natural division discovered in all forms of negation. Furthermore, logicians have shown that there is a symmetrical relation between internal and external negation such that the internal negation 'It will be the case that (it is not the case that) p' finds its external counterpart in 'It is not the case that (it will be the case that) p.' This replacement procedure has been refined by following Augustus de Morgan's laws with regard to the logic of 'and' and 'or' statements, according to which internal and external negation can be distinguished thus: 'Not (p and q)' and 'Either not-p or not-q' are true if p and q are not true together; 'Not-p and not-q,' 'Neither p nor q,' and 'Not (p or q)' are true only if p and q are both false. Or, by using so-called open sentences, we can formulate internal negation as 'For every x, if x is an n, then not (x is an m),' its external equivalent being 'not (for every x, if x is an n, then x is an m).'

In fact while internal and external negation appear to be pervasive, their specific symmetrical form is not so much natural as it is a consequence of logical construction. In ordinary language this symmetry does not hold as a general rule. Why not? Not because natural language needs to get its act

together but rather because it still reflects at every stage of its evolution, more than does logic, its emergence from the complexities of the corporeal, non-verbal social. And as argued earlier this complexity is made up of only partially commensurable forms of signification, pressed into unitary service by the linguistic. Formal languages, by contrast, do not have to struggle with such a phylogenesis. They are laboratory designed and hence termed 'pure.' Yet they, too, show iconic traces left in them by their engineers, social beings, whose natural languages are directional schemata which make sense only if their non-linguistic background is restored in discursive practice. Both linguistic and formal negation thus permit the tracing of their intersemiotic preconditions. Internal negation can be regarded as a negative qualification of a component of a sequence of social acts, while external negation may suggest a denial of a social act in its entirety.

Significantly, and contrary to the Fregean heritage, logically symmetrical formulations prove correct in formal operations only. No universal claim can be made about their applicability to ordinary language. Consider the following example:

A: Some husbands are pigs.

B: *Some* husbands aren't pigs. *All* husbands are pigs.

As Laurence Horn points out, if we apply the Fregean rule that 'all forms of negation are reducible to a suitably placed "It is not the case that,"' we fail to align the negation with the affirmation in such cases.[16] Yet language users have no problem construing meaning under these circumstances. The usual explanation is that we are dealing with contextual or metalinguistic uses of language which require special consideration. I take the opposite view. *All* natural language is always already metalingual in two senses: in natural language the operators themselves are open to modification, a situation ruled out in logic; and natural language is not meaningful without non-linguistic signification. The non-linguistic permits the construal of a social world on which linguistic expressions depend to make sense. Utterances A and B above thus require the construal of two separate social worlds, not merely an affirmation in response to a contradictory or contrary state of affairs. When we say that utterance B is a funny way of phrasing we do not mean that the linguistic expressions produce mirth but rather that we recognize the unexpected world that we are forced to construe as filled with swinish husbands as a comical extension of the world we know. What is funny is not a formal or verbal alternative but a corporeal one.

Symmetricalists and Asymmetricalists

Frege, Peter T. Geach, Alfred Jules Ayer, Quine, Wittgenstein, and others have argued that there is no separate form of judgment for negations and that every affirmative proposition presupposes the existence of a corresponding negative.[17] 'For every thought there is a contradictory thought,' says Frege.[18] Geach, following Frege, suggests that 'the understanding of "not-male" is no more complex than that of "male": they go inseparably together ... [A] predicate cannot really be any more definite than its negation is; the one is exactly as sharply defined as the other.'[19] Geach further insists that the asymmetricalists have it wrong when they claim that negations are parasitic on affirmations. 'We must a fortiori reject the view that a negative predication needs to be backed by an affirmative one – that we are not justified in predicating the negation of *P* unless we can predicate some *Q* which is positive and incompatible with *P*.'[20]

By contrast, for asymmetricalists such as Roger Bacon, Kant, Charles W. Morris, Bertrand Russell, Henri Bergson, Strawson, or Searle, 'every negative statement presupposes a corresponding affirmative ... but not vice versa. Negation is consequently a second order affirmation: negative statements are about positive statements, while affirmations are directly about the world.'[21] Or, as Maire Jaanus Kurrik writes in a comment on Noam Chomsky, 'negation is addition because it has to include the positive statement it seeks to deny as assertion. Negation superimposes itself on an assertion.' In this sense 'negation is always tantalizing, provocative, and ambiguous, a positive descriptive force which implies and promotes the very idea or thing that it seeks to deny.' For Kurrik negation is 'an absence yoked to a presence, or a presence-evoking absence.'[22]

If we join the asymmetricalists and regard negation as a second-order affirmation, I believe that we must follow the path towards an intersemiotic semantics. But if we do this the Fregean conflation of formal and natural sense has to be abandoned. One cannot simultaneously be an asymmetricalist on negation and hold to a strict notion of natural language meanings in terms of Frege's sense. Once affirmation *is taken* as the base – and not only are affirmations 'directly about the world' but the world is available to us only in terms of different kinds of signification – then every non-formal sense carries with it the intersemiotic and heterosemiotic references which in sum constitute our world within inferable constraints. Such intersemiotic references as visual, tactile, olfactory, haptic, and other non-verbal signs, though formalizable, are required as a base condition of human cognition. Their formalizations, as in digitization for example, have to be retranslated into heterosemiotic phenomena

and intersemiotically synthesized. From a very different perspective, intuition-ist logic, this kind of differentiation is supported by the distinction between primary or de jure (e.g., mathematics) and secondary or de facto negation (e.g., ordinary language).[23]

Certainly, the radical symmetricalist position that there is one negative sen-tence corresponding to every positive sentence and vice versa is demonstrably untenable. The asymmetricalist answer is that natural languages do not as a general rule allow this, as in the example quoted by Horn: 'I would (n't) rather be in Montpelier.' Horn has called this the 'paradox of negative judgment' (49). On a number of other occasions Horn speaks in the same fashion of the asym-metry between negation and affirmation.[24] One could object that depending on the context, 'I wouldn't rather be in Montpelier' does make sense, though this example does not eliminate Horn's paradox.

In summary we could say that symmetricalist arguments result from giving free rein to an artificial sign system: formal logic. Social reality provides a quite different picture, and in order to align the two pictures the symmetricalists, in accordance with Carnap's *Logical Structure of the World*, commit a constructivist fallacy: if it is logically construable, then this is how the world is.[25]

My account must part company with the critique offered by Horn on two counts: he retains the Fregean conflation of formal and non-formal sense; and he builds his view of semantics on a realist metaphysic. Horn's position has two sides, one pertaining to a misunderstanding about fictions, the other presupposing the givenness of the 'world.' He asks, 'What *on earth* can a negative statement or judgment be about?' as if all our linguistic expressions were bound to be about anything in the external world.[26] This is problematic quite apart from the circularity introduced by the term 'world' because it entails the premise that the world as realized is not a significatory construal but an unmediated given. Novels are full of negative judgments without readers being worried about the realist link. Physics is full of them without physicists being too much worried about real negative states. From a perspective in which reference is freed from the immediacy of the empirical world and becomes a linking procedure of different sign systems that make up our 'world' (within inferable constraints), this problem does not arise. It seems that Horn is trapped by a semantics based on a realism which we must reject.

Another way of arguing against symmetricalists and for the claim that posi-tive signs are logically prior to their negation is to point to the affirmative pre-suppositions underlying negations. *Presuppositional affirmation* can be construed for every negation, and we have already shown that the opposite is not the case. This is in addition to three facts. First, expressing a negation is always an affirmative act, and in this sense is part of all sign systems. Second, every

negation entails the 'is' of existence. Third, every negation is implicitly tied to a discursive domain which acts as a presuppositional background, just as generally no sign can be imagined without such embedding.

An unexpected argument in favour of asymmetricalism comes from an entirely different direction, in the claim that negation is logically prior to affirmation: 'The priority of the primitive "no" propositions to the "every" propositions accounts for the fact that the latter are undefined when both subcontrary propositions are false.' Fred Sommers cites category mistakes and vacuous subjects as fitting the bill.[27]

From within strictly logical parameters the symmetricalist position does not appear any weaker than its asymmetrical counterpart.[28] From the perspective of a broad intersemiotic approach able to address non-verbal as well as verbal signs, however, symmetricalism is demonstrably inferior. Consider, for instance, the notion of *falsehood*, the negation of which is true. To decide whether a falsehood has been uttered we need non-linguistic signs both for the construal of the referential and deictic background of the components of the sentence and for the specific (Fregean) reference of the expression. Intersemiotically speaking, a falsehood violates the heterosemiotic constellations agreed upon as applicable in certain situations and so contradicts the significatory habits of the community, while the negated falsehood sets the record straight, as it were.

How do we distinguish falsehood from non-sense in a formal, that is, a homosemiotic, semantics such as that expounded by Carnap, consisting of the definitionally ruled and systematically aligned relation between languages L1 and L2? In *Meaning and Necessity* Carnap tells us what a complete set of semantical rules for an extensional system S1 and its intensional counterpart S2 would look like.[29] Since all permissible combinations of terms are defined we have grammatically acceptable and unacceptable expressions as well as true and false statements. Accordingly, an expression which though grammatically correct violates logical truth is a falsehood, while non-sense is characterized by ungrammaticality. In the first case falsehood in L1 and L2, though grammatical, can be aligned within the rules only in its negated form. In the case of non-sense we do not know what is to be aligned, and its negation produces further non-sense. What, then, is the difference between the ways formal and non-formal sign systems permit the distinction of falsehood from non-sense?

'The mouse is blue' would be called a falsehood if the visual signs with which the speech community activates the term 'blue' were agreed to be termed 'white.' On the other hand, statements such as 'trep srot blig' or 'green howevers you' or 'horses digitize astringently' are regarded as non-sense. The first violates agreed-upon systems of signifiers, the second contains

an ungrammatically arranged term, and the third suffers from sortal incorrect-
ness. Intersemiotically speaking, the first expression is unrecognizable because
it does not qualify as a directional schema; the second does not allow the con-
strual of heterosemiotic relations because we do not know which kind of signs
to construe; and the third guides us to imagine a constellation of heterosemi-
otic signs which produce a non-standard 'world.' The two approaches to the
distinction between falsehood and non-sense, then, can be traced to the crucial
opposition between formal sense and non-formal sense. In the formal approach
falsehood violates logical truth, while non-sense is ungrammatical. From the
perspective of a corporeal semantics a more elaborate picture emerges, one
more appropriate to the description of the social.

The discussion of so-called *negative facts* is related in a similar manner to
the symmetricalist position.[30] If we could argue successfully for negative facts,
then the non-linguistic preconditions for both affirmation and negation could
be shown to be already divided into positive and negative states of affairs,
a situation favouring the symmetricalist game plan. Since Parmenides this
argument has been under attack, for 'there are no negative states of affairs
or properties.'[31] According to Bertrand Russell in the redundancy argument
we can describe the world 'without using the word "not."'[32] In addition there
exists a paradox in the stipulation of negative facts. Whenever we talk about the
fact of non-existence we invoke the thing itself which does not exist; existence
is thus a condition of non-existence.[33]

A useful summary of the main arguments against negative facts is given by
Richard Gale. It runs as follows: (1) negative events can be reduced to positive
facts by transforming a negative proposition into its positive alternative; (2) the
world can be described without resorting to negative facts; (3) negative facts
operate at a metaplane compared to positive facts, the former being about
negative abstractions from possible facts and the latter about events; and (4) so-
called negative facts are merely subjective by virtue of their dependence on the
mind. Unfortunately, given his analytical stance, Gale is able to demonstrate
only that positions (1) and (4) are untenable, leaving negative facts defensible
via (2) and (3).[34]

An altogether different route to the problem of negative facts is to say that if
we remain within the domain of the formal, any signifier can be stipulated as a
fact within the system. Yet as soon as we avoid this narrow perspective, facts are
no longer homosemiotic but heterosemiotic; they are compound significatory
events by means of which we locate ourselves in the 'world' with the help of
tactile, visual, olfactory, and other corporeal readings. In this case negative
facts, if there are any, cannot be removed by logical procedure. We need a
different kind of test.

If negative facts existed they would have to give rise to states of affairs in competition with the ones we habitually and heterosemiotically construe as our 'world.' If this were so, there would have to be, ex hypothesis, alternative versions of those constructions, which we would have to realize as positive constraints. It seems more plausible that such contradictory states of affairs are necessary fictions rather than facts. We can therefore resolve the issue by saying that there are no negative facts but certainly negative fictions which function as necessary, imaginative variations of our 'world.' This is precisely the answer we have to give to Wittgenstein's argument in the *Tractatus Logico-Philosophicus* concerning black spots on white paper. Rather than saying 'To the fact that a point is black there corresponds a positive fact, and to the fact that a point is white (not black), a negative fact,' we should say, 'Only because it is possible to imagine white and other alternative states of affairs are we able to decide on the fact of a black spot.' The alternatives, imagined white spots rather than an affirmable white background, are not negative facts but fictional variations of our habitual world, as the later Wittgenstein would probably concede.[35]

Negation plays a central role in such formal rules as: the *law of contradiction* ('Not both p and not-p' or 'If p, then not not-p'); the *law of excluded middle* ('Either p or not-p' or 'If not not-p, then p'); and the *law of double negation* ('P if and only if not not-p' or 'P iff not not-p'), which combines the two previous laws into one. On close inspection none of these demonstrates consistency when applied to the complexities of natural signs, whose meanings are a function as much of hermeneutic reconstruction as of negotiatory community agreements. Depending on the wealth of cultural material activated in such reconstructive processes and on the degree of flexibility of community consensus, paradoxes, non-excluded middles, and their combinations abound in the semantics of everyday life.

The caution against accepting those logical principles as universally valid is not new. In a general manner Kant points to the heuristic nature of all conceptuality in the *Critique of Pure Reason* when he speaks of the shaky boundaries of our concepts.[36] Hegel's dialectic specifically reincorporates the excluded middle as part of *Aufhebung*. More recently, intuitionist logicians such as L.E.J. Brouwer and Arend Heyting have questioned the law of the excluded middle and its derivatives, while current semiotic and poststructuralist theorizing has found various other objections to those traditional formulations.[37]

Likewise, standard accounts find it difficult to accept the legitimacy of what is known as *Buddhist four-cornered logic*. A later Buddhist, Sanyana, formulated the four-cornered logic in this way:

S is P
S is not-P
S is both P and not-P
S is neither P nor not-P

The logician feels compelled to put this to a sarcastic test. 'Is it good?' 'Is it not-good?' 'Is it both good and not-good?' 'Is it neither good nor not-good?' But perhaps the whole point of the four-cornered logic is to undermine the conceptual confines of our reasoning widget. As a result 'good' appears as a less stable entity than a formal approach demands. This reading seems to make sense when we face the following substitution:

Nirvana is Being
Nirvana is non-Being
Nirvana is both Being and non-Being
Nirvana is neither Being nor non-Being

Certainly, Horn's quip that this reads like a 'metaphysical multi-choice question on the qualifying exam for sagehood' is unnecessarily caustic.[38] From a broad intersemiotic perspective the four-cornered constellation could be read in the following manner: (1) Nirvana as indicating the horizon of the world, Nirvana as Being; (2) the denial that Nirvana is identical with the world; (3) Nirvana as both appearing as the world and at the same time not being identical with it (1, 2); and (4) Nirvana as something also outside our possibilities of signification but necessary as a ground, a transcendental condition (1, 2, 3). The pivot of these alternative readings is the copula 'is.' While any hard-headed logical critique assumes that the copula secures identity in all four formulations, this assumption may not be warranted. Once we loosen our formal grip on the meaning of 'is' the movement of predication towards increasing or decreasing inclusion becomes accessible. Such a reading also suggests a link between the four-cornered logic and the hierarchy of different states of consciousness in Buddhist thought, in which every advanced stage both negates and subsumes its precursor.

A number of commentaries on Buddhist logic emphasize another difference between formal logic and its non-Western counterpart. They suggest that 'negative judgment is nothing but non-perception' and as such remains 'within the borders of sensuous experience.'[39] This is supported by the view that we are dealing with 'inferential judgments' following the rule 'non-presence of X because there is presence of Y,'[40] as well as by the observation that 'not-red'

is just as much a property as 'red,' once more establishing the link between negation and perception.[41] Accordingly, Bimal Krishna Matilal notes, negation in Buddhist logic is not so much part of judging as of the content of judgment, a position reminiscent of Frege's 'chimerical construction.'[42]

Fuzzy Logic

Consider the traditional liar paradox from the perspective of fuzzy logic. 'If $p = 0$, then P tells us that $p = 1 - 0 = 1$. And if $p = 1$, then P tells us that $p = 1 - 1 = 0$.'[43] The consistent solution for the paradox in fuzzy logic is as follows: '$p = 1 - p$'; consistent solution, '$p = 0.5$'; '$p = q = 0.5$.'

In this formulation one has to account for the 'constant revision of your assessment of its truth value': $p \leftarrow 1 - p$. The sequence which reflects the subsequent oscillation between truth values is $0, 1, 0, 1, 0, 1 \ldots$ In this way 'you get an infinite sequence of truth values' which oscillates between two truth values. If P is 40 percent, the truth values oscillate between 0.4 and 0.6 for p, with 0.5 being the value which avoids oscillation.

The liar paradox can also be phrased as a 'logical dynamic' in this way: $p \leftarrow q$; $q \leftarrow 1 - p$; if $p = 0.3$, then $q = 0.8$; revision 1, $p = 0.8$, then $q = 0.7$; revision 2, $p = 0.7$, then $q = 0.2$; revision 3, $p = 0.2$, then $q = 0.3$; and revision 4, $p = 0.3$, then $q = 0.8$, to complete the cycle.

Another way of phrasing the dualist paradox is in terms of chaos logic: 'X: X is as true as Y is true; Y: Y is as true as X is false' (87) or

$$x \leftarrow 1 - / x - y /$$
$$y \leftarrow 1 - / y - (1 - x) /.$$

An alternative fuzzy logic formulation of the chaotic version of the liar paradox is, 'The assessed falsehood of this statement is not very different from its assessed truth,' whereby 'very' is represented by the square of a truth value (87).

An intersemiotic critique of the more garish claims of fuzzy logic could run like this. It is the case that fuzzy logic handles better than double-valued logic those aspects of states of affairs which are characterized by steps or gradation. And quite obviously the technical applicability of fuzzy logic is beyond doubt. The claim that fuzzy logic therefore solves the problem of describing how things actually occur is flawed, however, if by nothing else than the observation that it still requires fixed goal posts. The 0 and 1 of fuzzy logic between which its descriptions operate do not accurately reflect the shifty nature of the frames of any dynamic system and especially not those of social life. Only once the

limit frame of 0 and 1 becomes fuzzy itself will we have eliminated this obstacle. Until then the more modest claim of having introduced a dynamic and highly sensitive measurement operating between two fixed polarities will do.

Negation in Natural Languages: Neg-Raising

A fascinating case which highlights the difference interred by Frege between formal sense and natural language sense is the *neg-raising phenomenon*. Horn defines it as 'the availability of a lower-clause reading ... for a higher-clause negation'[44] and goes on to explain neg-raising as a 'lexically governed, cyclic, structure-preserving rule which extracts a negative element from a lower clause ... and raises it one clause up ... over a predicate marked to allow the rule's application' (312). The locus classicus is the substitution of *non debere peccare* (it is not a duty to sin) for *debere non peccare* (it is a duty not to sin). In this case what is possible in formal logic – the transformation of external negation to its internal equivalent – cannot be achieved without change of meaning.

The form of negation with which we are dealing here has received various descriptions. It is referred to as 'attracted, anticipated or adherescent negation' in traditional accounts of grammar (310). Otto Jespersen observed its tendency 'to attract to the main verb a negative which should logically belong to the dependent nexus.'[45] Charles Fillmore refers to the neg-raising phenomenon as a 'transposition of NOT,' while George Lakoff describes it in terms of '*not*-hopping' and 'negative transportation.'[46] Horn in his summary is right to emphasize the neg-raising phenomenon as a 'fundamental grammatical, semantic, and pragmatic process manifested across distinct, but systematically related, classes of predicates in genetically and typologically diverse families of languages' (309). Considering the ubiquity of the phenomenon, one must ask what reasons there are for the difficulties the neg-raising phenomenon causes for the formalization of negation in natural languages. In particular the formal exchange between external and internal negation appears to be thwarted by similar constructions in natural language expressions.

Commenting on the phrases *je n'espère pas* (I do not hope) and *j'espère que non* (I hope not or I hope that not), Horn concludes that we are dealing with the collapse of 'contrary and contradictory readings of negation' (310). In expressions such as 'I don't *think* he has come,' compared to 'I think he has not come,' the exchange does not seem to amount to much, while certain verbs such as *regret* or *claim* do not permit neg-raising. According to Fillmore, the expression 'I don't believe that he wants me to think that he did it' can be schematized as '[I believe [he wants [I think [not he did it]]]]' (313). On the

other hand, constructions like 'I don't regret (claim) that he has come here in weeks,' compared to 'I regret (claim) that he has not come here in weeks,' prohibit this procedure. What is happening here?

Contrary and Contradictory Negation

Following de Morgan's observations on negation we can say that the two kinds of negation, contrary and contradictory expressions, are often embedded in the same phrasing in natural languages. The two meanings can be rephrased simply as denial and the assertion of the direct opposite. Formal and natural languages part company here. Horn cites cases in which an alignment along the formal principles of negation is not permitted. In the clauses 'She isn't happy' and 'She is unhappy' we have two radically different meanings as a result of two different negative operators, 'not' and 'un-.' The polysemy of the first case arises from the external positioning of the operator (x is not [y]), while the direct contrary of happy in the second example could be said to be a function of its embedded negation (x is [not-y]). In the formal phrasing the result is a contradictory negation in both cases. Not so in our examples. How is it then that natural language negation often bars the equation of the two formulations, whereas its formal cousin not only permits but necessitates it? Why can there be equations in the formal case but not in the natural?

I suggest that the solution lies in the confusion of two kinds of sense, the sense of 'not-y' and the sense of 'unhappy.' The formal 'not-y,' which should be able to stand in for 'not happy' and 'unhappy,' fails to do so. The transfer of formal sense to its natural cousin proves to be a mistake. Just as the senses of the geometrical entities introduced early in Frege's 'On Sense and Reference' are different in nature from the senses of the *Morgenstern* and the *Abendstern*, so too are the senses of 'not-y' and 'unhappy.' The former can be understood as a stipulated definition; the latter requires a quasi-referential embedding quite separate from any particular reference. As a reminder, the referent Venus is to be distinguished from the referential background of mornings and planets without which *Morgenstern* and *Abendstern* make no sense to begin with. Nevertheless, the literature on Frege's seminal paper has focused largely on the sense–reference distinction, while the two kinds of sense Frege employs have received little attention.

This also challenges the standard conception that concepts secure reference by satisfying the core of the concept's intensional set, since that set tends to be understood as definitionally given within a single sign system, e.g., in language. This homosemiotic relation between a concept and an intensional set (more concepts) reduces natural language semantics to a double calculus

with transformation rules in the Carnapian mode. Missing is the exit from the calculus non-world into the domains of other significatory systems which supply the necessary backdrop for language.

If I take issue with the standard manner of securing reference, then it will not come as a surprise that Saul Kripke's account strikes me as an even more radical violation of what actually occurs. Reference for Kripke can be secured in defiance of all intensional sets associated with a concept.[47] In this I think he makes two errors. One is his inability to demonstrate the constraints which must affect a conceptual chain after baptism if the causal chain is not to go off the rails at any point. The second is his invocation of 'world' as an unmediated given into which we miraculously fit ourselves during the act of baptizing. This is not only pre-Kantian but also ignores everything semiotics has discovered since Peirce. In particular it violates the demand of the *tertium comparationis*, that before we can compare things, we need to express them in a manner which applies to both parts of the comparison. It seems preferable to view both 'world' and language from the perspective of sign systems.

Both the 'standard' account and Kripke's vitiate the description of negation because they contain unsatisfactory arguments about semantics. Yet it is the kinds of semantics that logicians adopt that causes them the difficulties they face in attempting to discover rules for negation in ordinary language. Confusing in all this is that the discrepancy between formal and non-formal phrasing does not occur as a general rule. Frequently, the mapping of natural language semantics by formal procedure goes ahead without a hitch. In these cases all we can say is that there is no logical contradiction. We should not conclude from such smooth translations that formalism has captured what goes on in natural signification. Hence the rule that formalism in semiotics must arise *after* the collection of a natural corpus.

Having said this I must reiterate that this does not preclude formal mapping for the more recalcitrant features of natural languages. Formalization is always possible, but it may not be economical. Once our formal apparatus merely accompanies the object language, step by step, as a logical paraphrase, it has lost its effectiveness as subsumption. The exception of course is digital computation, in which loss of spatial economy is more than made up for by the speed of the bit stream.

Semantics as Pragmatics

For a number of bothersome examples with 'pragmatic implication,' Horn invokes additional verbal clarification. There is no disputing that the exchange 'Is x a good chess-player?' 'No' is polysemous, encompassing such possible

elaborations as 'He is bad,' 'He is middling,' 'He is getting better,' or 'He is close to your own standard,' with a spectrum of possibilities from flattery to insult. An alternative phrasing to the polysemous 'No' is, for example, 'It's not that he's not good ...' Nevertheless, verbal clarification is not required. Intonation, for example, provides a fine mesh of semantic distinctions within negotiatory constraints. An up-down contour in this case tends to indicate 'bad,' whereas an up-down-up intonation suggests a graded or scalar predication, a range of positive answers.

Contrary to standard analytic practice, I suggest that a semantics without pragmatics is no more than a logician's dream. It is impossible even to imagine the non-use of a sentence if we wish to speak of its having meaning. When Horn contrasts two kinds of propositional negation, one of which produces a contradictory and the other a contrary meaning, we therefore need to say that it is not the pragmatic implications allowed for by the propositions that make the difference but the pragmatics of use which establishes meaning in the first place. Hence 'I don't like modern music' can be read as contradictory negation, as Horn does, to permit 'but I tolerate it,' or as contrary negation if we stress the 'don't' rather than the 'like.' In agreement with Horn, however, I find that 'I dislike modern music' tends to produce a contrary meaning such as 'I can't stand it' under any pragmatic constraint.

At a glance it may not strike the reader as persuasive if I say that the separation of semantics and pragmatics is one of the logical, if not historical, consequences of Frege's conflation of formal and natural sense. Yet indeed it is, since, in the formal domain, sense is produced in a manner which remains unaffected by such pragmatic moves as intonation, facial expression, body stance, or any other modal forces we may bring to bear on a formal proposition. Thus the pragmatics of symbolic logic looks like a non-pragmatic domain. Now this seemingly non-pragmatic domain is transferred to the realm of natural language semantics, a move which produces the possibility of modally neutral meanings. Yet the fateful mistake is the conflation of the formal with the non-formal, which still characterizes the orthodoxy in analytical accounts of meaning.

An important case is *scalar predication*, especially in its weak form. In an example such as 'I'm a bit tired' and 'I'm not a bit tired' Horn suggests that 'in a context licensing the pragmatic assumption $p \vee q$, to assert *not-p* is to implicate q. Thus a formally contradictory negation "*not-p*" will tacitly convey a contrary assertion – but only when p is a relatively weak positive scalar predicate, representing an unmarked term in its contrast set.'[48] Clearly, natural language here deviates from formal expectations. Horn handles this by way of metalinguistic explanation: 'Negation is effectively ambiguous ... but ... it is

not semantically ambiguous. Rather, we are dealing with pragmatic ambiguity, a built-in duality of use' (370). Contrary to Horn I suggest that the idea of semantic meaning as outside use is useless. Ironically, to say that there is a pragmatic but not a semantic ambiguity demonstrates the dubiousness of the performance of modal neutralization which produces semantic meaning, a meaning that cannot cope with meaning as use.

Another feature of natural languages is that they sometimes disallow the equation of different forms of negation. 'Not' and 'un-' sometimes produce radically divergent meanings. 'She was not fortunate enough to lose her husband' is not an acceptable paraphrase of 'She was unfortunate enough to lose her husband.' A unitary formal procedure clearly fails to account for the difference. A broad intersemiotic approach, however, which locates meaning at the virtual interface of language and corporeality, is well equipped to respond to semantic nuances produced by divergent states of affairs.

When we wish to point to the one state of affairs we use x (unfortunate enough); when we wish to point to the other, y (not fortunate enough). In this particular case the second phrasing results in an ironic reading. While 'unfortunate enough' appears to act as a schema grading 'lack of fortune,' 'not fortunate enough' appears to scale 'good fortune.' This is why the latter expression generates irony if linked with a phrase normally associated with bad luck.

The mistake is to assume that language has an underlying formal matrix or subsumptive, logical grid which, once discovered, would furbish a general explanation. Why do we tend to think that way? Probably because there happens to be a regularity, which we then assume to represent a rule, in the deep structure of language. Negation shows that this is not the case. The intersemiotic view is a preferable alternative. Language still carries the traces of the non-linguistic communication from which it emerged, and this 'background' has not disappeared: it functions as necessary cultural, mental imaginative material when the schematic structures of linguistic expressions are activated. This position could be described as a post-Peircean reformulation of Kant's schematism, applied to language.

In order to handle problem cases in natural languages and still retain the notion of meaning and semantics, Horn, as well as a large body of literature, indeed entire disciplines, continues to search for logically clean explanations that meet the linguistic requirements. His solution is to follow the distinction between semantics and pragmatics, so he can say that *semantically* a negation is not ambiguous, only pragmatically. The point is that the expression is ambiguous; it allows for at least two readings. Let us look for an appropriate explanation capable of handling discourse, not an artificial *Begriffsschrift*.

The distinction between pragmatics and semantics also returns in the separation of speaker and sentence meaning. As Horn puts it, 'we must acknowledge a divergence of speaker meaning from sentence meaning' (419). Instead one should say that if the two diverge there must be two speaker meanings. The distinction Horn makes in accordance with the analytical tradition has of course not thereby been eliminated. It reappears in the dialogic relation between different utterances. At the end of this section, it will become clearer what is gained by this move.

Acknowledging the long-standing disputes on negation throughout the history of philosophy and, more recently, linguistics, Horn offers a respite by suggesting that 'the recognition that while truth-conditional semantics does indeed ... contain a propositional – and/or term-level negative/operator, corresponding to descriptive negation in the object language, not all occurrences of natural language negation can be represented in this way ... A need clearly exists to accommodate the use of negation for (speaker) denial or rejection of an earlier statement' (420–1).

From the perspective of corporeal semantics this impasse is as unnecessary as its cause. It only occurs because pragmatics is placed after semantics. Change the relation between pragmatics and semantics by making the latter a special case of the former and the problem disappears. It is not pragmatics, the broad field within which meaning can be described fully, that should be seen as a special case of an extended semantics. Rather, semantics of the formal kind is a special case of and within pragmatics: the doing of logic. Alternatively, we can reconceptualize semantics into different branches, some of which are so specialized that they satisfy the formal language game. All meaning is then the result of speaking rather than of non-speaking, with logic as a certain kind of speaking in which the effects of deixis and reference are neutralized. Husserl's argument on the neutrality modification in noetic–noematic relations could be expanded to make this point.[49]

Now we can agree with Horn that 'no single logical notion of negation as a truth function can collect all natural language tokens of negation,' while insisting that pragmatics can very well subsume all truth-conditional semantics, if only because it does not have any non-pragmatic life of its own.[50] When a little later Horn pinpoints a misconception in a truth-functional account of negation his observation can be generalized to include natural languages at large. Negation is 'simply' one of the more obvious trip switches for this kind of insight: 'When we bear in mind what a truth function must be a truth function of, we recognize the implausibility in the view that negation is invariably truth-functional' (434). We might add that there is nothing to stop us importing truth-conditional measurements into natural language, but we should not be

surprised if they work only for the kind of cases they were designed for in the first instance. Once more we can turn the traditional relation around by saying that all negation is metalinguistic, except that by coincidence some cases can also be handled by truth-functional analysis. That is, pragmatics is the appropriate reflective frame for all linguistic signification, all signification is part of social semiosis, and social semiosis is the sum of significatory praxis of a community.

Another way of phrasing the orthodox distinction between a sentence-meaning semantics and pragmatics is by juxtaposing descriptive and meta-linguistic functions of negation. For Horn 'the vast majority of VP-scope nega-tion is descriptive in function' (434). Expressed differently, the descriptive function is still metalinguistic, except that it is the result of the metametalinguis-tic neutralization of its mundane metalinguistic frame. The metalinguistic level has been shrunk to zero effect. In the majority of natural language expressions, however, this is not appropriate. Indeed, from a radical pragmatic-semantic view this neutrality usually dissolves in analysis. Whether neutral or minimally modal, what remains is a special case of pragmatics.

Horn draws our attention to examples in natural language such as certain expressions employing 'although' and 'in fact' after negative operators and ar-gues that both descriptive and metalinguistic features occur in them at the same time. The examples he cites are 'It's not that I don't want to go – [although ... in fact ...] it's just that I've made up my mind to ...' Here 'the distribution of *although* and *in fact* ... suggests that descriptive and metalinguistic negation may be plotted on the same scale, with the former as the stronger item on that scale (not only is it that p, in fact not-p)' (435). The case is similar for 'Not that I loved Caesar less but that I loved Rome more,' in which negation functions as rec-tification. Generalizing, Horn writes that 'every language contains at least one negative morpheme which can be used either descriptively (to form a negative proposition) or metalinguistically (to reject a previous utterance), the choice between the two understandings often being made by the addressee' (442).

From a broader perspective one is inclined to argue that these examples are not representative of negation at all and that we are dealing here with forms of qualification. It really depends on the level of analysis we employ. If we speak from the level of signifiers and operators, any expression with a negative marker can be regarded as a negation of some kind. If we reject this approach, then neither marked nor unmarked expressions, nor indeed language expressions on their own, can be regarded as negations or otherwise. In this case, we have to adopt a much broader view, including intersemiotic considerations, and say that any signification whatsoever can be deemed a negation, depending on its interpretive frame.

The issue of descriptive and metalinguistic features of negation leads Horn to answer the nagging question of primacy. He speculates that although the metalinguistic function may be 'ontogenetically prior, in that the prohibitive or rejection refusal negative of early childhood language predates and evolves into truth-functional negation' (442–3), we should not assume that 'this order of development should be associated with any logical asymmetry in the account we give for negation (or, analogously, for any other operator) in an idealized model of the adult speaker's linguistic competence' (443). In the end Horn comes down on the side of a descriptive reading of negation. Following the orthodoxy of post-Fregean semantics he decides that 'the nonlogical meta-linguistic understanding is typically available only on a "second pass," when the descriptive reading self-destructs' (444). This also forms a standard argument in the discussion of ironic reversal and indirect speech acts, missing the point that both 'passes' are utterances and hence pragmatic, their important distinction being that they normally produce different meanings. One can also object to Horn's account by saying that the pragmatically sensitive language user more often than not guesses what is coming and notices the appropriate meaning on the 'first pass'; it is only the logician's bomber squad that needs to drop a second round.

A great pity then that Horn avoids answering the question of 'just how metalinguistic negation is to be presented within a formal theory of natural language discourse' (444). I almost suspect that he does not pursue the problem because the answer may have suggested to him just the kind of reversal of semantics and pragmatics I have proposed, the consequences of which would be far-reaching and radical.

Negation and the Unconscious

To take negation a step further, beyond the scope of formal and linguistic negation, an excursion into the domain of the unconscious will provide an additional vista. Here microstructural and macrostructural negation appear to go hand in hand. Negation can be read by way of operators in sentences in which speakers reveal meanings beyond their conscious control, but the level of the sentence proves inadequate to explain what is being negated. A larger picture is needed. Freud offers both an analysis of negated sentences and a broader view of meaning.

It may strike the reader as somewhat unexpected that Freud and Frege both emphasize the role of negation in judgment. Frege believes that even in its negated form the act of judgment consists 'in acknowledging the truth of a thought,' the negated thought furnishing the foundation for the judgment.

Thus he conceives of negation, like affirmation, as an abstracted logical operation independent of the subjective operations of the human mind. Like Frege, Freud puts the role of judgment (albeit of a somewhat different kind) at the centre of his discussion of negation, but unlike Frege he formulates generalized laws about negation via the detour of the fundamental function of judgment for the living organism. What motivates judgment for Freud is the decision that the individual organism makes, as a member of a species, in terms of what is acceptable and unacceptable in the relation between external world and self. 'Expressed in the language of the oldest – the oral – instinctual impulses, the judgment is: "I should like to eat this" or "I should like to spit it out"; and, put more generally: "I should like to take this into myself and to keep that out."' Thus 'the original pleasure-ego wants to introject into itself everything that is good and to eject from itself everything that is bad.' Freud argues that from the point of view of the ego this means an initial identity between what is external and what is regarded as bad.[51]

Moreover, the question of existence is thoroughly linked to the relationship between external and internal. Merely subjective or internal presentations are in a sense unreal compared to the reality of the presentations of the outside world. Yet both internal and outside presentations, Freud writes, 'originate from perceptions and are repetitions of them.' Here re-cognition plays a crucial role. 'The first and immediate aim ... of reality-testing is, not to *find* an object in real perception which corresponds to the one presented, but to *refind* such an object.'[52]

Judging then for Freud is 'a continuation, along the lines of expediency, of the original process by which the ego took things into itself or expelled them from itself, according to the pleasure principle.' Here Freud appears as a symmetricalist of a somewhat different brand if compared with his formal colleagues. He now concludes that 'the polarity of judgment appears to correspond to the opposition of the two groups of instincts which we have supposed to exist.' On the one hand affirmation, 'as a substitute for uniting,' is part of Eros; on the other negation is a consequence of 'expulsion' and part of 'the instinct of destruction.' If the balance between affirmation and negation is seriously disrupted in favour of negation, Freud speaks of an *allgemeine Verneinungslust*, a generalized tendency to negate which 'is probably to be regarded as a sign of a defusion of instincts [*Triebentmischung*] that has taken place through a withdrawal of the libidinal components.'[53] For Freud this would be a case of psychotic behaviour.

More to the point, negation has acquired a specific function beyond its originary survival task. Once tied to negative operators in language, negation

is regarded as a liberating mechanism of the psyche. Not only does Freud hitch judgment in general to negation of necessity – judging 'is not made possible until the creation of the symbol of negation' – but beyond that negation 'has endowed thinking with a first measure of freedom from the consequences of repression and, with it, from the compulsion of the pleasure principle' (239). Or, in an earlier formulation, 'with the help of the symbol of negation, thinking frees itself from the restrictions of repression and enriches itself with material that is indispensable for its proper functioning' (236).

How does this work in detail? Freud cites the expression 'Now you'll think I mean to say something insulting, but really I've no such intention' and adds that 'we realize that this is a rejection [*eine Abweisung*], by projection, of an idea that has just come up.' By way of disregarding the negation and focusing on the negated proposition, he is left with the 'subject-matter alone of the association,' which delivers the 'unconscious repressed material [*das unbewusste Verdrängte*]' (235). In this way the content of what is repressed is able to enter conscious thought, on condition of being negatable. One could argue that the translation at this point is slightly misleading. Freud's original suggests the reading 'on condition that it can be negated,' rather than 'is negated,' a *can* rather than a *must* rule. The distinction between *verneinen* (as negating) and *verleugnen* (as disavowing rather than denying) is also relevant to our discussion (235n. 2).

Negation then is both a move of liberation from the unsayable and an acknowledgment of what is repressed. Moreover, says Freud, negation is 'already a lifting of the repression, though not, of course, an acceptance of what is repressed.' Yet negation achieves the reversal of only one result of repression, namely permitting 'the ideational content' of the repressed material access to conscious thought (236). We need to insert at this point Freud's observation that 'we never discover a "no" in the unconscious' (239). In a note to the same page, the editor draws to our attention Freud's elaboration of this idea to the effect that ' "no" seems not to exist as far as dreams are concerned. Anything in a dream can mean its contrary.'[54] So negation itself does not belong to the unconscious and yet acts as a protection of the psyche from outside conscious judgment, a repair mechanism by means of which the organism shields itself against damage from repressed meanings.

From this Freud derives the psychological cause of the function of negative judgment, the rendering under a veil of what cannot be presented directly to intellectual judgment. Hence he can say that both in its predicative and in its existential form, 'a negative judgment [*Verurteilung*] is the intellectual substitute for repression; its "no" is the hall-mark of repression, a certificate of origin.'[55] Here we have the Freudian twist to Frege's acknowledgment in judgment of 'the truth of a thought.'

It is significant that Freud, not unlike Frege, offers a sort of 'unified field' theory of negation, subsuming all its deviant features under the umbrella of the 'return of the repressed.' Yet it would mean stretching Freud's claims beyond his project to suggest that all negation in natural language always serves to link the unconscious and intellectual judgment. Rather, his focus is on the claim that all forms of negation can acquire the functions he analysed. Even if we wish to dispute Freud's specific explanatory pathway we still require some kind of systemic perspective on the kinds of linguistic negation he investigated. If we do accept the claim that negation plays a role in our dealing with repressed materials, then we have acknowledged that negation occupies a broad spectrum of signification from perceptual fundamentals, via cultural sign systems, to the relation between the unconscious and conscious thought.

Cultural Negation

If we accept the double hypothesis that negation is not restricted to language and that language is an economizing grid system laid over all kinds of forms of non-verbal signification, then linguistic negation appears to have evolved of necessity. In other words language appears to have inherited negation as a rudimentary aspect of general semiosis and elaborated the phenomenon in its evolutionary history towards further and further kinds of differentiation.

Indeed, negation appears so fundamental to base signification, such as all forms of perception (ROSS, or read-only sign systems, and COSS, or communicative sign systems), that the conception of negation as parasitic on affirmation is pushed to its limits. For how would perception in its visual, tactile, olfactory, and other forms be thinkable without processes of negation by elimination as a corollary to focus? It may be that general negation follows so closely on the heels of general affirmation that the symmetricalist versus asymmetricalist dispute proves vacuous. We need this broad frame of inquiry in order to include negation at the microstructural level, as in sentence negation, as well as at the macrostructural level, as in the negation by replacement of one culture by another. Further, we must allow for the difference between marked and unmarked negation if we wish to capture negating phenomena in a broad sense. Just as ironic reversal can be regarded as an unmarked negation at the sentence level, so a great deal of cultural negation appears unmarked microstructurally, requiring the macrostructural perspective of culture as a whole for its meaning effects.

Another way of viewing negation is as one of a broad range of modalities, the one which marks the inversion of affirmation in a contrary or contradictory manner. In this scheme irony could be regarded as the unmarked modal shadow of negation. This is of course not entirely correct, as some kind of

marking is required to make irony at least the most likely meaning construction. 'Unmarked' here means simply that the marking does not take place within the immediate confines of the instantiated sign, for example a sentence. The idea of marking points to the larger theme of negation, whose sphere of complementarity is not binary but open and thus requires a broad textual web to be interpreted satisfactorily. In such cases of 'semantic underdeterminacy,' a certain attitude of expectation, or *Erwartungshaltung*, is produced by way of 'lacunae of indeterminacy.'[56] Accordingly, the reader focuses on ways in which the loosely negated element becomes more specific.[57]

Viewed from the angle of the Saussurean–Jakobsonian axis of syntagmatic–metonymic versus paradigmatic–metaphoric relations, negation appears as a shift from habitual metonymic to metaphoric substitutions. In the case of the contrary one specific alternative paradigmatic choice, the direct opposite, replaces the standard metonymic item. Contradictory negation, by contrast, activates the entire remainder of a given paradigm. Metonymic negation by comparison could be regarded as 'blanks,' or those signifiers which could have fitted into the metonymic chain but were not selected.[58]

Neither the perspective of logical operators nor that of structural linguistics, however, offers a satisfactory method of describing what occurs in cultural negation. A broad intersemiotic approach looks by far the most promising. With this caution in mind how can we best theorize the following examples of negation? Consider first the badger–wombat phenomenon.

The Badger–Wombat Phenomenon

What happens when familiar naming processes are replaced by a culturally alien naming practice? When early English settlers in Australia came across a marsupial creature now once more called the wombat, they gave it the name 'badger.' Though it was clearly distinct in shape, colour, and behaviour from the European badger, the settlers believed that there was enough of a likeness to warrant the transfer of the name – a forced attempt to construe familiarity with and a feeling of being at home in the new environment. For a while this renaming practice persisted but not without a sense that the perception of both badger and wombat was ill served by the equation. As the newcomers became more familiar with the native fauna, the badger label began to be regarded as increasingly inappropriate. In the end it was dropped and a version of the Aboriginal name was belatedly adopted. Since then 'wombat' has been the official term for this unmistakably Australian mammal and has entered the English vocabulary and dictionaries.

What kinds of negation are at work in this scenario?

(a) the negation of 'wombat' as a sign from an alien culture
(b) the negation of the non-linguistic semiosis habitually associated with the name 'badger' in the colonists' old culture: the wilful suspension, forgetting, or repression of badger behaviour
(c) the negation of the new non-verbal semiosis of wombat behaviour to facilitate the functioning of the naming process
(d) the negation (for a while) of the clash between (b) and (c)
(e) the negation of the re-naming practice.

The resolution of this multiple negation is the eventual rejection of the colonizing naming practice in favour of adopting the indigenous name for the animal. The negation of the new signifier implies the negation of a culture. The negation of the non-verbal associations of badger is heterosemiotic, as is the negation of the non-verbal signification by which the new mammal becomes familiar. The negation of the conflict between traditional and new ways of seeing is heterosemiotic and intersemiotic. Lastly, the negation of colonial renaming amounts to a complex of intersemiotic links between verbal and non-verbal signification.

Structurally isomorphic to this process is the replacement of traditional Aboriginal names for geographical features. Examples are legion. A well-known case is the renaming of a sacred rock formation Katatjuta as the Olgas, the name of a Russian princess. In this case negation explodes the narrow frame of naming inasmuch as it entails the negation of an entire cultural realm. This fact highlights the crucial difference between inclusive and exclusive discourses. While Aboriginal worship of landscapes subsumes technical, sacred, profane, geographical, communal, and other kinds of information within the inclusive heterosemiotic discourse about Katatjuta, languages such as chemical or mathematical symbols characterize the logos of exclusive discourse. Or, in the case of the 'Olgas,' the substitution trivializes the negated culture. By negating a name from an inclusive discursive culture much more is negated than merely a term. Quite apart from the contempt which speaks through this process of negation, its immediate consequence is a severe loss of understanding. This cognitive impoverishment is beginning to be recognized and a process of re-renaming is under way. Unlike formal double negation, such reconstructive acts never result in full restitution. Were formal and natural language senses of the same kind their Fregean equivocation should not produce this kind of discrepancy.

Genocidal Negation

When cultural negation is applied, as it has been, not just to fauna, flora, and landscape but directly to indigenous populations we witness horrific consequences. Indigenes around the globe have all suffered the fate of this kind of negation to various degrees. The notion of *terra nullius*, topical once more since a recent Australian High Court decision on Mabo land rights, is a case in point. In this notion the Aboriginal population of Australia was denied the status of ordinary human beings to whom the customary legal procedures enshrined in the laws of the British empire could possibly apply. The land was regarded as belonging to no one since Aboriginal people did not qualify as people. The recent juridical decision to rescind the concept of *terra nullius* as applicable to Australian soil marks the negation of the initial negation and so attempts to create a platform for negotiation between white Australians and the indigenous population.

Again the formal rule of *duplex negatio affirmat*, though superficially relevant, is not really applicable, if only for the obvious reason that the damage done over two hundred years as a result of the initial negation cannot be undone. Formal double negation hovers in a homosemiotic and timeless freeze-frame, as it were, just as does its main constituent, formal sense. Culturally embedded sense, by contrast, is subject to semantic drift in its entanglement with non-verbal heterosemiotic signification.

The crucial *temporal* dimension of cultural negation, which is not captured in its formal presentation, displays another feature. The longer the negation is in place, the more is being negated. This could be regarded as a special case of negation of existence. Paradoxically, one could also cynically say that the longer the negation persists, the less is being negated. What is negated tends to be lost, much of it forever, so that any extended form of cultural negation needs to negate fewer and fewer details of the original, more massive negation.

A serious consequence of the untheorized transition from formal sense to natural language sense and its concomitant neutralization of reference, deixis, and cultural frame is the loss of analytical and critical force. In the case of cultural negation this means primarily that traditional theories of negation have not been able to fashion appropriate tools of analysis. The kind of critical approach required is simply not within the purview of its analytical ideology. Yet what could be more important than an investigation of forms of negation which are both structurally complex and indefensible on almost any scale of values? Suffice it to conclude here that the starting point of the transfer of the principles of formal negation to its complex relations in natural sign systems renders the situation difficult, if not impossible, to rectify. It seems that a

corporeal semantics is best equipped to account for the dynamics of negation as a cultural phenomenon.

Conclusion

I have left unresolved the attempt to clarify a number of equivocations about negation which were the result of assembling a heterogeneous array of positions. A little more clarity in this respect will perhaps be provided by the following remarks.

I have favoured a broad view, from which negation is a function of judgment in a non-linguistic sense. From this vantage point negation is identical neither with its marked instances in either formal or natural languages nor with its psychoanalytical variant. Since negation, in this position, is resolved at the level of judgment in a liberal sense any verbal or non-verbal 'utterance' can be regarded as a negation no matter whether or not it is marked as such. The decision whether to regard an utterance so understood as a negation is based on the interpretive frame we impose on a communicative situation. We negotiate these frames within the limits set down by the rules of a semiotic community.

At the level of theorizing specific signifying systems one can say that such topics as formal negation, negation in natural languages, non-linguistic signs, and negation in Freud's sense need different kinds of analysis. In the process of the reduction from heterosemiotic negation to its formal and hence homosemiotic counterpart, for example, certain features have been eliminated, to which a number of difficulties sketched above are witness. It follows that for a comprehensive treatment of negation, unitary accounts, at least at the same level of specificity, are deficient. Instead a differential theory of negation is needed. Formal representations play an important part in all the diverse schemes of signification but cannot claim to subsume negation in all its complexities under an all-encompassing umbrella. This claim goes well with the suggestion that different kinds of semantics are required for the various kinds of meaning we live by. The lowest common denominator approach to meaning via strict, definitionally governed sense appears to be as disadvantageous for negation as it is for 'meaning' in general. Here it seems more promising to choose 'different horses for different courses.'

From an intersemiotic angle the various object-specific theories can be accommodated as specialized methods in a generous pragmatics. They tend to go wrong if they are applied across the semiotic board. Formal claims cannot be universalized to cover all linguistic signification. Freud's psychoanalytical perspective cannot account for formal relations; nor indeed can it be cogently

shown in generalized form to cover negation in natural languages. There is even some justified doubt whether its mechanics are able to deliver the goods in its own domain.[59] Yet all the approaches looked at yield to an intersemiotic perspective in which meanings result from links between at least two different kinds of signification. This applies to negation from the minimalist semantics of negative operators in extensional calculus logic, where two formal systems are matched, to macrostructural negation in the competition between cultures. Negation in the latter sense is never merely linguistic; it cannot be construed without access to imagined, non-verbal signification, without corporeality.

Macrostructural kinds of negation, such as cultural negation and what I have called 'genocidal negation,' suggest this: without a highly abstract account of negation at the level of judgment, which subsumes linguistic and non-linguistic signs, we are unable to theorize complex forms of negation that lack formal or linguistic markers but are related to their formal and linguistic cousins in their modality of negating. In the case of cultural negation what is so negated can be massive, indeed monstrous.

3.3 METAPHOR: HETEROSEMIOTIC PATHWAY TO MEANING

Reality is a cliché from which we escape by metaphor.

Wallace Stevens, 'Adagia'

All natural languages are parasitic on non-linguistic sign systems. This is a deviation from an orthodoxy in semantics which says that meaning is a relation either between language and world or between linguistic expressions and the dictionary. Both views are rejected here. Furthermore, I advocate a position that opposes the stipulation of a neutral kind of sentence meaning. From the broad corporeal perspective chosen, linguistic meaning is regarded as the activation of language by way of non-linguistic sign systems which constitute the world the way we see it. In this general picture, metaphor is a construction which highlights the intersemiotic and heterosemiotic nature of all discourse. As Umberto Eco puts it, metaphor 'draws the idea of a possible connection from the interior of the circle of unlimited semiosis.'[60] Intersemiotic holism and mainstream discussions of metaphor appear difficult to reconcile. This section offers a basis for negotiation between the two positions.

Metaphor, 'the dreamwork of language,' only means 'what the words, in their most literal interpretation, mean and nothing more.'[61] This fascinating thesis by Donald Davidson is central to this section but not for the reasons

one might expect. Davidson believes that in what it achieves metaphor 'uses no semantic resources beyond the resources on which the ordinary depends' (29). This assumption, which I share, is argued by distinguishing between 'what words mean and what they are used to do' (31). I suggest that Davidson's entire assault can be used in the opposite direction, not against the traditional claim that there is such a beast as metaphorical meaning but against the notion of meaning which forces Davidson, who takes the analytical definition on its word, to argue the way he does.

As I have suggested elsewhere, it is a great pity that Davidson does not draw the radical consequences from his insights concerning metaphor and turn against the tradition that has defined meaning in such a way that it cannot handle the metaphorical level. Had he done so, the house of cards built of strict meanings may have come tumbling down. The key for such a strategy is provided by Davidson himself when he speaks of a literal, or linguistic, or word, or sentence meaning, on the one hand, and its use, on the other. Yet early in his paper he conflates the two, the literal and use. Now I agree that even the most strictly literal is a use rather than a non-use, at best a 'most literal interpretation' (30). Having established that there is only use rather than meaning as such – and Davidson's more recent 'first use' seems to support this – we note that he allows for only one legitimate use when it comes to speaking about meaning in metaphors. Metaphorical meaning is the 'most literal interpretation' of the expression, while other uses fall outside the range of meaning. What a metaphor says is 'given in the literal meaning of the words' (41). Other uses do not produce the meaning or meanings of the metaphor but are merely ways of noticing all kinds of things. Indeed, says Davidson, 'there is no limit to what a metaphor calls to our attention' (44). And should we be foolish enough to 'say what a metaphor "means", we soon realize there is no end to what we want to mention' (44).

What if this is the secret key to an appropriate understanding of the notion of 'meaning' rather than the opening for an attack on theories of metaphor? What if definitional meaning is the villain? In that case the threat of infinite significatory regress would be a bonus and metaphorical meaning would be meaning par excellence, a meaning net to be cast well beyond the linguistic. This in a nutshell is the line of argument I shall pursue here. I believe that almost everything Davidson has said against metaphorical meaning can be turned against theories of definitional meanings. Davidson can be said to be right, but in reverse. I will return to his central claim a little later. Suffice it here to anticipate this much: metaphor appears to exaggerate the heterogeneous links between linguistic and non-linguistic signs which we perform whenever the event of meaning occurs.

My argument addresses two main weaknesses in the tradition of the theory of metaphor: the emphasis on linguistic features in isolation and definitionally governed meaning; and the foregrounding of content (substituted, compared, diverse, nonsensical, sensical, uttered, and interacting). An alternative route of inquiry should, I believe, stress the intersemiotic and heterosemiotic nature of metaphor, the referential character of metaphor, whereby reference is regarded as a joining of different sign systems rather than as a Fregean reference between language and world, and the methodological character of metaphor as multiple *pathway*. As I shall argue below, the meaning of metaphors, more conspicuously so than any other meaning, resides at the level of non-verbal semiosis.

Linguistic self-reflection has tended to foreground propositional contents in a stark fashion and in doing so has conjured up an unmediated relation between language and 'world.' A very different picture is offered by Dorothy Lee with reference to the Wintu language: 'We are aggressive toward reality. We say, This is bread; we do not say, as the Wintu, *I call this bread* or *I feel* or *taste* or *see it to be bread.*' [62]

For us the point is not the relative aggressiveness of different cultures in their ways of depicting reality but a difference in awareness of mediation. It appears that the Wintu formulation, assuming that it is typical, is epistemically more sophisticated than the assertoric certitude which comes across in English, or for that matter in other Indo-European languages. In fact all significatory variants (tactile, olfactory, visual interpretations) reflect the non-verbal sign systems by means of which we experience, or constitute, the world for ourselves within community guidelines and other more basic constraints. By contrast the stark proposition of 'this is bread' or 'p' appears to be a later inference from much more rudimentary descriptions. The transition from full metaphoricity of culturally saturated discourse to the formal can take the shape of an illicit conflation of two kinds of sense, as it does in Frege and the tradition he set in motion.[63] But once the transition is made from description of our interpretive non-verbal schemata to the stark assertion of logic or its analytical relations, the complexities of the former are lost and the abbreviated later version is taken to be the appropriate way of representing both practices.

Furthermore, the difference between the two kinds of formulations has metaphysical implications. While the Wintu manner of speaking remains in touch with the heterosemiotic nature of our reality constructions, the propositional sharpness of abbreviated identification invites an empiricist naïveté, a stance somewhat misleadingly called 'the *natural* attitude' by Edmund Husserl. The more natural attitude seems to me to characterize the sort of formulation which reflects its implied epistemic procedure. In fairness to Husserl, though, his phrasing is meant to draw our attention to our habitual descriptions, which appear natural to us but are in fact epistemically flawed.

Metaphors undermine the natural attitude or the assumption of an unmediated relation between language and world. One could say, with Wallace Stevens, that ordinary language mediates one kind of world which is in conflict with its metaphorical relation: 'Reality is a cliché from which we escape by metaphor.'[64] Mediation is always directional, and metaphorical expressions, more than technical terms, make visible the directionality of meaning. 'To come upon an interesting argument,' 'to sketch one's ideas,' and 'to present one's ideas' all demonstrate this fundamental feature of language: its directionality towards concrete social situations such as human confrontation with nature ('to come upon an object') or the dependence of abstraction on more tangible signification ('sketching' or 'presenting').

Such metaphors appear to be metaphorical only on reflection; hence they are sometimes called 'dormant' or 'dead' metaphors. One could say that the degree of recognizability of metaphor as metaphor depends on its evolutionary stage between innovation and convention. This should not be construed as a simple binary opposition but as a spectrum along which we can locate an infinite range of degrees of 'metaphorical force.' In this sense force is a function of the place a metaphor occupies between innovation and convention. At the end of the chapter we will be in a position to reformulate this in intersemiotic terms. Which position a metaphor is judged to hold on our scale depends as much on the structural tensions between the semiotic fields activated by the metaphor as on the community standards of what happens to be regarded as a striking intersemiotic relation at a given time.[65]

What I have said so far applies to all language as well as to most other sign systems. What is it that distinguishes metaphors from other expressions? I suggest that the distinctions we can draw appear convincing when we juxtapose striking metaphors with technical expressions but less convincing when we introduce metaphorical expressions such as 'sketching ideas.' This suggests a sliding scale of metaphoricity rather than a sharp distinction between metaphoric and technical use, or between the figural and the proper.

Nevertheless, in the vicinity of our stipulated polarities metaphors look markedly different from starkly propositional expressions. This is where the literature on metaphor has achieved much, except that I suspect Davidson to be right when he says that 'no theory of metaphorical meaning or metaphorical truth can help explain how metaphors work.'[66] They tend to demonstrate what a particular theory of meaning has to say about metaphor, a kind of a posteriori demonstration of the explanatory power of the theory. If we follow Davidson's hunch that 'metaphor runs on the same familiar linguistic tracks that the plainest sentences do,' then metaphor strikes me as an excellent case for testing the validity and usefulness of standard theories of meaning, as well as of my own corporeal semantics (41).

Aristotle: Metaphor as Enigmatic Resemblance

Since Aristotle metaphor has been looked at from the vantage points of abbreviated comparison, analogy, and substitution. The comparison theory, put simply, regards metaphor as a doubly shrivelled comparison, a process of reduction from 'the moon is like a papaya,' via the simile 'the papaya-like moon,' to 'the papaya moon.'[67] This line of argument dominated the discussion of metaphor roughly until the second half of this century, when a diverse range of alternative theories began to emerge. Monroe Beardsley still subscribed to the Aristotelian position in 1962 with his 'verbal-opposition theory,' and his view of metaphor as an 'elliptical simile, that is, a collapsed comparison.'[68] Later Beardsley put the comparison theory into a larger frame when he distinguished between 'constancy theories,' in which one element remains stable, and conversion theories, which emphasize the creation of new meanings by transformation of 'credence properties' (community associations) into intensional meanings.[69] Comparison theory is a type of constancy theory.

Searle rejects the comparison theory on the grounds that it confuses the mechanisms of metaphors with the way in which we construe meaningful utterances for sentences whose literal meanings are defective. Comparison theories are 'muddled about the referential character of expressions used metaphorically.'[70] George Dickie at least partly anticipates Searle's objections by claiming that metaphors link a specific item with classes rather than with another specific object. The problem here seems to me that classes are given in dictionaries, but certain metaphors cannot be understood by going to the dictionary.[71] Searle's objections work only if one accepts his own representation of the metaphorical process. Yet one could just as well turn the attack around and ask whether he is not muddled about the referential character of neutralized literal meanings. The referential stability of ordinary 'literal' utterances that Searle requires to distinguish defective sentences which turn meaningful in metaphorical utterances may very well prove to be just as vulnerable as the referential muddle he discovers in comparison theories.

Aristotle provides support for the comparison approach via substitution and analogy by tracing the meaning of the term metaphor itself. *Metapherein* means to give 'the thing a name that belongs to something else,' and metaphor thus refers to the 'transference ... from genus to species, or from species to genus, or from species to species, or on grounds of analogy.'[72] In this synopsis metaphor is a process of substitution in which linguistic expressions are varied while reference remains focused on the original item. According to Aristotle, this exchange operates on the principles of analogy, 'an equality of ratios containing at least four terms.'[73] This he elaborates by saying that the

explanation of metaphor by way of 'analogy is possible whenever there are four terms so related that the second (B) is to the first (A), as the fourth (D) to the third (C); for one may then metaphorically put D in lieu of B, and B in lieu of D.'[74]

Two less well canvassed aspects of Aristotle's treatment of metaphor are his comments that 'metaphors are a kind of riddle' and that the ability to use metaphor appropriately implies a perception of resemblances.[75] The reference to riddles suggests that Aristotle is to be taken here with more than merely a grain of salt. His remarks on comparison, substitution, and analogy cannot be read as a kind of grammar if at the same time we are reminded that metaphors produce a surplus meaning, something enigmatic to be figured out. It is the riddle aspect of metaphor, then, which I propose to revise from an intersemiotic perspective of meaning.

Similarly, the importance of Aristotle's phrase concerning the perception of resemblances tends to be underestimated. 'Perception of resemblances' is not a linguistic issue but the semiotic, non-verbal ground for linguistic constructions. It is not the signifiers that resemble one another in some way but their signifieds. Yet only the signifiers are supplied in linguistic expressions, leaving the signifieds to be construed by the listener or reader. I suggest that the recognition of resemblance is an operation within non-verbal semiosis, either homosemiotically, within one and the same sign system (e.g., the haptic), or heterosemiotically, by linking distinct systems (e.g., the aural and the visual; the tactile and the proximic). The capacity for recognizing resemblance of non-verbal semiosis, then, is the necessary ground for metaphoric language, a claim that can be extended to include all natural language semantics.

If I am on a fruitful track, it seems that the tendency to conclude from Aristotle's story that the right way of talking about metaphor is to pursue the mechanisms of substitution, analogy, and condensed comparison along narrow linguistic lines is to be avoided. This, I suggest, is where a large portion of the study of metaphor has gone astray. Although those processes can be shown to be at work they fail to capture the most important ingredient of metaphor, which is its expansive heterosemiotic effects.[76]

The Interaction Theory of Metaphor: Max Black

To the lascivious pleasing of a lute.

Richard III, I.i.13

The interaction theory of metaphor made popular by a number of seminal papers by Max Black has its roots in Wilhelm Stählin, Karl Bühler, I.A.

Richards, and to a lesser extent Beardsley. Stählin speaks of a 'state of consciousness of double signification,'[77] an exchange of characteristics, a unification of two spheres, and a merging of image and language: 'Es findet ein Austausch der Merkmale, eine Vereinigung beiderseitigen Sphären, eine Verschmelzung von Bild und Sache statt' (324). Karl Bühler suggests a partial overlap of projection, an imperfect congruence of spheres *(Sphärendeckung)*, and the blocking out of what is not appropriate to the metaphoric transfer (348–9). I.A. Richards' formulation of the interaction theory of metaphor, taken up by Max Black, was first formulated in Chapters 5 and 6 of *The Philosophy of Rhetoric*, where he argues that tenor and vehicle interact in such a way that the referential capacity of the vehicle remains intact while at the same time the tenor, the 'underlying idea or principal subject' (96), becomes effective, so that 'the co-presence of vehicle and tenor results in a new meaning' (100). Accordingly, metaphor is an 'interaction' of thoughts of different things facilitated by language, by an 'interanimation of words.'[78]

Since the 1950s Max Black has developed his own interaction view of metaphor. He employs terms such as 'filtering' and 'screening' and stresses the notion of systems of implications.[79] From his early writings onwards Black emphasizes the relationship between two different meanings: 'For metaphor to work the reader must remain aware of the extension of meaning – must attend to both the old and the new meanings together.'[80] At the same time, he holds an analytical view of semantics and rejects the phenomenological description of meaning as 'the thing-intended' on the grounds that it 'fails as a *comprehensive* account of meaning or significance.'[81] Likewise he rules out any mentalist theories as 'distinctly unpromising' (156) and regards 'any psychological theory of sign-using behaviour' as 'hopelessly inadequate' (160). However, he rejects truth-conditional accounts as inappropriate.[82] As Black sees it, meaning should not be regarded as necessarily designative (162) but 'will prove to be more like a handclasp than like a crystal' (167). This strikes me as the handcuff version of a directional view of language and one which, as I will argue later, makes it difficult in the end to render the interaction perspective fully persuasive.

Black's position is perhaps best recalled by itemizing his main points in 'More about Metaphor' and *Models and Metaphors*.[83] He underlines the importance of: (1) primary or principle and secondary or subsidiary subject, and refers to focus (expressions 'used non-literally') and 'the surrounding literal frame'; (2) the systemic nature of both the principle and the subsidiary subject; (3) the claim that metaphorical utterances project a set of associated implications on the primary subject 'comprised in the implicative complex, that are predictable of the secondary subject,' or put differently, a metaphor applies to its principal subject a system of 'associate implications' belonging to its subsidiary subject;

(4) the idea that metaphor 'selects, emphasizes, suppresses and organizes features of the primary subject by applying to it statements isomorphic with the members of the secondary subject's implicative complex,' and while 'associate implications' usually consist of commonplaces they may on occasion 'consist of deviant implications established *ad hoc* by the writer'; and (5) the interaction of primary and secondary subjects, by (a) the primary subject eliciting a selection of properties of the secondary subject, (b) inviting the construction of a parallel implication-complex suitable to the primary subject, and (c) reciprocally inducing parallel changes in the secondary subject.

Of the resulting semantic mutation Black says that 'there is, in general, no simple "ground" for the necessary shifts of meaning – no blanket reason why some metaphors work and others fail.'[84] As a result metaphor is able to 'generate new knowledge and insight by *changing* relationships between the things designated (the principal and subsidiary subjects).'[85] And somewhat tentatively, Black goes much further when he says that 'some metaphors enable us to see aspects of reality that the metaphor's production helps to constitute. But this is no longer surprising if one believes that the world is necessarily a world *under a certain description* ... Some metaphors can create such a perspective' (39–40). One is tempted to ask why only 'some' metaphors do so. If the principle is that for humans the world is necessarily significatory, then all signs, all language, and hence all metaphors provide descriptions.

Certain objections have been raised to the interaction account, some by writers who believe that Black has merely rephrased older theories, others by writers who argue that the theory fails to demonstrate 'interaction.' Carl Hausman's main objection to Black's interactionism is that in certain formulations Black lapses into the vocabulary of the shut case of language: what is new in metaphor was 'implicit' after all in the relations which we can see between the main terms.[86] Hausman here puts his finger on a narrow circularity (large circularities being unavoidable) in Black's narrative: the presupposition of the semantic relations which metaphors are supposed to create.

Searle's objection to Black's and other interaction theories is that they fail to demonstrate the production of new creative meanings as a result of interaction. According to Searle, the relationship between subject S, standard predicate P, and new predicate R is such that certain subjects restrict the scope of their predicates differently. The same predicate expression for different subjects means different things because the S term restricts the range of its predicates in a different way. The predicate 'is thirsty' produces different meanings when attached to 'car' and to 'John.' Beyond Searle, one might add, different direct objects vary the range of a predicate applied to the same subject as in 'John drinks water' and 'John drinks Cointreau.' Searle argues that no new meaning

emerges from the two predicate terms of metaphor. The new predicates R are already available within the range of predicates allowed by S for P. This rules out the creation of new meanings by way of metaphorical expressions. 'Where is the interaction?' asks Searle.[87]

George Lakoff and Mark Turner reject the interaction theory of metaphor by showing that in the metaphor 'life as a journey,' for example, the interaction – or in their terms the 'mapping' – is unidirectional from journey to life but not the reverse. Thus they assert that 'there is no evidence for the Interaction Theory' and that the 'predictions made by the claim of bidirectionality ... [are not] borne out, since neither the logic nor the language of the target domain is mapped onto the source domain.' Where we can discover such claimed interactions, they are of a different nature altogether.[88] One could defend Black on this point by suggesting that Lakoff and Turner are perhaps insensitive to the nuances of language; once we have associated life and journey by way of the metaphor we cannot return to the former 'neutrality' of either term, as 'journeys' will forever also retain the semantic fringe benefit of being 'in some respects like life.'

From the perspective of an intersemiotic and heterosemiotic semantics the critique looks somewhat different. Black's reasoning is unconvincing because it does not tell us how we discover the primary subject in the first place. Black assumes that we understand metaphors and then proceeds to describe how they work when we do. Although he concedes that deviant implications are possible and that we still 'lack an adequate account of metaphorical thought,' there is nothing in his interaction narrative that explores the interpretive difficulties which still unfamiliar metaphors pose for us.[89] Nor will we confront those difficulties if we restrict the analysis to metaphors which we can construe from the platform of the standard meanings of the terms, as in 'like a rat up a drainpipe,' 'he couldn't hit a bull in the bum with a handful of wheat,' or 'he wouldn't work in an iron lung.' The more telling test of whether or not a theory of metaphor explains how metaphors work is to demonstrate how precisely we cope with expressions with veiled meanings, as in, for instance, 'rats on sticks.' Otherwise the riddle aspect of Aristotle's description remains untheorized, and in that case one suspects that the theory presented is an a posteriori rationalization by way of a concealed calculus rather than a semantic explanation. I will return to this charge later.

Eileen Cornell Way's Cognitive Computational Theory

The atom is a solar system in miniature.

Niels Bohr

Perhaps it is no accident that Max Black's interaction theory has been absorbed recently by the kind of cognitive computational approach exemplified in the work of Eileen Cornell Way. In *Knowledge, Representation, Metaphor* she takes as her point of departure artificial intelligence (AI) studies and cognitive approaches to semantics. In particular she refers to John Carroll and Robert Mack's 'Metaphor, Computing Systems, and Active Learning,' in which they suggest that metaphor allows us to cope with new information by way of familiar knowledge. Another important source for her approach is Earl R. MacCormac's *A Cognitive Theory of Metaphor*. Her criticism of AI is that it often employs the term 'semantics' to stand simply for internal representation, whereas not merely a calculus transformation is required but also, and importantly, corresponding specifications of the 'meanings' of terms.[90]

Another important influence acknowledged by Way is Black's interaction theory. She follows Black a considerable way, while offering three forceful interventions: that the interaction mechanism remains vague; that filtering is a metaphor to explain metaphor; and that the theory does not account well for compound metaphors in which four or more terms interact. Having made this criticism Way rephrases Black's interaction theory in computational terms. She accepts the notion of 'systems of commonplaces'; the notion that the vehicle can be regarded as a 'filter' on the tenor; that a 'meaning shift' occurs in metaphor; that metaphor 'creates similarity' between tenor and vehicle; and the notion that metaphors allow us to 'perceive the world from different perspectives.' She uses the term 'associated schemata and canonical graphs' instead of 'systems of commonplaces,' and turns Black's 'filter' into a 'common supertype,' combining tenor and vehicle while highlighting certain aspects of the tenor and hiding others. 'Meaning shift' for Way is produced by 'additional linkages in a particular mask on the hierarchy' and by joining aspects of the vehicle's schemata to that of the tenor's. 'Supertype' has a directional aspect: 'the properties of the vehicle are imposed on corresponding properties of the tenor,' with the frequent result of similarity.

Way elaborates the notion of 'conceptual graphs' and employs them in the sense of 'finite, connected, bipartite graphs which comprise a knowledge representation of language.'[91] Out of these ingredients she develops a dynamic type hierarchy (DTH) theory of metaphor, which combines dynamic type hierarchies representing semantic networks and Max Black's interaction approach. By placing different 'masks' on a hierarchy Way shows how we are able to 'represent the different perspectives on the world created by metaphor' (147). Masks also represent 'the role that context plays' in our changing views of a semantic hierarchy.' In other words, they are involved in 'how we actually model the world' (126). Expressed from the position of

the linguistic expression, 'each mask picks out different trees and subtrees' (128).

One of Way's examples is the expression 'The atom is a solar system in miniature' (Niels Bohr). Prior to the metaphor the dominant semantic network looks like this (145):

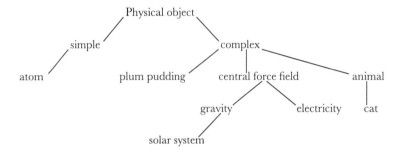

The metaphor transforms the hierarchy thus:

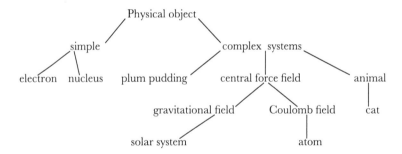

Way adds an important rider to her hierarchy when she notes that 'metaphors are inherently incomplete in that we do not know where the analogy ends' (146). In this sense metaphor shows the open-endedness of signification in all natural language expressions. This is why semantic closure is never definitional but always pragmatic and political.

The notion of 'mask' plays a pivotal role in Way's presentation. Metaphor, she says, works by putting into place new semantic connections as a consequence of 'coarse-grained masking' (126). New masks, for example, can blur the distinction between animate and inanimate, as in 'the car is thirsty.' In the process of masking 'the tenor is redescribed in terms of the new hierarchy brought into play by the ontology of the vehicle' (127). Another attractive feature of her account is that it grants metaphoric and literal language 'the

same status: *they are just different aspects of the hierarchy which comes into play with different masks*' (128). This contrasts dramatically with the tradition which separates sentence meaning and utterer's meaning. For Way the literal is simply the standard use, not a neutralized abstraction. Alternatively one could say, beyond Way, that the literal is a streamlined mask for technical purposes of communication, its ideal being the mask of Frege's *Begriffsschrift*.

This line of reasoning allows Way to view semantic similarity in a new manner. It appears as an '*abstraction* of some of the properties found in the tenor and vehicle' (129). Similarity is not simply an 'intersection of a list of features at the level of tenor and vehicle,' not merely a common denominator but a 'supertype,' a higher level abstraction in the 'semantic hierarchy' (129). Thus metaphor works by taking properties from the level of the vehicle and generalizing them into a 'common supertype' which selects parallel properties of the tenor. We are dealing here, Ways says, with a 'kind of reverse inheritance' (130).

Whenever metaphor violates existing semantic relations the disrupted constraints are pushed upwards in the hierarchy so that both vehicle and tenor are covered by a new supertype (130). In the metaphor 'the car is thirsty' the violated constraints of animate versus inanimate are replaced by the supertype of mobile entities requiring liquid. Way does not establish her own semantics but applies given semantic notions to the principle of the hierarchy, and she concedes that her approach 'can only be as precise as the semantics we have for the nature of the hierarchy' (130).

Nevertheless, the DTH theory does not merely support Black's intuitive claim that 'entire semantic domains are carried over into the tenor in metaphor.' Way asserts beyond Black that her theory is able to demonstrate 'precisely how this can take place' (131). She establishes further that paraphrases do not provide synonymous equivalents for metaphors (132). If literal and metaphorical masks differ, so must the resulting 'type hierarchies and conceptual graphs.' Likewise, Black's screening process can be made explicit by showing how a supertype 'allows the features of the vehicle to act as a filter in selecting, emphasizing, suppressing and organizing features of the tenor' (133). As well, Way's schema tolerates the notion of dead metaphors in that the semantic supertypes we associate with metaphor may gradually melt into the standard masks.

Way elaborates these principles persuasively into computational analyses in the remainder of her study. Significant in her work for our purpose is that she manages to show the limits of the interaction theory and a way beyond them, the limits being the constraints already inherent in the semantics of which interaction theory makes use. This has two sides. The practical side is that we can pursue the explanations furnished by Black, or for that matter by Way, only if we are familiar with the meaning perspectives which a metaphor

establishes, or at least if we are in a position to construe them with a certain degree of confidence. But what if we do not know the new perspectives created? The theoretical side is that the kind of semantics we have at our disposal is taxonomic, abstractive, and hence reductive, and therefore results in either idealized meanings of expressions or a semantics interested in how meanings are generated in the first place. Neither Black's nor Way's theory of metaphor does this, though Way acknowledges as much. Towards the end of this section I will attempt a more satisfactory explanation of how metaphorical meanings are produced.

John R. Searle

I could eat the crotch out of a low flying duck.

In spite of his attention to detail and his originality of approach, Searle, in 'Metaphor,' cannot cope with a low-flying duck which makes sense at both the literal and the figural level, as a cartoon caption and as a substitute for 'I am very hungry.' In Searle's account, metaphorical meaning is an utterance meaning construed in the face of a defective sentence meaning. This general claim is refined by a number of principles and necessary conditions:

(1) 'Things which are P are by definition R' (the latter being one of the 'salient' characteristics of the former).
(2) 'Things which are P are contingently R.'
(3) 'Things which are P are often said or believed to be R.'
(4) 'Things which are P are not R, nor are they like R things, nor are they believed to be R, nonetheless ... we just do perceive a connection, so that utterance of P is associated in our minds with R properties.' Any loose association we may discover between different concepts may suggest a metaphor.
(5) 'P things are not like R things, and are not believed to be like R things, nonetheless the condition of being P is like the condition of being R.' Neither shared properties nor assumed shared properties but comparable conditions provide the metaphorical nexus in this case.
(6) 'There are cases where P and R are the same or similar in meaning, but where one, usually P, is restricted in its application, and does not literally apply to S.' In this case the move from standard application to non-standard use produces a metaphor.
(7) 'This is not a separate principle, but a way of applying principles 1 through 6 ... not of the form "S is P" but relational metaphors, and metaphors

of other syntactic forms.' Searle refers here to expressions with 'predicate adjectives' and 'verbs,' such as 'The ship ploughs the sea,' in which the process of construing meaning is different from expressions employing a simple copula. Instead of proceeding from 'S is P' to 'S is R' we first construe an S-P relation to an absent subject S before we are able to link it with the new S-R relation.

(8) It is possible to regard 'metonymy and synecdoche as special cases of metaphor or as independent tropes … P and R may be associated by such relations as the part–whole relation, the container–contained relation, or even the clothing and wearer relation.' Searle decides to include metonymy and synecdoche under his description of metaphor but allows for the argument that they constitute a special subtype.

(9) Searle offers a ninth possibility, 'where an association between P and R that did not previously exist can be created by the juxtaposition of S and P in the original sentence.' This is how he understands the 'thesis of the interaction theorists.' His main objection is that has 'never seen any convincing examples, nor any even halfway clear account, of what "interaction" is supposed to mean,' though he does not dispute that 'different S terms restrict the range of possible R's generated by the P terms.' He rejects the idea 'that the different combinations of S and P create new R's,' arguing instead that 'the more plausible explanation is [that] one has a set of associations with the P terms … The principles of these associations are those of principles 1 through 7. The different S terms restrict the values of R differently.' This, according to Searle, destroys the interaction theory.[92]

Although the above principles are active one at a time in different metaphors, the following three conditions, says Searle, are necessary for all metaphors. First are 'strategies on the basis of which the hearer can recognize that the utterance is not intended literally' and cannot be taken as such without construing a defective meaning. Second are 'some shared principles that associate the P term (whether the meaning, the truth conditions, or the denotation if there is any) with a set of possible values of R.' Third is 'some shared strategy that enable[s] the speaker and the hearer, given their knowledge of the S term (whether the meaning of the expression, or the nature of the referent, or both), to restrict the range of possible values of R to the actual value of R.' The point here is that 'only those possible values of R qualify that indicate which possible properties of S can be 'actual values of R' (120).

Central to Searle's theory of metaphor is the distinction between sentence meanings and the speaker's or utterance meanings. Sentence meanings are what sentences mean by themselves, or their literal utterance. The speaker's

meanings are variants of this neutral base. Apart from its basis in speech act theory this is reminiscent of Monroe Beardsley's criterion of metaphor as a non-sensical expression capable of being transformed into a meaningful utterance.[93] Searle's theory of metaphor, then, rests on the assumption that metaphors derive their meanings from the recognition of a defective sentence meaning and a shift from the meaning of language to the meaning of utterance.

The deficient meaning argument is reminiscent of Nelson Goodman's reasoning along the lines of sortal error, when he says that a change of habitual extensions results in a kind of deliberate category mistake.[94] Another version of the category mistake move can be found in Colin Turbayne's *The Myth of Metaphor*, where he speaks of metaphor in terms of an intentional category mistake and 'sort crossing.'[95]

In a literal utterance the relation between S and P is a straightforward predication and R is identical with P, according to Searle. In ironical utterance R is a contradictory or the contrary of P. Indirect speech acts are described by having P embedded in R. Metaphor, lastly, is a relation in which the hearer proceeds beyond P to R or (R1 to Rn), while in so-called dead metaphors the hearer bypasses P to proceed directly to R.[96] Given his schema, Searle is consistent in concluding that the force of metaphors lies in the demands they make on the hearer: unravelling what is meant and activating an additional semantic field.

My first disagreement is with the analytical separation of sentence and utterer's meaning. In 'literal meaning' Searle collapses sentence meaning and utterance meaning into a neutral and fully sharable, single meaning. His argument requires an immutable base meaning against which other, deviant meanings can be measured. In the case of metaphors the base meaning is constructed as deficient, with the metaphorical utterance meaning providing the missing sense. Yet because Searle speaks of a literal utterance meaning as the base, all subsequent distinctions are distinctions between different kinds of utterance meanings rather than between sentence meanings and more or less deviant utterances. The stipulation of a neutral sentence meaning the utterance of which has no effect on the propositional content of the expression is both unnecessary and misleading. Except in technical language use, even seemingly fairly uncontroversial meanings are subject to social negotiation. Only a logician is able to construe a world in which this is otherwise. There is no such thing as semantic neutrality in natural language.

My second objection is to the inability of Searle's theory to deal with nascent metaphors, expressions which have not yet been absorbed into general usage but operate within still restricted social practice. Take the following metaphor used at a party: 'Where's John?'; 'John's driving the big white porcelain truck.'

Hearers not familiar with the idiom find Searle's principles and necessary conditions insufficient for the construction of meaning. If we don't know what the metaphor 'means,' we are in no position to test either Searle's eight (or nine) principles or his three necessary conditions. It is only a posteriori, once we have secured meaning by means other than Searle's, that we can proceed to check whether what Searle is saying actually applies. Once we have deciphered the meaning of the metaphor or have been given an interpretation, the most we can say in this case is that the relevant principle, principle (7), and the three stipulated necessary conditions do not contradict the facts of meaning.

According to Searle's schema, the S P-relation S, namely that John is driving a large, white truck made of porcelain, permits us to construe the S R-relation S as the metaphorical utterance meaning. It does not. Why does the explanation fail? Towards the end of the chapter I will travel a more promising route towards the S R-relation S. Here we must ask the simple question: What is the use of a theory of metaphor that does not help us to construe meaning? Searle could ask for assistance from Murray Turbayne, who suggests that some novel metaphors constitute 'inappropriate' use, which is to be distinguished from the middle stage in a metaphor's life, the 'triumph' of metaphor when it 'illuminates obscure or previously hidden facts' and from the final 'commonplace' stage of metaphor, when it lapses into ordinary discourse.[97]

In this manner metaphor highlights the problems of semantic theories which remain stuck at the level of linguistic relations that turn out to be merely a syntax or, put bluntly, a calculus. For the discussion of metaphor this is blatantly unsatisfactory. A different approach is needed.

Donald Davidson

He couldn't knock the dags off a sick canary.

Davidson's 'thesis is that metaphors mean what the words, in their most literal interpretation, mean, and nothing more.'[98] Consider the metaphor 'He couldn't knock the dags off a sick canary.' A straightforward reading would produce a sentence like, 'He is a useless fellow.' Yet Davidson argues that it is a mistake to speak of two kinds of sense: a literal and a metaphorical meaning. To make this claim Davidson, like Searle, distinguishes between 'what words mean and what they are used to do' (31). Metaphor in his account 'belongs exclusively to the domain of use.' But this is possible only because we have available 'the ordinary meanings of the sentences they comprise' in the first place. To explain metaphor by locating its meaning in its use is like trying to explain something by its effects. Davidson addresses a number of theories of

meaning and demonstrates that they all go wrong in their basic assumption that there is some kind of extended meaning and some 'specific cognitive content' to be found and explained (44).

Davidson appears to meet my earlier objection that his is a critique of meaning rather than of theories of metaphor by pointing to the hidden presuppositions which all standard accounts appear to share, namely that 'associated with a metaphor is a cognitive content that its author wishes to convey and that the interpreter must grasp if he is to get the message. This theory is false,' says Davidson, 'whether or not we call the purported cognitive content a meaning' (44). The Davidsonian narrative runs into difficulties when it comes to account for 'dead' metaphors. How do they 'mean' if their now 'literal,' or standard, meaning is what Davidson would have to deny as being a meaning at all, since it is no more than their forgotten manner of nudging us to note things, a meaning not provided by their earlier 'literal' meanings?

One important aspect of Davidson's attack on standard theories is often overlooked. He is certainly right in rejecting metaphorical meaning if it is presented as a cognitive content that is 'finite in scope and propositional in nature' (44). In this sense there is no metaphorical meaning. But then one would have to say that natural language has no meaning in this description. Meanings which are finite in scope and strictly propositional belong to the domain of the formal. Davidson has thus applied Frege's first sense, the sense of formal expressions, to what metaphors nudge us to notice. Given this move his answer is irrefutable: there is no such meaning. The question though, posed earlier, remains unanswered: Why does Davidson not apply the same critique to ordinary meanings? After all, he says in a footnote referring to Stanley Cavell, he would apply the same critique to 'any use of language' (45n. 16).

The Ubiquity Thesis

The folded meaning of your words' deceit.

Comedy of Errors, III.ii.36

One tradition that emphasizes the all-pervasiveness of metaphor is associated with the work of George Lakoff. In *More than Cool Reason: A Field Guide to Poetic Metaphor*, Lakoff and Mark Turner sum up the main features of the 'internal structure' of metaphor, a metaphorical mapping. In 'the journey of life' metaphor 'slots' in the 'source-domain schema' are mapped onto slots in the 'target domain.' 'Relations' in the source domain (journey), which get mapped onto relations in the target domain (life), result in the image

of a traveller reaching a destination. This maps onto the idea of a person achieving a purpose in life. The idea of a traveller reaching a destination is 'mapped onto' the states of affairs of a person accomplishing a set goal or purpose. Likewise, properties of the source domain are projected onto the target domain; the character features of a traveller who gets tired or who pushes on regardless are activated in terms of the hardships of life. In a similar vein but more broadly, knowledge is transferred from one domain to the other such that 'when a domain serves as a source domain for a metaphoric mapping, inference patterns in the source domain are mapped onto the target domain.'[99]

As long as we read a high degree of flexibility into this schema it can also cope with the interactive claim of surplus meaning. Where Lakoff and Turner are more exciting is in their summary of the 'sources of the power of metaphor.' They list five main grounds for the rhetorical force we note in metaphor: (1) The *power to structure* makes it possible for metaphors to provide concepts with patterning beyond what they provide by themselves. (2) The *power of options* allows us to specify conceptual schemata in a variety of ways. This offers the opportunity for nuances at different levels of specificity. (3) The *power of reason* in metaphor increases our toolkit of argument and explanation in relation to others and ourselves by letting us draw inferences from domains outside the immediate semantic range of the concepts used. (4) The *power of evaluation* refers to the ability of metaphors to carry evaluative ingredients into the source domain beyond its standard semantic field. (5) The *power of being there* refers to the idea that the availability in our vocabulary of conventional conceptual metaphors makes them powerful as 'conceptual and expressive tools' (64–5).

Less convincing is the distinction between conceptual metaphors and image metaphors. 'A lifetime is a day' and 'life is a fire' are regarded as conceptual metaphors in that they map 'concepts onto other concepts,' while the expression 'my wife ... whose waist is an hourglass' is seen as an image metaphor in which we are dealing with a process of reciprocal projection of images (89). This seems arbitrary. Why should the concept of a day be less dependent on nonverbal signification than is an hourglass? At the very least the difference has to be one of degree on a broad spectrum of concepts more or less immediately rooted in non-verbal signs. The separation of concept and image in natural languages must be rejected even for abstract terms in a corporeal semantics.

Although, in comparison to theorists who regard metaphor as a marginal phenomenon, Lakoff and Turner defend the ubiquity of metaphor their position is by no means radical. Commenting on the 'it's all metaphor' position they distinguish a weak and a strong thesis. According to the weak thesis, which they accept, 'every linguistic expression expresses a concept that is, at least in some

aspect, understood via metaphor' (134). The strong thesis, that there is nothing outside metaphor, they discard. Lakoff and Turner reason that metaphors allow us to understand one domain of experience in terms of another. To serve this function, they say, there must be some grounding, some concepts, not completely understood via metaphor, to serve as source domains. There seems to be no shortage of such concepts. Grounding concepts for them are to be found in plants, departures, fire, sleep, locations, seeing, and so on (135). One suspects at this point that the authors are not clear about the metaphysical position they wish to hold and what role significatory practices such as language play in their ontology. From what they say they could be regarded as realists or perhaps inferential realist, less likely constructivists, and obviously not radical relativists. Nevertheless, no semantics can avoid addressing the question of its implied metaphysics without risking fundamental inconsistencies.

Lakoff and Turner also appear to underestimate the long-term evolution of language. If we take a broad view of the historical trajectory of expressions in any language, their metaphorical roots become evident. In the composite nature of the forerunners of 'departure,' for example (*dis-part-ire*, separating and going), we note that there are still traces of the earlier images that gave rise to the term. The metaphorical root is obvious in 'window,' the eye of the wind, perhaps less so in 'plant' (*planta*, sprout, cutting). Here too, however, the mapping of an activity (planting) onto an object, is traceable to early significations of nature and agriculture. The etymological labour required to make the point should not obscure the deep metaphysical roots discoverable in all natural language expressions. Certainly the idea of grounding terms outside metaphorical processes appears highly problematic. The assumptions underlying such a position seem to have spilled over from formal systems but do not apply to natural languages. Ultimately grounding cannot lie in language itself but only in its linking processes with non-linguistic sign systems, such as the tactile, visual, aural, gravitational, olfactory, gustatory, thermal, haptic, and other primary significations. In this corporeal sense, language looks far less independent from 'images' than the 'linguistic turn' allows for.

Lakoff and Turner refer to two metaphors for understanding – as seeing (94) and as grasping (129) – without noting the metaphorical roots of 'understanding' in the sense of standing underneath something and so to carry it with us as it is. In the German *verstehen* the active prefix *ver-* is attached to *stehen* (standing), indicating that we stand in an active relation to an object, something that is thrown against us (*ob* and *iacere*). In this sense the 'carrying away' of signification from one domain to another is present ultimately in all expressions, albeit only as remote traces in some linguistic forms, such as in syncategorematic expressions or function words.

Such arguments do not, of course, resolve the issue. Rather, they postpone the distinctions still to be made between expressions that are more obviously metaphoric and expressions that are minimally so. On the one hand, the clear-cut identification of what is metaphoric and what is not is no longer an option; differentiations are now made on one and the same scale. On the other hand, and significantly, the entire discussion is moved from the domain of language to the much broader arena of general semiosis, of which language is a part. Only at the level of the relationship between the verbal and the non-verbal can we trace the degree of metaphoricity which still attaches to all natural language expressions.

In *Metaphors We Live By* and 'Conceptual Metaphor in Everyday Language' Lakoff and Johnson shore up the pervasiveness argument in terms of how metaphors structure our experience and how truth-conditional theories miss the point because they are bound to take the notion of literal meaning as their starting point.[100] The related extended claim that metaphor has a significant cognitive function in our conceptualization of reality can be found in Douglas Bergren's 'The Use and Abuse of Metaphor,' Warren Shibles's 'The Metaphorical Method,' Richard Boyd's 'Metaphor and Theory Change,' Mark Johnson and Glenn Erickson's 'Toward a New Theory of Metaphor,' Janet Martin and Rom Harré's 'Metaphor in Science,' and Jerry Gill's *Wittgenstein and Metaphor*.[101] In Carl Hausman's *Metaphor and Art* the claim reappears in radical form: 'Creative metaphors are the cutting edges of knowledge.'[102]

The ubiquity thesis of metaphor can be corroborated also with reference to Wittgenstein's later work. Jerry Gill makes just such a case, his central claim being that 'Wittgenstein views philosophy as an essentially metaphoric activity' and that 'the primary significance of Wittgenstein's work for philosophy lies in his suggestion that at the most profound level philosophy is a metaphorical enterprise.'[103] Given this conviction it is not surprising that *Lebensformen* are granted a prominent place in his reasoning.

If we agree with Gill that Wittgenstein's 'forms of life' is 'his most crucial epistemological contribution' (136), a view I have supported elsewhere, then it makes sense to foreground the features of his later writings which address the links between the rock bottom of our understanding and language. Wittgenstein speaks of the *Lebenselement* 'in which arguments have their life.'[104] This slant is evident also in *Wittgenstein and Metaphor* in Gill's summary of the later Wittgenstein, which he presents in the form of three succinct theses: world and mind are symbiotic; knowledge exceeds language; and tacit knowledge is best expressed indirectly, for example by metaphor (191). The first is reminiscent of Kant's arguments in the schematism chapter of the *Critique of Pure Reason*, the second reflects a radical deviation from the linguistic turn in philosophy,

and the third draws the procedural consequences of the others. The last claim is of key importance in Gill's account. He believes that in Wittgenstein's mature works 'metaphoric expression runs deeper than propositional expression,' that indeed we are dealing with a 'philosophy "by Invitation,"' which asks us to explore 'by means of a fresh set of metaphors.' And it is metaphor which brings us 'closest to the bedrock of our form of life' (205). Considering his starting point it is not surprising that Wittgenstein arrived at his insights into the non-linguistic bedrock of language only towards the end of his career. An intersemiotic approach is able to take those insights aboard as part of its premises. *Lebensformen* can now be defined as culture-specific clusters of non-verbal sign practices which determine the character of language games.

A recent contribution to the discussion of the pervasiveness of metaphor has come from poststructuralist writers. In fact one could read Jacques Derrida's 'White Mythology' and 'The *Retrait* of Metaphor' as in-depth explorations of Wittgenstein's tentative observations.[105] Not only is all conceptual endeavour argued to be profoundly and irrevocably metaphorical but metaphoricity becomes the groundless ground in which both our metaphors and concepts, whose metaphorical origins we are in the habit of denying, have their ultimately untraceable origins. *Metapherein*, a certain carrying away from where we seem to start, remains inescapable. Speaking of 'all the metaphorical possibilities of philosophy' Derrida insists that 'one metaphor, at the very least, always would remain excluded, outside the system ... the metaphor of metaphor.' Both the inquiry and its target remain incomplete.[106] Derrida speaks of a withdrawal not only of the metaphorical but of metaphoricity in 'The *Retrait* of Metaphor.' As we attempt to get a conceptual grip on the metaphorical traces of language they withdraw, but the withdrawal itself 'is no more proper or literal than figurative ... Withdrawal is neither thing, nor being, nor meaning. It *withdraws* itself both from the Being of being as such and from language, without being or being said elsewhere; it incises ontological difference itself.'[107] The debt to Heidegger throughout the paper is evident. Language is seen as only one domain in which the forgotten split of Being from being, the ontic–ontological difference, appears. Put simply, metaphor is one of the figures which reminds us of the incompleteness of language. Any homosemiotic explanation denies this fundamental feature. And although an intersemiotic perspective can show where language finds the resources which make linguistic schemata meaningful, Derrida's Heideggerian observation still applies: the significatory chain cannot be terminated logically. In fact logic requires its perpetuation. Only the politics of use can put a stop to semantic wanderings.

Derrida's return to Heidegger at crucial moments in his theorizing is well documented.[108] Yet there is a specific starting point which appears to inform much of Derrida's perspective on language, the passages in *Being and Time*

where Heidegger introduces his notion of the as-structure as fundamental to signification: 'That which is *explicitly* understood – has the structure of *something as something* ... The "as" makes up the structure of the explicitness of something that is understood. It constitutes the interpretation.'[109] Understanding without an interpretive 'as' occurs in 'the kind of seeing in which one *merely* understands.' If the 'as' is ontically unexpressed, warns Heidegger, 'this must not seduce us into overlooking it as a constitutive state for understanding, existential and *a priori*' (190). Linked with the triple fore-structure as a necessary condition of understanding, meaning as defined by Heidegger is 'the "upon-which" of a projection in terms of which something becomes intelligible as something; it gets its structure from a fore-having, a fore-sight, and a fore-conception' (193). The fore-structure of all understanding renders hermeneutic 'circularity' inescapable, a fact concealed in formal and narrowly technical description. Heidegger therefore distinguishes the existential-hermeneutical 'as' from the apophantical 'as' of assertion (201).

The role metaphor plays from the Heideggerian perspective is to problematize the 'as' structure of meaning. *Vorhabe, Vorsicht*, and *Vorgriff* become increasingly tentative the more innovatively radical the metaphor in question, to the point at which the 'something as something' fails. If we speak heterosemiotically, Heidegger's as-structure finds support in the fact that the 'as' can be shown to operate across different semiotic systems. We try to visualize things which we touch in the dark, we strain to smell the vapours we see, or we imagine the weight of something before we lift it. Bedell Stanford records John Locke's observation of the blind man 'who fancied that the *idea* of scarlet was like the sound of a trumpet.'[110] Stanford gets fairly close to an intersemiotic theory of metaphor when he introduces metaphors such as 'the *scarlet music* of Dvořàk' (47).

Stanford suggests that 'synaesthesia in words is a survival of the physical synaesthesia of primitive man when sense perceptions were far keener and far more efficiently co-ordinated than in more domesticated times' (56). From our perspective it is a pity then that Stanford views such 'synaesthetic or intersensal metaphor' as a borderline phenomenon (47ff.). A more radical position is required, one which regards metaphor as the sort of language schema which intensifies our imagination of possible connections across diverse semiotic domains: a husband 'as' a pig, at least in certain respects; a ship 'as' something that 'ploughs' the sea; Sally 'as' a block of ice; Kant's second argument for the transcendental deduction 'as' so much sandpaper; John's vomiting 'as' his driving the big white porcelain truck.[111]

Generalizing from Derrida and Heidegger, one could say that humans are signifying creatures who stand in a fundamentally metaphoric relation to a reality which remains forever textual, in both the linguistic and non-linguistic

sense. The ubiquity thesis of metaphor can be placed in this larger picture. But why should this emphasis be so important for the corporeal perspective of meaning advocated here? The following reasons seem to be the most urgent. Since Frege's influential conflation of formal sense and non-formal sense, the latter of which also gives rise to metaphorical meaning as an especially illuminating case, propositional explanations of meaning have been dominant.[112] In this view everything we can know and reason can be put in the form of sentence meanings, anonymized, idealized, and so modally neutralized. As a result the propositional, modal, and semiotic opacities which I have argued attach fundamentally to all language have been eliminated, leaving a meaning compliant with formal expectations.[113] Yet as Wittgenstein reminds us, the crystalline clarity of the formal is not so much the result of an inquiry as the requirement for a procedure. And since the formal is in the first instance a derivation from the discursive we should not be too surprised to rediscover it even in the most elaborate forms of discursivity, such as in metaphor. By doing so, however, we are not capturing its features but only the formal characteristics of metaphor, an insufficient set of aspects which do not allow a reconstruction of the phenomenon. Formalization is a one-way street.

Furthermore, if everything is propositional we are inclined to follow the Carnapian route in discovering the 'logical structure of the world' instead of our logical construction of it. We may even feel inclined to equate this perspective with what we think the world is 'in essence.' Thus we have proceeded from a significatory practice to a metaphysical commitment, with a naïve realist position as its result.[114]

One could say that the ubiquity claim for metaphor entails a reversal of the relation between formal and non-formal sense. In its strong form, if metaphor is all pervasive, if there is nothing but metaphor, propositional meaning and formal sense become a special case of discursive meaning, its stripped cousin. A foregrounding of the discursive, and hence also of metaphorical meanings, bars us from entertaining any naïvely realist metaphysics because the tentative construal of metaphorical meanings by definition disallows any representational certitude. The relation between world and language has become problematic. This allows for a range of metaphysical commitments, from a Kantian inferential realism, via various forms of textualism, to the kind of radical relativism some writers have read into Nietzsche's celebration of metaphor.[115]

Lastly, while formal sense remains confined within its homosemiotic arena, the system of formal signs within which it is definitionally located, metaphor requires a larger explanatory frame. When the definiens and definiendum are

collapsed, as tends to be the case in analytical approaches to metaphor, that requirement has been violated. This is crucial for my own position on metaphor: only a description of metaphor as a non-formal phenomenon will be able to accommodate the features I believe have not been captured in the dominant discourse on metaphor. Missing in particular are the directional nature of language and the non-linguistic semiosis which we employ in concretizing its schemata. While this is a problem for the description of all natural language phenomena, in the discussion of metaphor it is a fatal flaw.

Beyond the Linguistic

With the exception of certain self-referential cases, riddles cannot be solved if we stay strictly within the linguistic. Rather, we explore a range of situations imaginatively, giving rein to our non-verbal significatory faculties. If Aristotle's hunch that metaphors are like riddles is worth pursuing, then metaphor should be viewed in similar fashion. Its linguistic structures act as directional schemata for the actual work to be performed: the non-verbal significatory exploration of its possible projections of part of a 'world.' Pointing to the limitations of descriptions of metaphor as linguistic entities is of course nothing new. In the following I will address some approaches that transcend linguistic explanations, after which we will be in a better position to consider an intersemiotic view which goes well beyond such critiques.

Paul Ricoeur's *The Rule of Metaphor* offers a discourse-oriented approach. Two features in his work are of special interest to us: his emphasis on the referential function of metaphor and his view of the special nature of the metaphorical copula. Subordinating the semiotic to the semantic, Ricoeur insists that we need a theory accounting for 'application' that 'carries us across the threshold from *sense* towards the *reference* of discourse.'[116] This is an important move in that our focus is shifted from looking primarily at the internal linguistic and formal mechanisms of metaphorical expressions to their projected states of affairs. Reference is not altogether absent from a number of analytical theories – it is necessary for both Searle and Max Black, for example – but is seen more as a secondary feature of metaphor than as central property. In Ricoeur's discourse theory of metaphor what the metaphorical expression is about, how it refers to discourse at large and through it to the 'world,' takes on special significance.

As for its internal mechanisms, Ricoeur suggests that metaphor generates meaning via 'impertinent predication.' Here the focus is on the special role of the metaphorical copula. Contrary to its cousin in standard expressions the copula in metaphor complicates the resemblance and difference relations

between subject and predicate. In this Ricoeur foregrounds the paradoxical character of metaphor: 'There is no other way to do justice to the notion of metaphorical truth than to include the critical incision of the (literal) "is not" within the ontological vehemence of the (metaphorical) "is."' In this he 'draws the most extreme consequence of the theory of tension' without, however, remaining within the confines of such an approach (255).

It is disappointing in Ricoeur's presentation that although he shakes off the antireferential shackles of the Saussurean tradition, his definition of discourse is still locked within linguistic confines and shut off from non-linguistic signs in the fashion of Emile Benveniste. In making discourse rather than sentences the basis of his inquiry Ricoeur goes only half way. He is certainly right when he says that 'words have no proper meaning' in themselves but that 'it is discourse, taken as a whole, that carries the meaning, itself an undivided whole' (77). But how does discourse manage to incorporate the 'world' in a way that language does not? How does discourse relate to non-verbal signs?

My contention is that even discourse cannot carry meaning if discourse is described in linguistic terms as no more than language as social practice. It is the relation between discourse and non-linguistic sign systems, which gradually shifts along historical trajectories, that allows the event of meaning to occur in each instance. That discourse is systemic is not in dispute, but Ricoeur's notion of discourse as language in action, which he borrows from Benveniste (67ff.), is open to challenge. This description allows for a semantics of utterance within the horizon of discourse at large but fails to say where reference is to be located. If discourse refers to the world, as Ricoeur suggests it does, we need to know whether the referring act points outside discourse or whether the world is contained within discourse, in which case reference remains an internal relation. Expressed intersemiotically, if reference is an act of transgression of discursive boundaries, we are dealing with a heterosemiotic relation; if reference is an internal act of linkage within discursive boundaries, within language in action, then we are dealing with homosemiotic reference. Pending our reading of 'world,' Carl Hausman offers a more promising view of metaphoric reference when he speculates that 'evolution in the world as well as evolution in thought and language is the outcome of metaphorical interaction that is adequate and effective because it is referential.'[117]

Since in Ricoeur's case meaning is constituted within the 'undivided whole' of discourse and metaphoric meaning is referential, reference must be intradiscursive and thus homosemiotic. This makes it impossible to incorporate non-linguistic signification inside discourse, such as gustatory, visual, gravitational, thermal, haptic, olfactory, proximic, tactile, colour readings, and other interpretive non-verbal acts. To the degree to which

they can be 'incorporated' in discourse they have to be transformed into linguistic signs, leaving the actual non-linguistic signs to some other domain or else to some kind of unmediated physicalist or naturalist explanation. This is not a satisfactory description of what goes on in social semiosis at large, either. We need to accommodate heterogeneous kinds of sign systems, verbal and non-verbal, which by interacting fill the significatory horizon of our world. And somehow metaphor needs to fit persuasively into the picture.

Another attempt at overcoming the linguistic bias can be found in the work of Susanne Langer. 'A metaphor is not language,' she writes, but 'an idea expressed by language, an idea that in its turn functions as a symbol to express something.' Beyond Ricoeur she contends that metaphor 'is not discursive and therefore does not really make a statement of the idea it conveys.' Rather, 'it formulates a new conception for our *direct imaginative grasp*.'[118] Perceptual explanations such as Marcus Hester's 'Metaphor and Aspect Seeing' and Virgil Aldrich's 'Visual Metaphor' support a similar emphasis on visual and imaginational labour.[119] Not supplied in any of these three works is a comprehensive semantics which would clarify the relation between language and 'world' and the role that our direct imaginative grasp plays in this relation.

Compatible in principle with an intersemiotic theory of metaphor are phenomenological approaches such as those of James Edie, George Yoos, and, in a different vein, William Gass.[120] Phenomenological perspectives have inherited two drawbacks from Husserl, however. The first is the eidetic conviction about sentence meanings which Husserl adopted in response to Frege's early critique of his habilitation thesis and which he was reluctant to let go even when his interest in the *Lebenswelt* demanded a shift from eidos to typification. And even Merleau-Ponty, who reinstated the body in Husserl's geometry of experiences, failed to jettison the master's eidetic emphasis in the description of language. It was left to Alfred Schutz to embrace the transition. The second drawback is the notion of 'experience,' which in much post-Husserlian writing loses the subtlety of Husserl's noematic–noetic distinctions and so ironically parallels the use of the realist and naturalist concept of 'world' to account for meaning. Phenomenologists are not often associated with empiricists in this way, yet both duck the question of how a significatory system such as language can be linked with something non-significatory. Perception, experience, and world need to be translated into signs before the link can be made. Paradoxically, two philosophical traditions – one following Frege, the other Husserl – by committing themselves to opposite positions commit similar errors: the assumption of ideality in natural language meanings and of the possibility of non-significatory phenomena. On the other hand, a great deal in the Husserlian tradition can be adopted to strengthen an intersemiotic perspective.

The Corporeal Roots of Metaphors of 'Understanding'

The following does not focus on semantic universals, of which metaphors of 'understanding' are examples, but on a cluster of metaphors chosen to illustrate the close relation between linguistic expressions and non-linguistic signs, without which words would remain unintelligible. Many metaphors of understanding across a broad spectrum of languages reflect physiological processes engaged in the act of making sense of something. More abstract terms for understanding also exist and appear to be derived from the history of philosophical thought, but even these can be shown by way of a more elaborate argument to 'remember' their links to the human body. The arbitrary choice of one semantic field across natural languages corroborates the claim that the intersemiotic and heterosemiotic approach advocated here is not culture specific but is valid for natural languages in principle.

The Thai phrase *khwam khaojai* suggests that in the act of understanding, the gist of something enters the heart: *khwam* (sense, gist); *khao* (to enter); *jai* (heart). The implication, it seems, is that we understand things well once they have been taken to the centre of the body. This looks like an intense version of the Sanskrit-derived metaphors for understanding as grasping (from *grah*). Other Sanskrit root metaphors for understanding include *labh* (possessing, obtaining) and *anubhu* or *anubhava*, which refer to perceptual readings.

The European, Sanskrit-derived metaphors for understanding all display variants of tactile signification. In the Germanic *understanding* and *verstehen* we note an emphasis on the proximic, an indication of body stance in relation to the thing to be understood. *Grasp* and the German *begreifen*, on the other hand, highlight the tactile activity of touching and getting a grip on something to make it intelligible. Likewise familiar are the Latin branches of the Indo-European language tree, with such French and Italian forms as *compréhension* (*comprendre*) and *comprensione* (*comprendere*), in which the prefix *com*- foregrounds the intersemiotic acts of various tactile operations acting in unison. Similarly, *concevoir* and *concepire* recall the synthesizing act of getting hold of something by means of a concerted activity, resulting in a unified item of understanding. *Embrasser* and *abbracciare* achieve a similar effect of inclusive understanding, except here the tactile signification is not primarily that of grasping hands but of arms and body enveloping an object. A variant of tactile semiosis in French is *toucher du doigt*, similar to the English *to put one's finger on something*, suggestive of a subtle touch as sufficient for the production of meaning.

In Russian the following forms all employ the tactile as their semiotic base: *ponyat* (to understand, with the suffix *-nyat*, to seize, take, get); *khvatit'sya* (to

discover suddenly, to remember, with the prefix *khvat'*, grab, seize); *skhvatit' skhodstvo* (to catch a likeness); *skhvatit' mysl' na letu* (to catch a thought as it flies, seize on an idea); *on bystro skhvatyvayet* (he catches on quickly). The Polish *pojmowanie* (understanding), with the verbs *pojac* and *pojmowac*, and *pojecie* (concept, notion), have the act of embracing as their root metaphor. Tactile semiosis is also at the base of *chwytac* and *uchwycic*, the Polish version of grasping, as in the phrase *chwytac w lot* (to understand quickly, literally 'in flight').

In languages not related to Sanskrit, such as Japanese, the body, perceptual grasp, and ideational operations are likewise implicated in the main terms for understanding. *Rikaisuru* (to understand, comprehend) refers to two roots: (1) reason, justice, truth, principle, universe, with its etymological base in patterns of gemstones, the making of gemstones, and sorting things out; and (2) untying, loosening, disentangling, solving, cancellation, with an etymological history in the act of dissecting a cow by hand or sword and analysing it. In the verb *ryokaisuru* (to understand, comprehend) the prefix *ryo-* adds an emphasis on completion. In the alternative form, *wakuru*, the initial kanji character *wa*, which now stands for divide, distribute, distinguish, has its etymological roots in cutting and dividing by sword. Lastly, *haakusuru* (to understand, hold, grip, grasp) is made up of a kanji referring to bundle or sheaf and one indicating the act of grasping. As in their European and Thai counterparts, both body and mind are salient features, with a variety of semiotic acts being presupposed. To divide objects with a sword allows us both to see inside and to transform what is complex into an intelligible order. Here the combination of tactile and visual signification is a precondition for understanding.

Most languages also appear to have alternative expressions which accentuate our reasoning faculties rather than perceptual semiosis. The Sanskrit *jna* (to understand, to know) and the Hindi derivations *jan jana* (understanding in the sense of learning, literally, 'to know know') and *artha lagana* (to interpret, to apply substance), as well as the Sanskrit nouns for understanding and intelligence *samajh, buddhi, akal, vivek*, and *vyapti*, suggest mental processes rather than sensory interpretation. In Polish this role is played by the noun *rozum* (reason, understanding) and the related verbs *zrozumiec* and *rozumiec*.

The point here is not to extend this collection towards a point of exhaustion but to emphasize the visibility of two foci in natural languages: a focus on the perceptual interpretation of the 'world' (including ourselves) in its intersemiotic and heterosemiotic forms; and a focus on the mechanisms of reasoning. The intersemiotic approach sketched below is an attempt to recover the repressed quasi-perceptual features of metaphor.

The Corporeality of Metaphor

O for a beaker full of the warm South.

John Keats, 'Ode to a Nightingale'

Standard theories of metaphor since Aristotle can be accommodated by a series of relations at the level of linguistic signs. Metaphor is typically represented as a combination of what seems to be (a) an identity relation (x = y), (b) a non-identity relation (x not y), and (c) a seemingly paradoxical *tertium datur* (a + b = z) able to reconcile the contradiction. From Aristotle's condensation and substitution notions to Max Black's interaction scheme and Searle's utterance explanation, theories of metaphor argue their diverse cases along these lines. And they all deliver some goods as long as the examples used are familiar expressions. In other words the above formal analogy reflects their homosemiotic descriptions: once semantics is resolved and we are able to make sense of the metaphor the merely linguistic explanation works and so seems to be able to demonstrate its validity.

The error lies in the assumptions that we can proceed in a linear fashion from seeming identity to non-identity and that the paradox can be resolved within the dictionary, i.e., within the domain of linguistic substitution. I suggest that the entire procedure skirts the question of how we constitute meaning. 'John copped a rabbit killer' is the sort of example which alerts us to a more devious route via non-verbal signs. If we are not quite sure what the expression means, we employ our ability to vary imaginatively a number of non-linguistic scenarios which are likely to illuminate our understanding. To get to what it is that John 'copped' we tend to imagine typical ways of killing rabbits. Once we have done so perhaps more familiar expressions, such as 'rabbit blow' from the language of boxing, and their non-verbal realization act as bridges. The habitual semantics of expressions hides this procedure. If we formalize the principles involved in this intersemiotic picture, we arrive at a structure of the three steps of metaphoric meaning:

Given a linguistic text (1)

T: x → y → z
 My husband [is and is not] a pig ?

we do not proceed directly to z but first produce (2) *Vorstellungen*, a non-verbal picture

P: m → n → p
olfactory, visual, tactile, a mental experiment playfully
proximic, etc., signs allowing combining m and n into
the mental, schematic a picture of a swinish sort
representations of 'husband' of 'husband' in which we
and 'pig' anthropomorphize pigs and
 turn humans into animals

Having established the experimental mental picture p we are now in a position (3) to perform z, a linguistic paraphrase of the meaning of 'My husband is a pig.' Metaphoric meaning occurs as the necessary interaction of T and P. Likewise for all language.

What meaning we attach to the linguistic signs can be accessed only via the detour of non-linguistic signification. Unfamiliar metaphors foreground this otherwise veiled process. In the simplest terms, we understand x because we are able to activate it by means of m or, expressed in 'object' terminology, the verbal signifier x makes sense only by way of a cluster of non-verbal significations m. Likewise, we construe a meaning for y by activating it with the help of n. This construction sometimes remains tentative until we are clearer about p. What is a rabbit-killer: what are we to make of z? If we do not have a habitual signified for the term, we explore, by way of non-linguistic free play, typical situations to do with the killing of rabbits. From our non-linguistic grasp of such situations we settle on the social act of a blow to the neck. From this level of non-linguistic quasi-corporeal construction we can now ascend to the definitional level, or dictionary substitution, of 'blow to the neck.'

At this point I must attempt to fulfil two promises made in relation to Searle's account. First, I wish to reply to his rejection of the interaction thesis. The idea that 'different combinations of S and P create new R's,' says Searle, is false. Rather, 'different S terms restrict the values of R differently.'[121] If we take the values of S and P to be different clusters of non-linguistic signs, then we can say that their interaction allows us to imagine a new sign cluster with the help of which we can posit a new R. As well, Searle's preferred formulation can be said to amount to much the same thing, if we can make 'different S terms restrict' to mean 'act as distinct, directional schemata for our exploration of non-linguistic signs.'

As for my second promise, we saw that Searle's account failed to explain the meaning of the expression 'John's driving the big, white porcelain truck' because his theory did not address the relation between S, P, and R on the one

hand and their values on the other. He assumes the relation to be unproblematic. I suggest that one of the intriguing characteristics of metaphor is that it makes problematic precisely this relation. Without our imaginative variation of non-linguistic significations, Searle's 'values,' we have no way of getting from the S P-relation S to the S R-relation S. If, however, we activate visual, tactile, motoric, gravitational, and other non-verbal significations typically associated with trucks in relation to the non-linguistic signs we associate with parties, the social context of the utterance, then we are much more likely to be able to imagine poor John in an unenviable position in the bathroom on his knees, his arms around the toilet bowl. Once we have fantasized in this direction, i.e., have engaged in imaginative, non-linguistic labour, verbal substitutes offer themselves: the S R-relation S can be resolved.

Predictably, we are able to conclude that complex metaphors require a rich kind of interaction, not between definitions but between (a) signifier and clusters of non-linguistic signs, (b) the clusters of non-linguistic signs associated with each term, and (c) diagonally, between the linguistic signs and all the non-linguistic clusters associated with individual language expressions. If interaction theories are rephrased in such intersemiotic terms, I suggest, they can be made more persuasive.

The same criterion applies to my own emphasis on the directionality of meaning. If a directional theory of meaning is offered in homosemiotic terms, we remain within the confines of the linguistic mechanisms, which we are able to abstract from our knowledge of how a familiar metaphor works. Yet if we are unsure of its meaning this method is not accessible because it is a rationalization from hindsight.

Conclusion

If the activity of meaning-making is a quasi-circular hermeneutic in Heidegger's sense, if it always requires a degree of imaginative exploration of the horizon of our 'world,' then such an activity cannot be merely linguistic. The assumption here, of course, is that 'linguistic' means the relation between language expressions and the dictionary. Instead, meaning-making draws on all the significatory systems at our disposal. Metaphors, and especially novel metaphors, highlight this situation. Not surprisingly perhaps, the theoretical reconstruction of the hermeneutic exploration which results in the construal of metaphorical meanings turns out to be a transcendental process, an investigation into the conditions which must prevail for such meanings to be possible. In this we reflect on the technique of inventing rules as we play with intersemiotic and heterosemiotic relations that yield satisfying, semantic results.

In Kantian terms we employ a form of reflective judgment. An approach to metaphor invoking reflective reasoning has been attempted by Mark Johnson in 'A Philosophical Approach to the Problem of Metaphor.'[122]

An intersemiotic picture of how metaphor works stands in opposition to theories which attempt to describe metaphor at the linguistic and definitional level of signification. It requires a reassessment of the traditional emphasis on the content of metaphor, as compared and condensed, substituted, diverse, nonsensical and sensical, uttered, and interacting content. The position advocated here also demonstrates that the Fregean conflation of definitionally ruled sense and the sense of natural language expressions is fatal in a comprehensive description of natural language.

From the corporeal perspective chosen the following features of metaphor have been elucidated. (1) Metaphors are directional schemata which act as instructions for pathways towards new meanings. Novel metaphors demonstrate the need to take semantic detours via a number of non-linguistic significations before we are able to construe verbal texts about what these metaphors mean. Unlike formal and technical expressions, metaphors are characterized by what one might term their multiple pathway function. Metaphorical expressions appear to maximize the principle of negotiation and minimize directionality; their technical counterparts minimize negotiation and maximize directionality. (2) Metaphors require us to rethink reference in terms of heterosemiotic mediation between different sign systems such that, for example, the visual makes the verbal sensible, the tactile provides semantic stability to the visual, and so forth. What is actually being linked, then, are not diverse expressions but disparate non-linguistic semiotic domains. Metaphors make us relate to the signified 'world' in an unfamiliar manner. On the other hand, familiar language use is no more than habitual ways of linking diverse semiotic regions. Powerful metaphors stress the heterosemiotically relational nature of consciousness. Weakened metaphors, such as 'dead end,' tend to camouflage this relation. (3) Metaphoric 'content' reappears in a different guise. It *accrues*, as it were, in two related ways: intersemiotically, as the result of sign corroboration; and heterosemiotically, in that the various sign systems called upon are not naturally completely aligned but, since they can never be fully commensurate with one another, are wrenched into semantic alignment in use. (4) Our habitual response to 'dormant' or 'dead' metaphors suggests the sufficiency of homosemiotic readings as well as the possibility of a homosemiotic semantics. Novel metaphors destroy this illusion and demand the restoration of the body eliminated from semantics.

4

Meaning and Poststructuralism

4.1 TRANSCENDENTAL MOVES

In this chapter sections 4.2 and 4.3 single out two representatives of recent French theorizing, Jean-François Lyotard and Jacques Derrida, to demonstrate that in spite of their distinct ways of viewing language, they contribute to that branch of language philosophy which emphasizes the elaboration rather than the curtailment of signification. Both could be regarded as historical frontrunners at the end of a chain of hermeneutic arguments, except that neither focuses primarily on interpretions that illuminate a lost past but rather on certain consequences of the elaboration of meaning. Jettisoned is the project of meaning reconstruction; retained is a methodological inclination towards the celebration of semantic regress.

Lyotard and Derrida are not primarily interested in the question of meaning. What little significance can still be claimed for meaning nevertheless remains important for the broad picture presented in this book. Their respective interventions in the ways language has been viewed are indispensable examples if we are to include in that picture an argument about how the relation between semantics and syntax affects our view of the postmodern, a topic addressed in the last chapter.

Descriptions of poststructuralist theories tend to foreground the heritage of Hegel, Nietzsche, Saussure, Freud, Levinas, and parts of Heidegger, and with good reason. Differentiation, metaphor and figurality, *Nachträglichkeit*, alterity, and the ontic–ontological difference are prominent themes. Other features, however, should not be overlooked: the negotiation of meaning, infinite regress, constraints imposed by the community, exteriority in general, reinterpretation, and a method of retrogressive steps towards fundamental, even if 'empty,'

conditions. These issues rarely present themselves to the analyst as direct influences but as disseminated traces.

The secular hermeneutic tradition could be described as an acknowledgment of Leibniz's observation that truths of fact, unlike their logical cousins, are not self-evident but require an elaboration of reasons until social agreement is achieved. Translated onto the plane of semantics, this suggests that a semantics from outside a semiotic community, with its historically, geographically, or socially distant meanings, can be reconstituted to a high degree of intelligibility only by detailed semiotic interpretive procedures rather than by definitional transfer. In spite of their opposition to traditional hermeneutics, such poststructuralist theorists as Derrida, Deleuze, Foucault, and Lyotard can all be said to have refined, in very different and radical ways, the Leibnizian chain of reasoning.

Kant further assisted the birth of secular hermeneutics in two important ways: by his emphasis towards the end of the *Critique of Pure Reason* on the merely heuristic nature of all concepts except formally stipulated ones, by his formulations concerning reflective reasoning, and by his transcendental method. If 'an empirical concept cannot be defined, but only explicated,' the logical limits for such explications remain open. Furthermore, if the concept 'never stands between secure boundaries,' 'the alleged definition is nothing but the determination of a word,' and, most important, 'the completeness of the analysis of my concept is always in doubt,' then both the frame of our interpretations and their content forever require reinterpretation without guaranteeing definitional certitude.[1] I will address the prominence of transcendental procedures in poststructuralist writings below in my comments on Deleuze, Lyotard, and Derrida.

If, since Kant, concepts wobble, then all interpretation is affected by this new instability. To counter it theorists since the early 1800s have tried to design measures to shore up the interpretive process. Their main device has been the notion of interpretive circularity, which comes from moving between the stipulation of a contextual totality and the reading of a specific expression. In 1808 Friedrich Ast spoke of such a circle as occurring when 'the individual part can be understood only by way of the whole and the whole is intelligible only by means of the particular.'[2] This was echoed by Friedrich Schleiermacher in 1835 when he asserted that 'the particular can be understood only by way of the total and hence any explanation of the particular already presupposes our understanding of the whole.'[3] In this Schleiermacher's main focus was on language and on the way our conception of language should be able to produce a coherent interpretive method. Schleiermacher, especially, had great hopes for

hermeneutics as a theory for the interpretation of the arts. Hermeneutics could be turned into a specialist tool for interpreting the arts by evolving its rules in a cohesive fashion out of the nature of language and the basic conditions of the relation between utterers and receivers (165).

A further significant development in hermeneutics is Wilhelm Dilthey's combination of interpretive circularity and Schleiermacher's focus on the nature of language. In 1924 he emphasized the semi-determinate character of linguistic expressions. 'The sequence of words' is given, and each word is 'determined–indeterminate.'[4] It contains a 'variability of its meaning.' Furthermore, the syntactic relations of those words are 'polysemic within firm boundaries': meaning is the result of the determination of what is indeterminate by the construction. Likewise, the part–whole composition of the utterance is polysemic within definite limits and determined by the whole (220). A strategic step beyond the confines of the determined whole of a given text is Dilthey's proto-Heideggerian insight that any such whole 'is grounded in the nature of living experience,' so that 'what we set as a goal for the future, conditions the determination of the meaning of the past.'[5] Meaning in Dilthey is not restricted, then, to the meaning of linguistic expressions but is viewed more broadly, allowing for the non-verbal. Since meaning is the result of interpretive elaboration and always 'arises from man's involvement in the world,' Dilthey 'thought it misleading to talk about *the* meaning of anything.'[6] Nor could he, unlike E.D. Hirsch, who follows the early Husserl, separate meaning neatly from significance. For Dilthey every act of meaning constitution always stands in the larger context of lived experience, the description of which always remains an incomplete task and escapes definitional certitude.

Hans-Georg Gadamer's hermeneutic resumes the Kantian theme of fuzzy concepts when he speaks of 'die Naivität des Begriffs' (the naïveté of the concept).[7] Beyond the basic instability of our concepts, Gadamer also addresses some broader issues which critically affect interpretation, such as 'the prejudices that we bring with us.' They make up 'the horizon of a particular present, for they represent that beyond which it is impossible to see.' This horizon 'is being continually formed' and 'cannot be formed without the past.' As a result, understanding is always the consequence of 'the fusion of these horizons.'[8] For Gadamer the fusion of horizons is 'the task of effective-historical consciousness,' which he regards as 'the central problem of hermeneutics.'[9] Gadamer owes more to Heidegger's Being and Husserl's noema for his view of the relative stability of meaning than he does to the promise of insufficient reason. In poststructuralist theorizing, by contrast, the destabilizing ingredients of the hermeneutic tradition, as well as a host of other inspirations, have taken centre stage.

I have offered a critique of Husserl's noematic idealization elsewhere.[10] In Derrida Husserl's notion of noetic modification lives on as a focal point. Shifting the weight of the argument from noematic certitude to noetic modification of linguistic expressions leads us to foreground conceptual marginality over semantic centrality. If at least part of Derrida's work can be regarded as a radicalization of the noetic Husserl over his noematic preferences, the early Deleuze's critique of phenomenological signification can be seen as having retained Husserl's noema while transforming it into a virtual entity.

If we wish to express meaning in terms of the noema, then, according to Deleuze, we must rephrase 'noema' as a 'surface effect.'[11] Meaning for Deleuze does not exist 'either in things or in the mind' (20). Rather, he says, it 'inheres or subsists.' Thus the noema has an entirely different status which consists in *not* existing outside the proposition which expresses it – whether the proposition is perceptual, imaginative, recollective, or representative (21). When Deleuze speaks of propositions he either has a generous concept in mind, in which case he allows for the abstraction of non-verbal semiosis, or he assumes that such abstractions are able to produce a fully formal status, in which case the verbal and non-verbal are collapsed into the same formal schema. It is not entirely clear which reading Deleuze intended.

For Deleuze the same denotation can have many noemata, or meanings, such that 'evening star and morning star are two noemata' or 'two ways in which the same *denotatum* may be expressed in expression' (20). At the same time Deleuze retains the Husserlian conception of the noema as 'the intentional correlate of the act of perception.' Likewise, meaning does not 'merge at all with the proposition, for it has an objective *(objectité)* which is quite distinct' and 'has no resemblance whatsoever to the expression' (21). Meaning, for Deleuze, occupies a virtual space between propositions and the world in that it is *'both the expressible or the expressed of the proposition, and the attribute of the state of affairs'*; it 'turns one side toward things and one side toward propositions' (22). Expressed in terms of event, meaning occurs when different significatory systems interact such that the sense of, for example, 'tree' is achieved as a virtual entity between the world and propositions about it. This is why Deleuze can say that meaning is 'exactly the boundary between propositions and things' (22):

Sense is always an effect produced in the series by the instance which traverses them. This is why sense ... has two sides which correspond to the dissymetrical sides of the paradoxical element: one tending toward the series determined as signifying, the other tending toward the series determined as signified. Sense insists in one of the series (propositions): it is that which can be expressed by propositions, but does not merge with the propositions which express it. Sense crops up suddenly in the other series (states

of affairs): it is the attribute of states of affairs, but does not merge with the states of affairs to which it is attributed, or with the things and qualities which realize it. What permits therefore the determination of one of those series as signifying and of the other as signified are precisely these two aspects of sense (insistence and extra-being) and the two aspects of nonsense or of the paradoxical element from which they derive (empty square and supernumerary object ...). This is why sense is the object of fundamental paradoxes which repeat the figures of nonsense. (81)

Non-sense plays a central role in Deleuze's logic of meaning. He suggests that 'the gift of sense occurs only when the conditions of signification are also being determined' (81). If they are not, we become aware of the precarious border area, the aleatory point, where meaning is possible but not achieved, a 'region which precedes all good sense and all common sense' (79). Good sense could be read as qualitative identification of objects ad infinitum and common sense as quantitative identification of an object as a this–there (cf. 97). Humpty Dumpty indicates the possibility of semantic dictate, for he 'destroys the exercise of common sense' by allocating differences in a manner that removes 'fixed quality' and 'measurable time' from the object world (80). In short, Humpty Dumpty's rule replaces social constraints.

In consensus with pragmatics, Michel Foucault's elaboration of exteriority, and Lyotard's minimal requirement for a 'sentence' Deleuze insists on the triple relation of meaning to 'signification, manifestation, and denotation.' Meaning is to be understood 'in relation to states of affairs, to the manifested states of the subject, and to the signified concepts, properties, and classes' (96). In this sense, meaning is neutral. It is to be identified neither with 'the propositions which express it' nor with 'the states of affairs in which it occurs and which are denoted by the propositions.' As long as we remain within the purview of the proposition itself, meaning is an indirect inference. If we wish to apprehend it directly, we can do so only 'by breaking the circuit, in an operation analogous to that of breaking open and unfolding the Möbius strip' (123).

Meaning in Deleuze is both an effect and a precondition. On the one hand meaning is 'formed and deployed at the surface,' which is its transcendental locus (125). On the other hand the entire order of bodies, relations, and concepts 'presupposes sense and the pre-individual and impersonal neutral field within which it unfolds' (124). Meaning must also be distinguished from two kinds of representations, even if they are not thinkable without meaning. In Kantian manner Deleuze separates denotations as 'sensible representations' from significations as 'rational representations,' while meaning is itself an incorporeal event (145). Yet in spite of the neutrality of meaning and its

irreducibility either to propositions or to signifieds, the ties between meaning and the two kinds of representation are essential for our perception of the world. For example, 'the perception of death as a state of affairs and as a quality, or the concept "mortal" as a predicate of signification, remain extrinsic (deprived of sense) as long as they do not encompass the event of dying as that which is actualized in the one and expressed in the other' (145). This is of significance for any intersemiotic orientation in the theory of meaning in which the body plays a central role. While theories idealizing language rely on 'hypostatized significations,' whenever we confront the question ' "What is Beauty, Justice, Man?" we will respond by designating a body, by indicating an object which can be imitated or even consumed' (134–5). We quickly, says Deleuze, find something 'to designate, to eat, to break, which would replace the signification' (135).

Language requires 'the ground of bodies' (135) as 'sub-sense (*sous-sens*) or *Untersinn*' (136). Yet language is 'rendered possible by the frontier which separates it from things and from bodies (including those which speak)' (166). While pure propositions point to the void of empty signification, their opposite gestures towards the non-sense of an undivided *Untersinn*. In a certain sense the body is already 'language because it is essentially "flexion," ' while 'in reflection, the corporeal flexion seems to be divided, split in two, opposed to itself and reflected in itself.' This is why Deleuze says that 'if gestures speak, it is first of all because words mimic gestures' (286). The language of gestures precedes the verbal, just as gestures would not be thinkable without some *Untersinn*. In a sense 'everything is body and corporeal' (87). Bodies are seen in terms of depth, while meaning is virtual and pure surface. Meaning is always both 'the effect of corporeal causes and their mixtures' and the incorporeal cause and condition of the possibility of understanding (94). By contrast concepts at the level of philosophical argument are distanced from *Untersinn*. They are argued in *What Is Philosophy?* to be syneidetic rather than synaesthetic. This is where Deleuze and the present analysis part company. Syneidetic constructions presuppose the eidos of their components, a presupposition which can be argued coherently only in the domain of the formal. Even the most generalized notions of philosophy, since they are rooted in the contingent and in natural language, bear the synaesthetic traces of their diminished corporeality.

The style of Deleuze's argument in *The Logic of Sense* is transcendental, even if empirically so. 'The logic of sense,' he declares, 'is inspired in its entirety by empiricism' (20). This empiricism is transcendental in two senses. First, 'only empiricism knows how to transcend the experiential dimensions of the visible without falling into Ideas, and how to track down, invoke, and perhaps

produce a phantom at the limit of a lengthened or unfolded experience' (20). Second, 'empirical principles always "leave outside themselves the elements of their own foundation."'[12]

In contrast with the Fregean tradition in semantics of collapsing natural language sense into formal sense and definitional closure, Deleuze portrays the relations between signification, denotation, and manifestation in a highly complex manner. Above all, meaning appears as a virtual entity on a trajectory of infinite regress and so escapes definitional control. Sufficiency of reason confronts its shadows of definitional insufficiency. Nevertheless, there remains a certain formalism in Deleuze's early works which stands in sharp contrast to the conceptual experimentation in his later writing, co-authored with Félix Guattari, a discrepancy that deserves a separate investigation. The question of the definitional control of meaning is also one of the points of convergence in the writings of Deleuze and Derrida. In Derrida the pursuit of semantic instability reaches its climax in poststructuralist theorizing, and the way in which he proceeds bears more than a spurious resemblance to Deleuze's search for conditions which make certain concepts possible. Section 4.3 explores these two issues in detail by focusing on Derrida's influential paper 'Différance.'

On the surface at least the work of Lyotard does not yield easily to this kind of description. His association with the postmodern debate, his political interests, and his concern with ethical issues, especially in his theory of the differend, appear to position him more closely at the margin of poststructuralist themes. Yet it is precisely the theorization of the differend which necessitates an engagement with discourse and its effects and so suggests that his work is relevant to the topics canvassed here. It is of considerable interest to find out how Lyotard arrives at his general notion of agonistics via the route of sentences and how this affects semantics. Section 4.2 addresses this problematic by suggesting that the differend is the result of a concealed and incomplete transcendental argument which, in spite of its considerable interpretive usefulness, requires semiotic supplementation.

Other reasons why Lyotard is foregrounded include his emphasis on the minimal definition of a sentence as comprising at least a sense, a reference, an addresser, and an addressee. This separates what he is doing from the analytical orthodoxy of specifying only a subject and a predicate as minimal propositional ingredients. While the analytical definition allows sentence meanings to occur in isolation, Lyotard's starting point requires additional interpretive, inferential work on the exteriority of utterers and respondents. The point is, of course, that this interpretive labour does not stop at such constructions on any propositional level but extends to explorations into typical social situations within which sentences function.

Moreover, Lyotard's incorporation of any sentence into discourse regimens and discourse genres widens the gulf between analytical procedures and his own even further. Since discourse genres are in conflict with one another in his account, a further interdependency of an individual linguistic expression and its discursive background is introduced. The overall picture in Lyotard is a holistic one, even if it looks quite different from Heidegger's holism. Lyotard's minimal structure of the sentence reflects the Heideggerian parallel of predication (sense), pointing out (reference), and communication (addresser, addressee). In spite of such superficial parallels, however, Lyotard paints a picture which deviates sharply from those found in the hermeneutic tradition. Above all else his focus on the conflictual nature of diverse discourses distances him from the remainder of the tradition of elaborative interpretation. From an intersemiotic perspective on meaning we need to ask whether such discourses could be conflictual in the first place if they were merely linguistic structures and whether the conflictual arises only from the manner in which sentences are activated by non-verbal forms of signification. Lastly, we want to ask whether it is possible to argue coherently that the kind of picture we are offered in Lyotard is mere syntax, no matter how complex, rather than a semantics with deep roots in the corporeality of the social.

4.2 THE DIFFEREND AS SEMANTICS

The differend as formulated by Jean-François Lyotard is a useful heuristic tool for a broad range of critical practices. It is particularly well suited to a critique of textual violence committed on cultures and continents in the pursuit of various forms of domination. Anyone grateful to recent theory for having introduced us to fresh critical notions and so loosened the grip of traditional philosophical paradigms may therefore wonder at the motives of a work linking Lyotard's linguistic definition of injustice with Kant's transcendental procedure. If its purpose were to present Lyotard as a Kantian the reader's suspicion would be justified.

There are nevertheless some good reasons for a review of transcendental argumentation in the light of the differend. First, in *The Differend: Phrases in Dispute* Lyotard draws substantively on Kant's work in four separate and sizable 'Notices,' embedded in his texts at strategic moments.[13] Second, in Lyotard's other writings we find numerous references to Kant's work, not the least significant of which are Lyotard's numerous attempts at reworking the notion of the sublime and his recent, timely, *Lessons on the Analytic of the Sublime*.[14] Third, the gap between current theorizing and Kant's writings shrinks considerably when we remember the self-deconstructive move built into the *Critique of Pure Reason*,

where the author concedes that 'no concept given a priori, such as substance, cause, right, equity, etc., can, strictly speaking, be defined [and] the complete-ness of the analysis of my concept is always in doubt.'[15] From the moment of its inception the transcendental signified is understood as a somewhat fuzzy notion drifting away into infinite regress.

What I wish to demonstrate is that Lyotard's differend displays a degree of formality and universality which suggests a procedure of derivation, or in Peirce's terminology an abduction, not unlike that employed by Kant in the *Critique of Practical Reason*.[16] Furthermore, I think that as it is formulated by Lyotard the differend is 'incomplete.' As well I want to show that the differend cannot be argued only along the route of the structural agonistics between discourse genres, or a conflictual syntax of discursive formations, but requires a semantic rationale. My own argument is arranged in five steps: (1) a summary of the differend as part of Lyotard's theory of discourse; (2) a brief discussion of transcendental procedure; (3) a proposal about how Lyotard's differend and discursive agonistics can be seen to relate to one another in a transcendental argument; (4) a suggestion that the linguistic definition of the differend is the result of an 'incomplete' thesis and that Lyotard's linguistic emphasis needs to be broadened in its own terms to permit a broadly semiotic description; and (5) a brief analysis of the 'differend' in terms of 'meaning.' In conclusion I ask whether Lyotard's theory remains cogent.

Lyotard's Discursive Universe and the Differend

In *The Differend* Lyotard offers the reader a theory of reference as part of a 'realist textualist' view of the world, a construal rooted in the conflictual structure of 'phrases.' It is to the role these phrases play in his discursive universe that we must turn if we wish to understand the 'differend.'[17]

To begin with we may ask how Lyotard's significatory reality achieves what balance we sense it has. His textualist answer is that its relative stability is guaranteed by the cross-references of 'independent testimonies' (38). Both the empiricist's eyewitness and metaphysical presence lose their central roles in favour of 'future corroboration.' Reality is never given once and for all but is forever deferred and so becomes 'a matter of the future' (53).

In this discursive universe the locus of analysis is the level of 'phrases' (or 'sentences'), a term which collates the parlance of traditional language philosophy and the theory of meaning (131). Words, expressions, sentences, and their combinations become part of the economy of the phrase and its networks, termed 'genres of discourse.' Because every phrase 'entails a *there*

is' it constitutes a 'phrase universe,' which consists at least of an addresser, an addressee, a sense, and a referent (14). Phrases, moreover, have both a referential and a deictic side. Reference and thus the real is established by a combination of sense, name, demonstration, and metaphrase. Sense or signification can vary for one and the same referent; name or nomination fixes reference in a number of phrases; demonstration or ostension neither signifies nor names reality but shows it; and independent metaphrases compare these three functions and so produce a validation. In this way reality 'is able to be signified, to be shown, and to be named' (50).

In the course of Lyotard's reasoning it emerges how significations, names, and ostensions relate to one another. 'Cognitive phrases are backed-up by ostensive phrases' and linked with Kripke's 'rigid designator' or name, although, in agreement with Tarski, 'reference cannot be reduced to sense' (39–40, 41). In Lyotard a named referent acquires reality if it is also the potential carrier of an 'unknown sense,' a phrase which cannot yet be formulated. In other words reality is always underdetermined by any linguistic description. This is why Lyotard characterizes nomination as the 'inflation of sense': we cannot prove 'that everything has been said about a name.' In other words, barring contradiction, there is no limit to the descriptions or 'throng of senses' we may wish to attach to a named entity (47–8). Ostension, too, has its unstated shadow: for every assertion that 'there is x' there is an entailed negation, 'and it is not y.' Lyotard's referent can be strong or weak: strong, if it is backed up by a 'network of names' and their 'relations'; weak, if it is supported only by a 'sense' in heterogeneous 'phrase universes' (50). Lyotard seems to be saying, then, that nominative networks produce strong reference and predicative phrases produce weak reference.

Of equal importance in his theory are deictics, an addressor's designation of a 'given.' Lyotard distinguishes the 'I-here-now,' as 'current' deictics from its generalized form, in which 'names transform *now* into a date, *here* into a place.' In its most anonymous form this 'quasi-deictics' of names constitutes a 'world' made up of names independent of individual instantiations of ostension (33, 39, 40). Since names and their networks produce stronger referents than do sense relations, generalized deictics plays a crucial part in the establishment of Lyotard's reality.

In Lyotard phrases combine to form 'phrase regimens,' each of which in turn projects 'a universe.' The phrase universes are always social because they always contain at least one addresser, one addressee (apart from a name), a sense, and a reference: 'the social is always presupposed ... within the slightest phrase' (139). At a higher level of organization phrases enter into 'genres of discourse,'

which rule the manner in which phrases can be linked with one another. Phrase regimens, which group linguistic expressions into descriptions, and ostensive, prescriptive, constative, or performative passages are marshalled by genres to function in the rhetoric of persuasion, argumentation, refutation, pleading, and so on. In this way the multiplicity of heterogeneous phrase regimens can effect the modalities of the phrase, in short, 'what is at stake' in each phrase. Genres of discourse themselves, however, are not in harmony with one another. Quite the contrary. Genres such as logical, religious, or economic discourse are not just distinct but fundamentally hostile to each other, a condition responsible for the differend in particular and social agonistics at large. This, Lyotard argues, does away with the kind of 'anthropocentrism' which still informs Wittgenstein's language games (130).

All traditional genres pale before economics, which reconstitutes traditional discourse in terms of exchange. The economic phrase negates time, the heart of narrative, dismissing as it does 'the occurrence, the event, the marvel, the anticipation of a community of feelings' (178). Consequently, discursive agonistics looms large in the genre of economics, providing a special platform for instances of the differend.

One set of phrases, however, does not amount to a genre of discourse: politics. In its parasitic realization of the agonistics existing between different genres politics is nothing less than the linkage of the 'multiplicity of genres' itself (138, cf. 141). This allows Lyotard to argue once more for a de-anthropomorphized state of affairs. The stakes tied to heterogeneous genres of discourse, rather than people, are responsible for social agonistics in the first instance (137).

The textualist world which emerges looks like this: nothing precedes the sentence, so we are led to a logical and chronological linguistic foundation of the real. In Geoffrey Bennington's account of Lyotard language comes first, for 'there is always a first sentence': 'Reality is, then, neither simply given and awaiting more-or-less adequate transcription, nor is it magically produced by a demiurgic act of creation on the part of the speaker, but is an unstable state attributed to referents on the basis of operations of nomination, ostension and description ... Reality is established as the result of playing a language-game with specifiable component parts.'[18]

Sooner or later the reader of Lyotard expects some acknowledgment of semiotic relationships other than linguistic ones. But the solution offered by Lyotard is highly problematic. 'A wink, a shrugging of the shoulder,' he says, 'can be phrases.'[19] This amounts to the collapse at one stroke of the semiotics of gesture, proximic, kinetic, tactile, olfactory, visual, and aural sign systems onto the plane of language. We are dealing here with a form of linguistic imperialism.

Lyotard's 'here it is' and the 'shown referent' are phrases substituted for and summing up proximic-kinetic, pictorial, and gestural acts of signification. In order to jump from phrases to an 'extra-linguistic permanence' or in the other direction Lyotard not only eliminates the phenomenological pre-predicative *cogito* but also any possible non-predicative semiotics (33). This requires a certain bending of one of his main sources, Saul Kripke. Kripke's string of events, which includes both phrases and such non-verbal signs as birth and meetings, is simply levelled onto the plane of linguistics (39). Yet ostension is a broadly semiotic structure rather than a merely linguistic one: it can operate completely without words in painting, mime, or gesture.

Certainly, Lyotard's linguistically signifiable, showable, and nameable reality is 'pinpointed by a world' (50). Yet how do sentences and 'world' relate to one another? If reality is positioned by sentences but located by a 'world,' how then is this world related to sentences? If sentences are prior to everything else, the world too must be the result of sentences. As Bennington reiterates, 'reality is never given, but always situated by particular narratives as referents: just as story-teller and addressee do not precede the story told but are positioned by it'[20]

Again the need for an explanation which accounts for structured significatory activities outside language becomes evident. A much broader semiotic approach is needed. 'Surely,' asks Bennington, 'Lyotard cannot be claiming that everything that happens is linguistic? Not if a sentence is not necessarily linguistic.' Lyotard's stopgap is the introduction of a 'non-linguistic sentence.' This is a crucial shift in the emphasis of the theory.

To be fair to Bennington he acknowledges the importance of this move. 'If a referent is always (only) what is situated as such in a sentence-universe,' he argues, 'then saying anything about anything would involve linking onto a (possibly) non-linguistic sentence with a linguistic sentence.' This demands careful consideration. For one thing what would a non-linguistic sentence look like? What sort of grammar would have to be envisaged to make it function in a network of non-linguistic sentences? And if these quasi-sentences are something quite distinct from the verbal, is it not misleading to continue the linguistic metaphor? Lastly, we must ask how such non-linguistic sentences relate to Lyotard's 'extra-linguistic permanence,' mentioned earlier. However we look at this area of Lyotard's theory, as well as Bennington's account, it runs into serious difficulties.

Lacking in both is an argument for cognitive structures other than linguistic ones, and in turn a description of the structure of non-linguistic sentences. Also required is a broadly social semiotics which includes the linguistic as its most powerful sign system yet allows also for gustatory, visual, tactile, aural, and

other kinds of signification to which we resort of necessity. Having relegated the non-linguistic or quasi-sentence to the realm of 'matter' and the non-cognitive, Lyotard and Bennington are left with an exclusively linguistic vision of the world. Even so Lyotard's differend remains a powerful critical tool.

The Differend: Definitions

The differend is the necessary result of the structural hostility between genres of discourse. It is activated when speakers enter into discursive operations, whether their communicative attitude is deceptive, manipulatory, or consensual. In Lyotard's non-anthropomorphic scheme the injustice which arises in linguistic exchange does not have its origin in some kind of universal evil, nor in human nastiness, nor even in the poor management of language. As we have seen, the cause of such differends is a systemic agonistics which attaches to language in principle as a result of the ineradicable heterogeneity of phrases and genres of discourse.

It follows that the differend turns up everywhere. In its specific juridical application the differend is 'the case where the plaintiff is divested of the means to argue'; it is the victims' 'inability to prove' their case; and it shows itself when the adjudication of a dispute is conducted in the language of one party, 'while the wrong suffered by the other is not signified in that idiom.'[21] At its most general it appears as 'the unstable state and instance of language wherein something which must be able to be put into phrases cannot yet be' (13). Apart from its position in any specific regimen 'every phrase is in principle what is at stake in a differend between genres of discourse.' Thus the differend arises 'from the question, which accompanies any phrase, of how to link onto it' (137–8). Naming, too, is a site for the differend, for 'in and around names, vengeance is on the prowl' (56). The differend comes to the fore most threateningly in the competition arising from the 'multiplicity of genres,' which is politics (138).

The differend, then, appears at a number of distinct levels of specificity of discourse as well as in social agonistics, as a general rule. But before we can trace the evolution of Lyotard's concept in transcendental terms we need to glance briefly at the present status of the transcendental argument in the literature.

What Is a Transcendental Argument?

Kant called *transcendental* all knowledge concerned 'not so much with objects as with the mode of our knowledge of objects insofar as this mode of knowledge

is to be possible *a priori*.'[22] The transcendental thus deals with 'representations' which, though non-empirical, can nevertheless 'relate *a priori* to objects of experience' (B81). For statements constituting such knowledge Kant coined the term 'synthetic *a priori* judgments.' Kant's combination of empirical grasp, a priori faculties, and speculative reason is thus given the single term 'transcendental.' As one of his translators puts it, the term 'transcendental' refers 'to the conditions of a priori synthetic propositions.'[23]

Kant's procedure for establishing the umbrella condition for a multiplicity of conditioned phenomena would not have been as controversial as it has proved to be in the literature had he restricted himself to, for example, the game of chess. He could have shown what sort of logical metasystem is needed to explain, and more to the point to allow for, the possibility of the first-order logic of the game itself. This would have preempted a good deal of criticism which treats the so-called transcendental deduction as a homogeneous analytical argument gone awry. On the other hand, if Kant had remained within analytical systems, how could he have argued for necessity in the realm of the synthetic? Unfortunately, the complexities of the field of phenomena to which Kant applies the transcendental procedure in the *Critique of Practical Reason* has blurred its two-level structure.[24] These complexities also illustrate in a discursive rather than a logical fashion that we are dealing with an interpretive procedure rather than a strictly analytical but nevertheless cogent one.

At the centre of the *Critique of Practical Reason* we find the well-known categorial imperative, for which Kant offers a number of alternative formulations: 'Handle so, dass die Maxime deines Willens jederzeit zugleich als Prinzip einer allgemeinen Gesetzgebung gelten könne' (Act in such a manner that the maxims of your will are always able to function at the same time as a principle for *general legislation*.[25] Important in this version is the emphasis on 'general legislation' rather than on 'universal law.' In Lewis Beck's translation this difference is respected in the phrasing 'a principle *establishing* universal law.'[26] If we are insensitive to Kant's phrasing, we tend to read the categorial imperative at too specific a level, as does Terry Eagleton in *The Ideology of the Aesthetic*, where he reduces it to a formula of bourgeois ownership: 'You respect my property and I'll respect yours.'[27]

Kant instead aims for the emptiest kind of condition thinkable. Yet if we were to attach to this formal level any finality we would have construed an ultimate transcendental signified which Kant *does not* entertain: 'No concept given *a priori*, such as substance, cause, right, equity, etc., can, *strictly speaking, be defined*. For I can *never* be certain that the clear representation of a given concept, which as given may still be confused, has been completely effected ... But since

the concept of it (its object) may ... include many obscure representations ... *the completeness* of the analysis of my concept is *always in doubt.*'[28]

With this important proviso let us now look at the various steps which Kant employs to arrive at the categorial imperative and its transcendental condition, the freedom of the will. In the *Critique of Practical Reason* he distinguishes between the 'mechanism of natural necessity,' which permits us, at least in principle, to 'ascend from conditioned to condition *ad infinitum*' (*vom Bedingten zur Bedingung ins Unendliche*), and speculative reason, which allows us to stipulate an overall 'unconditioned' (*das Unbedingte*). However, we are not able to give any specific 'content to this supposition' (*diesen Gedanken nicht realisieren*). Instead speculative or 'pure practical reason now fills this vacant place with a definite law of causality in an intelligible world (causality through freedom). This is the moral law.'[29]

But how is it possible that we can conceive of moral laws in the first place? If 'the determination of the causality of beings in the world of sense as such can never be unconditioned, and yet,' as Kant views the matter, 'for every series of conditions there must be something unconditioned,' we need an all-encompassing horizon which can act as 'self-determining causality' (*eine sich gänzlich von selbst bestimmende Kausalität*), namely our freedom to subject our actions to moral laws and the freedom of the will in general.[30]

As Kant puts it 'the idea of freedom as a faculty of absolute spontaneity was not just a desideratum but, as far as its possibility was concerned (*was deren Möglichkeit betrifft*), an analytical principle of pure speculation' (57). To cope with the notion of an 'uncaused cause' we need to stipulate an all-encompassing umbrella, something like Heidegger's Being, which acts as the inferred transcendental horizon for the 'totality of involvements' or like Charles Sanders Peirce's overall semiotics, which accounts for everything thinkable in terms of interconnected signs.[31]

As H.J. Paton points out in *The Categorical Imperative* Kant's procedure 'is not to be confused with the analysis whereby we separate out common character-istics.' Nor should we take it to be 'an analysis which professes to set forth the successive stages in the supposed development of moral judgments.' It attempts to reveal 'the a priori element which must be present in moral judgments' for them to be possible at all.[32] This is an important point and does not deny the construal of a more detailed series of steps which allow us to imagine more easily how a transcendental argument could evolve from the observation of a specific social phenomenon, such as a single moral maxim, via a principle for general legislation, to that formally empty condition, the freedom of the will. I suggest the following ladder of reasoning:

I *Premise*: Moral rules look like this:
 (i) Specification (you must not steal {1}): typical, specific moral rule which we are able to decide to obey or disobey
 (ii) Generalization (you must not steal {1}, kill {2}, betray {3}, lie {4}, bully {5}, plagiarize {6}, etc.): typical string of similar moral rules
 (iii) Formalization (you must not {1} to {n} + 1): its principle
 (iv) Generalization of (iii) (everyone must not {1} to {n} + 1): community version of (iii)
 (v) Formalization (categorical imperative as principle linking individual moral rule and general legislation) (i) to (iv): we are able to accept or reject any such rule

II *Premise*: Moral rules exist.
 (vi) There is no dispute about the existence of moral rules.

III *Conclusion* There is an umbrella condition for I and II.
 (vii) Transcendental condition (if I and II then F and I and II iff F) (whereby F signifies 'freedom of the will').[33]

Seen epistemically, it would suffice to formulate 'if I and II then F.' Turning the perspective around and pretending to view the matter from the ontic stance of transcendentality, a biconditional relation reflects better what is at stake here. Hence I and II are possible if and only if F.

The main objection to Kant's transcendental procedure comes from analytical philosophy, typified by the kind of reasoning offered by Stephen Körner. Körner describes a transcendental argument as 'a logically sound demonstration of the reason why a particular categorial schema is' employed of necessity 'in differentiating a region of experience.'[34] He isolates two logical steps involved in establishing a schema of judgment, one which identifies and one which individuates an object. At the same time he insists on a uniqueness criterion, according to which 'one has to show that any and every possible method' is part of the schema. 'One must,' he says, 'demonstrate the schema's uniqueness' (320).

Three procedures are offered as a test. The first compares the schema with 'undifferentiated experience'; the second tests the schema with competing schemata; and the third gives an internal description of the schema. According to Körner all three methods fail, the first because undifferentiated experience cannot be formulated, the second because an alternative schema would disprove uniqueness in the first place, and the third because

any operational features which we may describe cannot establish uniqueness (320–1). He therefore concludes that Kant's procedure is circular and specifically that 'it is the impossibility of demonstrating a schema's uniqueness that renders transcendental deductions impossible' (321). In his later comments Körner repeats his substantive critique but grants transcendental reasoning a sort of *ignoratio elenchi* in that transcendental arguments, though doomed as a proper philosophical procedure, 'may incidentally clarify old or produce new ideas.'[35]

A number of writers have leapt to Kant's defence, and I wish to summarize only the chief features of their arguments. This will demonstrate that there are some good reasons to review transcendental moves at this stage and will help to reconstruct the evolution of Lyotard's differend in transcendental terms. The *circulus vitiosus* objection levelled by Körner, for instance, is rebutted in a number of ways. We can argue that it fails to distinguish between a vicious and an informative circle; transcendental knowledge, unlike formal logic, is concerned with 'conditions with which thinking must comply in order to achieve knowledge of things.'[36] Alternatively, we can say that the transcendental move sheds light on 'the discursive character of our intellect and its relation to sensibility.'[37] Another argument is that without a 'framework' thesis one cannot do justice to Kant.[38] As well, we must take into consideration Kant's unity of consciousness thesis, a 'fundamental assumption ... but only in the sense that we are here operating at the boundary of any conception of experience we can coherently envisage at all.'[39] Another argument against Körner's objections is that a categorial scheme is not simply a view such as a scientific theory and his approach therefore operates at too specific a level, misconstruing the unified character of deduction and being blind to 'the fundamentally holistic nature of interpretation.'[40] It also misses the point of Kant's deliberate move of self-referentiality, for the transcendental argument 'states what it states and says something about itself.'[41] As well, Körner's work fails to realize that transcendental reasoning links a first-order logic with a second-order logic or a metalevel, a procedure analogous to having 'quantified sentences ... connected with the reality they speak of through certain language-games' and 'deductive rules for first-order logic (that) reflect the rules of these games.'[42] Finally, Kant's procedure can be partially rescued by its transformation into a 'transcendental pragmatics.'[43]

Habermas resumes the Kantian reasoning from the perspective of the ideal of communicative negotiation free from domination in the public sphere. Transcendental reasoning here has to do with the 'nonempirical reconstruction of the a priori achievements of the cognizing subject' under communicative

constraints (2). For Habermas any negotiatory linguistic exchange 'rests on pragmatic presuppositions from whose propositional content the principle of universalism (U) can be derived' (82). Anybody who recognizes as necessary certain 'communicative presuppositions of argumentative speech and who knows what it means to justify a norm of action implicitly presupposes as valid the principle of universalization' (86).

Habermas's transcendental pragmatics claims to be able to accomplish the non-empirical reconstruction of the 'substantive normative rules of argumentation,' of which we 'always already make use' in discursive praxis (86). In this sense the transcendental procedure is neither viciously circular nor merely self-referential at a higher logical plane. It is not even just hermeneutically informative but is indispensable for any critical social and political pragmatic, in short for survival.

The Differend: A Kind of Transcendental Argument

Though they derive from opposite positions, the writings of Habermas and Lyotard address the desirability of communication. In Habermas communication free from domination is an ideal which we stipulate in order to engage in social negotiation at all; in Lyotard we communicate stubbornly in the face of the inevitable structural hostility which attaches to all speech.

But how does Lyotard's differend evolve from the anthropomorphic specifics of someone unable to prove his or her case to the non-anthropomorphic agonistics of all language? I suggest that the following ladder functions as the skeleton of his argument and summarizes what has been said thus far:

(1) Lyotard singles out the specific example of Auschwitz, 'the most real of realities,'[44] yet an occurrence difficult to retrieve, a differend forever irreparable. The gas chamber illustrates the ultimate case of 'a damage *(dommage)* accompanied by the loss of the means to prove the damage' (5). From the example of Auschwitz Lyotard unfolds his theory of discursive agonistics.

(2) In its specific juridical application, the differend is 'the case where the plaintiff is divested of the means to argue'; it is the victims' 'inability to prove' their case; and it shows itself when the adjudication of a dispute is conducted in the language of one party, while the injustice suffered by the other party is excluded by the juridical discourse (9–10). At this second level, then, Lyotard has generalized all legal injustice in terms of linguistic domination.

(3) The third rung of Lyotard's ladder deals with the main building elements
of all discourse, phrases. Phrases, as we have seen, are established by
a combination of an addresser, an addressee, a sense, and a referent
(13), whereby reference is established by sense (signification), name
(nomination), demonstration (ostension), and an independent metaphrase
which compares these three (validation). At any point of this 'phrase
universe' (13) a differend may evolve. Lyotard singles out nomination and
'networks of names' (50) as particularly suitable for its emergence. As we
remember, 'in and around names, vengeance is on the prowl' (56). Since
naming is a part of every phrase it follows that the differend is a general
feature of every phrase.

(4) On the fourth rung phrases are viewed from the higher order of genres
of discourse. Phrase regimens here arrange linguistic expressions in such
a manner that descriptions, and ostensive, prescriptive, constative or
performative passages become effective in the rhetoric of persuasion,
argumentation, refutation, pleading, and other discursive strategies. A
differend occurs when 'the rules of the genre of discourse by which one
judges are not those of the judged genre or genres of discourse' (xi).

(5) An altogether different perspective is required to describe the occurrence
of a political differend. Politics in Lyotard is once more a discursive notion
stripped of its usual anthropomorphic clothing. It is not itself a genre but is
the result of the inevitably hostile interaction between a 'multiplicity of
genres.' It is the 'threat of the differend ... and par excellence the question
of linkage' (138). Politics operates at a metalevel in relation to the order
of discursive genres, and since discourse genres are always already in
conflict with one another the differend is the structural consequence of
their interaction.

(6) The several moves of linguistic generalization and formalization presented
in steps (1) to (5) could not be argued if Lyotard had not made a
fundamental presupposition, that of the linguistic community. As he puts
it, 'the social is always presupposed ... within the slightest phrase' (139). At
this point the widest possible circle appears. Without a speech community,
the social, there could be no phrases or genres of discourse, and that
communal world is linguistically grounded. Wherever we look we see only
phrases in conflict with one another. Does it not follow then, Lyotard
appears to ask, that the ground for specific exchange is itself conflictual, a
horizon of general agonistics?

We can now construe the following summary, again in three parts:

I *Premise*: The differend is a characteristic of all phrases.
 (i) Specification (e.g., Auschwitz {1}): specific and yet representative differend
 (ii) Generalization (the legal differend: the victim of extermination camps {1}, the plaintiff who cannot prove his or her case {2}, the party whose idiom is denied in court {3}, etc.): typical string of similar cases
 (iii) Formalization (all instances {1} to {n} + 1 are constituted by phrases): linguistic principle
 (iv) Generalization (phrases {1} to {n} + 1 are organized into phrase regimens and discourse genres): discursive level of (iii)
 (v) Metalevel of (iv) (all discourse genres are in conflict with one another: politics): formal principle of (iv)

II *Premise*: Reality is linguistic.
 (vi) The world of speech communities is defined by phrases.

III *Conclusion*: There is an umbrella condition for I and II.
 (vii) Transcendental condition (if I and II then no speech community is thinkable without A and I and II iff A) (whereby A signifies 'linguistic agonistics').

Assuming for the time being that the two premises can be taken for granted we arrive at a conflictual linguistic universe characterized by a multiplicity of differends. This, then, is the transcendental condition of the social and hence the differend: an all-encompassing agonistics of language.

The 'Incomplete' Differend: A Semiotic Critique

We must now resume the observation made earlier of an unsatisfactory feature in the description of the differend: the delineation between the linguistic, the non-linguistic semiotic, and the non-semiotic constraints which Lyotard infers as an 'extra-linguistic permanence.' As a realist textualist he rightly insists that such a permanence 'is presented or co-presented with the universe of the phrase' and that 'it appears and disappears with this universe, and thus with this phrase' (33). This shortcut, however, marginalizes all those other non-verbal sign systems which assist us in our habitual daily routines: tactile, aural, proximic, olfactory, visual, and other forms of semiosis. Lyotard merely hints at such possibilities, as when he urges that 'the silent feeling that signals a differend remains to be listened to,' or observes that 'a wink, a shrugging of the shoulder …

a fleeting blush ... can be phrases' (70). Such quasi-sentences or non-linguistic sentences are unable to smooth over the roughness in the theory.[45] This linguistic bias has serious implications not only for Lyotard's theory of discourse, as pointed out earlier, but also for the explication of the differend. I believe that as described by Lyotard the differend is unnecessarily reductive, failing to account for a broad range of social injustices not accessible to a description based on 'phrases.' I suggest further that Lyotard's embedded transcendental argument can be reworked to allow for the missing non-verbal differend and so make a limited linguistic interpretive tool into a highly useful semiotic one.

A semiotic rewrite of Lyotard's ladder could look like this, again in three parts:

I *Premise*: We find the differend everywhere.
 (i) Specification of differend (e.g., Auschwitz): specific and yet representative case
 (ii) Generalization (Auschwitz {1}, verbal bullying {2}, the male gaze {3}, aggressive stance {4}, proximic domination {5}, physical violence {6}, etc.): typical string of differends
 (iii) Formalization (all instances {1} to {n} + 1 are constituted by a variety of sign systems): various agonistic semiotic practices
 (iv) Formalization (a variety of semiotic systems):
 (1) linguistic (e.g., Lyotard's theory of phrases)
 (2) non-linguistic (theories of the gaze, gestures, the tactile, etc.): distinct semiotic principles of agonistics
 (v) Formalization of general agonistic semiotics (e.g., a social semiotics along the lines suggested by Charles Sanders Peirce): formal principle subsuming (iv)

II *Premise*: Reality is semiotic.
 (vi) The world of speech communities is defined by verbal and non-verbal communication.

III *Conclusion*: There is an umbrella condition for I and II.
 (vii) Transcendental condition (if I and II then no community is thinkable without A and I and II iff A) (whereby A signifies 'semiotic agonistics').

Assuming for the moment that the first premise can be taken for granted we arrive at a conflictual semiotic universe characterized by a multiplicity of differends. The transcendental condition of the social and hence of any differend would thus be a general rather than merely linguistic agonistics.

This is the level of generality and formality required to produce the speech act underlying Lyotard's description of the differend as 'the unstable state and instance of language wherein something which must be able to be put into phrases cannot yet be' (13). In the absence of a Peircean quasi-mind outside our textual world the only way Lyotard could have stipulated the differend is by way of an embedded transcendental procedure. And since he is talking here about a pre-predicative form of signification only a broadly semiotic theory can fully account for the differend.

Having formulated the differend as the specific realization of an agonistic social semiotics we need to ask in conclusion whether agonistics is the necessary result of an abduction from *any* kind of semiotic specifics to general semiosis, or whether it is only the necessary result of a generalization from *agonistic* examples to a universal structural hostility. If there is not even the possibility of non-agonistic semiotic communication, then clearly Lyotard's account is cogent. The alternative is the kind of description offered by Habermas, in which such differends as manipulation and domination are only part of the total of communicative acts.

Is it perhaps possible that if Lyotard had pursued his argument further along transcendental lines he would have subsumed the differend in a general notion of semiosis? This question arises from a three-stage phrasing of the transcendental argument and the kind of premises Lyotard appears to require for his theory. But even if Lyotard's differend cannot be shown to be universal, in its semiotic formulation it is certainly a most useful heuristic device. By looking at the differend from the perspective chosen we can affirm that transcendental reasoning reveals the conditions for the relationship between specific phenomena and the systemic totality of our beliefs about 'how things really are.'

The Semantics of the Differend

An intersemiotic critique of the linguistic emphasis in Lyotard's argument entails from the very beginning a commitment to semantics. Nevertheless, it may appear that by describing the differend as the inevitable result of any interaction between different discourse genres, Lyotard has provided us with a syntactic rather than a semantic account. This impression is perhaps strengthened for some readers by the non-anthropomorphic nature of his description. It is not people and speech intentions that are primarily hostile to one another but rather the discourse structures which delimit their communicative possibilities.

In his minimal definition of a sentence, however, Lyotard insists on the retention of reference and the double deixis of addresser and addressee, in

addition to sense. This elaboration separates his notion of discourse radically from both a formal semantics offering a calculus picture of language and an analytic one requiring the stipulation of a neutral sentence meaning. Semantics in a pragmatic sense, then, appears to be presupposed in Lyotard's views of the sentence well in advance of the more elaborate arguments concerning the differend. But could the differend be argued on purely syntactic grounds? With this question we leave Lyotard's core concerns and turn to the Fregean tradition. Could Lyotard's differend be argued on the premise of the equation of formal and natural sense?

The reason I pose the question here is this. Assuming that the differend, in its modified intersemiotic version, is a viable and useful addition to the description of language as social action, or discourse, the answer to my question will tell us how well the Fregean branch of semantics copes with a new critical concept concerning language. In Lyotard's account the differend is a structural asymmetry resulting from the difference between what needs to be said and what cannot be said, between language control and linguistic disadvantage, between discursive power and powerlessness. An analysis of the sentence which does not include as necessary ingredients a function capable of exerting power and a function acting as recipient, with the possibility of a reversal of functions, is not in a position to deal with the differend.

An important aspect of Lyotard's contribution to the analysis of the sentence is the inclusion of addresser and addressee no matter whether they are marked or unmarked linguistically. A review of Frege's collapse of natural language sense into formal sense is significant at this point. I tried to show earlier that even such minimal signifiers as 'morning star,' 'evening star,' or 'Gaurisanker' carry with them not only a general referential background apart from their specific reference but also a deictic perspective. Natural language terms themselves always already imply cultural sedimentations which refer us to typical utterance situations. They direct us, in other words, to non-verbal semiosis in terms of both an imaginable world and the imaginable circumstances of utterance. They refer us to the body. This is the intersemiotic double background to the propositional and modal sides of linguistic expressions. Together they constitute semantics. In actual discourse intersemiotic sedimentations are activated under specific conditions of power relations. Lyotard's differend marks the structural moment when uneven power relations, which he regards as the norm, are realized discursively. In a semiotic rather than a linguistic sense the differend is semantic through and through.

If natural language sense behaved fundamentally like formal sense, as the Fregean tradition in semantics assumes it does, this argument could not be run even at the prepragmatic stage. Sense regarded definitionally does not permit

us to construe a non-linguistic world. Without the body as manifestation and designation, as utterance vehicle and object of *Bedeutung*, without intersemiotic linkage, linguistic expressions are not meaningful. And without meaning in this non-formal sense communicative situations are not thinkable. Without communication the corporeality of the social does not exist. Without the social there is no communication. Without the corporeal social there is no differend.

4.3 DIFFÉRANCE: MEANING AND TRANSCENDENTAL PROCEDURE

Since all division presupposes a concept to be divided, a still higher one is required, and this is the concept of an object in general, taken problematically, without its having been decided whether it is something or nothing.

Immanuel Kant, *Critique of Pure Reason*

In the Fregean tradition sense as the 'thought' of a proposition is ruled by definition, as are the senses of three intersecting geometrical lines. The elimination of *Vorstellung* (idea) as subjective and the stripping away of reference, utterance deixis, images, and generally non-verbal semiosis has left sense defined as *begrifflicher Gedanke* (conceptual thought). One broadly shared heritage of this tradition is the semantics of idealized sentence meanings, as distinct from the pragmatics of utterance and use and hence the necessity of negotiatory interpretation.

A Kantian tradition which emphasizes his heuristic caveats concerning conceptual purity takes quite a different route. It foregrounds the negotiatory character of *Anschauungen* and conceptual schemata and the complexities of reflective reason. What emerges as a result is a direction in semantics in which the problems of understanding and the necessity of interpretation are tied to all aspects of meaning. Hermeneutics, the phenomenology of noetic acts, the *Lebenswelt*, and Peircean semiology reflect this leaning by elaborating on interpretive complications, the horizonality of meaning-making, its question-and-answer structure, sedimented knowledge as a precondition of meaning, and the as-structure and hermeneutic circularity of understanding. All these, among other influences, play a significant role in how meaning is conceived in deconstruction. Meaning as contaminated, for example, can be shown to be a direct consequence of the Husserlian notion of noetic modification.

Importantly, meaning for Derrida has not vanished from the deconstructed world but has merely been uprooted. To be carried away further, it is now more like a bird than a plant. Moreover, meaning has been shown to have

been classified as the wrong kind of bird, a specious species. Instead of having any origin which we can trace by way of etymological spade work, meaning has turned out to be mobile, altering its significatory potential as it travels through ever new social histories. Etymology is not discarded, however, but freed from the seriousness of its positivist curriculum, even beyond Heidegger's hermeneutics, for a creative but still instructive playfulness. From Derrida's critique of Husserl's 'voice' in *Speech and Phenomena* to 'Limited Inc abc ...' we find no attempt to rid signification of meaning but rather a series of moves which deprive semantics of its assumed stability, either in historical origins or in conceptual certitude. In his most recent statements on 'the expansion of the concept of text,' Derrida remains evidently committed to some form of semantics.[46] Radicalizing Kant, Derrida shows that the boundaries of concepts are permeable frames allowing both leakage and contamination.[47] A catalogue of critical tools, or infrastructures, enables Derrida to make his point from a variety of angles. Without going into the manner in which these tools overlap with one another, I will merely indicate in the briefest possible way how they affect the notion of meaning, before addressing différance in detail.

One could say that in one sense Derrida extends Kurt Gödel's critique of logical systems to signification at large when he suggests that the reason for semantic 'undecidability' lies in 'syntactic praxis that composes and de-composes' signs. Accordingly, *undecidability* is not grounded in the lexicon and the complexities of its definitions of meanings but in the social practice of syntactic combinations of lexical items.[48] If Derrida were to accept the dis-tinction between internal and external, one could say that this occurs in-ternally when the system combines 'two incompatible meanings,' or externally when the code dictates contrary uses of the same word. As Derrida sees it meaning is a function of the work of syntactical units of various magnitude and 'the economic differences of condensation' so produced (221).

One might ask from an intersemiotic perspective how it is possible that syntactical praxis is able to do this. If 'natural' language expressions were not what they are, namely directional schemata which gather meaning with the help of non-verbal signs, then perhaps syntactical praxis would look very different, as indeed it does in formal languages. At the very least and without wishing to diminish the role of syntax in semantics, it is unsatisfactory to assume that the calculus of syntax acts as the prime mover for semantics; we must provide at the same time an intersemiotic and heterosemiotic picture in which verbal and non-verbal signs are shown to interact. Whatever the validity of such a question, Derrida argues that the explanation of undecidability which holds for *hymen* and *pharmakon* likewise applies to a series of other infrastructures, or deconstructive tools.

Without any specific origin the re-mark, or *le supplément de marque*, is regarded as a function of the use of a text. It falls 'outside of the text like an independent object' and yet 'turns back into a presence (or a sign)' when the desire for representation is aroused. The re-marking of the text ruptures the determination of meaning. (258). Yet the re-marking of a text not only operates at the level of representation but also refers to the way we deal with signs at the phonetic, syntactic, and various semantic levels. Furthermore, the mark alerts us to the necessity of stipulating absent signs whenever we make sense of a signifier. As far as it acts as a re-mark, every sign could thus be regarded as a 'vacuous signifier' in the sense that it draws our attention to signification as form but not as specific content. By the same token, we could not 're-mark' a text if we had access only to its syntax and not to its semantics. The re-mark appears dependent on the possibility of meaning inasmuch as meaning could not be envisaged without the condition of its being marked and re-marked.

'Iterability' has become notorious since Derrida's exchange with Searle in *Glyph*, which demonstrated its rhetoricopolitical force. Its strength as a deconstructive device lies in its high level of abstraction, permitting its subsumption of a number of concepts, such as repetition, reproduction, and repeatability, alteration and alterability, and idealization. Derrida speaks of the 'impurity of its self-identity' in that it alters repetition and identifies alteration.[49] Iterability embraces all those features which account for lateral semantic drift (from meaning to meaning at the same level of specificity) as well as for vertical semantic mutation (from meaning to meaning at increasing levels of generality) – in short, for re-identification with a difference. Under altered circumstances, different features of iterability come to the fore. In formal systems iterability would mean strict reproducibility. For natural languages no such law of reproduction can be assumed. Barring technical usage, the more frequently we iterate certain expressions, the more readily their meanings will shift.

Derrida coined the term 'supplementarity' to better undermine the idea of the stability of our conceptual structures and the assumed origin and essential nature of things, which he says are no more than 'the myth of addition, of supplementarity annulled by being purely additive.' Instead there is always 'a supplement at the source,' the supplement as 'always the supplement of the supplement' which renders originary purity inconceivable.[50] Supplementarity 'fissures and retards presence' and so foregrounds semantic differentiation.[51] In *Of Grammatology* 'originary différance is supplementarity as structure.'[52] Adopting a Heideggerian style of writing he says that 'the supplement supplements. It adds only to replace. It intervenes or insinuates itself in-the-place-of.' As a sign the supplement appears always as a proxy of

'the thing itself' (145), 'the mirage of the thing itself' (157). Derrida elaborates on the surrogate character of the supplement by describing it as 'compensatory (*suppléant*) and vicarious,' as an 'adjunct' and 'a subaltern instance which takes-(the)-place [*tient-lieu*]' (145). Furthermore, the assumption that signification depends on the primary differentiation between presence and absence is modified by Derrida's claim that 'the supplement occupies the middle point between total absence and total presence' (157). In spite of the importance of supplementarity, Derrida insists, in paradoxical fashion, on its non-essential character: 'It is the strange essence of the supplement not to have essentiality' (314). Yet its non-essentiality does not diminish its role of necessary condition of meaning in 'an infinite chain, ineluctably multiplying the supplementary mediations that produce the sense of the very thing they defer' (157).

The law of supplementarity refines Heidegger's schema of the as-structure of all understanding. Every case of constituting meaning occurs via the detour of a supplement. We understand something with the help of and as something else. Dictionary entries are a case in point. The left side of the page would be nothing semantically if the right side did not act as the necessary supplement. Meaning simply could not take place. The signifiers on the right are likewise in need of supplementation by further and further signs and, ultimately, by non-linguistic signs. The answer, then, to how we get off this syntactical merry-go-round of endless substitutions is provided in an intersemiotic semantics. How can we learn what at least one of those signifiers 'means'? The intersemiotic answer is that meaning further requires a different kind of supplementation, one by non-verbal signs which establish reference. Without intersemiotic reference, without corporeal supplementarity, there is no linguistic meaning.

Where, one might ask, does intersemiotic supplementarity stop? The answer again could be Heideggerian in that there is no logical termination but rather an ongoing exploration of the horizon of our understanding.[53] The short answer is, of course, that the significatory buck stops at the body. Once we are satisfied that meaning negotiation has been 'successfully' anchored in the body we move on.

Another infrastructure with a significant role in Derrida's writing is the notion of trace. A modification of Heidegger's *frühe Spur* (early or matinal trace), the trace is both the effacement and the remainder of something else. It 'can only imprint itself by referring to the other, to another trace.'[54] As such the 'trace can never be presented'; it 'can never appear and manifest itself as such.'[55] With reference to Husserl's analysis of inner time consciousness Derrida ties the trace to the possibility of meaning. If we were not able hold minimal retentions of experience, no differentiation would take place. We

would be dealing with full presence or total absence, and so the shading which constitutes the same, in contrast to formal identity, could not operate. As Derrida puts it, 'without a trace retaining the other as other in the same, no difference would do its work and *no meaning would appear*.'[56]

The trace makes it impossible to think consistently in terms of origins, since what we might term an origin always reveals at least a trace of something else. In this sense the trace can be regarded as 'the disappearance of origin.' Derrida goes further when he insists that 'the origin did not even disappear' as a result of the work of the trace but 'was never constituted except reciprocally by a non-origin, the trace.' Hence, Derrida concludes, the trace is 'the origin of the origin' (61). This has fundamental implications not only for every kind of semantics but also for Derrida's method of inquiry. Meaning takes on a much fuzzier character once we embrace the idea of traces. At the very least the acceptance of semantic traces disallows argument via definitions in natural language. Nevertheless, the Peircean semantic regulation in a community is compatible with Derrida's account to the degree that the notion of trace offers a possible explanation for semantic drift without requiring that relative stability within semiotic practice be abandoned. More generally, if we accept Derrida's claims, we must acknowledge the implication that the trace acts as the necessary condition for both the illusion of origins and their logical impossibility. In other words we cannot avoid the methodological entailment of a transcendental procedure of sorts.

Like Heidegger, Derrida understands signification as fundamentally decentred. Signs are proxies not only for something else – such as things, emotions, ideas, action, the world – but also in the sense that their semantic content requires further signs in order for the transformation from syntax to semantics to take place. These take the form of other linguistic signs, and more important, always also non-verbal sign systems. Heidegger's as-structure and Derrida's fundamental metaphoricity constitute two ways to cope with this asymmetry. One could say that meaning is forever carried away or, as Derrida puts it, 'one metaphor, at least, always would remain excluded, outside the system: ... the metaphor of metaphor.'[57] This leads Derrida to undermine the very distinction between the metaphorical and the conceptual rather than to continue its history. Not only can one show that all our concepts reveal metaphorical traces, but once we have done so we have also eliminated the conceptual force of the use of metaphor, for if 'everything becomes metaphorical, there is no longer any literal meaning and, hence, no longer any metaphor either.'[58]

Why then would Derrida grant the notion of metaphoricity such a privileged position? Without it, it seems, he could not speak of the 'foundational,' forced,

primary metaphors, or catachreses – those 'non-true metaphors that opened philosophy' – on the one hand and of the destructive and self-destructive forces inherent in metaphorical constructions on the other. Metaphor disrupts and disseminates the semantics of conceptual systems and also destroys itself: 'It always carries its death within itself.'[59] In these opposing senses metaphor is at the heart of all signification, and metaphoricity marks the general principle which allows for this fact.

One could go further by adapting Derrida's account to an intersemiotic semantics. If meanings are events of linkage between distinct sign systems – for example, between linguistic and non-verbal signs – then metaphoricity could be extended to cover the non-congruous and negotiatory matching between heterogeneous forms of signification. Metaphor foregrounds significatory alterity. There is no room to elaborate this point here. Suffice it to say that our non-verbal readings of the world are carried away into language in a community-sanctioned fashion so that any linguistic expression acts as an economizing metaphor. Metaphor in the philological sense, then, is the conspicuous remnant and permanent reminder of this ubiquitous intersemiotic metaphoricity.

I have left Derrida's main deconstructive device, 'différance,' dangling for a while in order to grant it a more elaborate analysis. In acknowledging the critical force of Derrida's various infrastructures, and perhaps in particular that of metaphor and metaphoricity, we nonetheless suggest that arguably the most effective tool in Derrida's workshop remains his notion of 'différance.' 'Original,' 'originary,' and conceptually rich, différance suggests to the theorist its central role in deconstruction – if centrality were a term permitted in the Derridian vocabulary. Perhaps a step-by-step analysis of this elegant paper is the best way of bringing out a hardly disguised classical procedure: a transcendental argument in the Kantian sense. For readers unfamiliar with Kant's moves, a brief summary of transcendental argumentation will serve as an introduction.

Transcendental Arguments

While one can agree with Rodolpe Gasché that Derrida's 'infrastructures are not *strictu sensu* transcendentals of conditions or possibilities,' I cannot resist the temptation to test how the derivation of an infrastructure such as différance is related to transcendental reasoning as a procedure. More cogently, if there is a weakness in Gasché's admirable book, it is, I think, that he fails in the end to make the point stick that Derrida's method of inquiry is clearly distinct from transcendental procedures. It seems that Gasché presses his point by widening the gap between what he terms Heidegger's 'finite or immanent

transcendentals' and Derrida's 'quasitranscendentals.'[60] Yet there seems to me no compelling reason why the Kantian methodological heritage should be so delimited. A broader conception of transcendental argumentation appears warranted.

Such a route is suggested by David Wood, who writes that 'despite his warnings that we should not do this, Derrida must be interpreted as offering, at least formally speaking, transcendental arguments.' If he does not, 'the force of all he says about différance ... evaporates.'[61] I suggest that he does, even if Derrida presents his argument in a writing that 'absolutely upsets all dialectics' and exceeds 'everything that the history of metaphysics has comprehended.'[62]

I propose to link two features of Kant's critical apparatus in order to fashion a responsive method with which to read Derrida's seminal paper. The first is Kant's insistence on the heuristic character of all concepts; the second is a loose paradigm of transcendental moves as it emerges from the three *Critiques* and the standard literature on the topic.

Towards the end of the *Critique of Pure Reason* Kant offers a sobering lesson. Empirical concepts, he says, 'cannot be defined at all, but only made explicit' if our standard is 'to present the complete, original,' that is, the underived 'concept of a thing within the limits of its concept.' In dealing with sensible objects we cannot be sure about the selection of characteristics but only employ an indeterminate and varying number of them 'for the purpose of making distinctions.' As a result, 'the limits of the concept are never assured.' The signifier, which we treat as a concept, is not so much one in any strict sense as it is a 'designation.'

As for 'given' a priori concepts 'such as substance, cause, right, equity,' a similar critique holds. Like empirical concepts they cannot be defined in any strict sense. Since there is no certainty over the clarity of representation of such a concept, 'a multiplicity of suitable examples' can accomplish no more than a certain probability of completeness of the concept. Thus 'the completeness of the analysis of ... [Kant's] concept is always in doubt.' He therefore proposes the term 'exposition' rather than definition to characterize given a priori concepts.

The only concepts which meet Kant's strict criterion are those 'arbitrarily invented' for formal purposes, such as mathematics. The reason for this, according to Kant, is that 'the object which it thinks it exhibits *a priori* in intuition ... cannot contain either more or less than the concept, since it is through the definition that the concept of the object is given – and given originally, that is, without it being necessary to derive the definition from any other source.' This has consequences for philosophy, in which, unlike in the formal domain, concepts cannot be defined, 'only explained.'[63]

One could mention here that both Kurt Gödel and Jacques Derrida have added to this heuristic account. Gödel's critique demonstrates that even in formal systems such as arithmetic the analysis of certain propositions cannot be resolved at the level of the system in question but requires a higher order resolution, resulting in an endless series of meta-operations.[64] If Gödel is correct, then Kant's idea that the completeness of analysis of his concept is always in doubt has been radically extended to include certain aspects of formal domains.

As for Derrida's contribution to the critique of conceptuality, one could say that his writings have dramatically revived Kantian heuristic caution at the end of the *Critique of Pure Reason*, to the point of shaking the foundations of philosophical argumentation. Whether we like it or not, Derrida offers a series of moves which explore in considerable detail why non-formal concepts do not hold water the way analytical philosophy insists they do. Since those infrastructural devices explore what Kant seems to have meant by the term 'derived,' as opposed to 'original,' we are bound to reject the validity of Kant's argument if we choose to deny Derrida's critique.[65]

The second feature of the Kantian apparatus I wish to appeal to as appropriate for analysing Derrida's 'Différance' is the notorious transcendental deduction. In disagreement with Gasché's no doubt well-intentioned but unacceptable limitation of transcendental procedures to the finite and immanent, I suggest that the characteristics by which Gasché singles out Derrida's 'quasitranscendentals' are already available in Kant. The transcendental deduction is introduced explicitly to pursue questions which require an inferential procedure rather than a method of describing objects of experience. As Kant says, we are dealing with 'that which transcends the limits of all possible experience' (A89). Différance, as we shall see, however wobbly conceptually can be arrived at only as an inference and, furthermore, a necessary inference. As something like a condition, it has no existence and so escapes empirical induction; it is not a function of a formal system and so eludes the process of deduction. Rather, it stands at the provisional end point of a series of retrograde conjectures, the validity of which is judged by whether each step in the series is cogent. Put simply, cogency in transcendental reasoning refers to the relation of a given A not being thinkable without the inference of B, B not being conceivable without the stipulation of C, and so forth, until current understanding of appearances terminates the series.

A chain of transcendental signification explains a conditioned necessity by revealing its condition: 'But to understand the necessity of the cause, we must discover the cause of the cause, and so *ad infinitum*.' However far back we

pursue our significatory chain, we always signify further and further 'conditioned necessities.' This situation is cut short by stipulating 'the totality of causes, which, because it is a totality of causes, cannot itself be caused.'[66] This summary reasoning provides the platform for the conception of a non-existing and entirely empty condition without which the entire chain would be unthinkable.

What, then, does a typical transcendental argument look like? An example of the inferential nature of Kant's transcendental procedure is found in the schematism chapter of the *Critique of Pure Reason*. There he argues that pure concepts and empirical intuitions cannot be compared since they are 'quite heterogeneous' (A137, B176); they are in need of a 'third thing,' a *tertium comparationis*, if intuitions are to be subsumed under concepts. Without such a mediating process the unity of concepts and intuitions cannot be consistently thought. He therefore stipulates as a necessary inference a 'mediating representation' which is 'void of all empirical content' yet in another respect 'sensible.' And since such a necessary inference transcends empirical experience but is not construed in the fashion of the formal principles of mathematics, Kant calls it a 'transcendental schema' (A138, B177).

According to Robert Paul Wolff, one of the tasks Kant sets himself in the *Critique of Pure Reason* is to prove that all appearances stand in thoroughgoing connection according to necessary laws. The proof could be summed up in this way:

(1) All the contents of consciousness are bound up in a unity.
(2) The only way to introduce synthetic unity into a manifold of contents of consciousness is by reproducing it in imagination according to a rule.
(3) The categories taken as a 'whole,' constitute the most general a priori rules of synthesis.
(4) If all the contents of my consciousness are bound up in a unity, then they have been synthesized according to the categories. (2 and 3)
(5) But, by 1, 4, and *modus ponens:*
(6) The manifold of contents of my consciousness must have been posited in uniform fashion according to a rule. (5 and 3)
(7) But the representation of a universal condition according to which a certain manifold *must* be posited in a uniform fashion is a *law*. (A113)
(8) Therefore by 6 and 7, all appearance (contents of consciousness) stand in a thoroughgoing connection according to necessary laws. QED.[67]

A seven-step reconstruction of the same argument could look like this:

(1) There exists a synthesis of a manifold.
(2) The synthesis is an expression of the unity of consciousness.
(3) The object (synthesis of the manifold) and the unity of consciousness thus determine one another.
(4) The unity of consciousness (and hence the unity of the object) is a necessary condition of experience.
(5) This unity is a priori and a necessary condition of all experience and is called transcendental apperception (it transcends all specifics; also 'pure' in Kant's term).
(6) Transcendental apperception is a necessary condition of
 (6.1) synthesis of the manifold
 (6.2) unity of the object
 (6.3) the use of concepts
 (6.4) judgments
 whereby (6.1) to (6.4) are different ways of phrasing the same 'thing.'
(7) Judgments are possible only if there are concepts. Their most basic forms are categories of thought which are the necessary condition of knowledge.

The central arguments in the other *Critiques* can likewise be schematized.[68] One might be tempted to think that Freud's critique of free will demolishes the procedure in the *Critique of Practical Reason*, but it is only part of the content of Kant's premises and conclusion that are affected; a post-Freudian chain of reasoning would produce a modified account. That such modifications are very much in Kant's own interest is supported by his statement that 'reason must not … hasten forward … as though the accepted premises could be so securely relied upon that there can be no need of constantly returning to them and of considering whether we may not perhaps, in the course of the inferences, discover defects which have been overlooked in the principles, and which render it necessary either to determine these principles more fully or to change them entirely.'[69] What remains intact is a method of non-empirical reasoning.

The notion of the sublime and the relation between determining and reflective reasoning, between personal likes and dislikes and aesthetic judgment, and between subsumption and teleological inference via reflective reason form a web of transcendental moves throughout the *Critique of Judgment*. Suffice it to observe here that in light of Lyotard's recent revival of Kant's arguments subsuming the teleological under the aesthetic, a renewed discussion of Kant's procedure is timely.[70]

Transcendental reasoning attempts to establish the conditions under which a series of phenomena can be consistently thought. In Kant's terminology

'transcendental' refers to the conditions of a priori synthetic propositions. Rejected by some as a flawed argument because of its circular form, transcendental reasoning has also been defended from various positions, of which Hintikka's argument via second-order logic is a persuasive case.[71] There is of course a 'hermeneutic' circularity in arguments establishing transcendental principles in that any transcendental condition has the 'peculiar character that it makes possible the very experience that is its own ground of proof, and that in this experience it must itself always be presupposed.'[72] The same interpretive circularity can be found in 'Différance' (as anywhere else, if we take a careful look). But I will leave the defence of the necessity of hermeneutic circularity to Heidegger.

Derrida's Transcendental Moves

If the Fregean tradition has meaning in its definitional grip – a picture which I believe contradicts the facts of social semiotics, where definitions are a posteriori construals – what role does différance play in relation to meaning? Derrida's différance occupies a position in a long historical chain of reasoning about meaning as the negotiatory result of interpretation, the last link of which is no doubt Heidegger's hermeneutic. To be sure, Derrida's paper 'Différance' addresses larger issues than those concerned with semantics. Yet the question of the stability or instability of our conceptual schemes or broader ontological issues cannot be broached without paying attention to signification. I would also argue that a semiotics without semantics is not possible, since the mechanisms of signification are what they are by virtue of belonging to a world of meaning rather than to one of calculus. Furthermore, from an intersemiotic perspective linguistic expressions appear intimately tied to non-linguistic sign systems, whence they receive semantic content under community constraints. Thus the question of meaning is inextricably involved in every step of Derrida's paper.

Apart from offering post-Heideggerian attempts at 'overcoming' ontology and metaphysics, 'Différance' provides a pathway to the deep reasons of instabilities of meaning. Différance provides historical, regional, and class- and gender-related forms of semantic drift with a general condition without which they are not thinkable in one and the same system. As Derrida says in *Positions*, 'différance is not preceded by the originary and indivisible unity of a present possibility that I could reserve'; rather it is 'the very basis on which presence is announced or desired.' At the same time 'Différance' proffers a new unstable baseline, a *sollicitatio*, for the entire edifice of conceptuality.[73] The paper is constructed as a playfully refined and elegant transcendental procedure, which looks as follows in outline:

To prove: A general condition is required to account for all possible forms of differentiation.

Since no available term is more general than difference and differentiation, a new term is coined: 'différance.'

(1) Differentiation is found everywhere.

(2) The new term 'différance' can be used as an example demonstrating the various levels at which differentiation typically occurs.

(2.1) Graphemic difference: the importance of the inaudible 'a'

(2.2) Phonetic difference: the secondary nature of phonemes

(2.3) Syntactic difference: the importance of word order and diction, e.g., as neologism

(2.4) Deictic differentiation: no signifying subject outside a system of differences (after the Hegel section)

(2.5) First-order semantic difference: kinds of difference

(2.6) Second-order semantic difference: reference in realism and textualism

(2.7) Third-order semantic difference: examples of theorizations of differential relations

(2.7.1) Saussure's differential system

(2.7.2) Hegel's *differente Beziehung*

(2.7.3) Husserl's retentional differentiation

(2.7.4) Nietzsche's differences between forces

(2.7.5) Freud's unconscious as 'alterity'

(2.7.6) Levinas' *autrui*

(2.7.7) Heidegger's ontic–ontological difference

(3) If (1) 'difference is found everywhere' and (2) the various kinds of difference which we observe in many forms and at different levels of generality appear related to one another, then a formal condition needs to be thought which would account for (1) and (2): différance. Put more forcefully, (1) and (2) iff (3) différance.

What we find then in 'Différance' is a reconstrual, by steps of exemplification, generalization, and formalization, of the necessary conditions of difference wherever it occurs and, by entailment, also of that which appears as a result of differentiation: all beings and hence, even Being. This is a tall order and not immediately obvious, considering the innocuous opening of 'Je parlerai, donc, d'une lettre' (I will speak, then, of a letter). In the English edition of *Speech*

and Phenomena an additional preface announces some of the major themes and methodological moves: the senses of spatializing and temporalizing in *différer*, marking non-identity and 'the order of the *same*'; the neologism 'différance'; the theorization of difference by various writers, in particular Heidegger's ontic–ontological difference; and the strategic role différance is to play in considering the 'closure of the conceptual order.'

Derrida draws our attention specifically to the inadequacy of the 'transcendental language' of temporalization and spatialization, primordial temporality and spatiality, and replaces them with temporalizing and spacing. Yet the preferred noetic formulation is not so much an outright rejection of the noematic phrasing as a kind of subsumption ('which is also' and 'also includes'). It is not that Derrida has given up the search for a more embracing theoretical strategy. Indeed, from the outset he makes clear to his English-speaking audience that a more radical solution than traditional Western philosophy has been able to offer is going to be sought.

In following his analysis of the foregrounding of difference by various philosophers we should keep in mind that Derrida is proceeding not by isolation of a lowest common denominator, nor by deductive summation, nor even by inductive projection. I suggest that he follows a transcendental procedure of a certain kind. The fact that it will not yield any transcendental signified, that indeed Derrida's entire paper aims to show that such a search would be fundamentally mistaken, should not blind the reader to the systemic nature of his process. In this a double movement cannot be overlooked. As the paper progresses, we are guided to think simultaneously in terms of increasing generality and in ever emptier terms of formalization. This is why we feel led by Derrida to apply the specifics of the vocabulary of differing and différance to an ever broader range of items, while at the same time we are drawn along a path from the materiality of a single grapheme to the emptiest possible formalization of a condition without which neither beings nor their constitution by difference could be thought.

The spelling error of différance is therefore more than a mere gesture with which to annoy the Académie Française. It anchors the chain of reasoning firmly at the material base of signification, while the remainder of the paper is designed, as Derrida says, 'to aggravate its obtrusive character' ('aggraver le jeu d'une certaine insistance'). At the same time he tries to avoid the use of traditional philosophical terminology, even though, as he himself concedes, this is not always possible. The next such move is his preference for the term *faisceau*, a bundled assemblage of items in which différance plays its various functions in the evolutionary trajectory of history or in a conceptual structure which reduces semantic flexibility. Both, however, operate at levels of specificity that

exclude a range of other illustrations which Derrida wishes to get access to in order to prepare us for his 'système général de cette économie' (4). The goal is named: the general system able to account for every kind of differentiation.

The term 'différance' functions early in the paper also to establish the irreducible primacy of the written text, a topic canvassed in much of Derrida's other writing. Here, the *néo-graphisme* of 'différance' indirectly encapsulates the suggestion that its semantic content cannot be imagined because it does not signify a 'something' but a condition for relations. Hence the term, like its silent 'a,' 'cannot even be made to resonate' (132). Nevertheless, graphematic difference illustrated by 'différance' permits the very possibility of writing in Derrida's broad sense. Différance here plays the role of a general condition of all such graphematic differentiation.

Phonetic difference, Derrida concedes, is inseparable from his argument. The play with two equivocal signifiers is possible only because it is carried out within a general culture of the phoneme. Yet strictly speaking there is no such thing as phonetic writing. We are dealing here with the paradox that on the one hand, according to Saussure, the functional condition of signification is difference and, on the other, the phonetic difference itself remains inaudible. We register different sounds but not their difference. Derrida speaks of an 'inapparent relation' (133), which eludes both sensibility and intelligibility and so points to a more general order. From the specifics of graphic and phonetic difference we are referred by the force of necessary generalization to a level beyond speech and writing, 'beyond the tranquil familiarity that binds us to one and the other, reassuring us sometimes in the illusion that they are two separate things' (134). This more general order is graphematics, beyond which, since Saussure, lies a system of differentiation which makes general writing possible. Yet we cannot conceive of an order or system without some informing principle. At the level of the phonemic–graphemic, then, we feel bound to follow Derrida in stipulating a general condition for differentiation: différance.

How can différance be presented, asks Derrida, if it is not a 'being-present' ('un étant-présent')? He points to the difference he wants to draw between the order of beings and the merely relational différance by bracketing the notions of existence and essence. As in arguments of negative theology about the description of God who is not and hence cannot be captured by any kind of predication, différance escapes description as a being; it is merely a condition for difference. Unlike negative theologists, Derrida does not invent an inconceivable higher level beyond existence and essence in order to accommodate différance. On the contrary différance escapes this kind of onto-theological hierarchy precisely because it is entirely empty, a mere condition

to make distinct kinds of difference thinkable.[74] Like Heidegger, Derrida here escapes too close an alignment with theology. As for his protestations concerning the philosophical tradition, however, matters are somewhat more complicated.

In Kantian manner Derrida realizes the derivative nature of a procedure which begins with the delineation of an 'assemblage' of kinds of difference. At the same time he wishes to avoid a philosophical discourse based on 'principle ... postulates, axioms and definitions' along the lines of a 'rational order.' Instead, he proposes in 'Différance' a 'blind tactics' ('tactique aveugle') informed by the play of the 'unity of chance and necessity in an endless calculus' (135). Yet here, it seems, lies a concealed move because empirical errancy and chance selection are already understood not to be able to go wrong. Whatever phenomena of differentiation are assembled will deliver the goods by virtue of the hermeneutic circularity of transcendental procedure: a generalizable and formalizable master trope, named 'différance.' Moreover, as I am in the process of demonstrating, Derrida has not quite managed to avoid a classical form of reasoning in the overall structure of his paper.

Before Derrida goes on to offer 'a simple and approximative semantic analysis' he repeats his earlier proposition that 'différance' is neither a word nor a concept. History has done its work since that pronouncement in 1968, so that 'différance' is now regarded at least as a word; with respect to its conceptual character we could say that it behaves like many other philosophical terms whose meaning cannot be captured by a brief dictionary entry, such as Heidegger's ontic–ontological difference. Certainly, 'différance' was then and still is a signifier with a shimmering semantic field or, to put it intersemiotically, a signifier which we tend to link with a varying assembly of other linguistic and non-linguistic signs. Beyond its graphemic and phonetic features as a signifier in a system of other signifiers, 'différance' also plays a syntactical role. A neologism, 'différance' depended on an initial introduction into syntax. This is one of the main tasks Derrida set himself in his paper, and by the end of it we have a fair grasp of the typical syntactic relations which the author envisaged as legitimate ('différance is ...') and illegitimate ('différance is not ...').

'Syntactical *praxis*' allows signification to occur. As he writes of 'hymen,' that other deconstructive device,

it produces its effect first and foremost through the syntax, which disposes the '*entre*' in such a way that the suspense is due only to the placement and not the content of words ... It is the 'between,' whether it names fusion or separation, that thus carries all the force of the operation. The hymen must be determined through the *entre* and not the other way around. The hymen in the text (crime, sexual act, incest, suicide,

simulacrum) is inscribed at the very tip of this indecision. This tip advances according to the irreducible excess of the syntactic over the semantic.[75]

Like other undecidables, 'différance' functions syncategorematically, as an 'incomplete signification' whose value always derives from syntax (221). Importantly, Derrida presses the point further when he insists that we are not in a position to say with any authority that the ' "between" is a purely syntactic function.' Because its semantic emptiness is re-marked 'it in fact begins to signify.' 'Spacing and articulation' are signified by the 'semantic void.' As a result différance has as its meaning 'the possibility of syntax; it orders the play of meaning. *Neither purely syntactic nor purely semantic*, it marks the articulated opening of that opposition' (222). The new syntactic relations introduced by a neologism such as 'différance' not only make new forms of semantic play possible but also point to the more fundamental level of the conditions under which both syntax and semantics are possible. Beyond the materiality of writing and sound, différance as syntax is a general and formally empty condition for specific syntactic and semantic processes, including those that allow us to 'claim [*prétendre*] to know who and where we "are" and what the limits of an "epoch" can be.'[76] In short différance is a sine qua non for the constructions which make up our world.

Derrida now proceeds to offer an 'approximative' semantics of *différer*, highlighting its foregrounded spatial and repressed temporal aspects. This is a well-canvassed part of the paper and permits me to restrict myself to pointing only briefly to the new meaning complex attached to 'différance,' to which *différer* directs us. In particular Derrida is concerned with the senses of non-identity in a stipulated system of co-ordinates and of postponement in a serial order. Furthermore, the syntax of the *-ance* in différance is shown to indicate a deliberate undecidability about the active and passive voice, so that it functions like the middle voice (*la voix moyenne*). This allows Derrida to remove his neologism somewhat from orthodox syntactic and semantic practice, according to which we are always guided to see the world either in terms of an agent's action on something or in terms of someone suffering something. Différance is outside this kind of order, enjoying a special kind of semantic freedom which enables it to account for the simultaneous reference of spatializing and temporalizing.

The position it occupies in relation to ordinary linguistic practice cannot be strictly in the middle between the passive and active voice, however, or even on the same plane. Since Derrida stipulates that différance is able to account for both, it is transcendent in relation to that conceptual plane; it has both a more general and a more formally empty character than the differences it

rules. Différance transcends their specificity. Because we can neither read it off some empirical set of phenomena nor make it deductively a feature of a closed formal system, such as an arithmetic order, nor moreover posit it inductively as an hypothesis to be corroborated or falsified later, the only other avenue of reasoning appears to be some transcendental process according to which we are bound to stipulate a condition without which a related series of phenomena and their specific conditions would not be thinkable. This, I suggest, is precisely what Derrida, in spite of some minor protestations to the contrary, is doing in 'Différance.'

We should also note here Derrida's speculative aside, in which he wonders whether philosophical reasoning is perhaps dependent on the distribution of the middle voice to two clearly decidable camps, the active and the passive voice, the middle voice having proved inconvenient for the binary perspective entailed in drawing distinctions (137, 9). If philosophy is indeed constituted in this manner, then Derrida's enterprise seems to be postphilosophical in the sense that he explores the foundations on which philosophical writing stands. Ironically, this sort of enterprise cannot help but become a philosophy of philosophical limits in the spirit of Kant. What is a problem to be acknowledged in Kant, namely the relative instability and therefore merely heuristic value of concepts, is turned by Derrida into an active process of considerable force. He shifts and invents terms so that their semantic instability is increased rather than curtailed. By sharpening their semantic undecidability he makes his 'concepts' less reliable, and so weaker if seen from the ideal of a Fregean *Begriffsschrift*, but powerful in the sense of a directed semantic multivalency. As a result the binary moves of reasoning as dis-tinction are deprivileged and a play of semantic possibilities within the directionality of a *faisceau*, a bundled and yet disseminating dynamics, is valorized instead.

Derrida postpones the question of how, precisely, temporalizing and spatializing are conjoined in différance at this stage of the argument in order to introduce what I have termed his explication at the level of a second-order semantics. Here he addresses a fundamental semiotic problem, the relation between signification and 'world.' In the space of less than two pages he sketches a 'classical' version of the debate about realism and textualism. He begins by stressing the character of the sign as that of a replacement, a standing in for what is signified: 'signs take the place of the present,' functioning as detours towards a presented reality which forever escapes us. All we have are signs, and so 'the sign would thus be a deferred presence.' Instead of 'the moment of encountering the thing itself,' we have the deferring 'movement of signs.'

If signification were to be understood in terms of substitution of presence, Derrida says, in terms of the 'authority of presence or its simple symmetrical

contrary, absence or lack,' then différance would have to be located outside any system of signification. More radically, he argues that rather than face the impasse of declaring 'différance' unable to signify at all, he prefers to challenge the classical assumption of presence beyond the sign: 'We thus interrogate the limit that has always constrained us, that always constrains us – we who inhabit a language and a system of thought – to form the sense of being in general as presence or absence, in the categories of being or beingness (ousia)' (138–9, 9–10).

Instead, Derrida argues for a significatory world, leaving its relationship to any constraining 'stuff' unanswered. Interesting for our purposes is that he employs Fregean terms such as sense and reference initially in their traditional manner, only to refuse them validity later when he rejects the notion of a presentable reality outside signification. This goes well with both Kant's schematism and Peirce's general semiotics. Moreover, Derrida's position invites us to reformulate the description of a number of terms which are part and parcel of the classical picture. We are unable to see the noumenal, but we can stipulate some sort of unknowable stuff as a base condition for the possibility of human experience. What we are able to see, grasp, smell, and verbalize is no more than Derrida's movement of signs. In Kant's terms what we see results from the combination of intuition and concepts, intelligible only if we stipulate the mediating condition of a transcendental schema. Peirce rewrites Kant in semiotic terms so that the world of human communities can only be one of signs within an infinite regress of semiosis. Quite wrongly, Derrida's position in this respect tends to be much too closely aligned with Saussure and the foregrounding of the linguistic. As for the question of signs, Derrida is much more a pupil of Peirce and, as a result, non-linguistic signs play an important role in his perspective. The notorious 'there is nothing outside the text' involves 'general propositions ... as regards the absence of the referent or the transcendental signified' and so needs to be read in an intersemiotic manner if it is to make sense.[77] Regarded merely linguistically, it makes no sense, and is not consistent with Derrida's overall position.

Given this reading, reference can be reformulated intersemiotically to ac-commodate Derrida's critique of presence without losing sight of the important Kantian question of constraints. To accomplish this, reference has to be re-defined as a relation between different signs instead of one between sign and unmediated world, sign and presence. As argued earlier, reference can then function as a relation between, for example, a linguistic expression (sign 1) and a specific tactile reading (sign 2). In this way meaning would not be possible without reference, actual or fictional. It results from the linkage between at least two sign systems, such as the olfactory and the visual, or the linguistic and

the haptic, the latter cashing in, as it were, the suggestion of the former. In the practice of everyday life a number of signs from different systems typically tend to corroborate one another. Reference, by contrast, is the specific relation between signs, including those within one and the same system. We can therefore have self-reference within language, while linguistic meaning cannot be established without activating non-verbal signs. Constraints on meaning and reference are partly institutional and partly inferential, in the sense that speech communities tend to eliminate forms of signification which they are forced to acknowledge as hostile to survival. This scenario goes well beyond Derrida's account, but some such semantics is needed if we are to read his 'semiological' world as coherent.

The problem of the presence or absence of signs is another feature not addressed in Derrida's brief account of signification and world. If presence escapes us altogether, so do signifiers, as far as they are objects in the world. Yet to register that we are dealing with a signifier, such as a linguistic expression, is to activate either a visual or an aural kind of signification, much in the same sense as we see and hear images and sounds, respectively. They are semiotic construals, and so are signifiers as signifiers. From this kind of reasoning we come up with Peirce's, and later Derrida's, infinite chain of signs, which returns us once again to the problem of constraints. What is it that keeps our signs in the sort of order which allows us to construe our world in a consistent manner? Is it in the nature of signs that they eliminate contradiction? If so, who or what decides which of the non-contradictory kinds of signification also produce consistent worlds? Or will any non-contradictory signification do? We can go along with Derrida in his rejection of a naïve realism, one which foregrounds presence independent of signification and regards texts as no more than a mirror of presence. On the other hand, radical textualist relativists fail by the definition of relativism to make any position coherent, including their own. Remaining, then, is a position capable of admitting the necessity of constraints without having to claim to know what they are: some form of inferential realism or, as I have called it elsewhere, a realist textualism.[78]

The transcendental move which Derrida makes in relation to second-order semantics is thus twofold. First, he suggests that if signification rests on the substitution of presence, then différance, which does not signify anything present or absent, lies beyond the order of signs. Because it signifies 'something,' however, even if no more than a series of relations, we are bound to stipulate différance as a general and empty condition without which signs referring to presence could not be conceived. Second, if presence and absence are misleading points of departure for arguments concerning signification and something more abstract is required, then différance itself becomes a possible candidate for a

more promising premise, a condition without which any kind of signification, including philosophical distinctions, would not be thinkable.

The next major step in 'Différance' is the introduction of a third-order semantics, in which Derrida displays a series of examples of how difference has been theorized in the past. In doing so he seems to have moved to the level of argument at which his own position and those of other writers compete, were it not that the whole purpose of his paper is to show how différance subsumes previous positions. Derrida gives seven examples – Saussure, Hegel, Husserl, Nietzsche, Freud, Levinas, and Heidegger – all of whom have added significantly to the theorization of difference. The selection is arbitrary to the extent that the list could have been expanded considerably. On the other hand, the seven writers chosen furnish a representative picture of how to address the importance of difference in a number of fields. The combination of the arbitrary and representative character of the selection is not itself arbitrary but is a typical feature of transcendental deductions. If the stipulation of a general condition holds, then any specific example within the frame of the argument will do. This is most obviously the case when the procedure is employed in order to crystallize a condition at the most general and formally empty level thinkable. Derrida attempts no less.

Saussure heads the list with the double claim of the arbitrariness and related differential nature of all signs. Perhaps one should add here that Peirce noted the arbitrariness of signs before Saussure, even if he insisted that we need to differentiate degrees of arbitrariness, that iconic and indexical signs were not entirely arbitrary and only symbolic signs could be properly described as such.[79] This observation also prevented Peirce from stipulating differentiation between signs as the chief feature of sign systems; instead he allowed for systemic, analogous relations between, for example, linguistic and non-linguistic signs. Derrida acknowledges the problematic nature of Saussure's account before focusing on the well-known claim that 'in language there are only differences without positive terms.'[80] Since, according to Derrida in 'Différance,' 'the signified concept is never present in itself,' all we can work with is its position in a chain of signifiers determined by 'the systematic play of differences.' He follows with another transcendental step, revealing the condition without which the Saussurean picture could not be conceptualized: 'Such a play, then – différance – is no longer simply a concept, but the possibility of conceptuality, of the conceptual process and system in general.'[81] A little later Derrida writes, 'différance is the nonfull, nonsimple "origin"; it is the structured and differing origin of differences' (141). The important qualifying final clause of the paragraph is missing in the English version: 'Le nom d'"origine" ne lui convient donc plus' (12).

Derrida prefers to designate différance as the 'movement' which allows significance to appear as a 'fabric of differences' ('tissu de différences') (141, 12–13). Yet terms such as 'movement,' 'constitution,' 'production,' or 'history' are employed only for strategic convenience and lack of a more suitable vocabulary. The reader is warned that they should be understood as no more than auxiliary tools since they carry with them the package of metaphysical assumptions which Derrida aims to disenfranchise. Importantly, their metaphysical flaw is their traditional association with an assumed possibility of access to presence. For this reason Derrida refers the reader to a series of 'nonsynonymic substitutions' in which différance should be seen to function: reserve, protowriting, prototrace, spacing, supplement, *pharmakon*, and *hymen*, those infrastructural devices familiar from his other writings.

At this point a simple but crucial difference must be re-emphasized: the difference between such transcendentals as 'constitution,' 'consciousness,' or 'history' and transcendental method. The promise of access to presence is not a characteristic of transcendental procedures, which are designed to guide our constructions along the path of the conditions of conditions towards the most general condition of a reasoning chain. The fundamental underdetermination of concepts and the necessity for revision[82] severs any direct bond between the transcendental deduction as procedure and the metaphysic from which it emerged. Contrary to subsumptive deduction, for example, transcendental operations are methodological processes which can be applied to anything at any historical moment, including to their own mechanisms. We cannot derive the possibility of ordinary deduction via deduction. In this sense transcendental arguments trace the conditions which must prevail for something to be thinkable, any sine qua non of cognition. So far, différance appears to be such a condition.

The next step in Derrida's *faisceau* is as crucial as it is brief: a critique of Husserl's position in *The Phenomenology of Internal Time-Consciousness*, though Husserl is not mentioned at this point presumably because Derrida's audience was familiar both with his recent writings on Husserl and with the referent of the terminology of 'retentions' and 'protentions.' I would like to ask at this point how far Derrida is able to leave behind his Husserlian starting point and make good his promise in 'Différance' of 'overcoming' what he terms the inadequacy of 'a phenomenological and transcendental language.'[83] He characterizes différance as making 'the movement of signification possible only if each element that is said to be "present" … is related to something other than itself but retains the mark of a past element and already lets itself be hollowed out by the mark of its relation to a future element' (142, 13). Instead of a homogeneous present and presence we are thus forever situated

in a 'modified present' self-divided by traces. Différance here functions as the synthesis of retentional and protentional traces and hence as the constitution of an 'irreducibly nonsimple' present. Let us see how far this position deviates from Husserl's. Of particular interest here should be Husserl's notions of 'now,' 'retentional modification,' and the heuristic nature of the 'present.'

'Retentional modification'[84] refers to the observation that 'consciousness is engaged in continuous alteration.' As a result, 'every actual now of consciousness ... is subject to the law of modification' (50) and 'every retention is already a continuum' (51). Likewise, 'every primordially constituted process is animated by protentions which voidly constitute and intercept what is coming ... These protentions were not only present as intercepting, they have also intercepted' (76). The combination of retentional and protentional modifications causes a crucial 'alteration according to which the primal impression continually "dies away"' (130).

As for Husserl's present in living consciousness, he speaks of moments of origin which correspond to actual 'nows.' However, 'these moments in the succession are continuously one, "go continuously over into one another"' (132). As Husserl points out, his 'now' is heuristic, a stipulated 'ideal limit' rather than something we can have and hold. 'We are concerned here,' he says, 'with a continuum of gradations in the direction of an ideal limit ... we always have and, according to the nature of the matter, can only have continuities of apprehensions, or better, a single continuum which is constantly modified' (62). The following two passages from Husserl are particularly relevant to Derrida's point:

If somehow we divide this continuum into two adjoining parts, that part which includes the now, or is capable of constituting it, designates and constitutes the 'gross' now, which, as soon as we divide it further, immediately breaks down again into a finer now and a past, etc.

... In an ideal sense, then, perception (impression) would be the phase of consciousness which constitutes the pure now, and memory every other phase of the continuity. *But this is just an ideal limit, something abstract which can be nothing for itself.* Moreover, it is also true that even this ideal now is not something *toto caelo* different from the not-now but continually accommodates itself thereto. The continual transition from perception to primary remembrance conforms to this accommodation. (62–3, emphasis added)

Rather than saying that Derrida 'overcomes' the position offered in *The Phenomenology of Internal Time-Consciousness*, we should argue that he radicalizes Husserl's already divided and modified 'now.' Derrida's destabilized present,

then, is not altogether new, but the consequences he draws from this insight are. Husserl's eidetic convictions held him back from pursuing these consequences himself, and these have been persuasively critiqued by Derrida in *Speech and Phenomena*. By the time Husserl was able to review his enterprise from the vantage point of the *Lebenswelt*, the themes of inner time-consciousness could have received a more advanced treatment. Be that as it may, Derrida here is the immediate heir to Husserl's investigations in the sense that he provides Husserl's continuously modified 'now,' via a transcendental chain of moves, with the condition which makes it thinkable: différance.

The section on Hegel in Derrida's 'Différance' is intriguing for two reasons. For one thing Derrida distances himself less from Hegel's present as a *différente Beziehung* than from Husserl's divided 'now'; and for another he does not explore the relation between différance and the temporal-spatial aspects of Hegel's dialectical chain.[85] The reader can be excused for having expected the critique of the 'now' to strongly motivate Derrida's review of Hegel's dialectic. Instead we are referred to his own writings on Hegel elsewhere. Derrida opens the section by asking why one would not use 'differentiation' instead of 'différance.' He offers two reasons. First, this would suggest the positive starting point of some unitary entity which was then divided into ever smaller components. Such an originary unity would defeat precisely what is at stake in différance. Second, the crucial feature of temporalizing is not well captured by the term 'differentiation.' Nevertheless, Derrida believes that at certain moments in Hegel's writing différance would be the most appropriate translation of *différente Beziehung*. This, I argue, applies even more poignantly to Hegel's *Aufhebung*. As Derrida writes, Hegel 'must be followed to the end, without reserve, to the point of agreeing with him against himself,' because he is 'indifferent to the comedy of the *Aufhebung*.'[86] Yet as Hegel sees it his *Logic* the dialectic 'apprehends the unity of terms (propositions) in their opposition – the affirmative, which is involved in their disintegration and their transition.' In this the *Aufhebung*, as the third phase of the dialectic, is able to account not only for traces from its preceding positive terms but above all for the temporal movement of differentiation. The *Aufhebung* temporalizes the spatial differentialization of its dialectical opposites: 'Wherever there is movement, wherever there is life, wherever anything is carried into effect in the actual world, there Dialectic is at work.'[87] When Derrida translates *Aufhebung* as 'to surpass while maintaining' he understates the triple meaning of the term: lifting to a higher level, cancelling, and preserving.[88] Nor is the dialectic as movement to be shrunk into a singular unit. As the entire structure of Hegel's *The Phenomenology of Mind* attempts to demonstrate, dialectical reasoning is a continuity of opposites and their synthesis to the point of an overarching

empty 'principle,' a term that reflects more appropriately this unthinkable formality than do the customary translations of Hegel's *absoluter Geist*. Though Derrida avoids a discussion of the *Aufhebung* at this point in 'Différance,' he rejects 'a definite rupture with Hegelian language' and notes the close relation between some of Hegel's notions and différance, except for the more encompassing generality of his own term. One might add to his Hegel section, then, by suggesting that a principle which carries the double meaning of temporalization and spatialization and yet is empty enough to account for all stages of the dialectic as a differential chain would allow the dialectical chain of reasoning to be conceivable. This would not violate what Derrida has said about différance so far, for all differences, including Hegel's, are ' "produced" – differed – by différance.'[89]

Between his comments on Hegel and Nietzsche, Derrida presents a brief interlude on agency by asking 'What differs? Who differs? What is différance?' He does this only to show that these questions, put in this manner, must inevitably lead to a misunderstanding of his entire argument (145, 15). One might have expected this 'deictic' section to precede those of the various levels of semantics or to form part of the commentary on Saussure or Husserl. As it stands, it mediates between his remarks on différance as 'productive' and Nietzsche's difference between forces. What, then, generates différance? The question is illegitimate because it assumes that différance is derivative. After all, Derrida's point is to show that différance, though a condition for everything else, does not draw on a more fundamental resource, a position in which Kant frequently found himself in the three *Critiques*. Neither the subject nor consciousness qualify as a prime mover either.

Following Saussure, Derrida insists that the relation between language and subject is such that the subject 'becomes a *speaking* subject only by conforming his speech ... to the system of linguistic prescriptions' understood as 'the system of differences,' at least as 'the general law of différance.' We note the Kantian transcendental parlance employed to make the point that without the stipulation of *langue* our *paroles* could not be thought consistently. Moreover, the relationship between *langue* and *parole* must be stated more generally with respect to all forms of signification. As Derrida puts it, 'the practice ... of any code implying a play of forms ... which also presupposes in the practice of this play a retention and protention of differences, a spacing and temporalizing, a play of traces, must be a kind of writing before the letter, and arche-writing without present origin, without arche' (16, my translation). Alfred Schutz, refining Husserl on this point, termed the general level prior to any specific sign system the level of 'typifications,' of which linguistic signs are the dominant application. In attempting to foreground the notion of writing in its most generalized

form, Derrida cannot avoid carrying the linguistic metaphor into the general domain of signs. Methodologically, the move is comparable to Schutz's, except that post-Schutzian phenomenology emphasizes the corroborative relations between different systems of typification, and beyond those a correlative relation between distinct ontic regions. Derrida, by contrast, highlights the differential nature of signs as their generative base. Différance facilitates this state of affairs.

With the analysis of the signifying subject Derrida once more returns to Husserl and the centrality of presence and self-presence. As we have seen, Husserl understands the 'now' as always already modified and divided. Hence, Derrida's critique of the 'absolute privilege of this form or epoch of presence' and 'consciousness as meaning [vouloir-dire] in self-presence' must reject even the heuristic stipulation of acts of consciousness and its explanatory force (147, 17). Yet Derrida sharpens the gap between the Husserlian and his own enterprise by now characterizing Husserl's 'presence' as 'the absolutely matrical form of being,' which must be redefined in terms of 'determination and effect' in an altogether different system, that of différance. In one perhaps too trivial sense, phenomenology will forever haunt theorizing. What can our construal of differences be except acts of consciousness? If they were not directional acts in Husserl's sense, they could not be argued, nor, ironically, could their sine qua non, différance.

Once more Derrida reminds us that the use of such terms as 'determination' or 'effect' is strategic, though unfortunately that language hitches the argument to a philosophical style which he wishes to leave behind. We note, however, that within the traditional vocabulary there are at least two radically divergent uses of 'cause' and 'effect': an empirical use which reads causal relations off the phenomenal world; and a transcendental notion according to which neither cause nor effect exist, although they need to be stipulated as a relation without which we cannot consistently conceive our perspectives of the 'world.' I suggest that in this latter sense différance can be argued, without loss of the kind of force Derrida wishes to grant the term, to effect all forms of differentiation.

In spite of its brevity Derrida's exemplification of différance via Nietzsche has considerable weight for a number of reasons. He draws attention to Nietzsche having made the proto-Freudian move of rattling 'the self-assured certitude of consciousness' (148, 18); to Nietzsche's description of quantity as inseparable from 'the difference in quantity'; and to his important distinction between what is 'identical' and what is the 'same.' The last of these can be developed into a powerful tool with which to describe specific philosophical moves, such as the untheorized transition from and so equivocation between formal sense

and the sense of natural languages in Frege.[90] Nietzsche's distinction could also be elaborated in order to gauge the deep divide, perhaps emanating from Leibniz's 'closure' via sufficient reason, between analytical philosophy in the Fregean tradition and critical-speculative theorizing, of which deconstruction is but a recent branch.

For his own argument Derrida draws from Nietzsche the presentation in an eternal return of 'the sameness of difference and repetition.' Nietzsche offers Derrida an alternative to the 'incessant deciphering for the disclosure of truth' by providing 'a system of ciphers which is not dominated by truth value.' That puts Derrida in a position to rewrite différance as 'that "active," dynamic discord of the different forces and the differences between forces which Nietzsche opposes to the entire system of metaphysical grammar wherever it rules culture, philosophy, and science.'[91]

Derrida discovers the same 'diaphoristics' in Freud's writing and finds it exemplary because it displays the differential effects of spacing and temporalizing in the analysis of the unconscious. Derrida focuses the Freudian corpus by juxtaposing the notion of the unconscious as radical alterity to the Husserlian consciousness, inasmuch as the former offers us 'a "past" that has never been nor will ever be present.' Hence, says Derrida in 'Différance,' the notion of trace is 'incommensurate with that of retention.'[92]

Likewise, the entire Freudian apparatus is viewed as yielding to Derrida's perspective of différance. *Bahnung* (the clearing of neural and other pathways), *Niederschrift* (inscription), *Vorrat* (reserve), *Aufschub* (deferral), *thanatos*, and *Nachträglichkeit* (postponement, or the relation between pleasure principle and reality principle) all provide evidence of kinds of differentiation which can be thought only if we stipulate an '*inconceivable*' (*impensable*) condition, différance.[93] Derrida foreshadowed this when he introduced 'différance' as neither a word nor a concept. By the same token he finds himself in a position indistinguishable from someone construing a transcendental argument: a condition has to be named that is general and formally empty enough to cope with differences, accounted and unaccounted for, which cannot be thought simultaneously and yet are thinkable as differences. They require a *Bahnung*.

Apart from a brief alignment of the critique of classical ontology from the angle of the absolute alterity of *autrui* with the general condition of différance, Derrida refers to Emmanuel Levinas mainly to make a methodological point. He belongs to an arbitrary, though exemplary, series of writers whose names 'serve here merely as signs' of our postontological epoch. We recognize this as a standard move in transcendental procedures: to select a series of particular items or positions as illustrations of a communality among them both at the same level and at a more general one. The general level needs to be stipulated

before we can note the more specific one. In this respect Derrida's 'bundle' of approaches to theorizing differentiation in diverse fields forms a recognizable rung on the ladder of transcendental reasoning.

The final example in Derrida's *faisceau* is the ontic–ontological difference, the difference between beings and Being, a difference which, as Heidegger says, we are in the habit of forgetting. 'Imperceptibly, presence becomes itself a present.'[94] This is by far the most elaborate section, not least because Derrida takes special care in demonstrating how very closely related the questions both he and Heidegger pose are and where the differences lie between the ontic–ontological difference and différance. At the surface, at least, this looks like a classical case of philosophical one-upmanship in which the younger writer attempts to topple his most influential theoretical father. That there is more to Derrida's move than this, however, should become clearer shortly.

So far he has been at pains to set up a radical difference between two kinds of method. One derives its positive terms from a chain of reasoning which ends with the transcendental signifieds of presence and ontology, the hallmarks of metaphysics. The other juxtaposes a series of abstractions within a chain of terms neither negative nor positive but of facilitating differentiation, a chain which ends in the stipulation of its empty condition, différance. Heidegger stands at the border between the two forms of reasoning in 'Overcoming Metaphysics' and his exploration of the ontic–ontological difference. Yet even the ontic–ontological difference is argued within a system of positive terms, the particulars of beings and their empty yet positive condition, Being. Différance, by contrast, is 'not marked by a capital letter'; it 'rules over nothing'; it not only escapes every thinkable domain, but rather is 'the subversion of every realm' (153, 22). If this is the case, Derrida asks, is différance to be located somewhere within the ambit of the difference Heidegger speaks of?

Derrida's first answer makes the point that in one sense the ontic–ontological difference can be conceived of as 'still an intrametaphysical effect of différance' in that the attempt at thinking it itself requires a formal condition (153, 23). Derrida also points to the relative historical specificity of Heidegger's concern, which emerges from a particular line of philosophy, our Greek heritage of *logos*. This kind of particularity cannot be attached to the 'bottomless chessboard' named différance. 'Turtles all the way down,' the Buddhist logician might add.

Why have we forgotten the essence of Being, which for Heidegger is the same as having forgotten the difference between Being and beings? One could answer by saying that we are simply not in the habit of questioning how beings are possible, just as we are not in the habit of questioning how differences

are possible. But Heidegger's question is addressed to metaphysics. As a result of this metaphysical forgetting, the ontic–ontological difference has 'disappeared without leaving a trace.' But if différance is the functioning of traces this would mean the loss of 'the trace's trace.' In Heidegger's words 'the matinal trace of difference effaces itself from the moment that presence appears as a being-present' (156, 25).

Derrida reformulates Heidegger by subjecting his being-present to the work of the trace: 'The present becomes the sign of signs, the trace of traces.' Presence is no longer the final reference of every signification but 'becomes a function in a structure of generalized reference,' without limits, one could add (156, 25). At the same time the trace of difference would by itself be 'lost in irretrievable invisibility' were it not for the presence of writing and the text, in which the trace of difference is protected. Derrida concedes that without some notion of presence we could not conceive of differences in their various forms, even less of their summary condition, différance. Yet he asks how we can conceive of trace and différance in terms of the essence of Being. Does not the disjunctive function of différance point beyond the metaphysics of Being, and haven't we reached a point at which we require a necessarily 'violent transformation' of the language of Being and its replacement by 'an entirely different language' (158, 26)?

The whole thrust of 'Différance' appears to demand a positive answer to these questions, yet Derrida hesitates. What would a text outside a text look like? Specifically, what would be an alternative 'to the text of Western Metaphysics'? Though disguised in the names of metaphysical writing, trace and difference do not appear. As Heidegger phrases it, 'The clearing up of the difference can therefore not mean that the difference appears as such.'[95] Derrida suggests that they cannot appear because they have no essence. Further, trace and difference undermine presence and essence wherever they occur as différance. Wherever they are at work, wherever différance comes to the fore, as it does in 'the play of writing,' we cannot fasten on Being or truth. As for the ontic–ontological difference, Derrida suggests that in spite of its position at the limit of the thinkable, it reveals itself as one of the effects of différance.

The discussion of Heidegger's ontic–ontological difference is the last in Derrida's demonstrations of the need for a notion which would allow us to think difference in all its forms. At this point he retreats from clinching the argument in traditional fashion by conceding the metaphysical character even of 'différance.' Thus the master device 'différance' remains provisional. What it is supposed to signify remains outside our language, outside essence and Being, because as soon as we describe it as, for example, différance, it disintegrates

into its various functions 'in a chain of different substitutions.'[96] As soon as we describe différance as différance it disintegrates. Given this emphasis on the base condition of all differentiation for which 'différance' is merely a provisional name, how do we adequately express the 'relation between speech and Being'? And how do we now, after all this, read Heidegger's words, 'Being speaks everywhere and always through every language'? We may feel tempted to add that if this is so, we require some kind of condition which permits Being to 'do' this. Let us call it, for example, différance.

Conclusion

To rephrase a recent formulation by Habermas in semiological terms, transcendental analysis is a nonempirical reconstruction of the a priori achievements of the system which constitutes the 'cognizing subject.' No signification 'shall be thought possible under *different* conditions.' For Habermas 'the hallmark of the transcendental justification is the notion that we can prove the nonsubstitutability of certain mental operations' – we would say significatory moves – 'that we always already (intuitively) perform in accordance with rules.'[97] Différance, we could say, is the reluctant signifier for such a justification. That Derrida is eager to show that différance is a condition of conditions rather than of entities if anything strengthens the claim that his procedure is indistinguishable from Kant's transcendental method. After all, Kant included 'nothing' as a possible object of transcendental inquiry.

Derrida feels obliged to justify his observation that différance yields the differential relations which make signification possible and with it everything we can conceive and 'write.' This is not unlike Kant, who assumed that 'justification was demanded for the fact that a scheme yielded synthetic *a priori* statements.' Importantly, 'justification of this sort can only be attempted by showing first that the categorial scheme must apply, not that if a scheme applies, it does so necessarily.'[98] In Derrida's case justification requires the demonstration that something like différance is indispensable for semiosis. This seems to be precisely the thrust of his paper.

Alternatively, let us assume that Kant's transcendental argument consists of two related processes, one, 'a concern with justifying a priori synthetic judgments' and, two, 'an appeal to the conditions of the possibility of experience to ground the argument.'[99] From this angle Derrida's procedure appears as two parallel moves: one justifies the all-pervasiveness of differential relations in signifying processes, and the other demonstrates the conditions for the possibility of differences as a ground for his argument and, by entailment, all argument. Like Kant, Derrida pursues a 'program of self-referential reasoning

on a metalevel between factual knowledge and pure principles of reason.' As Rüdiger Bubner notes critically about Kant's form of argument, the formal emptiness of the concept of synthesis makes it possible for the manifold nature of sense-data and different concepts in the connecting of judgments to be 'subordinated to a single structural property of understanding, namely synthetic achievements.'[100] If this is regarded as a weakness of method, a similar criticism can be levelled at Derrida. Here too, the formality of différance is such that from the outset it subsumes not only ordinary signs but also the meta-signs of all theorization about signification: a self-referential explication. In Derrida's defence one could say that such are transcendental procedures, Kant's as well as his own. Furthermore, this 'weakness' can be turned into a strength if it is seen as the result of the interaction of a first- and second-order logic.[101] Considering his method, and in spite of some protestations to the contrary, Derrida could well have said in the Kantian spirit that he entitled *transcendental* all writing which was occupied not so much with objects as with the mode of grasping their (non)presence, insofar as this mode of writing was to yield the conditions without which signification is not thinkable.[102]

Having aligned Derrida with the philosophical tradition in this way serves purposes other than that of reappropriation. Five insights relevant to *Semantics and the Body* emerge. (1) The foundations of meaning, even if they turn out to be no more than differential and so ultimately groundless, can be persuasively argued by transcendental moves. (2) The article 'Différance' succeeds as a posthermeneutic limiting project. (3) The concept of différance radically destabilizes non-formal meanings (sense 2), including high-level philosophical concepts, a result that does not apply to Fregean sense (sense 1). Hence différance can be used as an alternative approach to the description of the non-definitional character of social discourse. (4) Différance, and by implication Derrida's other infrastructures, cannot be restricted to the linguistic domain, for as he said recently, to confine deconstruction 'to linguistic phenomena is the most suspect of operations.' (5) Différance supports the description of meaning as the unstable result of negotiating heterogeneous, non-verbal signs by which we activate linguistic schemata. In such a corporeal semantics 'the body ... is an experience of the most unstable [*voyageur*] sense of the term; it is an experience of frames, of dehiscence, of dislocation'; in short, of différance.[103]

5

Semantics and the Postmodern

5.1 THE POSTMODERN SURFACE

The tendency to confuse the mechanisms of syntax and with those of semantics is widespread in recent theorizing. It has its main roots in Saussure's description of language as a system of differential relations at the morphological, phonetic, syntactic, and semantic levels. In this series semantics is the odd category, since it requires a linkage to other systems of signification outside language to operate. Possibly Saussure and his students read Frege's specific collapse of natural language sense into formal sense as a confirmation of this move. But while Frege had his eyes primarily on the ideal of a pure *Begriffsschrift*, the Saussurean tradition focuses on the analysis of natural language. It is here that the equivocation of syntax, or calculus, and referential semantics proves detrimental, for without the deixis of utterance situations and the contingencies of historical textuality as reference, the analyst is at a loss how to come to grips with the corporeality of the social and political aspects of culture.

When one describes the social, replacing meaning with syntactic operations is comparable to using statistics in the critical-interpretive disciplines. If there is no prior basis for critique, statistics, no matter how elegant and complex, will not be able to provide one. Like statistics, syntax needs to be told what to do. Signification as mere process without semantic content is a confusion of our ability to generalize and formalize our generalizations with an analysis of the determinants of the social. The social is always available only as a semantics, its syntax being no more than the formalization of its skeletal dynamics. Importantly, one can always proceed from semantics to syntax but not vice versa. In the social, as in natural languages, one cannot reconstruct a semantics from a syntax. This procedure works only in formal sign systems,

where 'semantics' is no more than a second-order syntax, for reasons elaborated earlier.

Nor will any sort of semantics remedy this situation. A semantics able to accommodate two important threads is required. Certain recent achievements in poststructuralist theorizing, especially the revival of the Kantian critique of conceptuality in the work of Derrida and the reformulation of textuality to include the non-verbal, another Kantian theme, which has arrived via Peircean semiotics. Such a semantics offers a solution to the question of reference; it is textual yet heterosemiotically so, encompassing tactile, visual, haptic and other non-verbal signs and thus able to furnish the required tether to social actuality. This is the political side of semantics. A semantics that cannot account for the body, or more generally for corporeality and materiality, cannot retrieve the historical specifics of social situations and agents. Without the non-verbal, semantics finds it hard to come to terms with the specificity of utterance and reference as relations between different kinds of signs generated by communities of bodies. An intersemiotic semantics, however, is able to account for dissemination and infinite regress without losing its footing for critique.

A sharp distinction must be drawn between poststructuralist theorizing and postmodern writings, even though poststructuralism has had a lasting impact on the postmodern debate. The former is primarily philosophical in nature, not least because it offers a critique of philosophy itself. In this sense Derrida, Deleuze, Foucault, and Lyotard theorize, while Baudrillard does not. The postmodern is largely characterized by a fascination with the variety of its façade. In the massive literature on the postmodern we find a tendency to assume that the most promising level of analysis is the description of surface phenomena. It is therefore not surprising that many portrayals of the postmodern remain with this analysis without asking the important questions. Missing above all are questions about the likely conditions for making those surface phenomena possible, and the *cui bono* question of what or who profits from them and in whose interest it is to multiply their appearances. To ask such questions a speculative, critical, and methodologically transcendental inquiry is needed.

Much of Baudrillard's writing illustrates the avoidance of those questions. It is primarily aesthetic both in focus and in mode of presentation. Provocative insights are flattened by the titillating; radical thought diminished by mere allure. Baudrillard is literally metaphorical, carried away by his own stylistic competence, especially in his more recent work, which in many ways appears symptomatic of the standard level of analysis of the postmodern. We can observe a markedly textualist turn from his early writings on the culture of

regulated consumption in *Le Système des objets* and *La Société de consommation* towards the celebration of the collapse of social semantics into the surface syntax of signification.[1] In Baudrillard's more recent descriptions there is a singular dynamics of simulation without an accompanying second dynamics as a control base, without a semantics. One could say that Baudrillard is exemplary among postmodern theorists in having fallen victim to his own vision of the social as mere syntax. This lends his portrayal of cultural mechanisms its seductively metaphorical force and at the same time a certain analytical impotence.

The end-of-history theme, with its demise of labour, production, political economy, and 'the classic era of the sign,' collapses social events and their deep structures into a singular 'state of simulation.'[2] Having abandoned the dialectic of signifier and signified, Baudrillard declares meaning 'fatal,' while raising appearances to the status of immortality. We are left with a world 'ruled by reversibility and indetermination,' a 'closed circuit' of communication, in which the social contract is replaced by 'a pact of simulation, sealed by information and the media.'[3] As a result of the 'circularity of all media effects' we confront 'the impossibility of any mediation' and hence a kind of significatory 'entropy' and 'the end of the medium' itself. Another consequence of Baudrillard's syntactic singularity is the effect of social self-referentiality and the 'triumph of objects.' Not surprisingly, perhaps, Baudrillard's metaphors race to climax in a vision of the 'pure event,' in which social agency is represented by the subject as 'digital Narcissus' characterized by the 'cancerous metastasis of his basic formula' of clone.[4]

Contradictions arise for Baudrillard on at least two fronts: his notion of the 'immorality of capital' and the 'neo-capitalist cybernetic order that aims now at total control'; and his assurance that 'strategic resistance' by the masses is possible. Neither Baudrillard's critique of capital, a motif from his early writings, nor his unfounded belief in resistance make much sense in the syntax of simulation. How is resistance possible in a 'process without any subject,' in a postmodern world permitting no more than 'a survival among the remnants'?[5]

What I have termed the collapse of the semantic into syntax and its consequences for analysis can be nicely demonstrated by reference to *Fatal Strategies*. Here Baudrillard acknowledges that radical theory is able to struggle 'against the promiscuity of concepts,' only to depreciate the insight by going no further than the description of theory as a kind of 'liturgy.'[6] Baudrillard devastates traditional conceptions of gender and sexuality but then perpetuates a sexual politics of asymmetry between seducer and seduced, a perspective not exactly relieved by his comparison of the enigma behind the eyes of animals to the ability of women to conceal things from men (122–3). Symptomatic of his procedure is his persuasive metaphorization of the entire world as 'a control

screen' and his concomitant failure to address the mechanisms of the controls (66). If, as Baudrillard says, 'it is never too late to go beyond Marx and Freud,' we are entitled to some indication of direction (102). But does the 'pure event' promise a new level of critique, especially when it is 'inconsequential' (17)? Do the metaphors of protuberance, cancer, obesity, promiscuity, excrescence, the immorality of competition, fashion, gambling, and seduction, and the debauchery of signs or the terminology of 'hyperdeterminacy,' 'hypervitality,' 'hyperfunctionality,' and 'hypertely' provide a method for interpreting the conditions of the postmodern (12–13, 73, 25)? He promises a critique of the 'orbital round of floating capital,' yet the mechanisms of international capital are represented at the same level as events and the instrumentalities of our age (25). Where there is mere differentiation at the same level we have no more than a syntactic sequence, however attractively styled.

If we attempt to reconstruct the reasoning underlying Baudrillard's metaphoric strings, we run into difficulties, partly because of specific contradictions, partly because of a general incoherence. His rejection of the possibility of meaning, for example, rests on his assumption that meaning is a securable property firmly attached to entities. 'Every event is today virtually inconsequential, open to all interpretations, none of which could determine its meaning: the equiprobability of all causes and of all consequences – multiple and aleatory imputation' (17). By rejecting the dummy of fixed meaning and a non-textual semantics, Baudrillard also gets rid of the possibility of semantics. 'Aleatory imputation' is mere syntax, and without a semantics Baudrillard has no rationale for hierarchizing his descriptions (17). All he is left with is books full of strings of seductive phrases, not unlike Shakespeare's 'lascivious pleasing of a lute.' Baudrillard practises what he preaches, replacing 'fatal' strategies by 'banal' ones (57). Yet once he has defined the new age as 'transpolitical,' with a 'malicious curvature' terminating 'the horizon of meaning,' so that catastrophes can no longer be regarded as crises, we need to know what the rules of this new beyond are (25). The answer, it seems, is given in Baudrillard's ubiquitous term 'aleatory.'

The syntax of the dice, however, affords us no clues why the social is what it is. To be sure, 'aleatory' characterizes well a certain randomness at the surface level of high-tech culture.[7] It even works as a metaphor for the fundamental differential indifference which informs the logic of the digital bit stream, the culture's main technological base. But it fails to account for how significatory debauchery, the disappearance of reference, the inconsequence of events, and the randomness of appearances square with the globally increasing control mechanisms of international capital in whose wake transnational accounting, the rotation of labour markets, regional military clean-up operations, refugees,

and restricted areas of famine form an increasingly cohesive pattern. At the level of international controls the market, it turns out, does not obey the aleatory law. It is not driven by a syntax. It uses syntax for semantic purposes. It knows what it wants. In this sense profit is a constant, not a variable. Without a new, powerful semantics capable of describing the world as committed corporeality it seems postmodern theorizing can do no more than continue to manufacture a syntax of seductive strings.

5.2 THE POSTMODERN CONDITIONS OF MEANING

The postmodern is an indirect speech act on a massive scale. Its overt random surface is not what is meant; its covert meaning is hidden behind an aesthetic screen. Semantics under postmodern conditions must address this paradox: that never before has the syntactic free play of differentiation been more celebrated than in recent cultural descriptions, but never have a greater number of people been more efficiently controlled on a global scale for economic purposes.

Contrary to the picture presented in a narrow conception of semantics, 'meaning' has always been a function of a sociocultural frame rather than the result of stipulated definitions. Late capitalist societies mirror their cultural structures in their semantics no less than did their religious and mythological forbears. Rather than demonstrating 'the destruction of meaning,' postmodernity merely conceals the semantics which makes it what it is.[8] Both the Fregean conflation of formal and natural language sense and the Saussurean collapse of semantics into the differential system of linguistic signs are inextricably linked with the fusion of science, its formal tools, and its socioeconomic consequences, and with the concomitant secularization of European metaphysics. This process has received a new impetus by the possibility of representing the reduction of formal logic to binary syntax by way of electronic materiality. Differentiation has entered a new stage. At the metaphysical periphery of this shift we find a redefinition of difference in its diverse guises, with Derrida's 'différance' as a master trope indicating the condition without which those differential relations could not be thought. For lack of a better term and under the pressure of a massive literature on the topic, we engage 'postmodern' to cover the new conditions under which 'meaning' must now be reformulated.

The importance of semantics for such a description cannot be overestimated. A generous conception of semantics is required, capable of attributing meaning to the specifics of the social, to gesture, linguistic expression, ways of looking, fashion, styles of transport and shopping, in short, to the minutiae of a culture. From this perspective two kinds of semantics have to be eliminated from the

start: an empiricist semantics in which meaning is guaranteed by the relation between language and the world as a physicalist given; and the tradition which conflates the sense of formal systems, such as geometry or formal logic, with the sense of natural languages. Instead, we need a semantics which includes the constructivist claim that the physical world is to a very large extent the result of our significations, with base constraints inferred of necessity. Likewise deficient is the semantic side of Saussure's linguistics, in which semantics mirrors syntax as a differential system, a description that works if you know French, thus avoiding question of how meaning is possible. In its minimalist Carnapian form semantics is always a secondary set of signs systematically linked with a stipulated primary language. In natural language the relation could be said to be reversed; its syntax is construed after the fact of semantics as signified social acts.

Contra Frege and Saussure, we need an intersemiotic description of reference, understood as a locatable link between various significatory practices and, at least as important, a way of theorizing deixis and modalities, which produce modifications of meaning as a consequence of utterance under specific historical circumstances. An intersemiotic semantics in which meaning is described as a nexus of diverse sign systems promises to characterize the meaningfulness of social doing as a whole without losing the force of arguing the specifics of human and political corporeality. Natural language meanings in particular would be characterized from the outset as always already having some referential and deictic background, features essential for a social picture of semantics. If semantics is to describe specific acts as meaningful within belief systems, then it will also have to address the heterogeneity of such frames within the social at large. Supposing that certain belief systems tend to be dominant at any given historical moment, we can schematize the shape of cultures in the following manner.

The Decline of the Pyramid

Let us assume a vertical axis representing value ranking, or engaged differentiation, and a horizontal base axis representing mere differentiation, or indifferent difference in time. Suppose further that the first figure to be inserted into this co-ordinate system is a steep, tall pyramid with a narrow base, its apex defined as a *summum bonum* of some kind. Further to the right, imagine a pyramid without an apex, its top cut off, resulting in some sort of trapezium. If we were to draw a straight line between the apex of the pyramid and the right top of the second figure, extending the line so that it intersects with the two co-ordinate axes, we would receive the following picture: a decline from

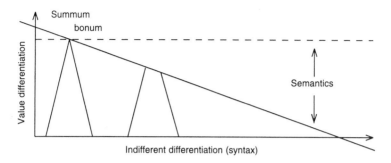

FIGURE 5.1

high-value hierarchization towards the axis of indifferent differentiation (see figure 5.1).

Simplifying drastically, one could say that European mediaeval societies, the Catholic church, or fundamentalist subcultures can be represented by steep pyramids in which every aspect of social life is governed by hierarchically ordered principles, culminating in a highest good. In other words, the vertical arrangement outweighs its horizontal extension in time. This of course suppresses the important fact that within such structures there always lurk counter-forces waiting for their historical moment to bid for supremacy. Whatever the specific textuality of the pyramid, however, it presents a metaphysic in which the meaning of linguistic expressions cannot be divorced from the whole, and the whole itself is not only a form of language. Rather, it is a way of social being in which language plays a special role, with its syntax a function of the semantics of hierarchically sorted beliefs and power relations. What a particular sentence means is not isolable as a free-standing propositional content. On the contrary, the entire value system acts as a massive modal force on the directional schema of the expression.

An intersemiotic description of meaning seems able to capture this picture. To repeat, linguistic meanings are events of linkage between verbal expressions and non-linguistic signs, such as visual, haptic, tactile and other perceptual readings. I have elsewhere referred to this explanation as the intersemiotic corroboration thesis.[9] In less hierarchized cultural formations this explanation is not replaced but merely modified by, for instance, a loosening of the rules which bind meaning clusters into metaphysical units.

If we were to canvass the opinions of people in the streets of London to discover what values they would place at the top of their cultural pyramid, some might suggest the Queen's corgies, others the Beatles, some perhaps Manchester United football team, few the Archbishop of Canterbury, fewer

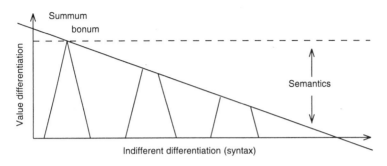

FIGURE 5.2

still the empire. To simplify, we are left with an image of a culture which has abandoned any singularity of leading values and is half way towards the baseline of indifference. The semantics of such a postindustrial culture is still best described in terms of an intersemiotic schema, with the difference that the bonds between meaningful sentences have lost their force. In this meaning mirrors the relations of the culture as a whole.

The Postmodern

A further step in this direction is a structure which looks like an increasingly flattened trapezium, yielding, it seems, more and more to the flatline of its base: a picture, perhaps, of the managerial society of bitstream commodification (see figure 5.2).

Viewed from the perspective of the apex of hierarchized culture, the new structure appears as a random assembly of values. Viewed from its base, the opposite is the case. We note an intricate structuration of every aspect of society from its footing. Let us call this the fundamental paradox of the postmodern. It is this paradox which also profoundly informs postmodern semantics. On the one hand, the bonds which bind social acts into a meaningful whole appear to be ruptured according to the free play of mere differentiation. This picture is portrayed by the majority of statements about the postmodern. On the other hand, the surface of randomness is observed by postmodernists to be an orchestrated illusion; in fact the seeming phenomenal jumble is a screen blinding us to the fundamental control exerted by the machinery of international capital. If this is so, then the syntax of indifferent differentiation should be able to produce a seductive microstructural semantics of playful and chaotic indifference while it is itself produced by a larger, coarse-grained semantics whose syntax reflects the control mechanisms of the market. As it

turns out, one and the same syntax serves two radically different structures of meaning equally well.

That the discourse about what constitutes the postmodern as a style (post-modernism), an economic process (postmodernization), and a philosophical perspective (postmodernity) is more tangible than are the phenomena it de-scribes is possibly the strongest argument for acknowledging the postmodern as a significant cultural shift.[10] The postmodern in this sense acts as an umbrella term for such stylistic features as an adversary aesthetics, the toxic sublime, mere listing, high-speed images, and the collapse of semantics into syntax, which we associate with postmodernism; for the digital, the bar code, virtual reality applications, DNA signification, gene shearing, the production of new species, remote control, and the self-regulating technology of postmoderniza-tion; and for antiteleological writing, deconstruction, conceptual instability, différance, dehierarchization, and the de-anthropormophization of discourse characteristic of postmodernity.

The difficulties in theorizing the postmodern are best summed up perhaps by the observation that the object of inquiry, the concept itself, radically under-mines traditional expectations of definitional focus and delimiting boundaries. As a cultural style it is 'internally conflicted and contradictory.'[11] As a social phenomenon it remains doubly incoherent. Its exemplification lurches from il-lustrative emptiness to overinclusiveness, while its periodization is vitiated by a teleological violence of totalization and the incompatibility of its objects.[12] As an 'epochal concept' the postmodern fails as a result of its dependence on 'historico-spiritual fictions' which blind us to what is going on, its *Nachträglichkeit* linking it problematically with modernity.[13] Nevertheless, as Fredric Jameson concedes, 'we cannot *not* use it.' And when we do use the concept, we can-not escape rehearsing its 'inner contradictions' and staging its 'representational inconsistencies and dilemmas.'[14]

Let us return to the point when the 'debate' was transformed from a dis-cussion in architecture and a small number of precursor texts into an aca-demic industry by Jean-François Lyotard's emphasis on the 'linguistic turn' in postindustrial knowledge. 'For the last forty years,' he writes, 'the "leading" sciences and technologies have had to do with language.'[15] But what is the rela-tion between the postmodern and its most characteristic technology, electronic circuitry? What are the discursive features which make the 'digital' a post-modern phenomenon, and how are certain features of postmodernity and its aesthetic, postmodernism, related to the 'discursive' workings of its dominant technology?

There is no shortage of literature addressing contemporary technology and its impact on social processes. Less frequently explored are the discursive

operations which inform digital technology and their social effects. To anticipate, the postmodern as a cultural style can be regarded as a vast ADA-converter, an analogue-digital-analogue exchange system of massive proportions. It transforms the semantic processes of traditional cultures into tera-flop bit streams, and retransforms them to be readable by Foucault's 'docile bodies' as bar-code commodities.

I want to pursue the link between a certain kind of technical apparatus and its larger social frame. I see this as a special case of what happens to the syntactic–semantic order in transformations from culturally saturated, natural sign systems into their formal abstractions. Such transformations are historical reversals, of which they still bear traces. All formal systems are either derived directly from natural languages or in a secondary manner via other formal systems, and all formally empty systems are what they are as the result of processes of referential and deictic reduction. When they are reapplied to socially saturated signs, the original semantic features of saturation cannot be restored; instead the syntax of the formal has new semantic effects on the non-formal. I suggest the reality effects of the digital apparatus constitute a special case of such a transfer.

The Postmodern Surface

As a style, the postmodern is the link between the ludic forms of culturally saturated discourse and the digital. Postmodernism takes its signifiers from the former and its syntax from the latter, while its surface semantics is in free play. This combination renders postmodernism both aesthetically attractive and politically insidious.

A survey of the literature on postmodern phenomena reads like a metaphorization of digital syntax. Ihab Hassan's 'indetermanence,' for instance, is indistinguishable from the indifference of differentiation in the bit stream. Almost all the features he lists reflect a merely differential deep grammar: disjunction, open play, chance, anarchy, process, happening, antithesis, absence, dispersal, text, intertext, syntagma, parataxis, metonymy, combination, surface, signifier, the scriptible, antinarrative, the polymorphous, androgyny, difference, and différance.[16] Hassan does not ask what kind of conditions must prevail for such a series to be visible. This is where his description, as well as a large body of literature on the subject, remains dissatisfying.

Another surface phenomenon of the postmodern as style is pop art, with its billboard and 'casino culture,' as well as Robert Venturi's 'landscape of Las Vegas' or Leslie Fiedler's celebration of popular literature, such as his defence of the Western.[17] This aspect of the 'postmodernist mentality' has been

characterized by three features: '(1) the renunciation of constitutive subjectivity and concomitant "individuality" of works (infinite reproducibility); (2) the reconciliation made with the world of commodity fetishism (commercialism); (3) a pronounced sense of politico-cultural resignation (no alternatives – no surreality – to the existing order).'[18] On the other hand, pop art is credited with having reopened 'a set of questions which the modernism gospel of the 1940s and 1950s had largely blocked from view: questions of ornament and metaphor in architecture, of figuration and realism in painting, of story and representation in literature, of the body in music and theatre.'[19] But how, one wants to know, do these features link with the social at large, and at what level of analysis does their diversity appear coherent?

Postmodern aesthetic is 'to play with pieces,' says Baudrillard.[20] Derrida's paper 'Point de folie: Maintenant l'architecture' on Bernard Tschumi's geometrical experiments supports this observation, even if 'play' is not to be taken too lightly.[21] Playing with pieces comes to the fore in the postmodern transformation of quotation into pastiche. In its celebration of a perpetual present, postmodernism is shown to transform quotations not into parody but into ahistorical pastiche. Whereas Mahler and Joyce still quote previous literary materials intertextually, the postmodern artists rework them to a degree to which traditional evaluations fail to capture the nature of the transformation.[22] Instead of an intertextuality which respects the cultural past, the postmodern pastiche is typically a process by which old styles 'are retooled and recycled.'[23] Jameson speaks of a 'complacent play of historical allusion and stylistic pastiche' which produces a number of different kinds of postmodernisms, gesturing towards baroque, rococo, classical and neoclassical, Mannerist and Romantic varieties.[24]

Postmodern art is said to question traditional knowledge and transform it by way of obsessional repetition, as in LeWitt's *Variations of Incomplete Open Cubes*. In opposition to definitional knowledge, which states a rule and invites its variations as imaginative extension, LeWitt employs a 'generative principle in each of its possible cases' in a style of garrulous digitality. This offers us a '"system" of compulsion, of the obsessional unwavering ritual, with its precision, its neatness, its finicky exactitude, covering over an abyss of irrationality.' We are dealing here with designs beyond the rational, 'design spinning out of control.'[25] Another way of looking at LeWitt's *Variations* is to read them as artistic expressions of the digital, which is likewise relentless in its pursuit of all possible options of a given problem. In this sense LeWitt at least reflects, if not critiques, the workings of a system well on its way to becoming the foundational technoscientific discourse of most social practices. Here as elsewhere, repetition radically undermines the idea of originality. As Rosalind Kraus shows

with reference to Sherrie Levine's 'photo-piracy,' the concept of originality is replaced by the activity of the art market. Repetition flattens the traditional hierarchies of high culture into general textuality, with the benefit of an increase in audience and the stimulation of the input–output dynamics of general production.

A similar transformation can be observed in the flattening of the semantics by way of hyperbole. If everything is hyperbolic, nothing is. The postmodern is a style of superterms not only in art but also in the culture of technology. We speak of supercolliders, superconductivity, superstrings, superfluidity, supervacancy, supercomputers, SuperCALC, supercommunication, supervacancy, the 'hyperreal' the 'hypertelic,' and let us not forget the information superhighway and the infobahn.[26] Yet there seems little doubt that the flatline effect of the superterm style conceals its oppositional shadow: the intensification of hierarchization and the possibilities of control.

Such rehierarchization is the flip side of the levelling effect of postmodern temporality, with its 'loss of history,' the absence of any 'temporal horizon,' leaving it wandering aimlessly 'between present and past, indiscriminately retrieving its aesthetic forms from the imaginary museum of the cultural tradition.'[27] In a series of perpetual nows the originality of modernism is replaced by an endless chain of repetitions, not unlike the procession of bytes in the digital bit stream.

The Digital

The binary digital is central to the production of discreteness in the logic gates of electronic circuitry, its binary character a technical realization of formal sign systems of two-valued logics. Digital machines employ the trans-semiotic principle of separating discrete units of whatever kind in order to realize algorithms. These procedures allow us to move from given input quantities to output quantities at high speed. If critical theorizing is to keep in touch with its Other, then technoscientific discourse, the repressed relation between digital technology and the postmodern, warrants attention. This is not because the discourse will itself furbish the concealed ground of the postmodern but because without at least a schematic understanding of its discursive principles we are unable to see important links between postmodern surfaces, their merely differential syntax, and the deep semantics which drives them both.

It strikes me as important that the technology itself which postmodern culture so conspicuously reflects has received little attention as a discursive phenomenon. When technology is referred to, as it is in all but the most unpolitical commentaries, its machines tend to be emphasized rather than what makes the

machines tick. Missing, it seems to me, is an attempt to theorize the new tech-
nologies as discursive operations in competition with other discursive regimes,
not as fetishization but as something that has been named too briefly and un-
der such mystifying umbrellas as 'the computers,' 'the electronic industry,' 'the
megachip,' or 'the databanks.' Although these metaphors are useful we are
not sure, I suggest, why postmodern culture should be particularly vulnerable
to depoliticization (as Habermas suggests) and commodification (as Eagleton
and Jameson argue), unless there are features in both the postmodern non-
technical and technoscientific discourses which display affinities of a kind and
degree absent in previous social structures. I propose to look at this at least
partly repressed Other of the postmodern in terms of the digital as a radically
reduced syntax.

 If we see Derrida's différance as that which allows all forms of differen-
tiation to be both thinkable and actualizable, different discursive operations
are informed by différance in a different manner. Looking at discursivity as
a gradation from culturally saturated discourses – such as jokes, the literary,
myth, or everyday speech – to technical and formal language, we can observe
a fundamental reduction of reference and deixis towards zero. We can imag-
ine a heuristic scale at one end of which we locate the richest realizations
of différance and metaphoricity and at the opposite their starkest, minimalist
counterparts. The former optimize différance and metaphoricity in reference
and deixis; the latter minimize them. The binary digital could be regarded
as the form of semiosis, in formal logical representation (0, 1) and in elec-
tronic form (off, on), which mirrors the barest version of differentiation: the
mere principle of semiotic discretion. Likewise, from the perspective of the
metaphoric relation of all sign systems to what they represent, the digital is
the most minimal version of metaphor. In Heidegger's vocabulary, collaps-
ing metaphoricity and différance, the as-structure of the digital is apophan-
tic rather than hermeneutic.[28] It is thereby not severed from discursivity but
merely reduced to the withered result of a shrivelled horizonality.

 Yet the binary digital still carries traces of the full social discursivity from
which is was derived, insofar as we are still dealing with a translatable se-
quence. Certainly at the level of digital machinery we engage with semiotic
bodies, with organs and orifices, pathways and memories. There are peripher-
als such as camera (eyes), microphone (ears), speakers (mouth), tactile devices
(hands, arms, legs), thermal sensors (skin), smoke detectors (smell), seismo-
graph, printer, keyboard, tape recorder, terminal display, magnetic disc, or
character recognition device. A central processing unit (CPU) interacts with
a program memory (ROM). Digitized signals are stored in a data memory
(RAM), from where they are retrieved and processed once more by the CPU

before they are sent via the digital analogue converter (DAC) through output ports to another set of peripherals, such as printer, monitor, or oscillograph. Logic chips with AND, NAND, OR, NOR, flip-flop gates, NAND flip-flop, NOR flip-flop, or 'gate arrays' combine into 'megachips' or one-million-chip combinations. The minimal discursive structure common to all parts of this organism is a syntax made up of strings of bytes, constituted by clustered bits of 0's and 1's:

01010100011101110110111100101111011101000111001001110 10
10111010011010000111000010111101100001011001001100101 00
10111101110100011011110110101111101100100

Two truths are told. (*Macbeth* I.iii.27)

Without translation we cannot read the binary string semantically, just as we are unable to make meaningful the signifiers of a foreign language. Yet even in this most radically reduced syntax, 'two truths are told.' Disembodied and arbitrary as the digital signifiers may look, they retain their intersemiotic corporeality as an encoded semantics. There is also an indirect meaning effect in that the digital syntax throws the shadow of its high-speed indifference on social semiosis at large.

Speed is a function of directness of wiring (printed microcircuitry) and the frequency of the tact generator (megahertz). The current speeds up to gigaFLOPs (billions of float-point operations per second) are now being challenged by the promise of teraFLOPs (trillions of operations per second). Although at the level of actual phenomena we are dealing with parallel, slow, simultaneous systems, at the level of the digital the complex flow of the phenomenal world has been transformed into time multiplex, high-speed linearity, an electronic channel into which the phenomenal world is poured as into a funnel. Parallel processing and time multiplex make linearity appear as simultaneity.

Important for its effects on semantics is that the digital as a discourse cannot process phenomena directly but depends on prior semiotization by a non-digital technology. The digital transforms qualitative identities (for example, the complexities of deixis and referentiality of a speech situation) into a series of quantitative identities or a series of numerical names. In doing so, the digital flattens complex simultaneities into seriality, so that the length of the syntagm or the number of frequencies makes up for complexity, while speed (FLOPs) makes up for the disadvantage of linear spread, or the length of the bit stream. In principle there is no theoretical limit to the dehierarchization of the phenomenal, but the digital is not readable except via retranslation and does

not offer any hierarchization of knowledge itself. Rather, it makes its digits available through its concomitant technology (RAM, ROM, DAC, ports) to those with a will to hierarchization as readily as to those who dream of the emancipatory force of the random. The issues of access and power, however, are not resolved at the level of this syntax.

The Social Metaphoricity of the Digital

When we describe the effects of electronic processes on culture we note what I would like to term the semantic paradox of the digital. While syntax is not transparent to semantics – we cannot proceed from phrase constructions to meaning unless we already know the language – the digital syntax can be said to have at least semantic effects. There appears to be a feedback relationship not at the level of propositional contents but at the level of syntax. The style of the digital operation itself affects social practice and thus contributes significantly to a shift in late twentieth-century textuality. As I have argued elsewhere, in this sense the digital furnishes a deep structure to match the new surfaces of our culture.[29] In summary this deep structure consists of: seriality, replaceability, speed, indistinction, indifference, forgetting, dissolution of subject, availability, shelvability, masking of mediation, repeatability, iterability, either/or syntax, the chain reaction of the textual, data flow, fusion of the actual and the fictive, fragmentation, dehistoricization, random access, dissolution of reference, dissolution of deixis, rapid creation and satisfaction of desire, packaging and speed of delivery, and the exchangeability of images. These features are recognizable not only as characteristic of the bit stream but increasingly also as characteristic of a social style. Thus the syntax of the digital has social effects and so could be said to generate its own semantics.

This transformation is reinforced by electronic metaphoricity, new discursive formations produced by the digital industry. The bar code reader, a photoelectronic scanner that deciphers bar codes printed on products, reappears in postmodern society in the shape of human bar code readers who recognize reality by the way it is packaged, shelved, organized, transformed, named, quantized, and digitized. The interaction of ordinary discourse and computer speech results in a metaphorical transfer between the two realms, thus diminishing the divide. Stack, bubble memory, droop, data smoothing, chopper, cross-talk, dumb terminal, bus, bus driver, bus delays, and card dealer have a strict technical application as well as being part of semantic leakage into everyday speech. Postmodern subjects are 'dumb terminals,' a digital version of Foucault's 'docile bodies,' in a dumb terminal society, or perhaps worse, a

GIGO ('garbage in, garbage out') culture. The consolation is that the more we align ourselves with machines, the less it will hurt. Cyborgs won't mind the difference.

Metaphenomena of the Postmodern

If the digital provides a conditional deep structure for the postmodern, this should be evident not only at the stylistic surface of social phenomena but also at the level of its theorization. Here we find a sharp divide between the celebration of the postmodern and its condemnation. Not surprisingly, theoreticians on the left have on the whole been the most critical.

Much has been said about postmodern commodification, but the principal observations in this debate are still to be found in early papers by Eagleton and Jameson. For Eagleton capitalist technology appears as a vast 'desiring machine,' a giant electronic exchange 'in which pluralistic idioms proliferate and random objects, bodies, surfaces come to glow with libidinal intensity.'[30] Both Jameson and Eagleton warn of the danger of mystification in the term 'postmodern,' stress the political hidden beneath the aesthetic, and draw attention to the 'brute self-identity of the postmodernist artefact' as 'commodity fetish.'[31]

In his early comments Jameson concedes to postmodernism the possibility of a revolt against totalizing reason but is sceptical of a postmodernist architecture which promises to democratize its buildings by eulogizing its place in 'the motel and fast-food landscape of the postsuperhighway American city.'[32] No matter whether we approve or disapprove of postmodernist cultural products, in entering the debate at all we also necessarily take a position on the question of multinational capital.[33] The focus of Jameson's interest in the link between the postmodern and the political is on how, for example, architectural space conspires in the commodification of human subjects. He suggests that we are now being confronted by postmodern architectural formations which create a space for which we are ill prepared, where the transformation of objects is in advance of the necessary transformation of subjects. We lack 'the perceptual equipment to match this new hyperspace,' and to cope with new and perhaps impossible dimensions we must 'grow new organs' (80). We must agree with Jameson that the postmodern cannot be analysed appropriately at the level of style alone. Since postmodernism is fundamentally an historical phenomenon it requires a critical historical investigation. Such an investigation discovers a radical extension of the 'cultural sphere.' In the new global postmodernist space, critical distance has been abolished and critique deprived of its ground. The remedy proposed by Jameson is the creation of a new political culture, a

'political form of postmodernism,' which would allow us to find once more our individual and collective co-ordinates for political judgment (85-92).

The recent Jameson is more derisive. He sees postmodern consciousness as a self-mirroring phenomenon which can do no more than enumerate the shifts in its own condition, clocking its variations, an aestheticization in Walter Benjamin's sense, 'consumption of sheer commodification as a process,' and thus a version of some sort of 'advanced monotheism.'[34] In attempting to theorize the postmodern we are trying 'to take the temperature of the age without instruments,' without being able to account for its 'quantum leaps, its catastrophes and disasters' (xi). Contrary to analyses which emphasize the postmodernist aesthetic as a new cultural paradigm, Jameson regards it as no more than 'the reflex and the concomitant of yet another systemic modification of capitalism itself' (xii). Because there is little inquiry into the conditions which make postmodern styles possible but merely lists of surface phenomena, 'virtually any observation about the present can be mobilized in the very search for the present itself and pressed into service as a symptom and an index of the deeper logic of the postmodern, which imperceptibly turns into its own theory and the theory of itself.' Jameson notes a certain 'frenzy' in the piling up of radical differences to earlier historical moments suggestive of a 'pathology distinctively autoreferential, as though our utter forgetfulness of the past exhausted itself in the vacant but mesmerized contemplation of a schizophrenic present that is incomparable virtually by definition' (xii).

We cannot help but note that the search for underlying conditions, transcendental or otherwise, makes no sense in postmodern terms. Postmodernism has developed a style ill suited to its own analysis, many of its descriptions looking like wish fulfilment or a significatory sublimation of its opposite. The surface description of random play belies the fact of an horrendous and fast-growing structuring from outside the playpen. Beneath, the binary-digital weaves its syntactic and grammatical web, controlled remotely by the semantics of transnational commerce: no metafictional and self-reflecting loops there, but instead hierarchization of an array of social phenomena in a well-integrated and detailed structure of control.

Without addressing the question of 'transnational business' we are not in a position to provide philosophical and sociological answers to any of those phenomena. As Jameson sees it, we must come to terms with 'the new international division of labour, a vertiginous new dynamic in international banking and the stock exchanges (including the enormous Second and Third World debt), new forms of media interrelationship (very much including transportation systems such as containerization), computers and automation, the flight of production to advanced Third World areas' and 'the crisis of traditional

labour, the emergence of yuppies, and gentrification on a now-global scale' (xix). In 'Secondary Elaborations,' the conclusion of *Postmodernism, or, the Cultural Logic of Late Capitalism*, Jameson looks for 'the logic of the very impulses of this field, which postmodernist theory itself openly characterizes as a logic of difference or differentiation' (342). I suggest that this search splits into two parts, one looking into the primary grammar of postmodern styles and the other investigating the conditions of this condition. The first will have to deal with the technical deep syntax of our present social performance, the second with the covert semantics which frames the social at large.

Yet postmodern theorizing has lost the critical tools with which to view the larger picture of the economy. Analyses of the media and representation and the ubiquitous notion of power allow for narratives which 'lack the allegorical capacity to map or model the system' (349). This has resulted in an inability to resolve such questions as how 'the very representation of the media itself manages to represent the market, and vice versa' (353). Instead of a sustained analysis, we are left with what Jameson terms 'postmodern schizofragmentation' (372). The double bind in the description of the postmodern is that it 'cannot be disproved insofar as its fundamental feature is the radical separation of all the levels and voices whose recombination in their totality could alone disprove it' (376). With 'expensive form' as the 'watchword' for postmodern commodities, 'exchange value' itself has turned into a commodity (386). With the loss of the individual as well as any collective subject, neither idealism, materialism, nor any other systemic positions can make any sense. The fully commodified world has made everything optional, or so it seems. Attractive in Jameson's analyses of postmodern culture is his concern 'with the conditions of the possibility of the concept,' for they must remain outside the control of postmodern styles (418).

I suggest that we are dealing here with two related conditions. On the one hand is the syntax which acts as the condition without which postmodern diversity cannot be thought, its deep grammar of mere differentiation; on the other, and more important, is the semantics of production, a master code within which that deep grammar and its surface phenomena make perfect sense. I stress semantics here because with the exception of stipulated formal systems, syntax is always a function of semantics. This is where the buck stops, at the covert pyramid of the engaged value hierarchy of advanced international capital.

Another significant metaphenomenon of the postmodern is the connection between postmodernity and poststructuralist theory. Part of Jameson's dismay at the abandonment of political will is echoed in Jürgen Habermas's critique of the neoconservative tendencies in poststructuralist theory. This critique needs

to be understood against the background of his writings since the 1960s and his critique of Herbert Marcuse's reinterpretation of Max Weber's rationality. Since then Habermas has been committed to the analysis of reason in its various forms, initially split into reason as manifest in symbolic interaction and the instrumental reason of purposive-rational action, with symbolic interaction holding the promise of emancipation to be realized in communication free of domination within the public sphere. Later, the critique projects a more elaborate set of distinctions of more or less consensual and manipulative forms of communication, with communicability as the transcendental condition of the social and hence of the potential for emancipation.[35]

Habermas finds the heritage of the Enlightenment, emancipation through rational debate free from domination, threatened by certain features of post-structuralism and by postmodern culture in general, and it is thus not surprising that he objects to the very term 'postmodernism.' It suggests that the 'project of modernity,' reason in its plural manifestations, has been completed. He likewise objects to theoretical positions which rely on the Nietzsche–Heidegger axis as a set of master texts.[36] His critique of Derrida illustrates this point. Habermas charges Derrida with 'an inversion of Husserlian foundationalism' in having transformed 'the originative transcendental power of creative subjectivity' into 'the anonymous, history-making productivity of writing.' In the place of philosophical foundationalism, he substitutes 'the still profounder – though now vacillating and oscillating – basis of an originative power set temporally aflow' with the help of his *Urschrift*. Habermas also takes Derrida to task for having replaced the authority of Heidegger's Being with 'the authority of a no longer holy scripture' inciting the 'frenzy of deciphering interpreters.' As a result, 'the labour of deconstruction lets the refuse heap of interpretations, which its wants to clear away in order to get at the buried foundations, mount even higher.' For Habermas, Derrida has merely returned 'to the historical locale where mysticism once turned into enlightenment.'[37] This reflects Habermas's general critique of poststructuralism as an aestheticization of the political and its reduction of the concept of rationality to a point at which precise distinctions can no longer be made. Rational, sociopolitical praxis has lost its footing, and with it any *Geltungsansprüche* (validity claims), which are central to his emancipatory social theory.[38] Yet for everyday praxis the 'unconstrained interaction of the cognitive with the moral-practical and the aesthetic-expressive elements,' for which poststructuralist theory has no program, needs to be guaranteed.[39] Habermas's concerns must be read against the central European situation from which he writes and in which they have their specific relevance. Having said this, one should be careful not to conflate too readily what is ground breaking in

poststructuralism with the surface descriptions which so characterize the post-modern, even if features in the former have left their visible traces on those descriptions.

As for depoliticization and commodification, the characterization of the postmodern and our sketch of the digital suggest a number of important relations. Postmodern dehistoricization, the removal of critical reason, fragmentation, random access, mere repetition, indeed the whole long list of postmodern features which one could compile, are mirrored on the side of the digital. Especially the digital dissolution of deixis and reference, its 'random subjectivity,' its 'brute self-identity,' and its high-speed retrievability turn out to be ideal ingredients for a hierarchized institution that knows precisely what it wants and so does not play by postmodern rules. Ironically, international commodification finds an ideal sorting base in the syntax of the postmodern. The shared transformability of the fictive (the metafiction of politics and tourism versus the transformability of the digital), the isolation of items from their sociopolitical and historical context, availability, local and locatable surfaces, shelving and shelf-life, mobility, nameability, speed of access, reading desire, creating desire, satisfying desire, packaging, and high-speed delivery all display their double character: randomness, if viewed from a postmodern aesthetics; and controlled functionality, if viewed from the semantics of international capital.

In contrast with the Habermasian project of social reason based on the possibility of consensus, Lyotard's 'postmodern condition' is characterized by heterogeneity, an 'agonistics' of language games, the difficulty of gaining access to the 'data banks,' the principle of 'performativity' as input–output ratio, local 'justice,' and a new form of the 'sublime.'[40] In 'Defining the Postmodern' Lyotard divides the debate about modernity and the postmodern, a debate his book helped to focus, into three main trends: (1) an architectural phase characterized by 'the abrogation of Euclidian geometry ... a sort of bricolage: the high frequency of quotations of elements of previous styles,' where quotation turns into mere repetition; (2) the realization that the 'modern project has failed,' that the 'techno-sciences' no longer constitute 'progress' and that progress has turned into 'motricity'; and (3) the transformation of traditional reflection into 'ana-lysing' as 'ana-mnesing.'[41] As a result, knowledge has been transformed into 'the stuff of TV game shows' and so can amount to no more than a form of 'eclecticism,' the 'degree zero of contemporary culture.'[42]

To Lyotard 'a work can only become modern if it is first postmodern,' whereby 'the postmodern would be that which in the modern poses the unpresentable in the presentation itself,' in other words, the sublime.[43] And it is in

the conception of the sublime that Lyotard discovers a parallel between Kant's notion as a response to art deprived of rules and the postmodern situation, where likewise a body of artistic rules has been abandoned.[44] This new sublime is contradictory, a mixed feeling of 'both pleasure and displeasure' with which we confront the new technologies and their 'complexifications.'[45]

In this Lyotard has tended to foreground the aesthetic over the teleological, as he does in his recent reading of Kant's *Critique of Judgment*.[46] One might ask here whether aestheticization is compatible with Lyotard's antitotalizing political agenda. I suggest that there is a paradox, a contradiction between what is required for knowing what to do in specific historical situations and the denial of a larger narrative within which the specific can be allocated a value. There seems to me a paradox in the very notion of local justice. Is not its sine qua non some submerged, cohesive narrative which Lyotard denies? Perhaps this is no more than a question of emphasis, but it seems clear that the central disagreement between Lyotard and Habermas, for instance, is that Lyotard rejects the Enlightenment narrative. Where Habermas sees a still unrealized program of emancipation, Lyotard, following Theodor Adorno, sees Auschwitz. For him the narrative of emancipation has been liquidated.[47] In its place the concept of local justice may be paradoxical, but it is preferable to large-scale fictions with a dubious past. The question remains whether Lyotard's antitotalizing solution can be used as a critical weapon against the control structures which govern the postmodern.

It is not that the antitotalizing motif is restricted to Lyotard's work. Indeed, it is central to all poststructuralist theorizing and therefore, not surprisingly, at the heart of Derrida's work. The value of Derrida's infrastructural critique of conceptuality in social semiosis is beyond dispute. Less clear is whether his antiteleological stance constitutes an advance over previous positions.[48] It seems that Derrida's rejection of teleology repeats part of the critique of teleology offered by Kant, who sharply distinguishes between a teleology of determining reason in closed systems, such as in the formal domain, and the teleology of reflective reason, which is open ended and so forever adjustable to interpretive needs. This latter form, Kant rightly insists, we cannot do without if we are to judge anything outside strictly formal procedures. How could Derrida conceive of the critique of the concept without teleology in this sense? And how could Lyotard judge any linguistic exchange as a differend if he were not to draw on something like it? Is not every teleological judgment a minor narrative? How could we think differends consistently if those minor narratives did not amount to some larger and, with a grain of salt, non-contradictory structure?

At the metaphenomenal level of postmodern theorization the digital syntax shines through in an emphasis on discontinuities (Foucault), dissemination, antitelos, and différance (Derrida), and a war against totalization (Lyotard). Yet here we again bump into the paradoxical semantics of the postmodern and the asymmetry of the digital syntax of the postmodern surface serving two kinds of semantics in opposing ways. Superficially, the postmodern displays itself as a world of seemingly free play with the attractions of an aesthetic and, for some, even an emancipatory promise. If, on the other hand, we see the political will of an economic master reading, the same syntax concentrates bureaucratic power and economic control of global populations. How are these two possible at the same time?

Indifferent differentiation, of which the digital is the most recent technical form, equally supports a semantics of phenomenal free play of dissemination and a semantics of control. The freedom of meaning which we celebrate in the former finds its semantic *Doppelgänger* in the latter. The irony is that the emancipatory potential of semantic freedom dissolves unless it is realized in a political culture with a will to projection. Without the will to engage in social projection the semantic free play of the postmodern is no match for the well-organized meaning structures of economic production and its military back-up. Here the syntax of indifferent information can be optimized by strict hierarchization. Nothing is lost, and everything can be viewed from the most promising parameters, reorganized at digital speeds, multiplexed, and put to productive use on a global scale.

Given the flexibility of its digital foundations, it is not surprising that the postmodern as a cultural style can subsume all existing genres: the tradition in bits and pieces, traditional hierarchies as parodic, quotation without source, pastiche without declared interpretive aim. Because semantic cohesion, diction, phrases, and image chains have been removed, because, in short, every signifier is compatible with every other, their common bond is purely syntactical. We are still able to translate items and data strings, but we are impeded by the same syntax from endowing the bit stream with a semantic umbrella. The digital signifiers cannot be transferred directly to saturated social discourse. The syntax itself is transferred. Like all formal systems the digital in itself has no semantics unless we add one, such as some kind of geometry or a natural language. There is thus a special relation between semantics and syntax at this level. On the one hand, we confront a special case of the arbitrariness of signs in that the stability or change of application can be rapid or stable, relative to the imposition of a master code. On the other hand, when the digital syntax is transferred important semantic consequences result, a situation I have summed up as the semantic paradox of the digital.

Habitual cultural contents now processed via digital machinery are affected such that traditional readings of contents are gradually replaced by different habits of reading. Specifically, readings increasingly accommodate thinking in terms of sequence, strings, replaceability, and availability – in short, features of indifferent differentiation – which clash radically with the intricate value hierarchization, the semantics of traditional culture. When what is important, let alone what is sacred, can be replaced, reinserted, left in memory, added to another string, or eliminated at the touch of a laptop key, the 'doing' of culture has been drastically altered. The weakening of the content so digitized is no more than a question of time and degree. Fundamentalisms of all shades have understood this deep threat, even if their attacks tend to be directed against specific visible embodiments rather than against the semantics of capital.

Social visions are by definition in conflict with mere differentiation. The former requires a committed semantics, the latter, in spite of producing semantic effects, has no semantics at all. The consequences of an unacknowledged transfer from the formal to saturated sociocultural signs are visible in the celebration of the randomness of signs at the phenomenal level of the postmodern. In this, Frege's conflation of two kinds of sense has found a political echo in the postmodern. We are now in a position to conflate the digital syntax of the postmodern, or its formal sense, with its semantics, its non-formal sense, and we have a host of opportunities and reasons for doing so. If we do this, we severely cripple two important features of culturally saturated semantics: actual social reference and with it the ability to affect the kind of world we want and the possibility of actual deixis, utterance in the full corporeal, social sense of speaking as political beings.

Without the telos entailed in the political moment of speaking the politics of what is said cannot be retrieved; it dissolves into random bits. Hence the paradox: postmodernism cannot articulate itself but merely demonstrates its own surface. Its description requires a different structure, the structure of the cultural production of social vision. In a sense, then, the project of modernity is indeed incomplete, or at least has to be followed by projects able to cope with the failures of the Enlightenment and with the necessity for a global extension of the public sphere.

Unperturbed, the rule of production continues globally, highly ordered in spite of, and even because of, the disrupted postmodern surface. Its deep structure shares with the surface the syntax of indifferent differentiation but not its semantics. In postmodern culture surface semantics and deep semantics belong to different domains. Severed from its referential base of realist constraints, the surface semantics of postmodernism is indistinguishable from its syntax, while the deep semantics of the new polis draws on a specific socioeconomic

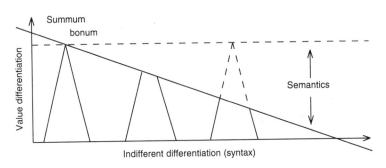

FIGURE 5.3

reality, organized by a powerful systematic beyond cultural forms of regional and national identities: transnational capital. The postmodern pyramid appears flattened to a syntax of indifferent differentiation (figure 5.3). Its semantics is effectively concealed, but continues to exert its pyramidal control over a depoliticized base of simulacra.

Meaning Now: Semantics under Postmodern Conditions

We have observed the asymmetrical relation between the syntax of the postmodern as mere differentiation and its twofold and oppositional semantics, a disengaged aesthetic corporeality of phenomenal free play and the corporate corporeality of economic control. How does this relate to our initial distinction between formal or calculus semantics and its intersemiotic, referentially, and deictically engaged counterpart?

Two fundamentally different kinds of meaning operate side by side here. In intersemiotic meaning, which retains cultural saturation, linguistic expressions are activated by corporeal, non-verbal forms of signification. In formal sense no such activation takes place. The collapse of these two kinds of meaning causes a shift in natural language from intersemiotic linkage of heterogeneous, corporeal signs to their virtual counterpart: the formalization of both verbal and non-verbal signs. When this process is complete, as foreshadowed in robotics, meaning in the social sense, some have argued, will have vanished.[49] Divested of the metaphysics of its social frame, meaning has neither social speech and an utterance situation nor a meaningful world as background, and so turns into syntax. This is the 'semantics' of logic gates: binary calculus. Though such a syntactic future is imaginable, postmodern semantics occupies a space well before this scenario.

If the Fregean conflation of two kinds of sense did no more than undermine the development of a rich form of semantics, the same cannot be said of

the conflation of digital sense with social meaning in dominant accounts of the postmodern. For here the separation of reference from sense and the elimination of deixis have far-reaching political effects. Once we accept the representation of meaning by formal means, by the digital bit stream, for example, we have given away the possibility of critique. Critique requires the specifics of historical background (reference), the specific circumstances of utterance (deixis), and the corporeality of their social frame. Without these political programs are interchangeable. In fact we could not even identify them. As a result, where the syntax of indifferent differentiation dictates its calculus structure to semantics, resulting in the abandonment of engaged reference and utterance, there cannot be any cohesive position from which to confront the highly motivated semantics of the market. This is why Derrida's recent statement concerning justice is not postmodern: 'If anything is undeconstructable, it is justice.'[50] Nor can the differend be resolved at the level of syntax.[51]

Analysis of the basis of the postmodern cannot stop at the identification of its syntax of indifferent differentiation. It needs to search for the conditions which make this syntax not only attractive but also so very useful. We will find that the actual control structure of the postmodern is not a syntax at all. Rather, postmodern control mechanisms lie within the well-organized semantics of international capital, in which mere differentiation and its current technical expression, the binary digital, act both as a vast and highly efficient retrieval system and as an attractive screening syntax against critical analysis.[52]

Conclusion:

The Corporeal Turn

I would now like to review in a more general frame the main theses that I have put forward, outside the context of the specific, technical problems addressed in each chapter, and to conclude by pointing to some implications for a range of disciplines in which the kind of semantics employed is crucial to their assumptions, procedures, and interpretive goals.

Meaning as Intersemiotic

According to the intersemiotic and heterosemiotic approach to semantics offered in this book, there is no meaning in language or in the dictionary. Rather, verbal meaning occurs when linguistic expressions are activated by non-verbal signs, such as tactile, olfactory, gustatory, thermal, haptic, aural, and other perceptual readings. As such, meaning is an intersemiotic and heterosemiotic event, a linkage among distinct sign systems. This, I suggest, applies not only to our 'primitive' readings at the level of human-scale perception but also to all communication about complex states of affairs. Even the most abstract signifiers, including syncategorematic terms, have been shown to display traces of the originary social situations from which they evolved. If we did not have a 'feel' for what words such as 'is', 'and,' or 'neither-nor' stood for (other than further linguistic expressions), their symbolic function would be much more variable than it actually is.

As a consequence of the intersemiotic basis of meaning we can formulate what I have termed the semiotic corroboration thesis, according to which the reality force of meaning increases in proportion to the number of sign systems activated in any meaning event. In problematic interpretation we tend to explore as many distinct systems as possible. When we walk down the stairs

of a dark basement we explore the unknown by way of tactile interpretations. Even in this kind of situation, however, we fantasize a quasi-visual scenario, which suggests that when we are deprived of the minimal secondary system we construe a fantasy equivalent. By contrast, in highly familiar surroundings even a set of signs from the same system, such as a visual readings, are able to stand in for others. This seems to be typical of habitual meaning construction.

Meaning as Heterosemiotic

In natural languages meaning as intersemiotic linkage of linguistic expressions with non-verbal signs is also always heterosemiotic. This suggests that the signs so combined are identical neither in form nor content. Tactile, olfactory, aural, and linguistic signs produce different results. In this picture meaning is an act of reconciliation between not entirely commensurate sign practices, such as seeing or smelling, as well as between their fantasy equivalents. Moreover, since verbal semiosis is radically different from non-verbal sign practices, though it entirely depends on them, all linguistic meaning is heterosemiotic to the core.

While natural language meanings are always heterosemiotic, the semantics of formal sign systems is homosemiotic. This means that formal sense is construed as a result of the combination of two definitionally controlled sets of signs. Both formal systems are homosemiotic. Only strictly formal semantics can be said to be homosemiotic. Hence we have two kinds of sense: the sense of formal signification and the sense of natural language terms. To equate them is an illegitimate move with baneful consequences.

The matter is complicated when formal signs are applied to non-formal phenomena, as in technical measurements. We now 'touch,' 'see,' and 'smell' the world through formal definitions, with strictly controlled heterosemiotic results. Robotic semantics is a logical extension of formal measurement. Non-technical language use can be seen to aim for the opposite, the experimental exploration of heterosemiotic associations.

ROSS and COSS

The intersemiotic thesis requires a redefinition of perception and 'experience' in semiotic terms. Accordingly, I have distinguished between read-only signs or, ROSS, and communicative signs, or COSS, the former emphasizing the interpretive labour involved in perceptual readings, the latter declaring all forms of communication to be an extension of basic semiosis. The rephrasing of

read-only signs also draws our attention to the claim that our understanding of the world is always mediated through our significatory practices and hence is perspectival. The argument for ROSS rests on the observation that perceiving the 'world' always involves acts of 'reading' and deciphering and hence variations of interpretation. And all interpretation is semiotic by definition. COSS embraces all communicative signs, verbal and non-verbal. Although there is a considerable body of literature on non-verbal communication and its relation to communication by language, intersemiotic, corporeal semantics advocates the work of the non-verbal *inside* language.

Language as Directional Schema

To argue this case we need to see language as a directional schema which functions on two intersecting axes. One axis indicates the degree of negotiation available between the zero point of formal sense and the infinity of meaning constructions in undirected discourse. The other axis shows the amount of directionality provided. This inverts the relations of the first axis. Formal signs provide maximal directionality, while discursive failure is characterized by zero directionality. As a result of the interaction of the two axes, formal signs are able to produce fully agreed-upon meanings or formal truth, while discursive failure can be defined as allowing for all and hence no specific meaning. Technical language, ordinary discourse and much literary speech, as well as its ludic extensions, can be placed between these two extremes.

Proposition and Modality

Every linguistic schema has two sides, one propositional and the other modal (in the broadest possible sense). When meaning occurs – when a directional schema of an expression is activated by non-verbal signs – both its proposition and its modalities are semantically established in two distinct but related processes. This applies even to such small linguistic entities as prepositions. The preposition 'on' changes its propositional meaning (what sort of 'on') according to the perspective from which the 'on-relation' is viewed. The camera in filmic representation well illustrates this relation. If we cannot imagine what kind of modality governs our 'on,' the preposition remains semantically empty. Understanding the preposition in context is precisely to have succeeded in activating relevant, specific, non-verbal quasi-representations. This double relation between the propositional and modal sides of linguistic expressions and their non-verbal activation can also be viewed from the perspective of reference and deixis.

Re-enter Vorstellung

When Frege eliminated *Vorstellung* from semantics on the grounds that it was 'wholly subjective' he did more than simply throw the baby out with the bath water. He banished an essential ingredient from natural language semantics. Guided as he was in his conception of sense and reference by the formal sign systems of geometry and arithmetic, he could see no useful function for *Vorstellung*. And for the purposes of a purely formal notation, his *Begriffsschrift*, he was right to argue that way. The analytical semantic tradition in the wake of Frege has continued this prejudice against *Vorstellung* in natural languages. Corporeal semantics by contrast demands its rehabilitation.

The standard English translation of *Vorstellung* as 'idea' is as convenient for formal semantics as it is misleading. A more accurate translation would be 'mental representation.' In this sense *Vorstellung* is at the heart of corporeal semantics. Without the fantasizing acts of quasi-tactile, quasi-visual, and other representations the schema of linguistic expressions could not be made to mean. More radically one could say that without *Vorstellung* we could not even walk.

Was Frege wrong when he dumped *Vorstellung* as entirely subjective? How subjective indeed is *Vorstellung*? I suggest that it is no more subjective than the varying substitutionary descriptions which make up the lexicon of different speakers. Furthermore, every one of those linguistic substitutions is again in need of non-verbal activation. Take, for example, the expression 'United Nations armoured vehicles in Bosnia.' The mental representations at our disposal here are highly standardized by televisual images, that is by culture, a control frame not unlike a dictionary. But who or what controls the control frame?

Community and Semantic Constraints

Constraints keep intersemiotic semantics from veering towards some subjective or mentalist abyss. We have dealt with two sets of constraints. One we could call deep constraints. Though we have no direct access to them we appear forced to infer them of necessity from whatever texts we construe about the world. Cultures typically respect them, even if the way that respect is expressed varies. Our descriptions of death, birth, survival, gravity, and similar phenomena suggest the rule of baselines that have to do with the universe and the limits of organic life. Mediated though they are, they powerfully control the boundaries of all semantics. Another set of constraints appears to be culture specific. Though they do not contradict inferable base boundaries, these constraints

enjoy a much greater degree of freedom and hence are responsible for cultural difference.

Sufficient Semiosis

In intersemiotic, corporeal semantics the notion of truth conditions is replaced by sufficient semiosis. While in formal and technical semantics it makes sense to invoke 'truth,' the complexities of typical social situations and hermeneutic choices make truth-conditional semantics a messy business. Instead of relying on truth conditions, the semantics of ordinary social exchange is typically governed by a negotiation of whether or not sufficient signs have been exchanged, a situation I have termed 'sufficient semiosis.' Even if truth could be successfully constructed, it is usually deemed to be too time consuming to be feasible or to require specialist expertise beyond social resources. Instead, primary semantic agreements and their higher level constructions are accomplished when the parties involved believe that sufficient interpretive negotiation has occurred for the communicative process to continue, to be successfully concluded, or to be terminated as unsatisfactory.

Metaphysical Commitments

A semantics that does not show its metaphysical cards can be said to cheat. Sooner or later every semantics will run into explanatory problems which require a declaration of its metaphysical deep structure. Corporeal semantics is no exception. Given what I have said about constraints and the role of the community, the kind of intersemiotic semantics I advocate involves an illative or inferential realism. This is the consequence of a number of features listed earlier. Nothing about the world can be grasped outside our interpretive schemata. (In Derrida's words 'there is nothing outside the text.') Nevertheless, not all imaginable texts can be carried out. Cultures typically regulate semantics to respect the base constraints which we cannot help but note through our readings of the world. There is indeed such a thing as failure. But since all this is forever filtered through our significations, we must accept having to infer the limits laid down by the 'stuff' of the universe. Our knowledge is fundamentally inferential and fallible.

Implications

In the wake of recent probing of the conceptual underpinnings of traditional descriptions of our world, most disciplines in the humanities and social sciences

have performed more or less radical forms of critical self-inspection. This has brought about a healthy scepticism towards disciplinary self-confidence as well as some very sophisticated new procedures. Yet much of this reorientation has also inherited some of the more dubious effects of postmodern theorizing, the most damaging of which is a leaning towards a naïve relativism. As far as the question of meaning is concerned this relativist bias has tended to loosen and even abandon the ties between syntax and semantics. This part of the Saussurean structuralist heritage shines through virtually all postmodern literature. At the same time such privileging of syntax over semantics has produced an uneasy alliance between the philosophical fathers of the linguistic turn and the posthermeneutic tradition. It has also robbed many disciplines of interpretive will.

While this may be regarded as a healthy loss of false self-assurance in traditional disciplines, it also renders illegitimate all questions concerning the semantic deep structure of the postmodern surface, as I have argued towards the end of this book. In whose interest is it to maintain an illusory picture of social life as a mere syntactic sequence? The question can no longer be posed, for it requires not only that syntax and semantics be distinguished but also that a metalevel of argument be used to view surface strings and their control mechanisms. No such privilege is available in the account given, for example, by Jean Baudrillard.

If there is a remedy for this loss of interpretive will, it cannot come from either a revival of traditional semantics and its formal or naïvely empiricist sureties or a combination of those traditions. I suggest that a corporeal, intersemiotic, and hetersemiotic semantics, in which meaning is an event of activating verbal schemata with non-verbal signs, offers an alternative path.

Recent work in anthropology from Sol Tax to Vincent Crapanzano could profit from an engagement with a semantics which reinstalls the body in verbal signification in both its biological and social formations. When Susan Ervin provides evidence from her work with Zuni Indians that linguistic and perceptual categories do not necessarily cut up the world in the same way, her findings concern not only anthropology but also traditional semantics.

Much feminist thought has for some time struggled with the heritage of Lacan's linguistic transformation of the Freudian perspective in order to regain access to the necessary theorization of the body. Not that the corporeal is altogether absent from Lacan's account. The much discussed mirror stage, for instance, is explicitly conceived to include, beyond merely visual terms, 'also what is heard, touched and willed by the child.' Freud's interest in both fantasy acts and broad cultural descriptions saved his work from the more radical implications of the linguistic turn. Even in as verbally dominated a field as the

analysis of retold dreams, Freud speaks of dream content as a 'pictorial script.' Unfortunately, the dominant Lacanian discourse projects an overwhelmingly linguistic view of both the unconscious and the symbolic.

A glance at Luce Irigaray's project well illustrates this influence. In *Speculum of the Other Woman* we are offered the double thesis of the necessity of re-emphasizing materiality, in an originary maternal sense, and a radical de-emphasis of representation. The first part of this thesis is aligned with the historically and philosophically oppressed feminine, while representation is regarded as essentially gynaecological, as viewing the world from a phallic perspective. While Irigaray is right in saying that 'parler n'est jamais neutral,' it is precisely representation that she requires in order to drive home her point about the importance of materiality. Her persuasive attack on a tendency towards abstract and formal representation confuses it with representation in general, including the quasi-material representations she should celebrate for her project of reviving feminine corporeality.

Hélène Cixous's slogan of 1974, 'Write yourself. Your body must be heard,' has been answered by an impressive corpus of 'écriture féminine,' but as yet not by a semantics exploring the conditions without which the presence of the body in language cannot be argued. *Semantics and the Body* offers one possible path to such a description of corporeal meaning.

The attack on representation is not restricted to a certain feminist perspec-tive. Perhaps not surprisingly, it can be found in much postcolonial litera-ture, where its motivation is rightly political rather than philosophical. Since Frege banned *Vorstellung* from sense, analytical philosophy has regraded rep-resentation in its mental form as an illegitimate adjunct to meaning. That a pragmatist such as Richard Rorty has launched a sustained attack on rep-resentation, however, poses a different problem. From the formal prejudice of analytical procedure it makes sense that the murkiness of intersubjective representations be eliminated. In Rorty's case I see two related problems: rep-resentations appear to be equated with realist representations, an unwarranted narrowing of the concept; and the role of fantasizing in community-steered mental representations seems to be entirely underrated.

A corporeal semantics is able to meet Francisco Varela's criticism of Hilary Putnam's internal realism. In *The Embodied Mind* Varela objects to Putnam's linking our grasp of the world to representations as making his position indis-tinguishable from idealism. From the perspective advocated here his criticism is overruled by turning the subjective into intersubjectivity. Television-induced images are just as stable as individual memories of dictionary definitions of phrases. *Vorstellung* in principle yields as much to Wittgenstein's private lan-guage argument as does language itself. And since in an intersemiotic theory

of meaning language does not mean without activation by non-verbal readings, the argument needs to be broadened to include *Lebensformen* understood as culture-specific clusters of non-verbal signs.

Pedagogy in many fields could be enriched by a systemic integration of nonverbal semiosis into a linguistically dominated syllabus. While teaching of the arts has always paid attention to the exploration of non-verbal signification, teaching of language has stayed clear of a perspective that would tie meaning-making to the filling of verbal schemata by fantasy variants of our perceptual readings of the world.

For the study of multiculturalism an intersemiotic and heterosemiotic semantics could focus on the question of the discrepancy of reference and speech modalities. The assumption that the meaning of an English phrase is secured by the right dictionary description shared by members of distinct ethnic communities is quite blatantly untenable. Each verbal explanation merely repeats, and often compounds, the semantic problems of the initial expression. Nor should recognizable discrepancies of reference and deixis be tied to assimilationist goals. Multicultural societies can only be enriched by the inevitable modification of standard meaning events by alternative representations.

Such disciplines as literature, film theory, translation theory, and cultural studies have a natural affinity to this book's intersemiotic emphasis. Indeed, the poverty of linguistically dominated literary theories has been a strong motivation in the writing of this and my earlier studies. Though theorists in these areas still pursue the linguistic turn, the re-emergence of the corporeal in the linguistic structures which they emphasize is inevitable. Language without tactile, aural, gustatory, olfactory, haptic, proximic, kinetic, and other non-verbal readings remains a syntax. Yet the verbal and the non-verbal must not be seen as merely interacting with one another, as semiotic studies have argued since Peirce. For meaning to occur the non-verbal must inhabit the linguistic schema. In itself language is no more than a symbolic grid which does not mean at all.

Notes

INTRODUCTION

1 John Locke, *An Essay Concerning Human Understanding* (London: Everyman 1993), Book III, Chapter 2, Part 1, 227.
2 Charles Sanders Peirce, *Collected Papers*, vols. 1–6, ed. Charles Hartshorne and Paul Weiss (Cambridge, MA: Harvard University Press 1974), 3.360, 4.544.
3 Paul de Man, 'The Epistemology of Metaphor,' in *On Metaphor*, ed. Sheldon Sacks (Chicago: University of Chicago Press 1979), 27–8, 14.
4 Jacques Derrida, *Of Grammatology*, trans. Gyatri Chakravorty Spivak (Baltimore: Johns Hopkins University Press 1978), 158.
5 Ibid., 159.
6 Immanuel Kant, *Critique of Pure Reason*, trans. Norman Kemp Smith (New York: St. Martin's Press 1965), A728.
7 Ibid., A290.
8 Edmund Husserl, *The Phenomenology of Internal Time-Consciousness*, ed. Martin Heidegger, trans. James S. Churchill (Bloomington: Indiana University Press 1966), 63.
9 Jacques Derrida, 'The Spatial Arts: An Interview with Jacques Derrida,' in *Deconstruction and the Visual Arts: Art, Media, Architecture*, ed. Peter Brunette and David Wills (Cambridge: Cambridge University Press 1994), 15.
10 Gottlob Frege, 'Booles rechnende Logik,' 13, quoted in J. Alberto Coffa, *The Semantic Tradition from Kant to Carnap: To the Vienna Station* (Cambridge: Cambridge University Press 1993), 64.
11 Gottlob Frege, *Begriffsschrift*, 97, in Coffa, *The Semantic Tradition*, 65.
12 Horst Ruthrof, *The Reader's Construction of Narrative* (London: Routledge and Kegan Paul 1981); 'The Problem of Inferred Modality in Narrative,' *Journal of Literary Semantics* 13 (1984); 'Language and the Dominance of Modality,' *Language and*

Style: An International Journal 21, no. 3 (1988); 'From Frege to Derrida: The Destabilization of Meaning,' *Australian Journal of Cultural Studies* 4, no. 1 (1986); 'Identity and Différance,' *Poetics* 17 (1988); 'Narrative and the Digital: On the Syntax of the Postmodern,' *Narrative Issues*, Special issue of *Journal of Australasian Universities Language and Literature Association* (1990); *Pandora and Occam: On the Limits of Language and Literature* (Bloomington: Indiana University Press 1992).

13 Gottfried Wilhelm Leibniz, *The Monadology and Other Philosophical Writings*, trans. Robert Latta (Oxford: Oxford University Press 1968), 235.

14 Ibid., 236n. 54, referring to the Appendix to 'Theodicee.'

15 Ibid., 237n. 55.

16 Ibid., 61n. 1, referring to *De Scientia Universali seu Calculo Philosophico.*

17 Ibid., 62, emphasis added.

18 Gottlob Frege, 'On Sense and Reference' (1892), in *Translations from the Philosophical Writings of Gottlob Frege*, ed. Peter Geach and Max Black (Oxford: Basil Blackwell 1970).

19 Friedrich Nietzsche, *On the Genealogy of Morals* (New York: Vintage Books 1967), 80.

20 Immanuel Kant, *Kritik der Urteilskraft*, ed. Karl Vorländer (Hamburg: Felix Meiner 1968), 248–9, 262ff., 270.

21 Umberto Eco, *Semiotics and the Philosophy of Language* (London: Macmillan 1984).

22 Martin Heidegger, *Being and Time*, trans. John Macquarrie and Edward Robinson (London: SCM Press 1962), 201.

23 John R. Searle, *Expression and Meaning. Studies in the Theories of Speech Acts* (Cambridge: Cambridge University Press 1979); 'The Background of Meaning,' in *Speech Act Theory and Pragmatics*, ed. John R. Searle, Ferenc Kiefer, and Manfred Bierwisch (Dordrecht: Reidel 1980); and *Intentionality: An Essay in the Philosophy of Mind* (Cambridge: Cambridge University Press 1983).

24 Jeff Malpas, *Donald Davidson and the Mirror of Meaning: Holism, Truth and Interpretation* (Cambridge: Cambridge University Press 1992).

25 Wilhelm Dilthey, *Gesammelte Schriften*, vol. 7, *Der Aufbau der geschichtlichen Welt*, ed. Bernard Groethuysen (Stuttgart: Teubner 1958), 233.

26 Jean-Jacques Lecercle, *The Violence of Language* (London: Routledge 1990).

27 Augusto Ponzi, *Man as Sign: Essays on the Philosophy of Language*, trans. Susan Petrilli (New York: Mouton de Gruyter 1990).

28 Patrick Fuery, *The Theory of Absence: Subjectivity, Signification, and Desire* (Westport, CT: Greenwood Press 1995), 74 and 45.

CHAPTER 1: TOWARDS A CORPOREAL SEMANTICS

1 Michael Devitt and Kim Sterelny, *Language and Reality: An Introduction to the Philosophy of Language* (Oxford: Basil Blackwell 1990), 15.

2 Max Black, 'More about Metaphor' in *Metaphor and Thought*, ed. Andrew Ortony (Cambridge: Cambridge University Press 1979), 39–40.

3 Kevin Mulligan, *Speech Act and Sachverhalt: Reinach and the Foundations of Realist Phenomenology* (Dordrecht: Martin Nijhoff 1987); John L. Austin, *How to Do Things with Words* (Oxford: Clarendon 1962).

4 John R. Searle, *Speech Acts. An Essay in the Philosophy of Language* (London: Cambridge University Press 1977), 49–50; see also *Expression and Meaning. Studies in the Theories of Speech Acts* (Cambridge: Cambridge University Press 1979).

5 Dieter Wunderlich, 'Methodological Remarks on Speech Act Theory,' in *Speech Act Theory and Pragmatics*, ed. John R. Searle, Ferenc Kiefer, and Manfred Bierwisch (Dordrecht: Reidel 1980), 298.

6 Ferdinand de Saussure, *Course in General Linguistics*, trans. Wade Baskin (New York: McGraw-Hill 1966), 112, 114. For a criticism of Saussure's neglect of reference, see Devitt and Sterelny, *Language and Reality*, 211ff.

7 Ruth M. Kempson, *Presupposition and the Delimitation of Semantics* (Cambridge: Cambridge University Press 1975), 32. For related and influential descriptions of meaning see, for example, Jerrold J. Katz, *Semantic Theory* (New York: Harper and Row 1972); Manfred Bierwisch, 'On Classifying Semantic Features,' in *Semantics*, ed. D.D. Steinberg and L.A. Jakobovits (Cambridge: Cambridge University Press 1971); and Noam A. Chomsky, 'Deep Structure, Surface Structure and Semantic Interpretation,' in *Semantics*, ed. Steinberg and Jakobovits. For standard definitions of meaning in the analytical tradition see, for example, F.R. Palmer, *Semantics* (Cambridge: Cambridge University Press 1982), passim, and especially 1–16, 83–117.

8 Immanuel Kant, *Critique of Pure Reason*, trans. Norman Kemp Smith (London: Macmillan 1973), A137ff.

9 Ibid., A728.

10 Immanuel Kant, *Kritik der Urteilskraft* (Hamburg: Felix Meiner 1968), 248–50, 262ff.

11 Ibid., 264, 282.

12 Charles Sanders Peirce, *Collected Papers*, vols. 7 and 8, *Science and Philosophy*, ed. Arthur W. Burks (Cambridge, MA: Harvard University Press 1958); and *Collected Papers*, vols. 1 to 6, ed. Charles Hartshorne and Paul Weiss (Cambridge, MA: Harvard University Press 1974); see also Jarrett Brock, 'Principal Themes in Peirce's Logic of Vagueness,' *Peirce Studies* 1 (1979); Wojciech Kalaga, 'The Concept of Interpretant in Literary Semiotics,' *Transactions of the Charles S. Peirce Society* 22, no. 1 (1986); and James Jakob Liszka, 'Peirce's Interpretant,' *Transactions of the Charles S. Peirce Society* 26, no. 1 (1990).

13 Charles Sanders Peirce, unpublished ms, MS 183,132, Harvard University Library, Cambridge, MA.

14　Roman Jakobson, 'On Linguistic Aspects of Translation,' in *Language in Literature*, ed. Krystyna Pomorska and Stephen Rudy (Cambridge, MA: Belknap Press 1987), 429.

15　John Dewey, 'Peirce's Theory of Linguistic Signs, Thought, and Meaning,' *Journal of Philosophy* 43 (1946): 91.

16　Peirce, *Collected Papers*, 5.7. The remaining parenthetical references in this section are all to the relevant volume and section numbers of Peirce's collected works.

17　For example, Paul Grice, *Studies in the Way of Words* (Cambridge, MA Harvard University Press 1989).

18　Michael Devitt and Kim Sterelny, *Language and Reality: An Introduction to the Philosophy of Language* (Oxford: Basil Blackwell 1990).

19　A study demonstrating the reverse motion, from a formalized ideal of natural language towards a holistic perspective, can be found in Martin Kusch, *Language as Calculus vs. Language as Universal Medium* (Dordrecht: Kluwer Academic Publishers 1989), in which the author traces stages in the writings of Edmund Husserl and Martin Heidegger.

20　Cf. Rudolf Carnap, *Meaning and Necessity* (Chicago: University of Chicago Press 1967) to, for example, John N. Martin, *Elements of Formal Semantics* (New York: Academic Press 1987).

21　Such a holistic project is stipulated but not followed through by Martin Heidegger in *Being and Time*, trans. John Macquarrie and Edward Robinson (London: SCM Press 1962), 188–213, and demonstrated in some of his later papers, as for instance in: 'The Way to Language,' in *On the Way to Language*, trans. Peter D. Hertz (New York: Harper and Row 1971); 'Language in the Poem,' in *On the Way to Language*; or 'Language,' in *Poetry, Language, Thought*, ed. and trans. Albert Hofstadter (New York: Harper and Row 1975).

22　As Charles Sanders Peirce insisted, 'We think only in signs' (*Collected Papers*, vols. 1–6, ed. Charles Hartshorne and Paul Weiss [Cambridge, MA: Belknap Press 1974], 2.302) or 'whenever we think, we have present to the consciousness some feeling, image, conception, or other representation, which serves as a sign' (5.283).

23　Because of the fundamental mediation of what we know, Peirce observes with reference to Kant that 'the Ding an sich, however, can neither be indicated nor found' (*Collected Papers*, 5.525).

24　Cf. the concluding claim of Chapter 6 in my *Pandora and Occam: On the Limits of Language and Literature* (Bloomington: Indiana University Press 1992). Earlier in that chapter I suggested a semiotic reformulation of Kant's notion of schematism.

25　This link between sign systems is what Wittgenstein's term *Lebensformen* points to, though he did not pursue the question far enough to allow the construal of 'Wittgenstein's semiotic.' On the other hand, strong support for this kind of thesis can be found in, for instance: Edmund Husserl's work on 'appresentation'; some papers

by Roman Jakobson in *Language in Literature*, ed. Pomorska and Rudy; Umberto Eco's *Semiotics and the Philosophy of Language* (London: Macmillan 1984); Thomas A. Sebeok's 'Zoosemiotic Components of Human Communication,' in *Semiotics: An Introductory Reader*, ed. Robert E. Innis (London: Hutchison 1986), or *A Perfusion of Signs* (Bloomington: Indiana University Press 1977); and in Fernando Poyates's *New Perspectives in Nonverbal Communication* (New York: Pergamon Press 1982).

26 See for example Cate Poynton, *Language and Gender: Making the Difference* (Geelong, Victoria: Deakin University Press 1986).

27 Ludwig Wittgenstein, *Tractatus Logico-Philosophicus*, trans. D.F. Pears and B.F. McGuiness, intr. Bertrand Russell (London: Routledge and Kegan Paul 1963), 5.6, 'Die Grenzen meiner Sprache bedeuten die Grenzen meiner Welt.'

28 Michael Dummett, for example, finds both convictions unsatisfactory because 'it is unclear whether the realist's defence ... can be made convincing' and 'whether the anti-realist's position can be made coherent' ('Truth' in *Truth and Other Enigmas* [Cambridge, MA: Harvard University Press 1978], 24).

29 Cf. the Introduction to Horst Ruthrof, *Pandora and Occam: On the Limits of Language and Literature* (Bloomington: Indiana University Press, 1992), where I argue for the notion of 'realist textualism' with reference to observations by Davidson, Devitt, Dummett, Goodman, Lukes, Lyotard, Malpas, Nagel, Nietzsche, Newton-Smith, Novitz, Pêcheux, Platts, Putnam, and Rorty.

30 Ibid., Chapter 1.

31 Edmund Husserl, *The Phenomenology of Inner Time-Consciousness*, ed. Martin Heidegger, trans. James S. Churchill (Bloomington: Indiana University Press 1966); Jacques Derrida's radicalization of Husserl's position in 'Différance' in *Speech and Phenomena*, trans. David B. Allison (Evanston, IL: Northwestern University Press 1973).

32 See, for instance, his 'The Semantics of Metaphor,' in *The Role of the Reader: Explorations in the Semiotics of Texts* (Bloomington: Indiana University Press 1979).

33 Devitt and Sterelny, *Language and Reality*, 15.

34 Paul Grice's famous distinction between natural and non-natural meanings supports the view that we are dealing with sign systems even in a case where we only observe such natural phenomena as spots on a person's skin. See his paper 'Meaning' (1957) in *Studies in the Way of Words*, especially 213–14. I would like to stress, however, that the interpretive weight in either of Grice's meanings is on the deciphering process. From this perspective the notion of a 'natural meaning' is odd.

35 Roman Jakobson speaks of a transmutational relationship between different kinds of signs in 'On Linguistic Aspects of Translation,' in *Language in Literature*, 429.

36 Aristotle, *De Anima*, Books II and III, trans. and intr. D.W. Hamlyn (Oxford: Clarendon 1968), III, 1, 425b4ff.; III, 2, 425b12; III, 2, 425b15ff.; III, 3, 428b30ff. This is why *sensus communis* in Aristotle is physiological and perceptual. By

contrast, the English conventional meaning of 'common sense' has to do with personal, sound judgment, while in Kant's *Critique of Judgment, sensus communis* refers to community agreement.

37 C.M. Meyers, 'The Determinate and Determinable Modes of Appearing,' *Mind* 68 (1958): 45.

38 John Gribbin, *In Search of Schrödinger's Cat: Quantum Physics and Reality* (New York: Bantam 1984), 146.

39 Summing up the field John N. Martin, for example, argues that 'in the case of extensional languages ... the structure of intensions is also homomorphic to that of referents.' This would mean that referents would likewise be ruled by definitions proper rather than by networks of open-ended signs (*Elements of Formal Semantics*, 313).

40 I have argued this point in detail in terms of a 'ladder of discourses' in Chapter 8 of *Pandora and Occam*.

41 Jakobson's six 'factors' (addresser, context, message, contact, code, addressee) and six 'functions' (emotive, referential, poetic, phatic, metalingual, conative) are designed to explain accurate meaning transfer even in complex situations ('Closing Statement: Linguistics and Poetics,' in *Style in Language*, ed. Thomas A. Sebeok [Cambridge, MA: MIT Press 1960]). See also Jakobson's many detailed studies demonstrating how this transfer works in practice, such as his analysis of the multistage communication of the 'nevermore' in Poe's 'The Raven' in 'Language in Operation,' in *Readings in Russian Poetics: Formalist and Structuralist Views*, ed. L. Matejka and K. Pomorska (Cambridge, MA: MIT Press 1971).

42 I am in sympathy here with the position taken by Jürgen Habermas in 'Universal Pragmatics,' in *Communication and the Evolution of Society* (London: Heinemann 1979), and in his more recent *Moral Consciousness and Communicative Action*, trans. Christian Lenhardt and Shierry Weber Nicholson (London: Polity Press 1990).

43 Alfred Tarski, 'The Establishment of Scientific Semantics,' in *Logic, Semantics, Mathematics*, trans. J.H. Woodger (Oxford: Clarendon Press 1956), 403; and 'The Concept of Truth in Formalized Languages,' in *Logic, Semantics, Mathematics*, 153.

44 As a starting point see Rudolf Carnap, *Meaning and Necessity*.

45 Saussure, *Course in General Linguistics*, trans. Baskin, 9–15; see also my critique of *langue* in Chapter 6 of *Pandora and Occam*.

46 Especially Chapter 1 of *Pandora and Occam*.

47 See, for instance, Kurt Gödel, *On Formally Undecidable Propositions of Principia Mathematica and Related Systems I*, ed. B. Meltzer, intr. R.B. Braithwaite (London: Oliver & Boyd 1962); 'Über eine bisher noch nicht benützte Erweiterung des finiten Standpunktes,' *Dialectica* 12 (1958); and 'What Is Cantor's Continuum Problem?' in *Philosophy of Mathematics*, ed. P. Benacerraf and Hilary Putnam (Cambridge: Cambridge University Press 1982).

48 Kant, *Critique of Pure Reason*, trans. Smith; *Kritik der Reinen Vernunft* (Hamburg: Felix Meiner 1956), A728, B756.

49 Peirce, *Collected Papers*, 1.339, 343. As in many other instances, Peirce here appears an astute reader and successor of Kant's philosophy.

50 Leibniz's 'sufficient' reason should be regarded as a pragmatic rather than as a logical tool. There is no logical limit to when the signifying chain of empirical concepts is to be terminated; there are only political–pragmatic boundaries. See 'The Monadology,' in *Leibniz: Philosophical Writings*, trans. Mary Morris and G.H.R. Parkinson (London: Dent 1934). For a critique of the *principium rationis sufficientis* see Martin Heidegger, 'The Problem of Reason,' in *The Essence of Reason*, trans. Terrence Malick (Evanston, IL: Northwestern University Press 1969); as well as my comments at the beginning of Chapter 5 in *Pandora and Occam*.

51 Peirce, *Collected Papers*, 5.311. While Peirce understands 'community' in the sense of shared interpretive attitudes – Kant's *sensus communis* – and perhaps also in the sense of Max Weber's *Gemeinschaft*, a more heterogeneous description of community can be found in Alec McHoul's *Semiotic Investigations: Towards an Effective Semiotics* (Lincoln and London: University of Nebraska Press 1996), in which 'communities can be connected by looser social structures and forms of knowledge' (49). McHoul suggests that community 'may be the concept with which effective semiotics can handle the space around the sign, its framing' (52).

52 A persuasive critique of the singularity principle which adheres to the addresser–addressee model can be found in Mary Louise Pratt, 'Ideology and Speech-Act Theory,' *Poetics Today* 7, no. 1 (1986).

53 Umberto Eco, *Semiotics*, 45.

54 Rudolf Carnap, *Introduction to Semantics and Formalization of Logic* (Cambridge, MA: Harvard University Press 1975), 22.

55 Gottlob Frege, 'On Sense and Reference' (1892), in *Translations from the Philosophical Writings of Gottlob Frege*, ed. Peter Geach and Max Black (Oxford: Basil Blackwell 1970); see also Horst Ruthrof, 'Frege's Error,' *Philosophy Today* 37 (1993), 306–17.

56 Peirce, *Collected Papers*, 5.311.

57 Ruthrof, *Pandora and Occam*, 8, 11–12, 15, 107, 120, 200.

CHAPTER 2: NATURAL LANGUAGE AND MEANING AS DEFINITION

1 Gottlob Frege, 'On Sense and Reference' (1892), in *Translations from the Philosophical Writings of Gottlob Frege*, ed. Peter Geach and Max Black (Oxford: Basil Blackwell 1970).

2 Garth Hallett, *Wittgenstein's Definition of Meaning as Use* (New York: Fordham University Press 1967), 23, 25.

3 Ludwig Wittgenstein, *Tractatus Logico-Philosophicus*, trans. D.F. Pears and B.F. McGuiness, intr. Bertrand Russell (London: Routledge and Kegan Paul 1963), 2.0121.

4 Ludwig Wittgenstein, *The Blue and Brown Books* (Oxford: Oxford University Press 1958), 69; P.F. Strawson, 'On Referring,' *Mind* 59 (1950); see also Gareth Evans, *The Varieties of Reference*, ed. John McDowell (Oxford: Clarendon Press 1982).

5 Gottlob Frege, *The Foundations of Arithmetic*, trans. John L. Austin (Oxford: Oxford University Press 1953), x.

6 Bertrand Russell, *The Analysis of Mind* (London: George Allen and Unwin 1921), 197–8; see also Bertrand Russell, 'Vagueness,' *Australian Journal of Psychology and Philosophy* 1 (June 1923).

7 Wittgenstein, *Blue and Brown Books*, 27.

8 Willard Van Orman Quine, 'Notes on the Theory of Reference,' in *From a Logical Point of View: Logico-Philosophical Essays* (New York: Harper and Row 1963), 130; see also his 'The Problem of Meaning in Linguistics,' in *From a Logical Point of View*.

9 See Quine's 'Ontological Relativity,' in *Ontological Relativity and Other Essays* (New York: Columbia University Press 1969); 'On the Reason for Indeterminacy of Translation,' *Journal of Philosophy* 67 (1970); and 'Indeterminacy of Translation Again,' *Journal of Philosophy* 84, no. 1 (1987).

10 Hilary Putnam, *Reason, Truth, and History* (Cambridge: Cambridge University Press 1981), 22–48; Jerrold J. Katz, *The Metaphysics of Meaning* (Cambridge, MA: MIT Press 1990), 202.

11 Michael Devitt and Kim Sterelny, *Language and Reality: An Introduction to the Philosophy of Language* (Oxford: Basil Blackwell 1990), 26.

12 Gottlob Frege, 'On Sense and Reference.' All subsequent parenthetical page references in this section are to this paper except where indicated otherwise.

13 See Chapter 3 in Michael Dummett, *The Interpretation of Frege's Philosophy* (Cambridge, MA: Harvard University Press 1981).

14 Michael Dummett, *Frege and Other Philosophers* (Oxford: Clarendon Press 1991).

15 Ibid., 280.

16 Cf. Michael Dummett, 'The Social Character of Meaning,' *Synthese* 27 (1974).

17 See Horst Ruthrof, *Pandora and Occam: On the Limits of Language and Literature* (Bloomington: Indiana University Press 1992), 81.

18 Martin Heidegger, *Being and Time*, trans. John Macquarrie and Edward Robinson (London: SCM Press 1962), 188–213.

19 Charles Sanders Peirce, *Collected Papers*, vols. 3 and 4, ed. Charles Hartshorne and Paul Weiss (Cambridge, MA: Belknap Press 1974), 3.621.

20 John R. Searle, *Minds, Brains and Science: The 1984 Reith Lectures* (Harmondsworth: Penguin 1984), 33.

21 Ruthrof, *Pandora and Occam*, 31–3.

22 Strawson, 'On Referring.'

23 Nelson Goodman, *Ways of Worldmaking* (Indianapolis: Hackett Publishing 1978), 128.

24 Donald Davidson, 'A Coherence Theory of Truth,' in *Truth and Interpretation: Perspectives on the Philosophy of Donald Davidson*, ed. Ernest Lepore (Oxford: Basil Blackwell 1989).

25 Ruthrof, *Pandora and Occam*, 93ff.

26 Dummett, *Interpretation of Frege's Philosophy*, 109.

27 Ruthrof, *Pandora and Occam*, 80ff.

28 David Wiggins, 'Meaning, Truth-Conditions, Propositions: Frege's Doctrine of Sense Retrieved, Resumed and Redeployed in the Light of Certain Recent Criticisms,' *Dialectica* 46 (1992).

29 Stephen Schiffer, *Remnants of Meaning* (Cambridge, MA: MIT 1987).

30 Ludwig Wittgenstein, *Philosophical Investigations*, trans. G.E.M. Anscombe (New York: Macmillan 1953), Part 1, 138.

31 Gottlob Frege, 'Zahlen und Arithmetik,' in *Nachgelassene Schriften*, ed. H. Hermes, F. Kambartel, and F. Kaulbach (Hamburg: Felix Meiner 1970), 297.

32 Jacques Derrida, *Husserl's Origin of Geometry: An Introduction*, trans. J.P. Leavy (Stony Brook: Nicolas Hays 1978).

33 Rudolf Carnap, *The Logical Syntax of Language* (1937; reprint, London: Routledge and Kegan Paul 1971), xvi; *Introduction to Semantics and Formalization of Logic* (Cambridge, MA: Harvard University Press 1975), x–xi.

34 Rudolf Carnap, *Meaning and Necessity* (Chicago: University of Chicago Press 1967), iii. A critique of Carnap's approach to natural language compatible with my argument, though presented from a different perspective, is offered by Jørgen Jørgensen in 'Some Remarks Concerning Languages, Calculuses, and Logic,' in *Logic and Language: Studies Dedicated to Professor Rudolf Carnap On the Occasion of His Seventieth Birthday*, ed. B.H. Kazemier and D. Vuysje (Dordrecht: Reidel 1962); see also Jaakko Hintikka's recent observations on Carnap's position on language as calculus and as universal medium in, 'Carnap's Work in the Foundations of Logic and Mathematics in a Historical Perspective,' *Synthèse* 93 (1992).

35 Carnap, *Meaning and Necessity*, 7–8.

36 Carnap, *Logical Syntax*, xiii.

37 Rudolf Carnap, *Philosophy and Logical Syntax* (London: Kegan Paul 1935), 99.

38 Rudolf Carnap, *The Logical Structure of the World and Pseudoproblems in Philosophy*, trans. Rolf A. George (1928; reprint, Berkeley: University of California Press 1967).

39 Carnap, *Meaning and Necessity*, 233.

40 Carnap, *Semantics and Formalization*, 9.

41 Rudolf Carnap, *Introduction to Symbolic Logic and Its Applications* (1954; reprint, New York: Dover Publications 1958), 2.

42 Carnap, *Semantics and Formalization*, 13.

43 Carnap, *Meaning and Necessity*, iii; cf. Jerrold J. Katz, who argues that there are two kinds of intensionalism and that only the Fregean kind deserves the criticism it has received. Carnap's version of Frege's position is not regarded by Katz as intensionalism ('The New Intensionalism,' *Mind* 101 [1992]).

44 Carnap, *Meaning and Necessity*, 1.

45 Carnap, *Semantics and Formalization*, 249.

46 Carnap, *Meaning and Necessity*, 6.

47 Carnap, *Semantics and Formalization*, 10.

48 Carnap, *Introduction to Symbolic Logic*, 15.

49 Carnap, *Semantics and Formalization*, 10.

50 Carnap, *Logical Structure*, 325.

51 Carnap, *Introduction to Symbolic Logic*, 40.

52 Carnap, *Meaning and Necessity*, 7.

53 Carnap, *Introduction to Symbolic Logic*, 37.

54 Carnap, *Logical Syntax*, 22, 90ff., 191–2.

55 Carnap, *Introduction to Symbolic Logic*, 45ff.

56 Carnap, *Philosophy and Logical Syntax*, 80ff.; see also *Logical Syntax*, 288ff.

57 Carnap, *Semantics and Formalization*, 47.

58 Carnap, *Meaning and Necessity*, 233.

59 Carnap, *Semantics and Formalization*, 17.

60 Carnap, *Introduction to Symbolic Logic*, 64.

61 Carnap, *Meaning and Necessity*, 239.

62 Carnap, *Introduction to Symbolic Logic*, 17. Cf. Willard Van Orman Quine's objection to the application of logical truth to analyticity: 'To segregate analyticity we should need rather some sort of accounting of synonymies throughout a universal language. No regimented universal language is at hand' ('Carnap and Logical Truth,' in *Logic and Language*, ed. Kazemier and Vuysje, 61). In defence of Carnap's notion of analyticity, see Richard Creath, 'Every Dogma Has Its Day,' *Erkenntnis* (1991).

63 Carnap, *Introduction to Symbolic Logic*, 18.

64 Carnap, *Meaning and Necessity*, 239.

65 John R. Searle, *Intentionality: An Essay in the Philosophy of Mind* (Cambridge: Cambridge University Press 1983), 33.

66 Searle, *Minds, Brains and Science*.

67 Karl R. Popper, *The Logic of Scientific Discovery* (1934; London: Hutchinson 1975), 265–6.

68 Carnap, *Introduction to Symbolic Logic*, 17.

69 Carnap, *Meaning and Necessity*, 222.

70 Carnap, *Introduction to Symbolic Logic*, 16.

71 Ibid., 101.

72 Alfred Tarski, 'The Establishment of Scientific Semantics,' in *Logic, Semantics, Metamathematics*, trans. J.H. Woodger (Oxford: Clarendon Press 1956); and 'The Concept of Truth in Formalized Languages,' in *Logic, Semantics, Metamathematics*.

73 Carnap, *Logical Syntax*, 51.

74 Martin Heidegger, 'The Origin of the Work of Art,' in *Poetry, Language, Thought*, trans. Albert Hofstadter (New York: Harper and Row 1975), 23.

75 Carnap, *Introduction to Symbolic Logic*, 103.

76 Searle, *Intentionality*, 145–6; Ruthrof, *Pandora and Occam*, 31–2.

77 Carnap, *Introduction to Symbolic Logic*, 2; as Jaakko Hintikka has pointed out, such notions of purity in Carnap follow from his 'single domain' convictions and his commitment to the conception of language as 'universal medium' ('Carnap, the Universality of Language and Extremality Axioms,' *Erkenntnis* [1991]).

78 Carnap, *Logical Syntax*, 27.

79 Carnap, *Introduction to Symbolic Logic*, 24.

80 Carnap, *Logical Structure*, 201.

81 Carnap, *Philosophy and Logical Syntax*, 29.

82 Carnap, *Logical Structure*, 312; cf. Robert G. Hudson, who speaks of the *Aufbau's* 'empirical foundationalism' ('Empirical Constraints in the "Aufbau,"' *Historical Philosophical Quarterly* 11 [1994]).

83 Carnap, *Introduction to Symbolic Logic*, 197.

84 Cf. J. Alberto Coffa's comment that 'the position displayed in the construction of the physical world (and beyond) is more properly described as an exercise in "scientific idealism" ... Carnap's construction of the world ... leaves us without the ability to distinguish ... between what science says and what is the case. If Carnap were right, science could never be false. As science changes, Carnap would instruct us to reconstruct the world' (*The Semantic Tradition from Kant to Carnap: To the Vienna Station* [Cambridge: Cambridge University Press 1993], 238).

CHAPTER 3: THE SEMANTICS OF NEGATION AND METAPHOR

1 Ruth M. Kempson, *Presupposition and the Delimitation of Semantics* (Cambridge: Cambridge University Press 1975).

2 George Yoos, 'A Phenomenological Look at Metaphor,' *Philosophy and Phenomenological Research* 32, no. 1 (1971).

3 Donald Davidson, 'What Metaphors Mean,' in *On Metaphor*, ed. Sheldon Sacks (Chicago: University of Chicago Press 1979).

4 Jacques Derrida, 'The *Retrait* of Metaphor,' *Enclitic* 2, no. 2 (1978).

5 Laurence R. Horn, *A Natural History of Negation* (Chicago: University of Chicago Press 1989), xiv.

6 Plato, 'Sophist,' 257–8B, quoted in Horn, *Natural History of Negation*, 5.

7 S.A. Altmann, 'Structure of Social Communication,' in *Social Communication among Primates*, ed. S.A. Altmann (Chicago: University of Chicago Press 1967), in quoted in Horn, *Natural History of Negation*, xiii.

8 Thomas A. Sebeok, 'Evolution of Signalling Behavior,' *Behavioral Science* 7 (1962); see also his 'Zoosemiotic Components of Human Communication,' in *Semiotics: An Introductory Reader*, ed. Robert E. Innis (London: Hutchison 1986).

9 Horst Ruthrof, *Pandora and Occam: On the Limits of Language and Literature* (Bloomington: Indiana University Press 1992), 102ff., 108–9, 114–15, 122–3.

10 Horn, *Natural History of Negation*, 156.

11 A more harmonious picture is offered, for example, in Lawrence E. Marks, *The Unity of the Senses: Interrelations among the Modalities* (New York: Academic Press 1978).

12 Humberto Maturana and F.G. Varela, *Autopoiesis and Cognition* (Dordrecht: Reidel 1980); Humberto Maturana and F.G. Varela, *The Tree of Knowledge* (Boston: New Science Library 1987); Humberto Maturana, 'Reality: The Search for Objectivity or the Quest for a Compelling Argument,' *Irish Journal of Psychology* 9, no. 1 (1988).

13 Gottlob Frege, 'Negation' (1919), in *Translations from the Philosophical Writings of Gottlob Frege*, trans. Peter Geach and Max Black (Oxford: Basil Blackwell 1970), 117.

14 Horn, *Natural History of Negation*, 134.

15 Ludwig Wittgenstein, 'Cause and Effect: Intuitive Awareness,' trans. Peter Finch, *Philosophia* 6 (1976).

16 Horn, *Natural History of Negation*, 370.

17 Ibid, 4.

18 Frege, 'Negation,' 131.

19 P.T. Geach, *Logic Matters* (Berkeley: University of California Press 1980), 78–9.

20 Ibid., quoted in Horn, *Natural History of Negation*, 79.

21 Horn, *Natural History of Negation*, 3.

22 Maire Jaanus Kurrik, *Literature and Negation* (New York: Columbia University Press 1979), 207.

23 Horn, *Natural History of Negation*, 134.

24 Ibid., 1–4, 45–79, 85–6, 94–5, 190ff., 198–203, 420–1.

25 Rudolf Carnap, *The Logical Structure of the World and Pseudoproblems in Philosophy*, trans. Rolf A. George (1928; reprint, Berkeley: University of California Press 1967).

26 Horn, *Natural History of Negation*, 49, emphasis added.

27 Fred Sommers, *The Logic of Natural Language* (Oxford: Clarendon Press 1982), 291.

28 Cf. Gilbert Ryle, 'Negation,' *Aristotelian Society Supplementary* 9 (1929); and G. Mabott, 'Negation,' *Aristotelian Society Supplementary* 9 (1929). See also Stephen B. Smith, *Meaning and Negation* (The Hague: Mouton 1974); and Ruth M. Kempson, *Presupposition*, 11–23, 34–5, 62–9, 95–100, 114ff.

29 Rudolf Carnap, *Meaning and Necessity* (Chicago: University of Chicago Press 1967), 233.

30 Ludwig Wittgenstein, *Tractatus Logico-Philosophicus*, trans. D.F. Pears and B.F. McGuiness, intr. Bertrand Russell (London: Routledge and Kegan Paul 1963), 4.063.

31 Horn, *Natural History of Negation*, 50.

32 Bertrand Russell, *Human Knowledge, Its Scope and Limits* (New York: Simon and Schuster 1948), 520.

33 Horn, *Natural History of Negation*, 49.

34 Richard M. Gale, *Negation and Non-Being* (Oxford: Basil Blackwell 1976), 4–61.

35 Wittgenstein, *Tractatus*, 4.063.

36 Immanuel Kant, *Critique of Pure Reason*, trans. Norman Kemp Smith (London: Macmillan 1973), A728, B756.

37 F.H. Bradley, *The Principles of Logic* (1883; reprint, London: Oxford University Press 1922); Gerd Buchdahl, 'The Problem of Negation,' *Philosophy and Phenomenological Research* 22 (1962).

38 Horn, *Natural History of Negation*, 80.

39 F.I. Shcherbatskoi, *Buddhist Logic*, vol. 1 (New York: Dover Publications 1962), 382.

40 Dhirendra Sharma, *The Negative Dialectics of India* (Chicago: Michigan University Press 1970), 119.

41 Bimal Krishna Matilal, *The Navya-Nyaya Doctrine of Negation* (Cambridge, MA: Harvard University Press 1968), 93.

42 Frege, 'Negation,' 130.

43 Ian Stewart, 'Mathematical Recreations,' *Scientific American* (February 1993): 86.

44 Horn, *Natural History of Negation*, 308, 312.

45 Otto Jespersen, 'Negation in English and Other Languages,' in *Selected Writings of Otto Jespersen* (London: Allen and Unwin 1917), 53.

46 Horn, *Natural History of Negation*, 309; cf. Charles J. Fillmore, 'The Position of Embedding Transformations in a Grammar,' *Word* 19 (1963).

47 Saul Kripke, *Naming and Necessity* (Cambridge, MA: Harvard University Press 1980).

48 Horn, *Natural History of Negation*, 361.

49 Edmund Husserl, 'Neutrality Modification and Fancy,' in *Ideas: General Introduction to Pure Phenomenology*, trans. W.R. Boyce Gibson (London: Collier-Macmillan 1969), 269; cf. Ruthrof, *Pandora and Occam*, 71, 133–64.

50 Horn, *Natural History of Negation*, 422.
51 Sigmund Freud, 'Negation' (1910), in *The Standard Edition of the Complete Psychological Works of Sigmund Freud*, vol. 19, trans. James Strachey (London: Hogarth Press 1978), 237 (German edition: 'Verneinung,' in *Gesammelte Werke*, ed. Anna Freud, E. Bibring, W. Hoffer, E. Kris, O. Isakower [Frankfurt: S. Fischer Verlag 1972]); see also *Complete Psychological Works*, trans. Strachey, 14:136, as well as Chapter 1 of Freud, *Civilization and Its Discontents* (London: Hogarth Press 1963).
52 Freud, 'Negation,' 237; see also section 5 of 'Three Essays' (1905d), *Complete Psychological Works*, trans. Strachey, 7:222: 'The finding of an object is in fact a refinding of it.'
53 Freud, 'Negation,' 239.
54 Freud, 'Negation'; editor's reference to 'The Anti-thetical Meaning of Primal Words,' in *Complete Psychological Works*, trans. Strachey, 11:155–61.
55 Freud, 'Negation,' 236; see also *Complete Psychological Works*, trans. Strachey, 8:175, 12:221, 14:186.
56 Roman Ingarden, *The Literary Work of Art* (Evanston, IL: Northwestern University Press 1973), passim.
57 Elizabeth Leinfellner-Rupertsberger, 'Die Negation im Monologischen Text: Textzusammenhang und "Foreground,"' *Folia Linguistica* 25 (1991).
58 Wolfgang Iser, *The Act of Reading* (London: Routledge and Kegan Paul 1979), final section.
59 See, for example, Jacques Derrida, 'Freud and the Scene of Writing,' in *Writing and Difference*, trans. Alan Bass (London: Routledge and Kegan Paul 1978).
60 Umberto Eco, 'The Semantics of Metaphor,' in *The Role of the Reader: Explorations in the Semiotics of Texts* (Bloomington: Indiana University Press 1979), 86.
61 Davidson, 'What Metaphors Mean,' 29, 30.
62 Dorothy Lee, 'Linguistic Reflection of Wintu Thought' (1944), *International Journal of American Linguistics* 10, quoted in Terence Hawkes, *Metaphor* (London: Methuen 1972), 82.
63 Horst Ruthrof, 'Frege's Error,' *Philosophy Today* 37 (1993).
64 Wallace Stevens, 'Adagia,' in *Opus Posthumous* (London: Alfred Knopf 1957), 179.
65 On metaphor and community see Ted Cohen, 'Metaphor and the Cultivation of Intimacy,' *Critical Inquiry* 5, no. 1 (1978).
66 Davidson, 'What Metaphors Mean,' 41.
67 Cf. Aristotle, *Rhetoric*, trans. W. Rhys Roberts (New York: Modern Library 1954), 1406b.
68 Monroe C. Beardsley, 'Metaphor,' *Encyclopedia of Philosophy*, vol. 5 (New York: Collier-Macmillan 1967), 285.
69 Monroe C. Beardsley, 'Metaphorical Senses,' *Nous* 12, no. 1 (1978); see also Paul Ricoeur, *The Rule of Metaphor* (Toronto: University of Toronto Press 1977), 90ff.

70 John R. Searle, 'Metaphor,' in *Metaphor and Thought*, ed. Andrew Ortony (Cambridge: Cambridge University Press 1979), 101.

71 George Dickie, 'Metaphor,' in *Aesthetics: An Introduction* (Indianapolis: Bobbs-Merrill, Pegasus 1971).

72 Aristotle, *Poetics*, in *Aristotle's Theory of Poetry and Fine Art*, trans. S.H. Butcher (New York: Dover 1951), 21, 1457b, 6–9.

73 Aristotle, *Nicomachean Ethics*, trans. M. Oswald (Indianapolis: Bobbs-Merrill 1962), 5, 5, 1131a31.

74 Aristotle, *Poetics*, 21, 1457b, 16–18.

75 Aristotle, *Rhetoric*, 1405b; *Poetics*, 22.

76 Cf. Aristotle's *De Anima*, Books II and III, trans. and intr. D.W. Hamlyn (Oxford: Clarendon 1968), II, 8, 420a28; II, 9, 421a26.

77 Wilhelm Stählin, 'Zur Psychologie und Statistik der Metaphern. Eine methodologische Untersuchung,' *Archiv für die gesamte Psychologie* 31 (1914); see also Karl Bühler, *Sprachtheorie. Die Darstellungsfunktion der Sprache* (Jena: 1934); I.A. Richards, *The Philosophy of Rhetoric* (Oxford: Oxford University Press 1936).

78 Richards, *Philosophy of Rhetoric*, 93; Max Black, 'More about Metaphor,' in *Metaphor and Thought*, ed. Ortony, 29.

79 Max Black, 'Metaphor,' *Proceedings of the Aristotelian Society* 55 (1954–5).

80 Max Black, *Models and Metaphors* (New York: Cornell University Press 1962), 39.

81 Max Black, *The Labyrinth of Language* (London: Pall Mall Press 1968), 151, 152.

82 For the opposite view see Martin Warner, 'Black's Metaphors,' *British Journal of Aesthetics* 13, no. 4 (1973).

83 Black, 'More about Metaphor,' 28ff.; and *Models and Metaphors*, 44–5.

84 Black, *Models and Metaphors*, 109–10.

85 Black, 'More about Metaphors,' 37.

86 Carl Hausman, *Metaphor and Art. Interactionism and Reference in the Verbal and Nonverbal Arts* (Cambridge: Cambridge University Press 1989), 40.

87 Searle, 'Metaphor,' 119; in defence of interaction see, for example, Felicity Haynes, 'Metaphor as Interactive,' *Educational Theory* 25, no. 3 (1975).

88 George Lakoff and Mark Turner, *More than Cool Reason: A Field Guide to Poetic Metaphor* (Chicago: University of Chicago Press 1989), 133.

89 Max Black, 'How Metaphors Work: A Reply to Donald Davidson,' in *On Metaphor*, ed. Sacks, 192.

90 Eileen Cornell Way, *Knowledge, Representation, Metaphor* (Dordrecht: Kluwer 1991); John M. Carroll and Robert L. Mack, 'Metaphor, Computing Systems, and Active Learning,' *International Journal of Man–Machine Studies* 22, no. 1 (1985); Earl R. MacCormac, *A Cognitive Theory of Metaphor* (Cambridge, MA: MIT Press 1988).

91 Way, *Knowledge, Representation, Metaphor*, 108.

92 Searle, 'Metaphor,' 116–19.

93 Beardsley, 'Metaphorical Senses.'
94 Nelson Goodman, *Languages of Art: An Approach to a Theory of Symbols* (Indianapolis: Bobbs-Merrill 1968), 68–95.
95 Colin Murray Turbayne, *The Myth of Metaphor* (Columbia: South Carolina University Press 1963), 11.
96 Searle, 'Metaphor,' 122.
97 Turbayne, *Myth of Metaphor*, 24–5.
98 Davidson, 'What Metaphors Mean,' 30; see also Donald Stewart, 'Metaphor and Paraphrase,' *Philosophy and Rhetoric* 4, no. 2 (1971) and George Yoos, 'A Phenomenological Look at Metaphor.'
99 Lakoff and Turner, *More than Cool Reason*, 63–4.
100 George Lakoff and Mark Johnson, *Metaphors We Live By* (Chicago: University of Chicago Press 1980); 'Conceptual Metaphor in Everyday Language,' *Journal of Philosophy* 77, no. 8 (1980).
101 Douglas Bergren, 'The Use and Abuse of Metaphor,' *Review of Metaphysics* 16 (1962–3); Warren Shibles, 'The Metaphorical Method,' *Journal of Aesthetic Education* 7 (1974); Richard Boyd, 'Metaphor and Theory Change,' in *Metaphor and Thought*, ed. Andrew Ortony (Cambridge: Cambridge University Press 1979); Mark Johnson and Glenn W. Erickson, 'Toward a New Theory of Metaphor,' *Southern Journal of Philosophy* 18, no. 3 (1980); Janet Martin and Rom Harré, 'Metaphor in Science,' in *Metaphor: Problems and Perspectives*, ed. David S. Miall (Brighton: Harvester 1982); and Jerry H. Gill, *Wittgenstein and Metaphor* (Washington, DC: University Press of America 1981).
102 Hausman, *Metaphor and Art*, 231.
103 Gill, *Wittgenstein and Metaphor*, vii, 201.
104 Ludwig Wittgenstein, *On Certainty*, ed. G.E.M. Anscombe and H.G. von Wright, trans. Denis Paul and G.E.M. Anscombe (Oxford: Basil Blackwell 1969), para. 105, and see also 358, 359.
105 Jacques Derrida, 'White Mythology: Metaphor in the Text of Philosophy,' in *Margins of Philosophy*, trans. Alan Bass (New York: University of Chicago Press 1982); 'The *Retrait* of Metaphor'; see also Paul de Man, 'The Epistemology of Metaphor,' *Critical Inquiry* 5 (1978).
106 Derrida, 'White Mythology,' 219–20.
107 Derrida, 'The *Retrait* of Metaphor,' 33.
108 Rodolphe Gasché, *The Tain of the Mirror: Derrida and the Philosophy of Reflection* (Cambridge, MA: Harvard University Press 1986), passim.
109 Martin Heidegger, *Being and Time*, trans. John Macquarrie and Edward Robinson (New York: Harper and Brothers 1962), 189.
110 John Locke, *An Essay Concerning Human Understanding*, II, iv, 5, quoted in W. Bedell Standford, *Greek Metaphor. Studies in Theory and Practice* (1936; reprint, New York:

Johnson Reprint Corporation 1972), 58; cf. John Locke, *An Essay Concerning Human Understanding* (London: Everyman 1993), 64.

111 Cf. also Martin Heidegger, *Der Satz vom Grund* (Pfullingen: Neske 1957); and *Unterwegs zur Sprache* (Pfullingen: Neske 1959).

112 Cf. Christopher Peacocke, ed., *Understanding Sense*, 2 vols. (Dartmouth: Cambridge University Press 1993).

113 Horst Ruthrof, *Pandora and Occam*, 4-5, 89-90, 182-3.

114 Cf. section 2.3 of this book.

115 Friedrich Nietzsche, 'On Truth and Falsity in Their Ultramoral Sense,' in *The Complete Works of Friedrich Nietzsche*, vol. 2, ed. Oscar Levy, trans. M.A. Mügge (London: Allen and Unwin 1911).

116 Ricoeur, *Rule of Metaphor*, 216-17.

117 Hausman, *Metaphor and Art*, 208.

118 Susanne Langer, *Problems of Art* (New York: Scribners 1957), 23, emphasis added.

119 Marcus B. Hester, 'Metaphor and Aspect Seeing,' *Journal of Aesthetics and Art Criticism* 25, no. 2 (1966); Virgil C. Aldrich, 'Visual Metaphor,' *Journal of Aesthetic Education* 2, no. 1 (1968); see also John B. Dilworth, 'A Representational Approach to Metaphor,' *Journal of Aesthetics and Art Criticism* 37, no. 4 (1979).

120 James Edie, *Philosophical and Phenomenological Research* 23 (1962-3); George Yoos, 'A Phenomenological Look at Metaphor'; and William H. Gass, 'In Terms of the Toenail: Fiction and the Figures of Life,' in *Fiction and the Figures of Life* (New York: Alfred A. Knopf 1970).

121 Searle, 'Metaphor,' 119.

122 Mark Johnson, 'A Philosophical Perspective on the Problems of Metaphor,' in *Cognition and Figurative Language*, ed. Robert Hoffman and Richard Honeck (Hillsdale, NJ: Lawrence Erlbaum 1980).

CHAPTER 4: MEANING AND POSTSTRUCTURALISM

1 Immanuel Kant, *Critique of Pure Reason*, trans. Norman Kemp Smith (London: Macmillan 1973), A728, B756.

2 'Auch hier tritt der oben bemerkte Zirkel ein, dass nämlich das Einzelne nur durch das Ganze und umgekehrt das Ganze nur durch das Einzelne verstanden werden kann' (Friedrich Ast, 'Hermeneutik' [1808] in *Seminar: Philosophische Hermeneutik*, ed. Hans-Georg Gadamer and Gottfried Boehm [Frankfurt: Suhrkamp 1976], 119).

3 Friedrich Schleiermacher, 'Über den Begriff der Hermeneutik' (1835), in *Seminar*, ed. Gadamer and Boehm, 149.

4 Wilhelm Dilthey, 'Entwürfe zur Kritik der historischen Vernunft' (1924), in *Seminar*, ed. Gadamer and Boehm.

5 Wilhelm Dilthey, *Gesammelte Schriften*, vol. 7, *Der Aufbau der Geschichtlichen Welt*, ed. Bernard Groethuysen (Stuttgart: Teubner 1958), 233.

6 H.P. Rickman, *Wilhelm Dilthey: Pioneer of the Human Studies* (London: Paul Elek 1979), 112; see also Richard Palmer, *Hermeneutics* (Evanston, IL: Northwestern University Press 1969), 120, and Rudolf A. Makkreel, *Dilthey: Philosopher of the Human Sciences* (Princeton, NJ: Princeton University Press 1977).

7 Hans-Georg Gadamer, 'Die philosophischen Grundlagen des 20. Jahrhunderts' (1967), in *Seminar*, ed. Gadamer and Boehm, 316; see also 'Das hermeneutische Problem der Anwendung' (1967), in *Seminar*, ed. Gadamer and Boehm; on the question of horizon see also his *Truth and Method* (New York: Crossroads 1985), 269ff., 460ff.

8 Kurt Mueller-Vollmer, *The Hermeneutics Reader* (New York: Continuum 1989), 272.

9 Gadamer, 'Die philosophischen,' in *Seminar*, ed. Gadamer and Boehm, 273.

10 Horst Ruthrof, *Pandora and Occam: On the Limits of Language and Literature* (Bloomington: Indiana University Press 1992), 65–77.

11 Gilles Deleuze, *The Logic of Sense*, trans. Mark Lester and Charles Stivale, ed. Constantin V. Boundas (London: Athlone Press 1990), 21.

12 Ronald Bogue, *Deleuze and Guattari* (London: Routledge 1993), 58; cf. Gilles Deleuze, *Différence et répétition* (Paris: PUF 1968), 328.

13 Jean-François Lyotard, *The Differend: Phrases in Dispute*, trans. Geoffrey Bennington and Brian Massumi (Manchester: Manchester University Press 1988), 61–5, 118–27, 130–5, 161–71. For a detailed discussion of Lyotard's theory of the differend see Ruthrof, *Pandora and Occam*, 120–32.

14 Jean-François Lyotard, *Lessons on the Analytic of the Sublime*, trans. Elizabeth Rottenberg (Stanford: Stanford University Press 1994); see also 'Complexity and the Sublime,' in *ICA Documents 4 and 5: Postmodernism*, ed. Lisa Appignanesi (London: Institute of Contemporary Arts 1986).

15 Kant, *Critique of Pure Reason*, trans. Smith, A728, B756; *Kritik der Reinen Vernunft* (Hamburg: Felix Meiner 1956).

16 'Abduction makes its start from the facts [and then] seeks a theory. Induction seeks for facts [having started] from a hypothesis' (Charles Sanders Peirce, *Collected Papers*, vol. 7, *Science and Philosophy*, ed. Arthur W. Burks [Cambridge, MA: Harvard University Press 1958], 218); cf. also 7.219 and *Collected Papers*, vols. 1 to 6, ed. Charles Hartshorne and Paul Weiss (Cambridge, MA: Harvard University Press 1974), 5.181, 184, 185, 188, 276.

17 Lyotard, *Differend*, 'phrases' or sentences, passim.

18 Geoffrey Bennington, *Lyotard: Writing the Event* (Manchester: Manchester University Press 1988), 121.

19 Lyotard, *Differend*, 70.

20 Bennington, *Lyotard*, 130, 112.

21 Lyotard, *Différend*, 9–10.

22 Kant, *Critique of Pure Reason*, A11, B25.

23 Lewis White Beck, *A Commentary on Kant's Critique of Practical Reason* (Chicago: University of Chicago Press 1960), 262; see also Mikel Dufrenne, *The Notion of the A Priori*, trans. Edward S. Casey (Evanston, IL: Northwestern University Press 1966).

24 Immanuel Kant, *Critique of Practical Reason*, trans. Lewis White Beck (New York: Bobbs-Merrill 1956); *Kritik der Praktischen Vernunft* (Hamburg: Felix Meiner 1967).

25 Kant, *Critique of Practical Reason*, Part I, Book 1, p. 7. Cf. H.J. Paton, *The Categorical Imperative: A Study of Kant's Moral Philosophy* (London: Hutchinson 1970), 129 (emphasis added).

26 Kant, *Critique of Practical Reason*, trans. Beck, 30, emphasis added.

27 Terry Eagleton, *The Ideology of the Aesthetic* (Oxford: Basil Blackwell 1990), 71.

28 Kant, *Critique of Pure Reason*, trans. Smith, A728, B756.

29 Kant, *Kritik der Praktischen Vernunft*, 57–8; *Critique of Practical Reason*, 50.

30 Kant, *Critique of Pure Reason*, trans. Smith, 57.

31 Paton, *Categorical Imperative*, 249; Martin Heidegger, *Being and Time*, trans. John Macquarrie and Edward Robinson (London: SCM Press 1962), 189; Peirce, *Collected Papers*, 3.621, 4.551, 539.

32 Paton, *Categorical Imperative*, 26.

33 I am using the double distinction between specification and generalization on the one hand and formalization and deformalization one the other, as employed by Husserl in *Ideas: General Introduction to Pure Phenomenology*, trans. W.R. Boyce Gibson (London: Collier-Macmillan, 1969)

34 Stephen Körner, 'The Impossibility of Transcendental Deductions,' *Monist* 51 (1967): 318–19.

35 Stephen Körner, *Categorial Frameworks* (Oxford: Clarendon Press 1974), 73.

36 D.P. Dryer, *Kant's Solution for Verification in Metaphysics* (London: George Allen and Unwin 1966), 74–5.

37 Robert Benton, *Kant's Second Critique and the Problem of Transcendental Arguments* (The Hague: Martinus Nijhoff 1977), 108.

38 Patricia Crawford, 'Kant's Theory of Philosophical Proof,' *Kant-Studien* 54 (1963); Malte Hossenfelder, *Kants Konstitutionstheorie und die Transcendentale Deduktion* (Berlin: Walter de Gruyter 1978).

39 Eva Schaper, 'Arguing Transcendentally,' *Kant-Studien* 63 (1972): 116.

40 Jeff E. Malpas, 'Transcendental Arguments and Conceptual Schemes: A Reconsideration of Körner's Uniqueness Argument,' *Kant-Studien* 81, no. 2 (1990): 247.

41 Rüdiger Bubner, 'Kant, Transcendental Arguments and the Problem of Deduction,' *Review of Metaphysics* 28 (1975): 460.

42 Jaakko Hintikka, 'Transcendental Arguments: Genuine and Spurious,' *Nous* 6 (1972): 277–8.

43 Jürgen Habermas, *Moral Consciousness and Communicative Action*, trans. Christian Lenhardt and Shierry Weber Nicholsen (London: Polity Press 1990), 82–98.

44 Lyotard, *Differend*, 58.

45 Lyotard is defended on this point, for example by Bennington, *Lyotard*, 131.

46 Jacques Derrida, *Speech and Phenomena*, trans. D.B. Allison (Evanston, IL: Northwestern University Press 1973); 'Limited Inc. abc ...' in *Glyph: Johns Hopkins Textual Studies* (Baltimore: Johns Hopkins University Press 1977), 162–254; and 'The Spatial Arts: An Interview with Jacques Derrida,' in *Deconstruction and the Visual Arts: Art, Media, Architecture*, ed. Peter Brunette and David Wills (Cambridge: Cambridge University Press 1994), 15.

47 Kant, *Critique of Pure Reason*, trans. Smith, A728.

48 Jacques Derrida, *Dissemination*, trans. B. Johnson (Chicago: University of Chicago Press 1981), 220.

49 Derrida, 'Limited Inc. abc ...' 203.

50 Jacques Derrida, *Of Grammatology*, trans. G.C. Spivak (Baltimore: Johns Hopkins University Press 1978), 167, 304.

51 Derrida, *Speech and Phenomena*, 88.

52 Derrida, *Of Grammatology*, 167.

53 Heidegger, *Being and Time*, trans. Macquarrie and Robinson, 188–214.

54 Derrida, *Dissemination*, 331.

55 Derrida, *Speech and Phenomena*, 154.

56 Derrida, *Of Grammatology*, 62, emphasis added.

57 Jacques Derrida, *Margins of Philosophy*, trans. A. Blass (Chicago: University of Chicago Press 1982), 219–20.

58 Derrida, *Dissemination*, 258.

59 Derrida, *Margins*, 259, 271.

60 Rodolphe Gasché, *The Tain of the Mirror: Derrida and the Philosophy of Reflection* (Cambridge, MA: Harvard University Press 1986), 224, 316ff.

61 David Wood, 'Différance and the Problem of Strategy,' in *Derrida and Différance*, ed. David Wood and Robert Bernasconi (Evanston, IL: Northwestern University Press 1988), 64, 65.

62 Derrida, *Margins*, 67.

63 Kant, *Critique of Pure Reason*, A727–30.

64 Kurt Gödel, *On Formally Undecidable Propositions of Principia Mathematica and Related Systems I*, ed. B. Meltzer, intr. R.B. Braithwaite (London: Oliver & Boyd 1962), 37–8; see also 'Über eine bisher noch nicht benützte Erweiterung des finiten Standpunktes,' *Dialectica* 12 (1958); and 'What Is Cantor's Continuum Problem?'

in *Philosophy of Mathematics*, ed. P. Benacerraf and Hilary Putnam (Cambridge: Cambridge University Press 1982).

65 Kant, *Critique of Pure Reason*, A730, A727.

66 Paton, *Categorical Imperative*, 249.

67 Robert Paul Wolff, 'A Reconstruction of the Argument of the Subjective Deduction,' in *Kant: A Collection of Essays*, ed. Robert Paul Wolff (London: Macmillan 1968), 130-1.

68 Paton, *Categorical Imperative*, 1970; Eva Schaper, 'Arguing Transcendentally'; Bubner, 'Kant, Transcendental Arguments and the Problem of Deduction'; Benton, *Kant's Second Critique;* Malpas, 'Transcendental Arguments and Conceptual Schemes'; Körner, 'The Impossibility of Transcendental Deductions.'

69 Kant, *Critique of Pure Reason*, A735–6, B763–4.

70 Lyotard, *Lessons on the Analytic of the Sublime*, trans. Rottenberg.

71 Körner, 'The Impossibility of Transcendental Deductions,' for example, rejects the argument. Jaakko Hintikka, in 'Transcendental Arguments,' supports it.

72 Kant, *Critique of Pure Reason*, A737, B765.

73 Jacques Derrida, *Positions*, trans. Alan Bass (Chicago: Chicago University Press 1971), 8; 'Différance,' in *Speech and Phenomena*; 'La Différance,' in *Marges de la philosophie* (Paris: Minuit 1972). It is evident from the page numbers cited throughout the chapter whether the English or the French edition of 'La Différance' is being referred to in each case. For parenthetical references that contain two page numbers, the English edition is given first and the French second.

74 Martin Heidegger, *Identity and Difference*, trans. Joan Stambaugh (New York: Harper and Row 1969), 42–74; cf. my 'Identity and Différance,' *Poetics* 17 (1988).

75 Derrida, *Dissemination*, 220-1.

76 Derrida, 'Différance,' 136, and 'La Différance,' 7.

77 Derrida, *Of Grammatology*, 158.

78 Ruthrof, *Pandora and Occam*, 8, 11–12, 15, 107, 120, 200.

79 Peirce, *Collected Papers*, 3.360.

80 Ferdinand de Saussure, *Course in General Linguistics*, trans. Wade Baskin (London: Fontana 1960), 120.

81 Derrida, 'La Différance,' 11, my translation.

82 Kant, *Critique of Pure Reason*, A728, A735.

83 Derrida, 'Différance,' 143, and 'La Différance,' 14.

84 Edmund Husserl, *The Phenomenology of Internal Time-Consciousness*, ed. Martin Heidegger, trans. James S. Churchill (Bloomington: Indiana University Press 1966), 50–1.

85 Derrida, 'Différance,' 143ff., and 'La Différance,' 14–15.

86 Jacques Derrida, *Writing and Difference*, trans. Alan Bass (Chicago: University of Chicago Press 1978), 257.

87 Friedrich Wilhelm Hegel, *Hegel's Logic*, trans. William Wallace (Oxford: Clarendon Press 1987), 119, 116.
88 Derrida, *Writing and Difference*, 275.
89 Derrida, 'Différance,' 145, and 'La Différance,' 15.
90 Horst Ruthrof, 'Frege's Error,' *Philosophy Today* 37 (1993).
91 Derrida, *Writing and Difference*, 149, 19, translation modified.
92 Derrida, 'Différance,' 152, and 'La Différance,' 22.
93 Derrida, *Writing and Difference*, 21, emphasis added.
94 Derrida, 'Différance,' 155, and 'La Différance,' 24.
95 Derrida, *Writing and Difference*, 27, my translation.
96 Derrida, 'Différance,' 159, and 'La Différance,' 28.
97 Jürgen Habermas, *Moral Consciousness and Communicative Action*, 2.
98 Eva Schaper, 'Arguing Transcendentally,' 113–14.
99 Benton, *Kant's Second Critique*, 4.
100 Bubner, 'Kant, Transcendental Arguments and the Problem of Deduction,' 466–7.
101 Hintikka, 'Transcendental Arguments,' 277–8.
102 Cf. Kant, *Critique of Pure Reason*, A11–12.
103 Jacques Derrida, 'The Spatial Arts,' ed. Brunette and Wills, 15.

CHAPTER 5: SEMANTICS AND THE POSTMODERN

1 Jean Baudrillard, *Le Système des objets* (Paris: Gallimard 1968); *La Société de consommation* (Paris: SGPP 1970).
2 Jean Baudrillard, *L'Économie politique du signe* (Paris: Gallimard 1976), 20; 'Forget Baudrillard,' in *Forget Foucault* (New York: Semiotext(e) 1987), 69.
3 Jean Baudrillard, 'On Nihilism,' *On the Beach* 6 (1984); 'Forget Baudrillard,' 71; *Simulations*, trans. P. Foss and P. Patton (New York: Semiotext(e) 1983), 102–3; *De la séduction* (Paris: Éditions Denoel-Gonthier 1979), 221–2.
4 Baudrillard, *Simulations*, 102–3; *In the Shadow of the Silent Majorities*, trans. Paul Foss, John Johnston, and Paul Patton (New York: Semiotext(e) 1983), 100; 'Forget Baudrillard,' 69–70; *De la séduction*, 235; 'Clone Story of the Artificial Child,' *Z/G* 11 (1984): 17.
5 Baudrillard, *Simulations*, 27, 111; 'Forget Baudrillard,' 75; 'Games with Vestiges,' trans. R. Gibson and P. Patton, *On the Beach* 5 (1984): 25.
6 Jean Baudrillard, *Fatal Strategies*, trans. Philip Beitchman and W.G.J. Nieluchowski (New York: Semiotext(e) 1990), 178.
7 The different uses of 'aleatory' in Baudrillard and Deleuze mark a deep disagreement between postmodern and poststructuralist theorizing.
8 Jean Baudrillard, 'On Nihilism,' *On the Beach* 6 (1984).

9 Horst Ruthrof, *Pandora and Occam: On the Limits of Language and Literature* (Bloomington: Indiana University Press 1992), defined, 114–15; see also ix, 6, 14, 24, 25, 32, 36, 50, 64, 102–3, 108–9, 119, 122, 127, 171, 184; 'Frege's Error,' *Philosophy Today* 37 (1993); 'Meaning: An Intersemiotic Perspective,' *Semiotica* 104, no. 1–2 (1995).

10 John Frow, *What Was Postmodernism?* (Sydney: Local Consumptions 1991), 16; Fredric Jameson, *Postmodernism, or, the Cultural Logic of Late Capitalism* (New York: Verso 1993), ix.

11 Jameson, *Postmodernism*, xxii.

12 Frow, *What Was Postmodernism?* 9ff.; cf. also Julia Kristeva, 'Postmodernism?' in *Romanticism, Modernism, Post-modernism*, ed. Harry R. Garvin (London: Associated University Presses 1980).

13 Frow, *What Was Postmodernism?*, 35.

14 Jameson, *Postmodernism*, xxii.

15 Jean-François Lyotard, *The Postmodern Condition: A Report on Knowledge* (Minneapolis: Minnesota University Press 1984), 3; cf. Seyla Benhabib, 'Epistemologies of Postmodernism: A Rejoinder to Jean-François Lyotard,' *New German Critique* 33 (1984); see also Paolo Portoghesi, *Postmodern: The Architecture of the Postindustrial Society* (New York: Rizzoli 1983); and Charles Jencks, *The Language of Post-modern Architecture* (London: Academy 1977).

16 Ihab Hassan, 'The Question of Postmodernism,' in *Romanticism, Modernism, Postmodernism*, ed. Garvin, 123–4.

17 Andreas Huyssen, 'Mapping the Postmodern,' *New German Critique* 33 (1984): 15–16; see also his 'The Search for Tradition: Avant-Garde and Postmodernism in the 1970s,' *New German Critique*, 22 (1981).

18 Richard Wolin, 'Modernism vs. Postmodernism,' *Telos* 62 (1984–5): 19.

19 Huyssen, 'Mapping the Postmodern,' 16.

20 Jean Baudrillard, 'Games with Vestiges,' trans. Gibson and Patton, 24.

21 Jacques Derrida, 'Point de folie: Maintenant l'architecture,' *Folio VIII* (La Case Vide: La Villette 1985) in *AA Files* 12 (1985).

22 Fredric Jameson, 'The Politics of Theory: Ideological Positions in the Postmodernism Debate,' *New German Critique* 33 (1984): 65; cf. Linda Hutcheon, 'The Politics of Postmodernism: Parody and History,' *Cultural Critique* 5 (1986–7).

23 Hal Foster, '(Post)Modern Polemics,' *New German Critique* 33 (1984): 67.

24 Fredric Jameson, 'Postmodernism, or the Cultural Logic of Late Capitalism,' *New Left Review* 146 (1984): 55.

25 Rosalind E. Kraus, *The Originality of the Avant-Garde and Other Modernist Myths* (Cambridge, MA: MIT Press 1987), 253–4.

26 Baudrillard, *Simulations*, trans. Foss and Patton, 146; 'Fatal Strategies,' in *Selected Writings*, ed. M. Poster (Cambridge: Polity 1988), 189.

27 Christa Buerger, 'The Disappearance of Art: The Postmodern Debate in the U.S.,' *Telos* 68 (1986): 97.
28 Martin Heidegger, *Being and Time*, trans. John Macquarrie and Edward Robinson (London: SCM Press 1962), 188ff.
29 Ruthrof, *Pandora and Occam*, 164.
30 Terry Eagleton, 'Capitalism, Modernism and Postmodernism,' *New Left Review* 152 (1985): 69.
31 Jameson, 'Postmodernism,' 53; Eagleton, 'Capitalism,' 62.
32 Jameson, 'The Politics of Theory,' 64–5.
33 Jameson, 'Postmodernism,' 55.
34 Jameson, *Postmodernism*, ix–x.
35 Jürgen Habermas, from 'Science and Technology as Ideology,' in *Towards a Rational Society* (London: Heinemann 1978) to *Communication and the Evolution of Society* (London: Heinemann 1979); and *Moral Consciousness and Communicative Action* (London: Polity Press 1990).
36 Peter U. Hohendahl, 'Habermas' Philosophical Discourse of Modernity,' *Telos* 69 (1986): 50.
37 Jürgen Habermas, *The Philosophical Discourse of Modernity* (London: Polity Press 1987), 178–84.
38 Hohendahl, 'Habermas,' 63.
39 Jürgen Habermas, 'Modernity versus Postmodernity,' *New German Critique* 22 (1981): 11; see also Richard Rorty, 'Habermas and Lyotard on Postmodernity,' in *Habermas and Modernity*, ed. Richard J. Bernstein (London: Polity Press 1985).
40 Lyotard, *Postmodern Condition*.
41 Jean-François Lyotard, 'Defining the Postmodern,' *ICA Documents 4 and 5: Postmodernism*, ed. Lisa Appignanesi (London: Institute of Contemporary Arts 1986), 6.
42 Jean-François Lyotard, *The Postmodern Explained: Correspondence 1982–1985* (Minneapolis: University of Minnesota Press 1993), 8.
43 Jean-François Lyotard, 'Reply to the Question: What Is the Post-Modern?' *ZX, A Magazine of the Visual Arts* (1984): 16–17.
44 Jean-François Lyotard, 'A Response to Philippe Lacoue-Labarthe,' *ICA Documents 4 and 5*.
45 Jean-François Lyotard, 'Complexity and the Sublime,' *ICA Documents 4 and 5*, 10.
46 Jean-François Lyotard, *Lessons on the Analytic of the Sublime* (Stanford: Stanford University Press 1994).
47 Lyotard, *Postmodern Explained*, 78, 18.
48 Derrida, 'Point de folie,' 69.

49 Cf. Donna J. Haraway, *Simians, Cyborgs, and Women: The Reinvention of Nature* (New York: Routledge 1991); and Zoe Sofia, 'Virtual Corporeality: A Feminist View,' *Australian Feminist Studies* 15 (1992).

50 Jacques Derrida, 'The Deconstruction of Actuality: An Interview with Jacques Derrida,' *Radical Philosophy* 68 (1994): 36.

51 Jean-François Lyotard, *The Differend: Phrases in Dispute* (Manchester: Manchester University Press 1988).

52 For a broad philosophical critique see Christopher Norris, *The Truth about Postmodernism* (Oxford: Basil Blackwell 1994).

Glossary

Concepts Schemata of natural language whose boundaries are 'never secure' and the analysis of which is 'never complete' (Kant). Concepts are recipes for aligning non-verbal signs such that a certain community-sanctioned perspective of objectivities is achieved. Concepts thus allow us to cut up the world or grasp (*con-capere*) aspects of the world in gustatory, proximic, kinetic, haptic and other ways under social control.

Constraints Base limits which 'shine through' all cultural texts are distinguished from culture-specific constraints.

Corporeal semantics A pragmatic semantics which acknowledges the role the body plays in meaning-making. In this semantic, non-verbal, perceptual readings of the world do not merely go hand in hand with linguistic expressions but are essential ingredients of meaning in language. Without the non-verbal, language is empty.

Corporeal turn The rediscovery of the important role that the body and materiality in general play in semantic practice (in reaction to the excesses of the 'linguistic turn'). Even the most abstract terms, including function words, can be shown to bear traces of the materiality of the social situations from which they evolved.

COSS Communicative sign systems (see ROSS).

Deixis Redefined as reference to the speech situation in its broadest social sense and as such an essential part of all linguistic expressions, including prepositions and function words. (See the example of 'Gaurisanker' in sections 2.1 and 2.2.) Neutralized only in formal speech and reduced in technical language use.

Directional schemata Linguistic expressions are regarded here as community-sanctioned directional schemata which focus non-verbal readings to produce meanings.

Facts and fictions Regarded here as operating on one scale. Facts are semiotically overdetermined, while fictions are semiotically underdetermined. When all our 'sensory' readings are engaged we can no longer distinguish between the two – hence the power of 'virtual reality' simulations. Towards the fact end of the scale, base constraints 'shine through' our texts.

Formalization The elimination of quasi-material content from the signifieds of natural language by a process of substituting formal syntax for natural language syntax (e.g., 'x' for 'academic freedom').

Frege's 'error' Frege's conflation of formal and non-formal sense.

Heterosemiotic Pertaining to combinations of distinct sign systems (as in natural languages). The term also suggests that meanings are not always smooth operations but often the result of violent superimpositions of semantic solutions on a disparate group of intersemiotic readings (the hole in the tooth in haptic, tactile, visual, and x-ray readings).

Homosemiotic Pertaining to definitionally ruled systems (e.g., formal systems). In natural language, syntax, but not semantics, is homosemiotic.

Intersemiotic Emphasizes the interaction between signs from distinct semiotic practices in the act of making meaning.

Intersemiotic constraints The inferential limits of our world and hence of sign practice as mediated by culture.

Lebensform Wittgenstein's 'form of life' can be reformulated as a community-controlled set of intersemiotic practices. As such it not only acts as a necessary background to language but also provides its schemata with semantic 'content.' *Lebensformen* are culture-specific clusters of non-verbal signs.

Linguistic turn The important realization that the definiens always plays a role in the constitution of the definiendum (e.g., linguistic expressions are not neutral with respect to their representations); a tendency to regard all significatory practices as linguistic.

Meaning The act of combining distinct sign systems, such as tactile and visual readings, or verbal and gustatory associations. Linguistic meaning is the activation of language by non-verbal signs.

Meaning as definition Possible only in formal semantics (sense 1). Natural language dictionaries do not provide definitions but only descriptions of varying length (depending on the size and purpose of dictionary). Moreover, dictionaries can be designed only after the fact of speech, a situation which reverses the role of definitions proper.

Meaning as linkage of language and world The assumption that the 'world' the way we see it is given physically rather than mediated. This disallows constructivist and perspectival views and also violates Kant's demand for a *tertium comparationis*.

Meaning as simulacrum (postmodern) Theory which reduces natural language signification to syntax and so deprives itself of the semantic deep ground which gives rise to that syntax (Baudrillard). A conception of natural language strangely akin to formal semantics.

Meaning as transcendental Since meaning in natural languages is not definitionally grounded, all understanding – even as minimal interpretation – involves transcendental moves, or reasoning about the conditions which must prevail for signs to function. In conscious interpretation this hermeneutic principle is foregrounded. (See Kant, *Critique of Judgment* and its consequences in the hermeneutic tradition and in Lyotard.)

Metaphor Linguistic expressions which display the heterosemiotic nature of all language. Metaphoric meaning cannot be established via the route of 'definitions' but only via imaginative, non-verbal experimentation. 'Dead' metaphors demonstrate the evolution of meaning practice from heterosemiotic exploration to habitual grasp, wrongly assumed to be definitional.

Modality The manner in which linguistic expressions are instantiated. It is never neutral or reducible to zero. It includes everything that shifts propositional contents. In natural languages modality overrides propositional sense. Modality is crucial to the relation of language and power.

Negation Like metaphor, negation highlights the limitations of formal and strictly linguistic approaches to meaning. The interpretation of such forms of negation as cultural and genocidal negation requires an intersemiotic rather than a merely linguistic approach. Instead of regarding negation as a formal relation, we can understand it as a deep semiotic potential, with verbal and formal negation as special cases.

Opacity Semantic underdetermination of the modal and propositional aspects of linguistic expressions. It requires interpretive construction of imaginary non-verbal scenarios. Opacity, however, can never be eliminated altogether.

Perception The sum of ROSS; primary significatory practice largely as a result of pedagogy; integration of heterosemiotic readings which compose the world as we sense it within constraints; provides the raw materials with which we 'fill' the schemata of verbal expressions. Unlike formal languages, natural languages require perceptual readings as necessary 'referential' background.

Pragmatics Incorporates semantics, since we can address language only as use, which is viewed here from the perspective of social semiosis and the role that non-verbal sign practice (see COSS and ROSS) plays in the activation of linguistic schemata.

Realism, inferential An indirect form of realism in which our construals or texts of the world require us to acknowledge base constraints. Cultures can be regarded as different texts respecting shared constraints. At more elaborate levels of social construction cultures invent constraints which we call culture specific.

Reference Unlike traditional reference, reference here is redefined as intersemiotic, i.e., as a specific relation between, for example, verbal expressions and non-verbal realizations; traditional reference at one (significatory) remove.

Representation A necessary ingredient of natural language semantics. Recent attacks on representation tend to confuse representation with realist representation. Without representation, there is no meaning.

ROSS Read-only sign systems (all perceptual readings).

Semantics Formal (homosemiotic) 'semantics' is sharply distinguished from (heterosemiotic) natural language semantics. Formal semantics is always a syntax, while natural language is always a multisemiotic practice. The idea of a natural language semantics outside pragmatics is regarded as misguided.

Semiotic corroboration thesis The thesis that reality occurs when at least two distinct sign systems are aligned with one another. The more signs from different sign practices can be activated in a habitual manner – that is, in social or community practice – the more we feel 'at home.' The uncanny is produced by an array of signs not sanctioned by the community.

Semiotic differend The semiotic differend leaves intact Lyotard's emphasis of domination by signification but widens its linguistic frame to allow for injustice as a result of non-verbal semiosis.

Semiotic overdetermination A situation in which there exists a broad social agreement on how to identify something by a large number of distinct sign practices.

Sense 1 Strict sense, definitionally controlled. (Definitions function a priori.)

Sense 2 Natural language sense, which is always already generally referential on both the propositional and the modal (deictic) side of signs. Here 'definitions' are a posteriori; they can be produced only after the social fact of meaning practice.

Sufficient semiosis Community agreement on sufficient common ground for communication to take place. (This replaces truth conditions for semantics.)

Synonymy A formal stipulation of meaning identity that does not occur in natural languages.

Use The activation of signifiers by non-verbal signs according to social instructions (e.g., pedagogy).

Vorstellungen Mental representations which are largely controlled by the community rather than merely subjective and mentalist. Frege 'illegitimately' eliminated *Vorstellung* from meaning on the grounds of its subjectivity. *Vorstellungen* are seen here as largely cultural, i.e., as no less controlled than dictionary entries. Both are intersubjective rather than subjective or objective.

Bibliography

Aldrich, Virgil C. 'Visual Metaphor.' *Journal of Aesthetic Education* 2, no. 1 (1968): 73–86

Altmann, S.A. 'Structure of Social Communication.' In *Social Communication among Primates*, edited by S.A. Altmann, 325–62. Chicago: University of Chicago Press 1967

Aristotle. *De Anima*. Books II and III, translated and introduced by D.W. Hamlyn. Oxford: Clarendon 1968

– *Nicomachean Ethics*. Translated by M. Oswald. Indianapolis: Bobbs-Merrill 1962

– *Poetics*. In *Aristotle's Theory of Poetry and Fine Art*. Translated by S.H. Butcher. New York: Dover 1951

– *Rhetoric*. Translated by W. Rhys Roberts. New York: Modern Library 1954

Ast, Friedrich. 'Hermeneutik' (1808). In *Seminar: Philosophische Hermeneutik*, edited by Hans-Georg Gadamer and Gottfried Boehm, 111–30. Frankfurt: Suhrkamp 1976

Bakhtin, Mikhail. *The Dialogic Imagination*. Translated by Carl Emerson and Michael Holquist. Austin: University of Texas Press 1981

Baudrillard, Jean. 'Clone Story of the Artificial Child.' *Z/G* 11 (1984): 16–17

– *De la séduction*. Paris: Éditions Denoel-Gonthier 1979

– *L'Économie politique du signe*. Paris: Gallimard 1976

– 'Fatal Strategies.' In *Selected Writings*, edited by Mark Poster, 185–206. Cambridge: Polity Press 1988.

– *Fatal Strategies*. Translated by Philip Beitchman and W.G.J. Nieluchowski. New York: Semiotext(e) 1990

– 'Forget Baudrillard.' In *Forget Foucault*. New York: Semiotext(e) 1987

– 'Games with Vestiges.' *On the Beach* 5 (1984): 19–25

– *In the Shadow of the Silent Majorities*. Translated by Paul Foss, John Johnston, and Paul Patton. New York: Semiotext(e) 1983

– 'Nihilism.' *On the Beach* 6 (1984): 38–9

– *Simulations*. Translated by P. Foss and P. Patton. New York: Semiotext(e) 1983

- *La Société de consommation*. Paris: SGPP 1970
- *Le Système des objets*. Paris: Gallimard 1968

Beardsley, Monroe C. 'Metaphor.' In *Encyclopedia of Philosophy*, vol. 5, edited by Paul Edwards, 284–9. New York: Collier-Macmillan 1967
- 'Metaphorical Senses.' *Nous* 12, no. 1 (1978): 3–16

Beck, Lewis White. *A Commentary on Kant's Critique of Practical Reason*. Chicago: University of Chicago Press 1960

Benhabib, Seyla. 'Epistemologies of Postmodernism: A Rejoinder to Jean-François Lyotard.' *New German Critique* 33 (1984): 103–26

Bennington, Geoffrey. *Lyotard: Writing the Event*. Manchester: Manchester University Press 1988

Benton, Robert. *Kant's Second Critique and the Problem of Transcendental Arguments*. The Hague: Martinus Nijhoff 1977

Bergren, Douglas. 'The Use and Abuse of Metaphor.' *Review of Metaphysics* 16 (1962–3): 237–58, 4550–72

Bierwisch, Manfred. 'On Classifying Semantic Features.' In *Semantics*, edited by D.D. Steinberg and L.A. Jakobovits, 410–35. Cambridge: Cambridge University Press 1971

Black, Max. 'How Metaphors Work: A Reply to Donald Davidson.' In *On Metaphor*, edited by Sheldon Sacks, 181–92. Chicago: University of Chicago Press 1981
- *The Labyrinth of Language*. London: Pall Mall Press 1968
- 'Metaphor.' *Proceedings of the Aristotelian Society* 55 (1954–5): 273–94
- *Models and Metaphors*. New York: Cornell University Press 1962
- 'More about Metaphor.' In *Metaphor and Thought*, edited by Andrew Ortony, 19–43. Cambridge: Cambridge University Press 1979

Bogue, Ronald. *Deleuze and Guattari*. London: Routledge 1993

Boyd, Richard. 'Metaphor and Theory Change.' In *Metaphor and Thought*, edited by Andrew Ortony, 356–408. Cambridge: Cambridge University Press 1979

Bradley, F.H. *The Principles of Logic*. 1883. Reprint, London: Oxford University Press 1922

Brock, Jarrett. 'Principal Themes in Peirce's Logic of Vagueness.' *Peirce Studies* 1 (1979): 41–50

Brooks, Peter. *Body Work: Objects of Desire in Modern Narrative*. Cambridge, MA: Harvard University Press 1993

Bubner, Rüdiger. 'Kant, Transcendental Arguments and the Problem of Deduction.' *Review of Metaphysics* 28 (1975): 453–67

Buchdahl, Gerd. 'The Problem of Negation.' *Philosophical and Phenomenological Research* 22 (1962): 163–78

Buerger, Christa. 'The Disappearance of Art: The Postmodern Debate in the U.S.' *Telos* 68 (1986): 93–106

Bühler, Karl. *Sprachtheorie. Die Darstellungsfunktion der Sprache*. Jena: 1934

Carnap, Rudolf. *Introduction to Semantics and Formalization of Logic*. Cambridge, MA: Harvard University Press 1975

– *Introduction to Symbolic Logic and Its Applications*. 1954. Reprint, New York: Dover Publications 1958

– *The Logical Structure of the World and Pseudoproblems in Philosophy*. Translated by Rolf A. George. 1928. Reprint, Berkeley: University of California Press 1967

– *The Logical Syntax of Language*. 1937. Reprint, London: Routledge and Kegan Paul 1971

– *Meaning and Necessity*. Chicago: University of Chicago Press 1967

– *Philosophy and Logical Syntax*. London: Kegan Paul 1935

Carroll, John M., and Robert L. Mack. 'Metaphor, Computing Systems, and Active Learning.' *International Journal of Man–Machine Studies* 22, no. 1 (1985): 39–57

Chomsky, Noam A. 'Deep Structure, Surface Structure and Semantic Interpretation.' In *Semantics: An Interdisciplinary Reader in Philosophy, Linguistics and Psychology*, edited by Danny D. Steinberg and Leon A. Jakobovits, 183–216. Cambridge: Cambridge University Press 1971

Clifford, James, and George E. Marcus, eds. *Writing Culture: The Poetics and Politics of Ethnography*. Berkeley: University of California Press 1986

Coffa, J. Alberto. *The Semantic Tradition from Kant to Carnap: To the Vienna Station*. Cambridge: Cambridge University Press 1993

Cohen, Ted. 'Metaphor and the Cultivation of Intimacy.' *Critical Inquiry* 5, no. 1 (1978): 3–12

Crawford, Patricia. 'Kant's Theory of Philosophical Proof.' *Kant-Studien* 54 (1963): 257–68

Davidson, Donald. 'A Coherence Theory of Truth.' In *Truth and Interpretation: Perspectives on the Philosophy of Donald Davidson*, edited by Ernest Lepore, 307–19. Oxford: Basil Blackwell 1989

– 'What Metaphors Mean.' In *On Metaphor*, edited by Sheldon Sacks, 29–45. Chicago: University of Chicago Press 1979

de Man, Paul. 'The Epistemology of Metaphor.' In *On Metaphor*, edited by Sheldon Sacks, 11–28. Chicago: University of Chicago Press 1979

Deleuze, Gilles. *Différence et répétition*. Paris: PUF 1968

– *The Logic of Sense*. Translated by Mark Lester and Charles Stivale, edited by Constantin V. Boundas. London: Athlone Press 1990

Deleuze, Gilles, and Felix Guattari. *What Is Philosophy?* Translated by Hugh Tomlinson and Graham Burchell. New York: Columbia University Press 1994

Derrida, Jacques. 'The Deconstruction of Actuality: An Interview with Jacques Derrida.' *Radical Philosophy* 68 (1994): 28–41

– 'Différance' In *Speech and Phenomena*, translated by David B. Allison, 129–60. Evanston, IL: Northwestern University Press 1973

- 'La Différance.' In *Marges de la philosophie*, 3–29. Paris: Minuit 1972
- *Dissemination.* Translated by B. Johnson. Chicago: Unversity of Chicago Press 1981
- 'Freud and the Scene of Writing.' In *Writing and Difference*, translated by Alan Bass, 196–231. London: Routledge and Kegan Paul 1978
- *Husserl's Origin of Geometry: An Introduction.* Translated by J.P. Leavy. Stony Brook: Nicolas Hays 1978
- 'Limited Inc. abc ...' In *Glyph: Johns Hopkins Textual Studies*, edited by Samuel Weber and Henry Sussman, 162–254. Baltimore: Johns Hopkins University Press 1977
- *Of Grammatology.* Translated by Gyatri Chakravorty Spivak. Baltimore: Johns Hopkins University Press 1978
- *Margins of Philosophy.* Translated by A. Blass. Chicago: University of Chicago Press 1982
- 'Point de folie: Maintenant l'architecture.' *Folio VIII.* La Case Vide: La Villette 1985. In *AA Files* 12 (1985): 65–75
- *Positions.* Translated by Alan Bass. Chicago: University of Chicago Press 1971
- 'The *Retrait* of Metaphor.' *Enclitic* 2, no. 2 (1978): 5–33
- 'The Spatial Arts: An Interview with Jacques Derrida.' In *Deconstruction and the Visual Arts: Art, Media, Architecture*, edited by Peter Brunette and David Wills, 9–32. Cambridge: Cambridge University Press 1994
- *Speech and Phenomena.* Translated D.B. Allison. Evanston, IL: Northwestern University Press 1973
- 'White Mythology: Metaphor in the Text of Philosophy.' In *Margins of Philosophy*, translated by Alan Bass, 207–71. New York: University of Chicago Press 1982
- *Writing and Difference.* Translated by Alan Bass. Chicago: University of Chicago Press 1978
Devitt, Michael, and Kim Sterelny. *Language and Reality: An Introduction to the Philosophy of Language.* Oxford: Basil Blackwell 1990
Dewey, John. 'Peirce's Theory of Linguistic Signs, Thought, and Meaning.' *Journal of Philosophy* 43 (1946): 85–95
Dickie, George. 'Metaphor.' In *Aesthetics: An Introduction*, 131–40. Indianapolis: Bobbs-Merrill, Pegasus 1971
Dilthey, Wilhelm. 'Entwürfe zur Kritik der historischen Vernunft' (1924). In *Seminar: Philosophische Hermeneutik*, edited by Hans-Georg Gadamer and Gottfried Boehm, 189–220. Frankfurt: Suhrkamp 1976
- *Gesammelte Schriften.* 17 vols. (1914–74). Vol. 7, *Der Aufbau der geschichtlichen Welt*, edited by Bernard Groethuysen. Stuttgart: Teubner 1958
Dilworth, John B. 'A Representational Approach to Metaphor.' *Journal of Aesthetics and Art Criticism* 37, no. 4 (1979): 467–73
Douglas, Mary. *Essays in the Sociology of Perception.* London: Routledge and Kegan Paul 1982

– *Implicit Meanings*. London: Routledge and Kegan Paul 1975

Dryer, D.P. *Kant's Solution for Verification in Metaphysics*. London: George Allen and Unwin 1966

Dufrenne, Mikel. *The Notion of the A Priori* . Translated by Edward S. Casey. Evanston, IL: Northwestern University Press 1966

Dummett, Michael. *Frege and Other Philosophers*. Oxford: Clarendon Press 1991

– *The Interpretation of Frege's Philosophy*. Cambridge, MA: Harvard University Press 1981

– 'The Social Character of Meaning.' *Synthese* 27 (1974): 523–34

– 'Truth.' In *Truth and Other Enigmas*, 1–28. Cambridge, MA: Harvard University Press 1978

Eagleton, Terry. 'Capitalism, Modernism and Postmodernism.' *New Left Review* 152 (1985): 60–73

– *The Ideology of the Aesthetic*. Oxford: Basil Blackwell 1990

Eco, Umberto. 'The Semantics of Metaphor.' In *The Role of the Reader: Explorations in the Semiotics of Texts*, 67–89. Bloomington: Indiana University Press 1979

– *Semiotics and the Philosophy of Language*. London: Macmillan 1984

Edie, James. 'Expression and Metaphor.' *Philisophical and Phenomenological Research* 23 (1962–3): 538–61

Evans, Gareth. *The Varieties of Reference*. Edited by John McDowell. Oxford: Clarendon Press 1982

Fillmore, Charles J. 'The Position of Embedding Transformations in a Grammar.' *Word* 19 (1963): 208–31

Foster, Hal. '(Post)Modern Polemics.' *New German Critique* 33 (1984): 67–78

Frege, Gottlob. *The Foundations of Arithmetic*. Translated by John L. Austin. Oxford: Oxford University Press 1953

– 'Negation' (1919). In *Translations from the Philosophical Writings of Gottlob Frege*, translated by Peter Geach and Max Black, 117–35. Oxford: Basil Blackwell 1970

– 'On Sense and Reference' (1892). In *Translations from the Philosophical Writings of Gottlob Frege*, edited by Peter Geach and Max Black, 56–78. Oxford: Basil Blackwell 1970

– 'Zahlen und Arithmetik.' In *Nachgelassene Schriften*, edited by H. Hermes, F. Kambartel, and F. Kaulbach. Hamburg: Felix Meiner 1970

Freud, Sigmund. *Civilization and Its Discontents*. London: Hogarth Press 1963

– Negation' (1910). In *The Standard Edition of the Complete Psychological Works of Sigmund Freud*, vol. 19, translated by James Strachey, 235–9. London: Hogarth Press 1978

– 'Verneinung.' In *Gesammelte Werke*, vol. 14, edited by Anna Freud, E. Bibring, W. Hoffer, E. Kris, and O. Isakower, 11–15. Frankfurt: S. Fischer Verlag 1972

Frow, John. *What Was Postmodernism?* Sydney: Local Consumptions 1991

Fuery, Patrick. *The Theory of Absence: Subjectivity, Signification and Desire*. Westport, CT: Greenwood Press 1995

Gadamer, Hans-Georg. 'Das hermeneutische Problem der Anwendung' (1967). In *Seminar: Philosophische Hermeneutik*, edited by Hans-Georg Gadamer and Gottfried Boehm, 327–32. Frankfurt: Suhrkamp 1976
- 'Die philosophischen Grundlagen des 20. Jahrhunderts' (1967). In *Seminar: Philosophische Hermeneutik*, edited by Hans-Georg Gadamer and Gottfried Boehm, 316–26. Frankfurt: Suhrkamp 1976
- *Truth and Method*. New York: Crossroads 1985
Gale, Richard M. *Negation and Non-Being*. Oxford: Basil Blackwell 1976
Gallop, Jane. *Thinking through the Body*. New York: Columbia University Press 1988
Gasché, Rodolphe. *The Tain of the Mirror: Derrida and the Philosophy of Reflection*. Cambridge, MA: Harvard University Press 1986
Gass, William H. *Fiction and the Figures of Life*. New York: Alfred A. Knopf 1970
Geach, P.T. *Logic Matters*. Berkeley: University of California Press 1980
Gill, Jerry H. *Wittgenstein and Metaphor*. Washington: University Press of America 1981
Gödel, Kurt. *On Formally Undecidable Propositions of Principia Mathematica and Related Systems I*. Edited by B. Meltzer, introduced by R.B. Braithwaite. London: Oliver & Boyd 1962
- 'Über eine bisher noch nicht benützte Erweiterung des finiten Standpunktes.' *Dialectica* 12 (1958): 280–7
- 'What Is Cantor's Continuum Problem?' In *Philosophy of Mathematics*, edited by P. Benacerraf and Hilary Putnam, 470–85. Cambridge: Cambridge University Press 1982
Gombrich, Ernst H. 'The Visual Image.' *Scientific American* 227 (1972): 82–96
Goodman, Nelson. *Languages of Art: An Approach to a Theory of Symbols*. Indianapolis: Bobbs-Merrill 1968
- *Ways of Worldmaking*. Indianapolis: Hackett Publishing 1978
Gribbin, John. *In Search of Schrödinger's Cat: Quantum Physics and Reality*. New York: Bantam 1984
Grice, Paul. *Studies in the Way of Words*. Cambridge, MA: Harvard University Press 1989
Grosz, E.A. *Volatile Bodies: Toward a Corporate Feminism*. Sydney: Allen and Unwin 1994
Habermas, Jürgen. *Communication and the Evolution of Society*. London: Heinemann 1979
- 'Modernity versus Postmodernity.' *New German Critique* 22 (1981): 3–14
- *Moral Consciousness and Communicative Action*. Translated by Christian Lenhardt and Shierry Weber Nicholsen. London: Polity Press 1990
- *The Philosophical Discourse of Modernity*. London: Polity Press 1987
- 'Science and Technology as Ideology.' In *Towards a Rational Society*, 81–122. London: Heinemann 1978
- 'Universal Pragmatics.' In *Communication and the Evolution of Society*, 1–68. London: Heinemann 1979

Hallett, Garth. *Wittgenstein's Definition of Meaning as Use*. New York: Fordham University Press 1967

Haraway, Donna J. *Simians, Cyborgs, and Women: The Reinvention of Nature*. New York: Routledge 1991

Hassan, Ihab. 'The Question of Postmodernism.' In *Romanticism, Modernism, Postmodernism*, ed. Harry R. Garvin, 117–26. Lewisburg, PA: Bucknell University Press 1980

Hausman, Carl. *Metaphor and Art. Interactionism and Reference in the Verbal and Nonverbal Arts*. Cambridge: Cambridge University Press 1989

Haynes, Felicity. 'Metaphor as Interactive.' *Educational Theory* 25, no. 3 (1975): 272–7

Hegel, Friedrich Wilhelm. *Hegel's Logic*. Translated by William Wallace. Oxford: Clarendon Press 1987

Heidegger, Martin. *Being and Time*. Translated by John Macquarrie and Edward Robinson. London: SCM Press 1962

– *Identity and Difference*. Translated by Joan Stambaugh. New York: Harper and Row 1969

– 'Language.' In *Poetry, Language, Thought*, edited and translated by Albert Hofstadter, 189–210. New York: Harper and Row 1975

– 'Language in the Poem.' In *On the Way to Language*, translated by Peter D. Hertz, 159–98. New York: Harper and Row 1971

– 'The Origin of the Work of Art.' In *Poetry, Language, Thought*, translated by Albert Hofstadter, 15–87. New York: Harper and Row 1975

– 'The Problem of Reason.' In *The Essence of Reason*, translated by Terrence Malick, 11–33. Evanston, IL: Northwestern University Press 1969

– *Der Satz vom Grund*. Pfullingen: Neske 1957

– *Unterwegs zur Sprache*. Pfullingen: Neske 1959

– 'The Way to Language.' In *On the Way to Language*, translated by Peter D. Hertz, 111–36. New York: Harper and Row 1971

Hester, Marcus B. 'Metaphor and Aspect Seeing.' *Journal of Aesthetics and Art Criticism* 25, no. 2 (1966): 205–12

Hintikka, Jaakko. 'Transcendental Arguments: Genuine and Spurious.' *Nous* 6 (1972): 274–81

Hohendahl, Peter U. 'Habermas' Philosophical Discourse of Modernity.' *Telos* 69 (1986): 49–67

Horn, Laurence R. *A Natural History of Negation*. Chicago: University of Chicago Press 1989

Hossenfelder, Malte. *Kants Konstitutionstheorie und die Transcendentale Deduktion*. Berlin: Walter de Gruyter 1978

Husserl, Edmund. *Ideas: General Introduction to Pure Phenomenology*. Translated by W.R. Boyce Gibson. London: Collier-Macmillan 1969

– *The Phenomenology of Internal Time-Consciousness*. Edited by Martin Heidegger, translated by James S. Churchill. Bloomington: Indiana University Press 1966

Hutcheon, Linda. 'The Politics of Postmodernism: Parody and History.' *Cultural Critique* 5 (1986–7): 179–207

Huyssen, Andreas. 'Mapping the Postmodern.' *New German Critique* 33 (1984): 5–52

– 'The Search for Tradition: Avant-Garde and Postmodernism in the 1970s.' *New German Critique* 22 (1981): 23–40

Ingarden, Roman. *The Literary Work of Art*. Evanston, IL: Northwestern University Press 1973

Irigaray, Luce. *Parlez n'est jamais neutre*. Paris: Minuit 1985

– *Speculum of the Other Woman*. Translated by Gillian C. Gill. Ithaca, NY: Cornell University Press 1985

Iser, Wolfgang. *The Act of Reading*. London: Routledge and Kegan Paul 1979

Jakobson, Roman. 'Closing Statement: Linguistics and Poetics.' In *Style in Language*, edited by Thomas A. Sebeok, 350–77. Cambridge, MA: MIT Press 1960

– *Language in Literature*. Edited by Krystyna Pomorska and Stephen Rudy. Cambridge, MA: Belknap Press 1987

– 'On Linguistic Aspects of Translation.' In *Language in Literature*, edited by Krystyna Pomorska and Stephen Rudy, 428–35. Cambridge, MA: Belknap Press 1987

– 'Language in Operation.' In *Readings in Russian Poetics: Formalist and Structuralist Views*, edited by L. Matejka and K. Pomorska, 79–81. Cambridge, MA: MIT Press 1971

Jameson, Fredric. 'The Politics of Theory: Ideological Positions in the Postmodernism Debate.' *New German Critique* 33 (1984): 53–65

– 'Postmodernism, or the Cultural Logic of Late Capitalism.' *New Left Review* 146 (1984): 53–92

– *Postmodernism, or, the Cultural Logic of Late Capitalism*. New York: Verso 1993

Jencks, Charles. *The Language of Post-Modern Architecture*. London: Academy 1977

Jespersen, Otto. 'Negation in English and Other Languages.' In *Selected Writings of Otto Jespersen*, 3–151. London: Allen and Unwin 1917

Johnson, Mark. 'A Philosophical Perspective on the Problems of Metaphor.' In *Cognition and Figurative Language*, edited by Robert Hoffman and Richard Honeck, 47–67. Hillsdale, NJ: Lawrence Erlbaum 1980

Johnson, Mark, and Glenn W. Erickson. 'Toward a New Theory of Metaphor.' *Southern Journal of Philosophy* 18, no. 3 (1980): 289–99

Kalaga, Wojciech. 'The Concept of Interpretant in Literary Semiotics.' *Transactions of the Charles S. Peirce Society* 22, no. 1 (1986): 43–59

Kant, Immanuel. *Critique of Practical Reason*. Translated by Lewis White Beck. New York: Bobbs-Merrill 1956

– *Critique of Pure Reason*. Translated by Norman Kemp Smith. New York: St. Martin's Press 1965

– *Kritik der Praktischen Vernunft*. Hamburg: Felix Meiner 1967
– *Kritik der Reinen Vernunft*. Hamburg: Felix Meiner 1956
– *Kritik der Urteilskraft*. Edited by Karl Vorländer. Hamburg: Felix Meiner 1968
Katz, Jerrold Jacob. *Semantic Theory*. New York: Harper and Row 1972
Katz, Jerrold Jacob. *The Metaphysics of Meaning*. Cambridge, MA: MIT Press 1990
Kempson, Ruth M. *Presupposition and the Delimitation of Semantics*. Cambridge: Cambridge University Press 1975
Kevelson, Roberta. *Law and the Human Sciences: Fifth Round Table on Law and Semiotics*. New York: Peter Lang 1992
– *Peirce, Paradox, Praxis*. Berlin: de Gruyter 1990
Körner, Stephen. *Categorial Frameworks*. Oxford: Clarendon Press 1974
– 'The Impossibility of Transcendental Deductions.' *Monist* 51 (1967): 317–31
Kraus, Rosalind E. *The Originality of the Avant-Garde and Other Modernist Myths*. Cambridge, MA: MIT Press 1987
Kripke, Saul. *Naming and Necessity*. Cambridge, MA: Harvard University Press 1980
Kristeva, Julia. 'Postmodernism?' In *Romanticism, Modernism, Post-modernism*, edited by Harry R. Garvin, 136–41. London: Associated University Presses 1980
Kurrik, Maire Jaanus. *Literature and Negation*. New York: Columbia University Press 1979
Kusch, Martin. *Language as Calculus vs. Language as Universal Medium*. Dordrecht: Kluwer Academic Publishers 1989
Lacan, Jacques. *Écrits: A Selection*. Translated by Alan Sheridan. London: Tavistock 1977
– *Feminine Sexuality: Jacques Lacan and the École freudienne*. Edited by Jacqueline Rose and Juliet Mitchell, translated by Jacqueline Rose. London: MacMillan 1985
– *The Language of the Self: The Function of Language in Psychoanalysis*. Translated by Anthony Wilden. Baltimore: Johns Hopkins University Press 1974
Lakoff, George, and Mark Johnson. 'Conceptual Metaphor in Everyday Language.' *Journal of Philosophy* 77, no. 8 (1980): 453–86
– *Metaphors We Live By*. Chicago: University of Chicago Press 1980
Lakoff, George, and Mark Turner. *More than Cool Reason: A Field Guide to Poetic Metaphor*. Chicago: University of Chicago Press 1989
Langer, Susanne. *Problems of Art*. New York: Scribners 1957
Lange-Seidle, Annemarie. *Approaches to Theories for Non-verbal Signs*. Lisse: Peter de Ridder 1977
Lecercle, Jean-Jacques. *The Violence of Language*. London: Routledge 1990
Ledbetter, Mark. *Victims and the Postmodern Narrative*. New York: St. Martin's Press 1996
Leder, Drew. *The Absent Body*. Chicago: Chicago University Press 1990
Lee, Dorothy. 'Linguistic Reflection of Wintu Thought' (1944). *International Journal of American Linguistics* 10, quoted in Terence Hawkes, *Metaphor*. London: Methuen 1972, p. 82

Leibniz, Gottfried Wilhelm. 'The Monadology.' In *Leibniz: Philosophical Writings*.
 Translated by Mary Morris and G.H.R. Parkinson. London: Dent 1934
– *The Monadology and Other Philosophical Writings*. Translated by Robert Latta. Oxford:
 Oxford University Press 1968
Leinfellner-Rupertsberger, Elizabeth. 'Die Negation im Monologischen Text:
 Textzusammenhang und "Foreground."' *Folia Linguistica* 25 (1991): 111–42; 135
Liszka, James Jakob. 'Peirce's Interpretant.' *Transactions of the Charles S. Peirce Society* 26,
 no. 1 (1990): 17–62
Locke, John. *An Essay Concerning Human Understanding*. London: Everyman 1993
Lucy, Niall. *Debating Derrida*. Melbourne: Melbourne University Press 1995
Lyotard, Jean-François. 'Complexity and the Sublime.' In *ICA Documents 4 and
 5: Postmodernism*, edited by Lisa Appignanesi, 10–12. London: Institute of
 Contemporary Arts 1986
– 'Defining the Postmodern.' *ICA Documents 4 and 5: Postmodernism*, edited by Lisa
 Appignanesi, 6–7. London: Institute of Contemporary Arts 1986
– *The Differend: Phrases in Dispute*. Translated by Geoffrey Bennington and Brian
 Massumi. Manchester: Manchester University Press 1988
– *Lessons on the Analytic of the Sublime*. Translated by Elizabeth Rottenberg, Stanford:
 Stanford University Press 1994
– *The Postmodern Condition: A Report on Knowledge*. Minneapolis: Minnesota University
 Press 1984
– *The Postmodern Explained: Correspondence 1982–1985*. Minneapolis: University of
 Minnesota Press 1993
– 'Reply to the Question: What Is the Post-Modern?' *ZX, A Magazine of the Visual Arts*
 (1984): 10–18
– 'A Response to Philippe Lacoue-Labarthe.' *ICA Documents 4 and 5: Postmodernism*,
 edited by Lisa Appignanesi, 8. London: Institute of Contemporary Arts 1986
Mabott, G. 'Negation.' *Aristotelian Society Supplementary Volume* 9 (1929): 67–79
MacCormac, Earl R. *A Cognitive Theory of Metaphor*. Cambridge, MA: MIT Press 1988
McHoul, Alec. *Semiotic Investigations: Towards an Effective Semiotics*. Lincoln and London:
 University of Nebraska Press 1996
Madison, G.B. *The Hermeneutics of Postmodernism: Figures and Themes*. Bloomington:
 Indiana University Press 1990
Makkreel, Rudolf A. *Dilthey: Philosopher of the Human Sciences*. Princeton, NJ: Princeton
 University Press 1977
Malpas, Jeff. *Donald Davidson and the Mirror of Meaning: Holism, Truth and Interpretation*.
 Cambridge: Cambridge University Press 1992
– 'Transcendental Arguments and Conceptual Schemes: A Reconsideration of
 Körner's Uniqueness Argument.' *Kant-Studien* 81, no. 2 (1990): 232–51

Marks, Lawrence E. *The Unity of the Senses: Interrelations among the Modalities.* New York: Academic Press 1978

Martin, John N. *Elements of Formal Semantics.* New York: Academic Press 1987

Martin, Janet, and Rom Harré, 'Metaphor in Science.' In *Metaphor: Problems and Perspectives*, edited by David S. Miall, 89–105. Brighton: Harvester 1982

Matilal, Bimal Krishna. *The Navya–Nyaya Doctrine of Negation.* Cambridge, MA: Harvard University Press 1968

Maturana, Humberto. 'Reality: The Search for Objectivity or the Quest for a Compelling Argument.' *Irish Journal of Psychology* 9, no. 1 (1988): 25–82

Maturana, Humberto, and F.G. Varela. *Autopoiesis and Cognition.* Dordrecht: Reidel 1980

– *The Tree of Knowledge.* Boston: New Science Library 1987

Merleau-Ponty, Maurice. *Phenomenology of Perception.* London: Routledge and Kegan Paul 1974

– *The Primacy of Perception and Other Essays on Phenomenological Psychology, the Philosophy of Art, History and Politics.* Evanston, IL: Northwestern University Press 1964

Meyers, C.M. 'The Determinate and Determinable Modes of Appearing.' *Mind* 68 (1958): 32–49

Mueller-Vollmer, Kurt. *The Hermeneutics Reader.* New York: Continuum 1989

Mulligan, Kevin. *Speech Act and Sachverhalt: Reinach and the Foundations of Realist Phenomenology.* Dordrecht: M. Nijhoff 1987

Nietzsche, Friedrich. *On the Genealogy of Morals.* New York: Vintage Books 1967

– 'On Truth and Falsity in Their Ultramoral Sense.' In *The Complete Works of Friedrich Nietzsche*, vol. 2, edited by Oscar Levy, translated M.A. Mügge, 171–92. London: Allen and Unwin 1911

Norris, Christopher. *The Truth about Postmodernism.* Oxford: Basil 1994

Ormiston, L. Gayle, and Alan D. Schrift. *The Hermeneutic Tradition: From Ast to Ricoeur.* New York: State University of New York Press 1990

Palmer, F.R. *Semantics.* Cambridge: Cambridge University Press 1982

Palmer, Richard. *Hermeneutics.* Evanston, IL: Northwestern University Press 1969

Paton, H.J. *The Categorical Imperative: A Study of Kant's Moral Philosophy.* London: Hutchinson 1970

Peacocke, Christopher, ed. *Understanding Sense.* 2 vols. Dartmouth: Cambridge University Press 1993

Peirce, Charles Sanders, *Collected Papers.* Vols 1 to 6, edited by Charles Hartshorne and Paul Weiss. Cambridge, MA: Harvard University Press 1974

– *Collected Papers.* Vols. 7 and 8, edited by Arthur W. Burks. Cambridge, MA: Harvard University Press 1958

– Unpublished ms. MS 183,132. Harvard University Library, Cambridge, MA

Plato. 'Sophist.' In *Plato's Theory of Knowledge: The Theaetetus and the Sophist of Plato*, translated by Francis Macdonald Cornford, 257–8B. London: Routledge and Kegan Paul 1935

Popper, Karl R. *The Logic of Scientific Discovery*. 1934. Reprint, London: Hutchinson 1975

Portoghesi, Paolo. *Postmodern: The Architecture of the Postindustrial Society*. New York: Rizzoli 1983

Poyates, Fernando. *New Perspectives in Nonverbal Communication*. New York: Pergamon Press 1982

Poynton, Cate. *Language and Gender: Making the Difference*. Geelong, Victoria: Deakin University Press 1986

Ponzi, Augusto. *Man as Sign. Essays on the Philosophy of Language*. Translated by Susan Petrilli. New York: Mouton de Gruyter 1990

Pratt, Louise. 'Ideology and Speech-Act Theory.' *Poetics Today* 7, no. 1 (1986): 59–71

Putnam, Hilary. *Reason, Truth, and History*. Cambridge: Cambridge University Press 1981

– *Representation and Reality*. Cambridge, MA: MIT Press 1988

Quine, Willard Van Orman. 'Indeterminacy of Translation Again.' *Journal of Philosophy* 84, no. 1 (1987): 5–10

– 'Notes on the Theory of Reference.' In *From a Logical Point of View: Logico-Philosophical Essays*, 130–8. New York: Harper and Row 1963

– 'On the Reason for Indeterminacy of Translation.' *Journal of Philosophy* 67 (1970): 178–83

– 'Ontological Relativity.' In *Ontological Relativity and Other Essays*, 26–68. New York: Columbia University Press 1969

– 'The Problem of Meaning in Linguistics.' In *From a Logical Point of View*, 47–64. New York: Harper and Row 1963

Rauch, Irmengard. 'Linguistic Method: A Matter of Principle.' In *Linguistic Method: Essays in Honour of Herbert Penzl*, edited by Irmengard Rauch and Gerald F. Carr, 19–23. The Hague: Mouton 1979

Rescher, Nicholas. *The Primacy of Practice: Essays towards a Pragmatically Kantian Theory of Empirical Knowledge*. Oxford: Basil Blackwell 1973

Richards, I.A. *The Philosophy of Rhetoric*. Oxford: Oxford University Press 1936

Rickman, H.P. *Wilhelm Dilthey: Pioneer of the Human Studies*. London: Paul Elek 1979

Ricoeur, Paul. *The Rule of Metaphor*. Toronto: University of Toronto Press 1977

Rorty, Richard. 'Habermas and Lyotard on Postmodernity.' In *Habermas and Modernity*, edited Richard J Bernstein, 161–75, 224–5. Cambridge: Polity Press 1985

– *The Linguistic Turn*. Chicago: Chicago University Press 1992

Rotman, Brian. *Signifying Nothing: The Semiotics of Zero*. New York: St. Martin's Press 1987

Russell, Bertrand. *The Analysis of Mind*. London: George Allen and Unwin 1921
– *Human Knowledge, Its Scope and Limits*. New York: Simon and Schuster 1948
– 'Vagueness.' *Australian Journal of Psychology and Philosophy* 1 (June 1923): 84–92
Ruthrof, Horst. 'Frege's Error,' *Philosophy Today* 37 (1993): 306–17
– 'From Frege to Derrida: The Destabilization of Meaning.' *Australian Journal of Cultural Studies* 4, no. 1 (1986): 77–92
– 'Identity and Différance.' *Poetics* 17 (1988): 99–112
– 'Language and the Dominance of Modality.' *Language and Style: An International Journal* 21, no. 3 (1988): 315–26
– 'Meaning: An Intersemiotic Perspective.' *Semiotica* 104, no. 1–2 (1995): 23–43
– 'Narrative and the Digital: On the Syntax of the Postmodern.' *Narrative Issues*. Special issue of *Journal of Australasian Universities Language and Literature Association* (1990): 185–200
– *Pandora and Occam: On the Limits of Language and Literature*. Bloomington: Indiana University Press 1992
– 'The Problem of Inferred Modality in Narrative.' *Journal of Literary Semantics* 13 (1984): 97–108
– *The Reader's Construction of Narrative*. London: Routledge and Kegan Paul 1981
Ryle, Gilbert. 'Negation.' *Aristotelian Society Supplementary* 9 (1927): 80–96
Saussure, Ferdinand de. *Course in General Linguistics*. Translated by Wade Baskin. London: Fontana 1960
– *Course in General Linguistics*. Translated by Wade Baskin. London and New York: McGraw-Hill 1966
Schaper, Eva. 'Arguing Transcendentally.' *Kant-Studien* 63 (1972): 101–16
Schiffer, Stephen. *Remnants of Meaning*. Cambridge, MA: MIT 1987
Schleiermacher, Friedrich. 'Über den Begriff der Hermeneutik' (1835). In *Seminar: Philosophische Hermeneutik*, edited by Hans-Georg Gadamer and Gottfried Boehm, 131–65. Frankfurt: Suhrkamp 1976
Searle, John R. 'The Background of Meaning.' In *Speech Act Theory and Pragmatics*, edited by John R. Searle, Ferenc Kiefer, and Manfred Bierwisch, 221–32. Dordrecht: Reidel 1980
– *Expression and Meaning. Studies in the Theories of Speech Acts*. Cambridge: Cambridge University Press 1979
– *Intentionality: An Essay in the Philosophy of Mind*. Cambridge: Cambridge University Press 1983
– 'Metaphor.' In *Metaphor and Thought*, edited by Andrew Ortony, 92–123. Cambridge: Cambridge University Press 1979
– *Minds, Brains and Science: The 1984 Reith Lectures*. Harmondsworth: Penguin 1984
Sebeok, Thomas A. *Animal Communication: Techniques of Study and Results of Research*. Bloomington: Indiana University Press 1968

– 'Evolution of Signalling Behavior.' *Behavioral Science* 7 (1962): 430–42
– *A Perfusion of Signs.* Bloomington: Indiana University Press 1977
– *Perspectives in Zoosemiotics.* The Hague: Mouton 1972
– *Sight, Sense, and Sound.* Bloomington: Indiana University Press 1978
– *A Sign Is Just a Sign.* Bloomington: Indiana University Press 1991
– 'Zoosemiotic Components of Human Communication.' In *Semiotics: an Introductory Reader*, edited by Robert E. Innis, 294–324. London: Hutchison 1986
– ed. *How Animals Communicate.* Bloomington: Indiana University Press 1977
Sebeok, Thomas A., and Umberto Eco, eds. *The Sign of Three: Dupin, Holmes, Peirce.* Bloomington: Indiana University Press 1983
Sebeok, Thomas A., Jean Umiker-Sebeok, and Adam Kendon, eds. *Nonverbal Communication, Interaction, and Gesture.* The Hague: Mouton 1981
Sharma, Dhirendra. *The Negative Dialectics of India.* Chicago: Michigan University Press 1970
Shcherbatskoi, F.I. *Buddhist Logic.* Vol. 1. New York: Dover Publications 1962
Shibles, Warren. 'The Metaphorical Method.' *Journal of Aesthetic Education* 7 (1974): 25–36
Smith, Stephen B. *Meaning and Negation.* The Hague: Mouton 1974
Sofia, Zoe. 'Virtual Corporeality: A Feminist View.' *Australian Feminist Studies* 15 (1992): 11–24
Sommers, Fred. *The Logic of Natural Language.* Oxford: Clarendon Press 1982
Stählin, Wilhelm. 'Zur Psychologie und Statistik der Metaphern. Eine methodologische Untersuchung,' *Archiv für die gesamte Psychologie* 31 (1914): 297–425
Standford, Bedell. *Greek Metaphor. Studies in Theory and Practice.* 1936. Reprint, New York: Johnson Reprint Corporation 1972
Steiner, Wendy. *Image and Code.* Chicago: University of Michigan Press 1981
Stevens, Wallace. 'Adagia.' In *Opus Posthumous*, 157–80. London: Alfred Knopf 1957
Stewart, Donald. 'Metaphor and Paraphrase.' *Philosophy and Rhetoric* 4, no. 2 (1971): 111–23
Stewart, Ian. 'Mathematical Recreations.' *Scientific American* (February 1993): 85–7
Strawson, P.F. 'On Referring.' *Mind* 59 (1950): 320–44
Tarski, Alfred. 'The Concept of Truth in Formalized Languages.' In *Logic, Semantics, Metamathematics*, translated by J.H. Woodger, 152–278. Oxford: Clarendon Press 1956
– 'The Establishment of Scientific Semantics.' In *Logic, Semantics, Metamathematics*, translated by J.H. Woodger, 401–8. Oxford: Clarendon Press 1956
Tax, Sol, ed. *Horizons of Anthropology.* Chicago: Aldine Publishing Company 1964
Turbayne, Colin Murray. *The Myth of Metaphor.* Columbia: South Carolina University Press 1963

Uexkuell, Thure von. 'Die Zeichenlehre Jakob von Uexkuell's.' In *Die Welt als Zeichen: Klassiker der modernen Semiotik*, edited by Martin Krampen, Klaus Oehler, Roland Posner, and Thure von Uexkuell, 233–79. Berlin: Severin and Siedler 1981

Varela, Francisco, Evan Thompson, and Eleanor Rosch. *The Embodied Mind: Cognitive Science and Human Experience*. Cambridge, MA: MIT Press 1993

Warner, Martin. 'Black's Metaphors.' *British Journal of Aesthetics* 13, no. 4 (1973): 367–72

Way, Eileen Cornell. *Knowledge, Representation, Metaphor*. Dordrecht: Kluwer 1991

Wiggins, David. 'Meaning, Truth-Conditions, Propositions: Frege's Doctrine of Sense Retrieved, Resumed and Redeployed in the Light of Certain Recent Criticisms.' *Dialectica* 46 (1992): 61–90

Wittgenstein, Ludwig. *The Blue and Brown Books*. Oxford: Oxford University Press 1958
– 'Cause and Effect: Intuitive Awareness.' Translated by Peter Finch. *Philosophia* 6 (1976): 3–4
– *On Certainty*. Edited by G.E.M. Anscombe and H.G. von Wright, translated by Denis Paul and G.E.M. Anscombe. Oxford: Basil Blackwell 1969
– *Philosophical Investigations*. Translated by G.E.M. Anscombe. New York: Macmillan 1953
– *Tractatus Logico-Philosophicus*. Translated by D.F. Pears and B.F. McGuiness, introduced by Bertrand Russell. London: Routledge and Kegan Paul 1963

Wolff, Robert Paul. 'A Reconstruction of the Argument of the Subjective Deduction.' In *Kant: A Collection of Essays*, edited by Robert Paul Wolff, 88–133. London: Macmillan 1968

Wolin, Richard. 'Modernism vs. Postmodernism.' *Telos* 62 (1984–5): 9–29

Wood, David. 'Différance and the Problem of Strategy.' In *Derrida and Différance*, edited by David Wood and Robert Bernasconi, 63–70. Evanston, IL: Northwestern University Press 1988

Worth, Sol. 'The Development of a Semiotic of Film.' *Semiotica* 1 (1969): 282–321

Wunderlich, Dieter. 'Methodological Remarks on Speech Act Theory.' In *Speech Act Theory and Pragmatics*, edited by John R. Searle, Ferenc Kiefer, and Manfred Bierwisch, 291–312. Dordrecht: Reidel 1980

Yoos, George. 'A Phenomenological Look at Metaphor.' *Philosophical and Phenomenological Research* 31, no. 1 (1971): 78–88

Index

Adorno, Theodor, 249
agonistics: intersemiotic critique, 197–8; as social semiotics, 197
Ajdukiewicz, Kasimierz, 76
Aldrich, Virgil C., 279n119
aleatory, 180, 232, 284n7
Altmann, S.A., 274n7
analytical ideology, 142
analyticity, 55–9
appresentation, 31, 103
arbitrariness of signs, 3–4
Aristotle, 38, 109, 148–9, 172, 267n36, 276n67, 277nn72–6; resemblance, 109, 149; riddle, 109, 149, 152
Ast, Friedrich, 12, 20, 177, 279n2
auditory signs, 35
aural signs, 4, 11, 47, 49, 51, 65, 74, 84, 162, 186, 187, 254, 261
Austin, John Langshaw, 25
Ayer, Alfred Jules, 122

Bakhtin, Michael, 9
Baudrillard, Jean, xii, 112, 230–2, 239, 259, 284nn1–8, 285n20, n26
Beardsley, Monroe, 148, 150, 158, 276nn68–9, 278n93
Beck, Lewis, 189, 281n23

Begriffsschrift, 4, 7, 49
Benhabib, Seyla, 285n15
Bennington, Geoffrey, 186–7, 280n18, 281n20
Benton, Robert, 281n37, 283n68, 284n99
Benveniste, Emile, 168
Bergren, Douglas, 163, 278n101
Bierwisch, Manfred, 26, 265n7
biological determinism, 7
Black, Max, 24, 149–51, 152, 153, 155, 172, 264n2, 277nn79–81, nn83–5, n89
body, 5, 6, 7, 17, 21, 22, 29, 52, 107, 181, 199, 228, 230, 259; as anchor of meaning, 202; deictic presence, 66; exclusion of, 112; referential presence, 66; and syncategorematic words, 66
Bogue, Ronald, 280n12
Bohr, Niels, 38, 152, 154
Boyd, Richard, 163, 278n101
Brentano, Franz, 36
Bradley, F.H., 275n37
Brouwer, L.E.J., 126
Bubner, Rüdiger, 281n41, 284n100
Buchdahl, Gerd, 275n37

Buddhist logic, 126–8; intersemiotic view, 127
Buerger, Christa, 286n27
Bühler, Karl, 149–50, 277n77
Butler, Guy, v

Carnap, Rudolf, 11, 20, 41, 47, 54, 76–106, 266n20, 268n44, 269n54, 271nn33–8, 272nn39–64, 273nn68–71, n73, n75, nn77–83, 274n25, 275n29; constants and variables, 97; critique of, 94–5, 98–101, 102–5; derivative meaning, 86–7; emphasis on syntax, 78; on extra-linguistic facts, 77; his more general aim, 77; imagination, 105; intensional vagueness, 83, 90; kinds of meaning, 85; meaning and sense, 85–8; meaning and truth, 85; meaning identity, 87; overdeterminateness, 103; pure derivation, 97; range, 91–2; rules and conventions, 95–6; satisfying a rule, 88–92; semantical system, 80; semantics as syntax, 81; sense, defined, 86; sleight of hand, 78, 99–100; suppressed textualism, 105; and syntactic world, 79; world, 101–6
Carroll, John, 153
censorship, 112
Chinese room, 68
Chomsky, Noam A., 265n7
Cixous, Hélène, 260
Clifford, James, xi
Coffa, Alberto, 7, 273n84
Cohen, Ted, 276n65
colour readings, 168
commensurability of signs, 48; relative, 4; restricted to the formal, 48
community, 7, 25, 29, 35, 36, 39, 43; 44–6, 48, 49, 69, 74, 124, 135; 177,

257; defined, 33; as ingredient in signification, 66; and machine, 91; and negation, 143
concepts: fuzzy, 178; as heuristic, 177; instability of, 28; as permeable frames, 200; social roots, 66
concretization, 31, 114, 167; of meaning, 47
conditions, 112; of concept, 246; empty, 21, 214; postmodern, of meaning, 233–53
conflation of two kinds of sense, 112–44, 146: and metaphor, 166; political implications, 142; and the postmodern, 251
constraints, 7, 24–5, 50, 217, 257; base, 24, 50; community, 24, 49; deep, 49; intersemiotic, 34–5
contradictory expressions, 113, 130; contrariness and community, 119; contrary expressions, 113, 130; formal and non-formal, 130; intersemiotic solution, 130; and social semiosis, 118
copula, 30, 52, 59, 66–7; as comparative social act, 66
corporeal: perspective, 113, 115, 144 166, 175; roots, 170–1; semantics (see semantics) ; supplementarity, 202; turn, xii, 4, 21, 254
corporeality, 3, 17, 52, 66, 76, 81, 90, 107, 116, 183, 199, 230, 233; and metaphor, 172–5; and political programs, 253; and pragmatic ambiguity, 133
COSS (Communicative Sign Systems), 37, 49, 139, 256
Crapanzano, Vincent, 259
cratylic delusion, 4
Crawford, Patricia, 281n38

critique: and deixis, 252–3; and reference, 252–3

Davidson, Donald, 8, 32, 72, 75, 109–10, 144–5, 147, 271n24, 273n3, 276n61, n66, 278n98; on metaphor, 159–60; right in reverse, 145, 160
deictic (deixis), 89, 234, 256; background, 124; conditions, 66; corporeal, 251; discrepancy of, 261; perspective, 58–9, 65–6; postmodern dissolution of, 247; quasi-, 185; reference, 26, 51, 65, 134; removal of, 91
Deleuze, Gilles, vii, 17, 21, 177, 179–82, 230, 280n11; and Guattari, Felix, 17, 182
De Man, Paul, 4, 263n3
Derrida, Jacques, 5–6, 8, 20, 21, 32, 42, 76, 110–12, 179, 182, 199–228, 230, 239, 247, 250, 253, 263n4, n9, 271n32, 274n4, 276n59, 278nn105–7, 282n46, nn48–52, nn54–9, n62, 283n73, nn75–7, n81, n83, nn85–6, 284nn88–9, nn91–6, n103, 286n48, 287n50; blind tactics, 213; discourse, 6; and intersemiotic perspective, 164; metaphor, 110–12, 164–5; metaphoricity and 'as-structure,' 13, 110–12; the non-linguistic as potential critique of conceptuality, 43; retrait, 110–12, 164; semantic analysis, 213
De Saussure, Ferdinand, xii, 3, 21, 26, 42, 168, 176, 212, 216, 218, 229, 265n6, 268n45, 283n80
Devitt, Michael, 23–6, 58, 264n1, 266n18, 267n33, 270n11
Dewey, John, 266n15
Dickie, George, 148, 277n71
dictionary, 86; as double syntax without meaning, 46, 254

différance, 199–228
differend, 183–99; defined, 188; incomplete, 184, 195–7; in need of semantics, 253; semantics of, 197–9; semiotic critique, 195–7; as structural hostility, 188
differentiation: indifferent, 21, 251, 253; mere, 21; –, and social vision, 251
digital, 114; semantic effects, 242–4; as semiotic management, 119; social metaphoricity, 243–4; as syntax, 21, 242–3
Dilthey, Wilhelm, 20, 178, 264n25, 279n4, 280n5
Dilworth, John B., 279n119
directionality: concrete situations, 147; double, 52; of linguistic expressions, 47; of meaning, 147; quasi-deictic, 52; quasi-referential, 52; quasi-representational, 51; underdetermined, 40
discourse: culturally saturated, 74; and non-verbal signs, 168
double negation, formal vs. natural, 141
Dryer, D.P., 281n36
Dufrenne, Mikel, 281n23
Dummett, Michael, 60–1, 72, 267n28, 270nn13–16, 271n26

Eagleton, Terry, 241, 244, 281n27, 286n30
Eco, Umberto, 13, 32, 36, 44, 59, 264n21, 266n25, 269n53, 276n60
Edie, James, 169, 279n120
eidetic (eidos), 22
entailment, 55; critique of, 57
Erickson, Glenn, 163, 278n101
Ervin, Susan, 259
experience, 36–7,
extension, xii, 62, 81–5

falsehood, intersemiotic critique, 124–5
fictional: entities, 71; expressions, 61; as
 necessity, 104; reference, 61, 63, 84;
 representational function, 104
figuration, 4
Fillmore, Charles, 129
formalization: as a posteriori, 131; and
 deformalization, 91; a one-way street,
 85, 166
formal semantics. *See* semantics; Carnap
Foster, Hal, 285n23
Foucault, Michel, 177, 230, 238, 250
Frege, Gottlob, xii, 7–8, 11, 20, 21, 25,
 32, 49, 51, 52, 53, 59–76, 78, 115,
 116, 122, 130, 132, 138, 166, 229,
 263nn10–11, 264n18, 269n1, 270n5,
 n12, 271n31, 274n13, n18; conflation
 of two kinds of sense, 7, 59–76; two
 kinds of signified, 62
Freud, Sigmund, 21, 136–8, 176, 224,
 276nn51–5
Frow, John, 285n10, nn12–13
Fuery, Patrick, 264n28
function words, 52, 66; and body, 66;
 copula, 30, 52; and reflection of the
 social, 52
fuzzy logic, 128–9; not fuzzy enough,
 128–9

Gadamer, Hans-Georg, 12, 178, 278n7,
 n9
Gale, Richard M., 275n34
Gasché, Rodolphe, 204, 206, 278n108,
 282n60
Gass, William H., 169, 279n120
Geach, Peter T., 122, 274nn19–20
genocidal negation, 142–3
gestures, 113; of negation, 115
Gill, Jerry, 163–4, 278n101, n103
glances, 113

Gödel, Kurt, 76, 200, 206, 268n47,
 282n64
Goodman, Nelson, 71, 158, 271n23,
 278n94
gravitational signs, 47, 162, 168
Gribbin, John, 38, 268n38
Grice, Paul, 25, 266n17, 267n34
gustatory signs, 7, 35, 74, 84, 113, 162,
 168, 187, 254, 261

Habermas, Jürgen, 192–3, 227, 241,
 246–8, 268n42, 282n43, 284n97,
 286n35, n37, n39
habit, 3, 124,
Hallett, Garth, 54, 269n2
Halliday, Michael, 80
haptic signs, xii, 6, 7, 24, 35, 47, 49, 52,
 65, 74, 84, 113, 168, 235, 254, 261
Harraway, Donna J., 287n49
Harré, Rom, 163, 276n101
Hassan, Ihab, 285n16
Hausman, Carl, 151, 163, 168, 277n86,
 278n102, 279n117
Hegel, Friedrich Wilhelm, 221, 284n87
Heidegger, Martin, 8, 9, 13–17, 20,
 24, 110–11, 164–5, 176, 183, 200,
 202, 225–7, 241, 247, 263n8,
 264n22, 266n21, 270n18, 278n109,
 279n111, 281n31, 282n53, 286n28;
 as-structure, 13, 66, 165, 203; and
 heterosemiosis, 165; non-verbal
 implications, 17
hermeneutic tradition, 8, 12; circularity,
 177, 199, 209; and Kant, 177–8
Hester, Marcus, 169, 279n119
heterosemiotic, xii, 6, 7, 20, 35, 46–
 51, 112, 175, 200; associations, 255;
 constellations, 124; examples, 38–9;
 frame, 112; relations, 174; results,
 255

Heyting, Arend, 126
Hintikka, Jaakko, 282n42, 283n71, 284n101
Hirsch, E.D., 178
Hohendahl, Peter U., 286n36, n38
Horn, Laurence, 112–15, 121–3, 125–7, 129–36, 274n5, n10, n14, nn16–17, nn20–1, n26, 275n31, n44, n46, n48, 275n31, n33, n38, n44, n46, n 48, 276n50; paradox of negative judgment, 123
Husserl, Edmund, xii, 5, 8, 31, 36, 76, 99, 100, 103, 134, 146, 169, 178, 200, 219–23, 263n8, 267n31, 275n49, 281n33, 283n84; appresentation, 31, 103, 266n25; heuristic 'now,' 5, 220; horizon, 59; inner time consciousness, 202, 219–21; noetic modifications, 179, 199; protensions, 36; retentions, 36
Huyssen, Andreas, 285n17, n19

iconicity, 4, 6, 114
identification, qualitative and quantitative, 52
imaginative exploration, 167
incompatibility, 120
indeterminacy, 30, 58, 140
Ingarden, Roman, 8, 276n56
instantiation, 42
intension, xii, 39, 58, 62, 81–5; restricted to formal domain, 62
interpretive approximations, 47
intersemiotic, xii, 6, 7, 11, 31, 40, 49, 50–2, 107, 112, 116, 117, 171, 172; acts and machines, 91; corroboration, 8, 34, 35, 37–8, 42, 235; fantasies, 104; frame, 112; metalingual, 121; perspective, 144, 169, 200; preconditions, 121; reference, 202;

relations, 90, 174; schema, 236; supplementarity, 202; and syntax, 96; textualism, 106–7
Irigaray, Luce, 260
Iser, Wolfgang, 276n58

Jakobson, Roman, 45, 265n14, 266n25, 267n35, 268n41
Jameson, Fredric, 241, 244–6, 285n11, n14, n22, n24, 286nn31–4
Jauss, Hans Robert, 12
Jencks, Charles, 285n15
Jespersen, Otto, 129, 275n45
Johnson, Mark, 163, 175, 278n100, 279n122
judgments, as frames for sense, 116

Kant, Immanuel, 5, 8, 9, 12, 24, 27–8, 122, 126, 166, 183–4, 188–92, 199, 205–9, 228, 249, 263nn6–7, 264n20, 265nn8–11, 269n48, 275n36, 279n1, 280n15, 281n22, nn24–6, nn28–30, 282n47, n63, 283n65, n69, n72, n82, 284n102; critique of concept, 43, 177; critique of telos, 12, 28; open teleology, 28; reflective reason, 12, 28, 48; schematism, 27, 75
Katz, Jerrold J., 58, 265n7
Kempson, Ruth M., 26, 108–9, 265n7, 273n1, 275n28
kinetic signs, 186, 261
Körner, Stephen, 191–2, 281nn34–5, 283n71
Kotarbinski, Tadeusz, 76
Kraus, Rosalind E., 285n25
Kripke, Saul, xii, 131, 185, 275n47
Kurrik, Maire Jaanus, 122, 274n22
Kusch, Martin, 266n19

Lacan, Jacques, xii, 259

Lakoff, George, 129, 152, 160–2, 277n88, 278n99, n100; intersemiotic critique, 161–3

Langer, Susanne, 169, 279n118

language (natural): as always already referential, 65, 234; and calculus, 78, 152; as corporeal, 162; as directional schema, 42–3, 49, 67, 75, 167, 256; and formal grid, 133; as heterosemiotic, 47; as meaningless, 46, 254, 261; and metaphor, 107; and negation, 107; no intension without extension, 84; no L-equivalence, 85; parasitic on non-verbal signs, 144; and pure derivation, 97–8; and referential ingredients, 64; teaching experiment, 68; and variables, 96

langue, as parole, 42

Lebenselement, 163

Lebensformen, 11, 74, 163–4, 261; redefined, 164; as theoretical primitivum, 31

Lecercle, Jean-Jacques, 17–18, 264n26

Lee, Dorothy, 146, 276n62

Leibniz, Gottfried Wilhelm, 8, 9–11, 49, 54, 264nn13–17, 269n50; and poststructuralism, 177

Leinsfellner-Rupertsberger, Elizabeth, 276n57

Lesniewski, Stanislav, 76

linguistic expressions, 235; as directional schemata, 47, 49, 76, 113, 164; –, double directionality of, 51; as economizing grid, 75, 139; as substitute, 20

linguistic imperialism, 186

Locke, John, 3–4, 8, 278n110, 279n110

Lukasiewicz, Jan, 76

Lyotard, Jean-Francois, 8, 20, 21, 176, 177, 182–3, 183–99, 230, 248–50, 280nn13–14, n17, n19, 281n21, 282nn44–5, 283n70, 285n15, 286nn40–7, 287n51; extralinguistic permanence, 187; liquidation of emancipation, 249; non-linguistic sentence, 187

MacCormac, Earl R., 153

McHoul, Alec, 269n51

Mack, Robert, 153

Malpas, Jeff, 264n24, 281n40

Marcus, George E., xi

Marcuse, Herbert, 247

Marks, Lawrence E., 274n11

Martin, Janet, 163, 278n101

Martin, John N., 268n39

Matilal, Bimal Krishna, 275n41

Maturana, Humberto, 274n12

meaning, xiii, 7, 11; as abduction, 30; as activation by non-verbal signs, 254; as alignment, 25, 50; analytical, 110; as a posteriori description, 11, 48; axes of, 39–42; as carried away, 199; class-dependent, 41; as contaminated, 199; as corporeal, 27, 166, 181; and cultural perspective, 59; curtailment of, 52; defined, 24, 25, 39–46, 50–2, 110; as definition, 11, 24, 48, 203; definitional, 145–6; derivative, 86; as dialogical dynamic, 42; as directional, 40–3; as emancipatory potential, 41; and exteriority, 182; gender-dependent, 41; in Heidegger, 13–17; as heterosemiotic, 50, 144, 255; as holistic, 32; identity of, 39; and ideological saturation, 41; as indirect reference, 180; as inexhaustible, 29; as infinite regress, 13, 30, 43–4, 51; as intersemiotic, 50–2,

74, 144, 254–5; as intuitive grasp, 33; literal, 25, 69, 73–4; ludic, 40; and the Möbius strip, 180; as negotiation, 40–2, 50; as noetic, 51; as non-linguistic activation, 42, 51, 144; not a property of signs, 42; as part–whole relation, 177–8; pragmatic, 40; as process, 36; as relational instantiation of signs, 35; socially distant, 177; under social rules, 113; spectrum of, 40; as strict sense, 26, 47; as syneidetic, 181; –, rejected, 181; as transcendental, 228; as virtual event, 24, 25, 52, 179, 182; wobbliness of, 41, 177

mediation, 5, 27; directional, 147

mental–material content, 6

Merleau-Ponty, Maurice, xii, 21–2, 169

metaphor, 20, 144–75; and AI, 153; and body, 175; cognitive function, 163; as comparison, 148; conceptual, 161; and conceptual graphs, 153–6; and corporeality, 172–5; dead, 147, 175; dormant, 147, 175; and DTH, 153–6; heterosemiotic nature, 146, 175; as heterosemiotic reference, 175; image, 161; as imaginative exploration, 167; and interaction, 149–50, 153; as intersemiotic instructions, 175; as mask, 153–4; as multiple pathway, 146; and non-linguistic signs, 162; referential function, 167; and resemblance, 149; as riddle, 149, 152; strong version, 162; as substitution, 148; and ubiquity thesis, 160–6; weak version, 161–2

metaphorical force, 147; degrees of, 147

metaphoricity, 13, 110–12, 203–4; electronic, 243; sliding scale, 147

metasemantics, 7, 8

Meyers, C.M., 38, 268n37

Miall, David S., 278n101

Mill, John Stuart, 58–9

misunderstanding, as social fact, 41

modal force, 235

modalities, 40, 234, 256

modality, 41; political 42

Morris, Charles W., 79, 122,

Mueller-Vollmer, Kurt, 280n8

Mulligan, Kevin, 265n3

negation, 20, 112–44; as affirmation, 114; and animals, 114; beyond language, 114, 119, 121; contrary and contradictory, 130–1; cultural, 107, 139–43; external, 21; formal, 115–21; genocidal, 112, 142–3; heterosemiotic, 143; and heterosemiotic signs, 115; holistic perspective, 108; homosemiotic, 143; internal, 121; as interpretation, 113; as intersemiotic, 135; and irony, 139; as liberating, 138; macrostructural, 144; marked and unmarked, 139; metalinguistic, 136; as modality, 117; in natural language, 129–30; not restricted to language, 139; as part of judgments, 117; as refinement, 115; as rudimentary semiosis, 139; and the unconscious, 136–9; as *Verurteilung*, 139

negative facts, 125; as heterosemiotic fictions, 125–6

neg-raising, 129–30

Nietzsche, Friedrich, 11, 21, 38, 43, 50, 166, 176, 222–4, 247, 264n19, 279n115

non-linguistic: background, 75; free play, 173; negation, 121; quasi-corporeal constructions, 173;

readings, 47; relations, 49, 165;
semiosis, 167; signs, 34, 47, 49, 67,
75–6, 84, 144, 168–9, 202, 216
non-signs, 33
non-verbal, 20, 49, 109, 230; acts, 168;
grasp, 5; negation, 119; readings,
4, 261; schemata, 146; signs, xii,
6, 24, 51, 52, 202, 203; –, and
metaphor, 161, 167, 172; –, web of,
96; utterances, 113
non-verbal signification, 4–5, 6, 21, 75,
167, 173, 252; and body, 66; and
cultural negation, 141; and metaphor,
146, 167; as quasi-perception, 51; vs.
truth, 74
Norris, Christopher, 287n52
'now': heuristic, 5, 220; and meaning,
36, 52

odour, 29
olfactory signs, xii, 7, 35, 42, 49, 51, 52,
74, 84, 113, 146, 162, 168, 186, 254,
261
opacity, 8, 60, 166; modal, 166;
propositional, 166; semiotic, 166
oral signs, 113
Ortony, Andrew, 278n101
ostension, broadly semiotic, 187

Palmer, F.R., 265n7
Parmenides, 113
Paton, H.J., 190, 281nn31–2, 283n66,
n68
Peacocke, Christopher, 279n112
Peirce, Charles Sanders, 3–4, 8, 13,
17, 19, 28–31, 48, 59, 131, 217,
218, 263n2, 265nn12–13, 266n16,
266nn22–3, 269n49, n51, n56,
270n19, 280n16, 283n79; assertoric
judgments, 30; community, 31, 45;

copula, 30, 67; double indefiniteness
of sign, 30; inferential realism,
31; infinite regress, 43–4, 51;
interpretant, 30
perception, xii; defined as ROSS, 49; as
semiotic, 37; as sign practice, 49
perceptual: grasp, 5; readings, 235
pictorial signification, 187
Plato, 113, 274n6
Ponzi, Augusto, 18–19, 264n27
Popper, Karl, 272n67
Portoghesi, Paolo, 285n15
postmodern, 21; denial of meaning,
229; and the digital, 237–8, 239–44;
double character of, 248; elimination
of deixis, 253; as indifferent
difference, 236; as indirect speech
act, 233; paradox, 236; postures, 113;
and realist constraints, 251; schizo-
fragmentation, 246; semantics, 252;
as sorting base, 248; superterms, 240;
surface, 230, 238; –, and production,
251; syntax, xii, 229, 250
poststructuralism, 176–228; elaboration
of meaning, 176; semantic regress,
176
Poyates, Fernando, 267n25
Poynton, Cate, 267n26
Pragmatics, 79; as semantics, 131, 135;
and speaker meaning, 134
Pratt, Mary Louise, 269n52
predicates, intersemiotically entrenched,
71
presence, 5
proximic signs, 35, 47, 49, 51, 84, 113,
168, 186, 261
public sphere, global, 151
Putnam, Hilary, 58, 260, 270n10

quasi-corporeal grasp, 109

quasi-corporeality, 97
quasi-deixis, 52
quasi-reference, 52, 69
Quine, Willard van Orman, 3, 8, 19,
 24, 54, 55–8, 82–4, 122, 270nn8–9

realism, 123; inferential, 25, 29, 31, 49,
 106, 166; metaphysical, 35, 49; naïve,
 166; textual, 25, 39
realist textualism, 35, 39, 45
reason: insufficient, 9–10; reflective, 12,
 28; sufficient, 9–10
reference, xii, 5, 11, 55–68, 184–5, 217;
 defined, 47; deictic, 26, 51, 65, 134;
 discrepancy of, 261; fictional, 63;
 general, 65, 67; as heterosemiotic
 transgression, 168; intersemiotic, 26,
 55, 123, 202, 234; and metaphor,
 167; minimal, 67; necessity of, 68;
 postmodern dissolution of, 248;
 specific (Fregean), 65, 67
referential: background, 124;
 embedding, 75
relativism: radical, 34–5; naïve, 259
representation, 69, 70, 85–6, 246, 260;
 aural, 4; filmic, 256; intersubjective,
 70
representational certitude, 166
Richards, I.A., 150, 276nn77–8
Rickman, H.P., 280n6
Ricoeur, Paul, 167–9, 279n116; critique
 of, 168–9; impertinent predication,
 167
ROSS (Read-Only Sign Systems), 37,
 49, 139, 255–6
Russell, Bertrand, 122, 125, 270n6,
 275n32
Ryle, Gilbert, 275n28

scalar predication, 132

Schaper, Eva, 281n39, 283n68, 284n98
Schiffer, Stephen, 73, 271n29
Schleiermacher, Friedrich, 177, 278n3
Schutz, Alfred, 8, 31, 169, 222–3
Searle, John R., 25, 32, 68, 122,
 148, 151, 264n23, 265n4, 271n20,
 272nn65–6, 277n70, n87, n92,
 278n96, 279n121; on metaphor, 156–
 9; –, critique of, 158–9, 173–4
Sebeok, Thomas A., 266n25, 274n8
semantic: background, 87; drift, 39,
 203; holism, 27
semantics, 3, 12, 42, 68–9, 78–106;
 and body, 7; as calculus, 252;
 corporeal, 19, 23–31, 66, 107,
 112, 134, 147, 228, 256, 257, 259;
 culturally saturated, 251; definitional,
 12; descriptive, 80; formal, 32,
 41; heterosemiotic, 7, 46–7, 254,
 261; homosemiotic, 19, 46–7;
 intersemiotic, 2, 26, 28, 204, 230,
 234, 254, 259, 261; metaphysics of,
 49–50, 162, 258; murky, 66; and
 non-verbal signs, 4; and postmodern,
 21; as pragmatics, 131, 135, 136;
 pure, 80; social, 66, 91, 233–4
semiosis: and culture, 59; general, 35;
 infinite regress, 29; social, 43
semiotic: corroboration, 33–4, 37, 38,
 42; holism, 30; overdetermination,
 71, 103
semiotics of gesture, 186
sense: always already referential, 65;
 formal, 141; formal and non-formal,
 13, 16, 19, 59–76, 141; intensional,
 58, 62; and metaphor, 166; natural,
 15, 56, 65, 142; as schema (Frege),
 75; strict, 41, 54, 143; two kinds, 48,
 59–76. See also Frege, Gottlob
Sharma, Dhirendra, 275n40

Shcherbatskoi, F.I., 275n39
Shibles, Warren, 278n101
signification: directed, 40; non-linguistic,
115; non-verbal, 4, 6, 26, 66
significatory: abyss, 43; acts, 32;
Anschauungen, 75; confirmations, 39;
practice, 4; processes, 24, 36; world,
216
signs: enacted, 36; formally empty, 41;
infinite chain, 217; infinite regress of,
44; intersemiotic, 115; meaning of,
39; non-linguistic, 65, 76, 87; non-
verbal, 52, 94
Smith, Stephen B., 275n28
social semiosis, 135; and double
negation, 142
social semiotics, 36, 42, 44
Sofia, Zoe, 287n49
Sommers, Fred, 275n27
speech processes. *See* deictic
speech situation, 19, 51, 58–9, 65
Stählin, Wilhelm, 149–50, 277n77
Standford, Bedell, 165, 278n110
Sterelny, Kim, 23–6, 58, 264n1,
266n18, 270n11
Stevens, Wallace, 147, 276n64
Stewart, Ian, 275n43
Strawson, P.F., 54, 71, 122, 271n22
subjectivism (mentalism), 25, 36, 51,
69–70
substitutability, 87
sufficient semiosis, xiv, 11, 38, 44, 70,
258; defined, 48–9
symmetricalists, 122–6; asymmetricalists,
115; critique of, 117, 123; and
intersemiotic signs, 115
synaesthesia, 165; radicalization of, 165
syncategorematic words, as corporeal,
66, 87, 254
synonymy, xii, 48, 55–8, 61–2

syntactic: bias, 21; praxis, 200, 213; re-
lations, xii, 51, 214; substitutions, 52
syntax, 6, 8, 32, 51, 68–9, 78–106, 183;
of the dice, 232; does not mean, 91;
mere, 68; as politics, 112; tolerance
in, 95

tactile signs, xii, 6, 7, 11, 17, 24, 35, 36,
47, 49, 50, 51, 52, 65, 74, 113, 146,
162, 168, 186, 235, 254–5, 261
Tarski, Alfred, 41, 53, 75, 76, 185,
268n43
Tax, Sol, 259
teleology, open-ended, 12, 28
telos, 251
thermal signs, 47, 65, 75, 162, 168, 254
transcendental: argument, 188–93, 204–
28; incomplete, 182; moves, 20, 209–
10, 217; procedure, 21, 28, 181–2,
203, 204–9, 219; signified, 5, 21, 28,
184, 216
truth, xii, 9, 41, 55–7, 71–5; and non-
verbal signs, 74
truth conditions, 23, 36, 49, 60, 74;
as infinite regress, 27; replaced by
sufficient semiosis, 48
truth conventions, 41
Turbayne, Colin, 158, 278n95, n97
Turner, Mark, 152, 160–2, 277n88,
278n99
typifications, 31, 65, 69, 222

underdetermination, 30, 38, 40, 219;
of directionality of meaning, 43; and
fiction, 71
understanding, as social signification, 66
use, xii, 45, 54, 73–4; politics of, 164
utterance, 234; neutral, 25–6; perspec-
tive, 58–9, 65; situation, 19, 65–6, 89,
252; as social, political deixis, 251

Varela, Francisco, 260, 274n12
verstehen, 12, 162; in a flash, 75
visual signs, xii, 4, 7, 11, 17, 24, 35, 36, 47, 50, 69–70, 113, 162, 168, 186
volition, 29
Vorstellung, 5, 49, 51, 99, 257, 260; as mental representation, 257

Warner, Martin, 277n82
Way, Eileen Cornell, 152–6, 277n90–1
Weber, Max, 247
Whitehead, Alfred North, 76
Wiggins, David, 73–5, 271n28; semiotic problematic, 74

Wittgenstein, Ludwig, 25, 31, 34, 54, 55, 71, 74, 75, 76, 122, 126, 163–4, 166, 260, 266n25, 267n27, 270n3, n4, n7, 271n30, 274n15, 275n30, n35, 278n104
Wolff, Robert Paul, 207, 283n67
Wolin, Richard, 285n18
Wood, David, 205, 282n61
'world,' xii, 5, 6, 7, 16, 23, 24, 27, 30, 31, 33, 34, 36–7, 44, 49, 50, 66, 123, 131, 167
Wunderlich, Dieter, 25, 265n5

Yoos, George, 109, 169, 273n2